The Poethical Wager

Joan Retallack

UNIVERSITY OF CALIFORNIA PRESS
Berkeley · *Los Angeles* · *London*

University of California Press
Berkeley and Los Angeles, California

University of California Press, Ltd.
London, England

© 2003 by The Regents of the University of California

For acknowledgments of permissions, please see
page 269.

Library of Congress Cataloging-in-Publication Data

Retallack, Joan.
 The poethical wager / Joan Retallack.
 p. cm.
Includes bibliographical references and index.

 ISBN 978-0-520-21841-3 (pbk. : alk. paper)

 1. Feminism and literature. 2. Women in
literature. 3. Literature, Modern—History and
criticism. 4. Literature and morals. I. Title.

 PN56.F46 R48 2003

 809'.93352042—dc21

 2002151319
 CIP

Printed in the United States of America

12 11 10
10 9 8 7 6 5 4 3 2

*This book is dedicated to Holly Arnao Swain,
Caitlin, Walker, and Erin*

The only thing that is different from one time to another is what is seen and what is seen depends upon how everybody is doing everything.

It is understood by this time that everything is the same except composition and time, composition and the time of the composition and the time in the composition.... The composition is the thing seen by every one living in the living they are doing, they are the composing of the composition that at the time they are living is the composition of the time in which they are living.

<div align="right">Gertrude Stein, "Composition As Explanation"</div>

Contents

Acknowledgments

I feel lucky to have known so many whose improbable minds and work have enlarged my sense of poetic possibility and who have, in countless ways, affected this book. Tina Darragh and Peter Inman have been friends in conversation and experimental spirit since the late 1970s. A sustained correspondence with Jackson Mac Low helped me clarify my working concept of poethics. Lyn Hejinian, Anne Tardos, and Rosmarie Waldrop have contributed directly and indirectly to my projects of the last decade through generosities of many kinds, by humor and example, by questions and challenges, and by the energies and lucidities of their own work. Ulla Dydo has been a source of inspiration and assistance in all the work I've done on Gertrude Stein since the early 1990s. I am indebted to Marjorie Perloff's work that, at least since the 1981 publication of *The Poetics of Indeterminacy,* has changed the topography of academic discourse on twenty-first-century experimental poetics in important ways. Her research on international, interdisciplinary historical contexts linking avant-garde movements from the late nineteenth century on has led many of us to a new understanding of indeterminacy in Euro-American literatures prior to the influence of John Cage.

Others from whose friendship and conversation—on and off the page—I have benefited enormously are John Ashbery, Peter Baker, Caroline Bergvall, Charles Bernstein, Robert Creeley, Rachel Blau DuPlessis, Lynne Dreyer, Carolyn Forché, Dominique Fourcade, Alan Golding, Burton Hatlen, Susan Howe, Lynn Keller, Susan Kirschner,

Laura Kuhn, Doug Lang, Ann Lauterbach, Tom Mandel, Jerome McGann, Bill Mullen, Jena Osman, Bob Perelman, Meredith Quartermain, Peter Quartermain, Phyllis Rosenzweig, Jacques Roubaud, Ron Silliman, Myra Sklarew, Mary Margaret Sloan, Rod Smith, Juliana Spahr, Keith Waldrop, Mark Wallace, Terence Winch.

Alan Devenish, whose friendship in life and literature (with no gap implied) has been a two-decade pleasure, read large portions of the final manuscript, caught many inadvertent unintelligibilities and offered invaluable suggestions for elucidating language at difficult conceptual intersections.

Jane Flax has been a cherished friend whose lucid mind has often helped me clarify ideas that enter into my work. The surprising, humorous scope of our conversations has been a constant delight.

The two H.A.S.s in my life—my daughter Holly Arnao Swain and my late husband, and beloved friend, Henry Albert Segal—are in this book in more ways than probably even I can know. Holly gave me crucial help during the final editing of many of the essays.

Had I not met John Cage and Buckminster Fuller in my early twenties, my methodical optimism might not exist. It was Cage's lifework that led me to the term *poethics*.

I wish to thank the editors with whom I've worked at the University of California Press. Linda Norton invited me to submit the manuscript of this book and encouraged me to put it together in the way I believed it needed to be done. I appreciate her early support of the project, along with that of her assistant Randy Heyman. I am grateful to Laura Cerruti and Rachel Berchten for guiding the book through production and to Joe Abbott for his knowledgeable and precise copyediting. Bard students Ella von Holtum and Kate Schapira worked with dedication on the bibliography and permissions requests. Eirik Steinhoff's active reading-through of the page proofs gave me much needed assistance and courage to finally face what I have done.

A small disclaimer. The essays in this book are the product of more than a decade of writing about and applying a conceptual framework I've been calling poethics. I have wanted them to remain independent as essays but also to work together in the formulation of the argument of the book. The sequence in which they are placed is significant, but, because they are essays, I know they will not necessarily be read sequentially. I have therefore repeated some (I hope not too many) key quotations and explanations of terms where I felt they were necessary to the internal logic of a piece.

Essay as Wager

In the dream a small plane falls out of the sky. The writer is lucky. She crawls out and walks away with bad memories and a crooked smile.

> Dita Fröller, "Autobio: A Littered Aria," from
> *New Old World Marvels*

Former Guerrillas Are Dressed in Dark Suits and Children Play in Foxholes

> *New York Times*, 9.28.01

Life is subject to swerves—sometimes gentle, often violent out-of-the-blue motions that cut obliquely across material and conceptual logics. If everything were hunky-dory, it might not be so important to attend to them. As it is, they afford opportunities to usefully rethink habits of thought. Relativity theory, the quantum mechanical principles of complementarity and uncertainty, constituted major conceptual swerves with consequences in the culture at large, as did Freud's theory of the unconscious and, more recently, chaos theory. Dada and surrealism, the work of James Joyce, Marcel Duchamp, Ludwig Wittgenstein, Gertrude Stein, Benoit Mandelbrot, John Cage have all created productive cultural dislocations. The sudden interconnectedness of the planet via satellites and the internet has brought on a cascade of unforeseen consequences. September 11, 2001, was a paradigmatic swerve, wrenching a parochial "us" into a new world of risks without borders.

How can one frame a poetics of the swerve, a constructive preoccupation with what are unpredictable forms of change? One might begin by stating this: what they all have in common is an unsettling transfiguration of once-familiar terrain. They tend to produce disorientation, even estrangement, by radically altering geometries of attention. In today's world politics a geometry of straight lines in the sand ("we dare you to cross") is obsolete. Whether global leaders recognize it or not, "world us" is now in a situation where the fractal geometry of coastlines, with their ecologically dynamic, infinite detail, may be a more

productive model for the interrelationships of cultures. You may notice
that my sense of geometries of attention crosses disciplinary and generic
boundaries. I believe we learn the most about what it can mean to be
human from border-transgressive conversations.

In the third century B.C.E. the Greek philosopher Epicurus posited
the swerve (a.k.a. clinamen)[1] to explain how change could occur in
what early atomists had argued was a deterministic universe that he
himself saw as composed of elemental bodies moving in unalterable
paths. Epicurus attributed the redistribution of matter that creates no-
ticeable differences to the sudden zig or zag of rogue atoms. Swerves
made everything happen yet could not be predicted or explained. Lu-
cretius put it this way in his Epicurean poem *De Rerum Natura*:

> While the first bodies are being carried downwards by their own weight in a
> straight line through the void, at times quite uncertain and [in] uncertain
> places, they swerve a little from their course, just so much as you might call
> a change of motion. For if they were not apt to incline, all would fall down-
> wards like raindrops through the profound void, no collision would take
> place and no blow would be caused amongst the first-beginnings: thus
> nature would never have produced anything.[2]

Assigning such a crucial role to chance roused many critics, Cicero
chief among them. Cicero saw that the refusal of preordained necessity
opened up disquieting possibilities. He accused Epicurus of, among
many other offenses, denying that there was no alternative to state-
ments of the form "either this or not this."[3] In an interesting post-So-
cratic, or perhaps neo-pre-Socratic, blurring of genres, the poesis of the
swerve had shown up in Epicurus's logic and in what one would now
call his social philosophy, as well as his physics. (He felt no need to dis-
tinguish between micro- and macropatterns.) Epicurus founded a com-
munity, remarkable for its time, known as "The Garden." It was de-
voted to friendship, philosophical conversation, and delight in simple
pleasures of the senses (free sex not among them). Women and those of
humble origins participated on equal terms with educated men. Ethical
and aesthetic values were considered inseparable. Epicurus's belief in
free will engendered, if anything, a heightened sense of ethical responsi-
bility. But, if Cicero could feel impelled to characterize Epicurean meta-
physics as brazen and shameful,[4] imagine the reaction to The Garden.
This community swerved so startlingly from accepted norms that it was
from its inception reviled. And that is certainly less surprising than the
fact that a utopian community based on the Epicurean maxim, "it is im-
possible to live pleasantly without living prudently, honorably, and

justly and impossible to live prudently, honorably, and justly without living pleasantly,"[5] appeared circa 300 B.C.E. at all. Social and historical forces—their all-too-familiar patterns perhaps more than their unpredictable complexities—make every new idea with a lot at stake, every consciously constructed swerve, a highly vulnerable wager.

Many, I know, find this discouraging. If innovative ideas with the best of intentions are likely to be misunderstood and maligned, isn't it better to forgo the trajectory of the swerve for routes more familiar and thus more widely intelligible from the outset? There are numerous versions of these qualms about the efficacy of experimental thought, except in the sciences, where it's seen as the nature of the enterprise. My inclination is to respond by identifying a certain poetics of responsibility with the courage of the swerve, the project of the wager—what I call a poethical attitude. Swerves (like antiromantic modernisms, the civil rights movement, feminism, postcolonialist critiques) are necessary to dislodge us from reactionary allegiances and nostalgias. This is, one way or another, what all the essays in this book are about.

I write the "project" of the wager because I'm interested in a poethics that recognizes the degree to which the chaos of world history, of all complex systems, makes it imperative that we move away from models of cultural and political agency lodged in isolated heroic acts and simplistic notions of cause and effect. Similarly, the monolithic worldview that leads to assessments of success or failure in the arts based on short-term counts of numbers persuaded—for example, the size of *the* audience—is particularly misguided. Although news media operate on the premise of a single worldwide field of events, from which the most important are daily chosen for review, human culture has always consisted of myriad communities with very different interests, values, and objectives. There are disparate "audiences" to define the character of culturally significant events and no way to know which will have the greatest effect on our multiple futures.

It makes much more sense to conceive of agency in the context of sustained projects, during the course of which many swerves may occur but which one guides with as much responsible awareness as possible. Whatever the outcome, such projects will make contributions to climates of value and opinion. In our unpredictable, polyglot world this means working out some kind of dynamic equilibrium between intention and receptivity, community and alterity. Collaborative, conversational values and a patience for duration may increase the chances of large-scale constructive effects, but the most realistic aim is a fairly modest one—to be-

have with concern and courage as an artist. The role of the clinamen is never entirely of anyone's own choosing, and this should be a relief. As my teenage daughter used to say when we were engaged in a particularly stubborn battle of wills, You don't really want to be responsible for all the choices I make, do you? Of course she was right. That all events are to a large extent other- and overdetermined, as well as subject to chance, releases one into the appropriate role of inquirer.

I count on the form of the essay—as urgent and aesthetically aware thought experiment—to undertake a particular kind of inquiry that is neither poetry nor philosophy but a mix of logics, dislogics, intuition, revulsion, wonder. The result can be a philosophical poetics as lively as current developments in the form of the prose poem. These mixed genres are the best way I know to make sense of the kind of world in which we live. To wager on a poetics of the conceptual swerve is to believe in the constancy of the unexpected—source of terror, humor, hope. I've attempted to use the energy that comes from that triad in all the forms my writing takes, to develop a poetics that keeps mind in motion amidst chaos. This motion on the page is analogous to that of the swimmer who takes pleasure in the act that also saves her from drowning.

In the late nineteenth and twentieth centuries, avant-garde poetries became a laboratory of languages colliding with an accelerated onrush of the new. The essay, with its capacity to accommodate interruptions and digressions, may be the chief prose-based experimental instrument of humanistic thought. At its best it detaches itself from the epistemology implied by narrative grammars, a tone of certainty that pervades even the most provisional material. (It may be happening right here.) By contrast the distractible logics of the essay are, or should be, attempts at nothing other than productive conjecture. This is the work of the literary humanities as they meet up with the intrusive unintelligibilities of breaking experience. The source of vitality for the essay is its engagement in conversational invention rather than ordinal accounts of things (including thoughts) that have already taken place.

Because it seems that what is most meaningful to our complex species will never make complete rational sense, will always defy paraphrase and description, may be wonderful and frightening at the same time, that is, approach paradox, genres that wholly depend on principles of identity, sequential narration, noncontradiction can only be of limited help. They're just not generous or improbable enough to encompass a complex realist perspective. It takes work to sustain complex rather than naïve realisms. (According to a complex realist view, for in-

stance, optimism may be best understood as a constructive form of pessimism.) Naïve realisms, fantasy-driven surrealisms, faux naturalisms are the specialty of mass culture. Everything in mass culture is designed to deliver space-time in a series of shiny freeze-frames, each with its built-in strategy of persuasion. One writes essays and poetry to stay warm and active and realistically messy. Everything in mass culture is designed to deliver space-time in a continuous drone. One writes poetry and essays to disrupt that fatal momentum. The sense that's broadcast by dominant public voices calls for intellectual and imaginative resignation, a naturalization of normapathic desire. The aim of my essay projects is to attend to alternative kinds of sense and—if possible, if lucky—to come up with some oddly relevant, frankly partial meaning. The difference between sense and meaning is important here: sense has to do with patterns and logics; meaning (which is larger than but includes this sense of sense) is what makes life worth living.

The most vital meaning has always come out of a dicey collaboration of intellect and imagination. The intuitive nature of this (inherently playful) balancing act makes it hard to fully know what one is doing while one is doing it. At the end of my work on this book, I wonder if it was about arriving at realizations still barely articulated in it—that a poetics of memory, for instance, must be transfigured by an informed poetics of desire if it's to nourish agency. (The question of meaningful cultural agency is what's always at stake.) By poetics of desire I mean whatever moves us toward a responsive and pleasurable connection to the world by means of informed sensualities of language. But in all this is an afterimage, aftertaste of discomfort with my own poetics of desire—an acute sense of chronically irresolvable reciprocal alterities.

Reciprocal alterity, as ethical and epistemological destabilizing principle, reveals itself in the problem of pronouns. However much one (or is it I?) may try for clarity, the conversation will never arrive at the apotheosis of the insider. Neither will it arrive at the status of reliable narrator. My implied "I am" as I write is as other to myself as any other that is an I whom I/we can never fully know. It propels me toward grammatical alienation from the very experience my language is clumsily trying to touch. The pronouns teeter on the know ledge, negotiating a calculus of entitlement, attempting a decorum of respect for tenuous distinctions between the scope of *my* experience, *one's, ours, yours, hers, his, theirs.* In the excitement, on the threshold, of what appears to be an enlarging perspective, the enterprise may seem not more but less troubling than it should. The pronoun should betray itself as contingent

even as it must never be arbitrary; it—this "it" for instance—is as necessary as it is insufficient.

So, as antidote to my incorrigible earnestness I feel it incumbent upon myself to admit that I experience the I in my essay writing as something of a stranger although I know that the ethos of the work is entirely dependent on it. (This situation is different from poetry as I experience it, since any I in poetry is by definition persona.) Something disturbingly like individual will, even ego, is pushing itself into the conversation with what clearly lies outside the scope of its understanding. Perhaps that disturbance is its saving grace. Drawn to the object—whose existence as object one has already denied in one's up-to-date epistemology—does that one still dare to want to know and be known, to understand and be understood? In one's fallen epistemologies of desire is one seeking the relief from or of otherness? Is this why I'm attracted to languages and worlds that are too beautifully, terrifyingly opaque and distant to care about or even register what I think about them? Paradoxically or not, the whole enterprise is entirely intimate. Touching, being touched, partaking of textual transfigurations in the unsettled weathers along personal/cultural coastlines is irreversibly compelling, incorrigibly real.

What prevents the logic of the essay from being arbitrary is the degree of its engagement as wager. The essay is a commitment to a thought experiment that is itself an ethical form of life. As such, for better and/or worse, it yields consequences like any troth. Troth is as close to truth as I can hope to get, and perhaps that's for the best because it discloses the rise in danger and responsibility as poetics of desire threaten to become socially enacted wagers. The nature of the wager is nothing other than complex realist conversation. But conversation—in too many of the greatest hits of Western thought—mutates into polemics. Conversation demands holding an image of the other in one's mind long enough to notice the difference between one's own point of view and possible alternatives. What was the Epicurean alternative to either/or?

Nietzsche's *Birth of Tragedy* troubles and astonishes in its simultaneous acquiescence to the Apollonian-Dionysian bifurcation (which Euripides' *Bacchae* identifies as M and F) and its refusal to declare a winner. Apollo and Dionysus are fierce contestants in a wrenching equilibration that has given distinctive form to that pattern-bounded disorder we call Western civilization. Together they locate the dangerously ungrounded current that is our source of cultural energy. Alone they stand for something too fundamental to be trusted. Because ratio-

nalist/irrationalist logics have studded all avenues with scintillating bi-
naries, beckoning to invidious comparison, I choose an agon transval-
ued by a dire and humorous, against-the-odds kind of play. It comes less
from Johan Huizinga's famous analysis in *Homo Ludens* than from
D. W. Winnicott's theories of play *as* the imaginative activity that con-
structs a meaningful reality in conversation with the world as one finds
it.[6] There, I think, is the location of the essay as wager—in the interme-
diate zone between self and world, in the distancing act of play. The dis-
tance engendered by a poethical recognition of reciprocal alterity stim-
ulates curiosity and exploration. Very different from the play of
postmodern irony—ironic distance is a closed case, a conspiracy of
knowing that can leave little room for noticing the nascent swerve.

Among my most cherished conversational pleasures were some that
occurred regularly during the 1990s with an elderly neighbor in a Wash-
ington, D.C., neighborhood, a career government employee who had
nurtured an active unlived life as a classicist through fifty years with the
Civil Service Commission and twenty years of retirement. When I
moved to Ridge Street, he informed me that its golden age was over. It
had come and gone in the 1950s, when a former Miss America lived
there. For this and more profound sadnesses—the death of his wife, the
death several years later of his companionable dog, the infrequency
with which he saw his children and grandchildren, the continuing
degradation of culture (monitored daily on TV talk shows)—his conso-
lation and sustaining passion was Latin.

What I noticed immediately was that Mr. G. almost entirely refrained
from the clichés of small talk, except in Latin: *Ars longa vita brevis! Sic
transit! Potius sero quam nunquam!* (Better late than never!)...I experi-
enced him as a Virgilian specter gingerly cruising the neighborhood,
neck extended forward, head held high and stark still, eyes fixed on an
internal horizon while nonetheless scanning peripherally for passersby.
One day, nodding hello, he leaned over to pet my dog and said, You
know, this is not one of your better centuries—*Ilias Malorum!* (An Iliad
of evils!). His preferences weren't surprising—fifth century B.C.E., the
seventeenth and eighteenth, the first half of the nineteenth. How could
I protest? How could I protest the mythical past, but also the brutality
of our own times?

It's hard not to see the twentieth century's violent lurches between
utopian dreams and catastrophic revenge of the real as having improved
the mechanics of hatred much more than hope. What was once rather
romantically called "unspeakable" has been spoken so many times over

it's an enervated commonplace awaiting the next corroborating terror. As framed by a hyperactive and repetitive media, the probability of more (and less) apocalyptic forms of brutishness, greed, terrorism, war, and genocide is on the rise, punctuated by instances of heroism, patriotic fervor, avowed faith in God. There seems to be little of interest to the media in a cultural ethos that might lie between spectacular event and hackneyed response. When the foreground of the most widely viewed (and there's an important distinction between viewing and reading) popular reportage must, for reasons of market statistics, be filled with endless platitudes about cruel certainties and flag-waving hopes, one might forget to doubt the psychology of inevitability. Evidence ranges from "ancient grudges" to the nefarious motives of "evil doers" to commonsense observations, for example, a European economist's assertion (on BBC news) that the world economy can't flounder for too long because the "American consumer is born to shop." There are naturalized conventions in any genre—literary as well as journalistic. Packaging can make anything and everything look disarmingly familiar.

The linguistic packaging of an event that took place three days before 9/11 in Durban, South Africa—"United Nations Conference against Racism, Racial Discrimination, Xenophobia and Related Intolerance"—is instructive. The aftermath of its success/failure was couched, like all similarly earnest meetings, in a "declaration" rendered effectively invisible by the clichés of its own evocations and injunctions:

1. We are conscious of the fact that the history of humanity is replete with major atrocities as a result of the gross violation of human rights and believe that lessons can be learned through remembering history to avert future tragedies....

5. We are conscious that humanity's history is replete with terrible wrongs inflicted through lack of respect for the equality of human beings and note with alarm the increase of such practices in various parts of the world, and we urge people, particularly in conflict situations, to desist from racist incitement, derogatory language and negative stereotyping.[7]

Attempts at international consensus typically embed themselves in self-neutralizing linguistic decorums—prolegomena to a putative solution on the eve of the next disaster. They predictably underscore the need to remember (that is, to describe what has happened in the past); the need to recognize certain descriptions as legitimate and others not; the need to acknowledge what certain descriptions imply; the need to

cease using language that leads to psychological and physical violence; the need to make restitution if necessary. Except when they are trumpeting the rhetoric of revenge, they are full of exhortations to "move on," to "look forward," to "not point fingers backward."[8] What all this does is create unwitting holding patterns, embalming reconstituted memory in amber, mistaking it for a lens giving on a future. It's clearly no way to construct the kind of dynamic present-tense poetics of human rights that might swerve minds out of intractable gridlock.

The metaphorical placement of history—as "the past" "back there" rather than "here"—is to see history as having literally "passed" out of current space-time. Could this semantically embedded misconception make the problem of linking a poetics/politics of tragic memory to a poetics/politics of constructive agency all the more difficult? A descriptive legitimation of memory does not change the cultural ethos or the power relations that spawn violence unless it is already enacting a poetics outside the patterns of that ethos. It's the poetics of memory— what is made of it now—that might create a difference. It's not that the grudge is ancient that causes volatility; it's precisely that the language by which it is evoked is very much a present form of life, sustaining an ethos of lethal anger. This is a question of poethics—what we make of events as we use language in the present, how we continuously create an ethos of the way in which events are understood.

The poetics of inevitability is everywhere. Images of being locked in the past aren't erased by the formulaic "if you don't know history you're doomed to repeat it" because, unfortunately, the converse isn't automatically true. If the message is that history is bent on repeating itself, then the knowing mind must take on—as unawares as the unknowing mind—a syntactical thrust toward predestined climax. It's all, again, all too familiar—a cheap-thrill déjà vu. Aren't these the patterns of classical drama embedded in nineteenth-century temporal arts— music, metanarrative philosophy, the locomotive novel, the well-made play, the epiphanic poem? It's the engine of political rhetoric from Pericles to the latest "saber rattling" occupant of the oval office. All describe trajectories of hyper- and hyporational (that is, romantic) destiny. As war maintains the health of the state, patterns like these maintain the health of what Pierre Bourdieu calls the habitus—culturally congealed values and practices carried largely unconsciously from one generation to the next.[9] So thoroughly established that many "against-the-grain" strategies produce little more than Ptolemaic epicycles. One thing is cer-

tain (as certain as only one thing can be): marveling, squinting on the threshold of a new century, or millennium, one needs a great deal of assistance to survey anything other than the past.

The present is, in fact, made out of the residue of the past. What, after all, is there materially but all that is after? Light takes time to travel to the eye across the space of a room. The speed of sound is slower still. All images are after; this is their seduction and their terror—the distance they imply and traverse, the possible betrayal of one's senses. If the cultural future is invisible until we've noticed what we ourselves have fashioned out of the residue—by accident, habit, intention—the act of noticing, and its transformation (all present-tense matters), may be the most relevant focal point for an aesthetic. As it indeed happened to be for Marcel Duchamp, John Dewey, Gertrude Stein, John Cage, and others. Noticing becomes art when, as contextualizing project, it reconfigures the geometry of attention, drawing one into conversation with what would otherwise remain silent in the figure-ground patterns of history. The legibility of these projects can remain poor for decades. Stein opined that it takes forty years for aesthetic innovation to sink in, much less become intelligible. What is the work of human culture but to make fresh sense and meaning of the reconfiguring matter at the historical-contemporary intersection we call the present?

If the only active time bracket is at the rim of human consciousness and sensation, at the rim of history—that is, of making and occurring[10]—then that excitable rim may be identical with signals across synapses in the brain. An amusing thought, that the location of the making of culture may be the degree of space-time located in the cleft between neurons. That this infinitesimal space-time bracket turns out to be as expansive as the sum total of thought processes at work on the planet at any given moment suggests how important the quality of those thoughts is to a cultural ethos. What it clearly indicates is that the present *is* activity and vice versa.

Meanwhile, grammars—which must carry on the pragmatics of everyday life—lag behind changing awarenesses and intuitions that exceed old forms. Vocabularies mutate more than grammars. This is why an avant-garde in the arts and theoretical humanities—philosophy and science—will always have work to do, work that only gradually (sometimes never) enters the common language. Historical metaphors tend to support an image of time travel toward an absent past, paradoxically full of objects to be retrieved. Traversing this image in the other direction, one can bring those objects, framed as data, into the present. "That *was*

not one of your better centuries" might imply that it's over. That it's cut off from the present. As the temporal train pulls further and further from the twentieth-century station, the 1900s vaporize, settling into the ether of memory. Imaginary visits can be arranged, day trips to archives and historical sites or peering through memory's telescopes at something like antimatter. One might note echoes or reminders—afterimages, more déjà vus. Meanwhile the present is taking us for a ride in the opposite direction, off the edge of a cliff. (Cliff notes anyone?)

I'm troubled by this construction and its consequences, the most obvious of which is nostalgia for an idealized, irrecoverable past. (An irremediable past should be the greater concern—the past that tragically persists in our barbarous proclivities.) The contemporary doesn't leave history behind; it further complicates it. We're still embedded in the detritus of all your centuries, better and worse. The only thing that's changed is the composition of the materials of living. Composition is everything in culture; and the act of composition, which is an act of presentness, when brought into the foreground as the making of form *(poesis),* is the preoccupation of that part of culture we call the arts. The poethics of the contemporary, that is, the ethos of making something of one's moment in the historical-contemporary, is another preoccupation of this book.

Literature (in contrast to journal writing) is an entry into public conversation. At its best it enacts, explores, comments on, further articulates, radically questions the ethos of the discourses from which it springs. Hence my use of the word *poethics.* Every poetics is a consequential form of life. Any making of forms out of language (poesis) is a practice with a discernible character (ethos). Po*ethos* might in fact be a better word for this were it not for persistent sociological contentions that matters of ethos are inherently value free. We can disagree about their implications, agree on their contingency, but values are an inextricable dimension of all human behavior. Our values are what we care about; they are always contingent; but there's too much at stake for values to be arbitrary.

The efficient cause of my coining the term *poethics* in the late 1980s (a time when I was working closely with John Cage)[11] was an attempt to note and value traditions in art exemplified by a linking of aesthetic registers to the fluid and rapidly changing experiences of everyday life. I present this hybrid as frank and unholy union of modernist and postmodernist questions joined to the Aristotelian concern for the link between an individual and public ethos in pursuit of the good life—a good life that must be contrived in the midst of happenstance and chaos.

A neo-Aristotelian like Martha Nussbaum might lament the swerve from universal grounding.[12] That Greek philosophers were rationalists, essentialists, universalists need not deter those of us for whom the only universal is contingency from appreciating their questions about citizen and polis. In fact it's the innocent contingency of their How-To books, along with their against-the-odds reasonableness, that stimulates the imagination. (Although the justification for Alexander the Great's murderous imperial campaigns—that the Greek way embodied universal virtues—came straight from his Great teacher, Aristotle.) Despite proportional differences in contemporary relations of individuals to society, the question of that relation remains urgent. We—some of us—think of ourselves now as citizens of the world, as well as of nation, province, state, county, city, perhaps even city-state.[13] When modified by circumstantial evidence and something like Pascal's dilemma (what to think in conditions that preclude certainty), one can see how ethical questions become matters not of calculating a position within a range of absolutes but of wagering on values in order to remain in motion in the face of otherwise paralyzing doubts, if not fears.

To place *ethos* in the foreground of the discussion of aesthetic process is to think about consequential "forms of life"[14] specific to formally distinct experiences of art. What kind of life is one living *in the act of reading* Gertrude Stein? Is it the same as the act of reading Wallace Stevens or John Cage?[15] What of Flaubert or a romance novel? (How are these different from *viewing* a film or *watching* TV?) What of the sensitive I-lyric, innocent of contemporary vocabularies that might trouble its carefully controlled "poetic" tone? The most pressing question for me is how art, particularly literature, helps form the direction and quality of attention, the intelligences, the senses we bring into contact with contemporary experience. A related question concerns the ways in which contemporary poetics invites us into an ethos of the collaborative making of meaning. "Making," poesis, is always key. This is an imaginative activity that materially affects the life one lives in language, the life of language at large, the world of which language is both made and inextricable part. Another way to ask the question of poethics is, How can writing and reading be integral to making sense and *new*sense (sometimes taken for *non*sense) as we enact an ongoing poetics of daily life? We do that of course among many languages, social structures, events, persons... in humorous juxtapositions and Venn overlaps of the familiar, the mysterious, the unintelligible.[16]

In acute consciousness of the twentieth century's inventions and disasters, the reexamination we call postmodernism has brought a growing range of conceptual frameworks to the roles literatures play, as well as to the language games constructed out of poetic energies. One recognizes, for instance, significantly different poetics of memory and desire. There is the frank poetics of direct witness; the poetics of a restless longing that refuses delayed gratification, rushing to epiphany; poetics with more complicated epistemologies and a self-imposed resistance to closure. These and many other directions also determine the poetics of the essay as form.

My own frame of mind comes (inevitably?) out of that postmodern angst and introspection—mixture of sorrow, humor, irony, and incredulity—over how easily grand hopes can go wrong, how the ridiculous and sublime, like tragedy and farce, are consanguineous. The self-consciousness we've labeled postmodernism has created a constructive geometry of attention, foregrounding clusters of cultural silences that range from retrovalued styles to inquiries into the ethically suppressed. As the formerly colonized now come to colonize the streets and imaginations of the new city-states of multinational empire, there are increasing demands that projects of a global political ecosystem come into conversation with articulations of localized desire. What poethical explorations are crucial to such a situation? Those, I wish to suggest, having to do with complex realism, reciprocal alterity, polyculturalism, polylingualism, contemporaneity. A search for new ethical and aesthetic models is inevitably, haphazardly, contingently under way.

At some point I realized that the lurking question in everything I've written about literature is this: how can imaginative, responsible, meaningful agency thrive in such a complex and perilous world, fallen many times over, hardly off its knees when it comes to matters of hope? One model that's been useful to me in thinking about this is chaos theory.[17] The poethical wager—to act against the odds in composing contemporary language (both lightly *and* with great seriousness)—presumes the mess of complexity, the near-automatic pilot of large cultural trajectories along with constantly changing local configurations. In this light I've begun to find "modernity" and "postmodernity" less useful for my inquiry than the more dynamic concept of a (chaotic) continuous contemporary.

The continuous contemporary is the scene of the poethical wager as I construct it. It's my view that a vital poetics must acknowledge the de-

gree to which the rim of occurring and making is now formed by the electronic intimacy of this chattering, arguing, densely interimpacted, explosive planet. The shadow question under which we live has become *whether* there's a viable future for humanity—not just *what* it will be. This question is linked to so many uncontrollable factors that nostalgia for "the" bomb is not at all unthinkable; the mushroom cloud has already appeared as a quaint retro image in a *New Yorker* cartoon. In one's probable derangement humorous thought experiments are called for.

Here's one: The horizon of the future is visible only as it has become that part of the very recent past we call the contemporary. The contemporary rises (as the sun doesn't) out of the residue of the past. One might even think one glimpses a thin crack of light in the near-hallucinatory state of envisioning that moment as the future breaking over the dotted line of the present. (Tear here.) This is of course image of a mirror image; the horizon is the mirror of futurity only as envisioned out of history. (Cf. Hegel: "Philosophy concerns itself only with the glory of the Idea mirroring itself in the History of the World.")[18] Insofar as they exist at all (in the imagination) the horizon of the future and the horizon of the past are one and the same. There is no temporal direction for gazing at the past or the future, other than nondirectionally outward. Get up and look around, as Cage once said. You will see everything there is to work with right (t)here, at the conceptually contingent location of your besieged senses.

The image of horizon that has been so crucial to romantic idealist philosophies and literatures may not be a threshold of possibility at all, unless one locates possibility in a mirror. Suppose one asserts that a po-ethics of possibility must be founded on improbability, pattern-bounded unpredictability, the intercourse of chance and intention, self and not-self. Then one must move from idealized images of Euclidean horizons (which turn out to be nothing but a series of vanishing points) to fractal coastlines. The horizon is always a function of the position of the viewing subject. This is clear in perspectival painting, where the vanishing point directly locates the position of the eye of the artist.[19] As such, the Heideggerian horizon of time may well throw us into conversation only with our own logics of identity, inevitability, destiny, will—subject masquerading as object revealing itself as subject in the sigh of genius. Heidegger's limiting condition of inquiry in *Being and Time* is couched in the metaphor of the "horizon of time." This, in my view, because his own "primordial" desire is located at the same horizon as Hegel's historical destiny—the rendezvous with spirit. Romantic idealism charts the destinies of its geniuses along the imaginary line spanning a series of what

can easily turn into sociopolitical vanishing points. That Heidegger's thought recycles the spirit of nineteenth-century German romantic ideal-ism, projected via the phantom eloquence of self-identified "primordial" genius (that is, will with a self-reflexive destiny), along *his* horizon of time may be (despite intricate attempts to separate his philosophical and political logics) quite consonant with National Socialist proclivities.

I raise this specter because the "horizon of time" is an example of a class of heavily freighted metaphors (emanating out of eighteenth- and nineteenth-century—chiefly German—poetries and philosophies) whose incompletely examined historical implications exert a gravitational force that warps the edge of the contemporary as it emerges into critical view. Imagining a cultural coastline (complex, dynamic) rather than time's horizon (dare I say it?—linear, static) thrusts the thought experiment into the distinctly contemporary moment of a fractal poetics. If art can be con-ceived as having a fractal relation to life, then I think the infamous art vs. life gap is closed because it's no longer needed to account for mirror-image representational symmetries.[20]

Pascal's wager was framed in the computational science of his era, as our wagers must be cast in terms that construct our time.[21] Future ex-plorers of the continuous contemporary will no doubt structure their wa-gers in the new terms by which they understand the nature of their worlds. This is one way of saying that the working idea of the poethical wager is nothing more than a casting of one's lot into contemporary con-versation as it is occurring not on a pseudoserene horizon of time but along the dynamic coastline of historical poesis. The continuous contem-porary, not so much as label but as challenge, suggests a poesis of the in-creasingly unintelligible present. That poesis creates the foreground of our acts of noticing. In "Composition As Explanation" Gertrude Stein wrote, "Nothing changes from generation to generation except the thing seen..."[22] She emphatically asserts that the thing is *made* to be seen in the act of composition. In this essay and others Stein recognizes the impor-tance of working with the material contemporary. This is not merely an acknowledgment of one's condition but an aesthetic judgment. She says quite normatively in "How Writing Is Written" that it is the business of the writer to live one's contemporariness in the composition of one's writ-ing. This is what I have intended as the poethics of this book.

During the mid-nineteenth-century acceleration of those changes we notice as "contemporary," those artists identified as avant-garde took it on themselves to bring barely legible elements of change into their com-positions. The present as locator of experimental adventure is the active

"in-between zone" of historical residue and hope.[23] I argue, in
":RE:THINKING:LITERARY:FEMINISM:" that the avant-garde is the ex-
perimental feminine inextricably linked in continuous cultural agon to
the officiating masculine. It's an argument that benefits from Julia Kris-
teva's work on poetic language but differs with her reluctance to ac-
knowledge that in Western rationalist philosophy, as in popular culture,
the experimental has always been constructed (and feared) as feminine.
I see feminine/masculine, like all those other dualing active principles—
Apollonian/Dionysian, rational/sensual, self/other, yin/yang...—as
compound scenes of exploration, by means of which thought moderates
its tendencies to congeal into ideas of inevitability. These are sites where
the cultural weather is always turbulent and uncertain, that is, fluid,
that is, productive of terrifying and humorous swerves. A chief role
taken on by the avant-garde has been to explore messy unknowns in the
fluid dynamics of the kinds of improbability that yield possibilities. The
aesthetics of probability—unlike its mathematics—can be mercifully
fluid. Absent radical fluidity—for example, constructive recognitions of
global interpermeabilities—we face overwhelming prospects of ruin.
Could it be that to know history all too well is to repeat it in the poet-
ics of the very act of knowing?

To see things anew, to notice fresh possibility despite the empirical
odds against this, requires complex realist devices and, yes, our post-
modern self-conscious complicating of the most ingrained longing for
certainty. This book is indebted to all those authors and artists of the
improbable who help us sustain a culture that can yield pleasant sur-
prises. A disciplined inclination to be pleasantly surprised is really the
only poetics of hope that, no matter what happens, still works for me.
Like the readiness of the student of Zen to make sense of no-sense, it
comes of strenuous practice.

The work in this book is as much exploration of the form of the essay
as the declared cluster of concerns I query under the rubrics of poethics,
complex realism, the experimental feminine, reciprocal alterity. In
thinking about engagements with texts and consequences of form I'm
equally indebted to Wittgenstein's concept of socially contextualized
language games; Dewey's notion of art *as* experience, D. W. Winnicott's
distinction between fantasy and imagination—his emphasis on the role
of play in the self-invention of a cultural life that's worth living; Cage's
idea of chance operations (composed clinamen) highlighting a produc-
tive sense of contingency, his redefinition of silence as all that we're not
attending to at any given moment; Stein's sense of the business of writ-

ing being nothing more or less than living and composing one's contemporariness.

One might also term this the against-all-odds project of recomposing some small portion of the habitus. Bourdieu's idea of the habitus has been helpful to me in my attempt to gain perspective on the cluster of assumptions and behaviors that characterize the social matrix of any historical moment. In the tragic apotheosis of one such habitus Adorno came to think that it is a chief function of art to awaken us to those influential cultural vectors that are persistently obscured by ideology. The most vital art is not oppositional ideology but an attempt to be as free of ideology as possible, even as it can never be free of values. (I'm convinced, contrary to many thoughtful people I know, that art can be free of ideology, never of politics.) The habitus, as Bourdieu describes it, is not something over which we have much conscious control, insofar as it is composed of "[s]ystems of durable, transposable dispositions, structured structures predisposed to function as structuring structures, that is, as principles which generate and organize practices and representations that can be objectively adapted to their outcomes without presupposing a conscious aiming at ends or an express mastery of the operations necessary in order to attain them."[24]

The contained, but squirming, matrix of habitual, value-laden, self-perpetuating practices, all but invisible until something dramatic goes awry, is in fact the continuous present of our experience of history. The habitus is "embodied history, internalized as a second nature and so forgotten as history...the active presence of the whole past of which it is the product."[25] This is how attitudes and genres become naturalized, including the genres in which we write our histories. Is it in fact any easier to achieve perspective on the implications of genres than on the infinite complexities of lived sociopolitical experience? The logics and values of aesthetic genres are in conversation with that experience, but, to the extent that they are independent of ideology, they enact an alternative language game. That language game can be analyzed, however tentatively, for its poethical consequences.

Although it's usually only the irruption of undeniable trouble (the post–WW II rise of feminist consciousness, the civil rights crisis of the 1940s and 1950s, the Vietnam War, the outbreak of AIDS...) that jolts us into reevaluating discrete aspects of the habitus, experimental arts have tended to launch more global challenges to the values of containment and closure, boundary and identity logics of genres (including those of gender). This can be a pleasurably alarming project since aes-

thetic inquiry is usually removed from immediate life-and-death conse-
quences, even as one explores life principles in conversations between,
for example, intention and chance, masculine and feminine.

A primary value I assume in the essays that follow is that of the
difficult pleasures of the most significant literatures. The kind of endur-
ing and cumulative pleasure that Aristotle called The Good, or happi-
ness, comes of an ethos of rising again and again to the occasion of
those activities that require strenuous engagement of one's whole
being—intellect, passions, sensual presence, meditative awareness. This
is happiness *as* activity, *as* project, *as* agency. The poetries that stimulate
us in this way, that ask us to rise to the sometimes baffling occasions
they present, are also inviting us to stretch toward a readerly action of
complex awarenesses. Literary pedagogies, among others, need to catch
up with the active, collaborative reading demands of new forms.[26] Hap-
piness is struggle as well as the bliss of wide-angled attentiveness. To
wrestle with life's Relentless Ness monsters without becoming one[27]—
to find the perilous, pleasurable game in that—requires exacting
artifice. It also requires the long views of projects generous enough to
form a dynamic equilibrium amidst contradictions and contingencies,
injustices and suffering, serenity and delight. Perhaps happiness isn't re-
ally possible over the long range. Perhaps it's only possible over the long
range. Whatever the case, it takes humor to sustain energy of the kind
that can make meaning of historical-contemporary collisions.

Both Gertrude Stein and John Cage ask implicitly in their art, and
explicitly in their writing about it, How does one develop a contempo-
rary aesthetic, a way of being an artist who connects with the unprece-
dented character of one's times? Their starting principle was that we
must meet the contemporary moment on its terms—not in ignorance of
history but in informed composition of it. Is there any aspect of one's
work that poses greater difficulty? Although one can draw on many
models and examples, there is no one to follow into the future. Stein
and Cage each tell us—in the spirit of the undeniable, as well as exper-
imental adventure—although we can never really know where we're
going, we must be on our way. Over the centuries this has been said in
many ways. It's part of Buddhist traditions; it's at the heart of Pascal's
wager; it's expressed in a villanelle by Theodore Roethke, hardly an ex-
perimental poet—"I learn by going where I have to go."[28] This should-
n't be hailed as invidious comparison between thinking and feeling. I
take it as an awareness that the range of complexities in the world—a
range that careens between certainties of cultural logics and unintelligi-

bilities of chaotic experience—requires the development of complex in-
tuitions to make anything of it at all.

If psychologists have any inkling about the mechanisms of impulse,
memory, and desire, if Bourdieu is right about the default mode of the
habitus, every society has the capacity to live in radical innocence of its
own self-perpetrated destinies. Acts of responsible consciousness are
difficult, but the refusal of that difficulty is never benign. In poetries
whose energies depend more on questions than answers, whose moving
principles engage in exploratory projects and procedures, it is the work's
poethical form of life—what informs its geometries of attention—that
makes a difference. The contemporary work from which I benefit is by
poets who care enough about the world in which they live to experience
it broadly, to think and learn about it with dedicated intensity.

Where does this leave one? Current ideas of memory as witness often
serve to imprint guilt and prophylactic horror rather than to examine a
poetics of memory that recomposes the actively present elements of his-
torical tragedy. Who knows what might lead some *us* or another to be-
come better at transfiguration than reenactment. Or what humorous
collision of novel circumstances might lead some *us* or another to
swerve out of a suddenly illuminated detail in one of the many patterns
of ruin. The shape of historical outcome reveals itself by chance as
much as intention, yet at any moment one can act out of considered val-
ues that inform the projects of one's poethically cultivated intuitions.

> Is happiness the name for our (involuntary) complicity
> with chance?
>
> Lyn Hejinian, *Happily*

I sometimes wonder whether the attitudes that propel my aesthetic
come down to instinctive hope, strategic optimism, or an unaccount-
ably cheerful—always precarious—retrofit of despair. Perhaps it's more
truthful to say I'm in search of a poesis that wagers on all three in un-
settling but synergistic conversation. The many strange texts that popu-
late my library are there because in one way or another they have taken
part in this sometimes euphoric, often troubled, intercourse. Luckily,
one never knows the circumstances in which one will find oneself, the
circumstances in which a happy coincidence might give meaning to oth-
erwise perverse pleasures. Of one thing I feel certain: it's much too
early/too late to abandon (the humor of) improbable attempts.

The Poethical Wager

Oui, mais il faut parier. Cela n'est pas volontaire, vous êtes
embarqué.

Yes, but you must wager. This is not voluntary, you are
embarked.

<div align="right">Blaise Pascal, Pensées</div>

INSERTING AN *H* IN *POETICS*: A SLEF INTERVIEW

This interview between old friends (only sometimes at odds), Joan Re-
tallack and Quinta Slef, took place in a short-circuited corner of cyber-
space on a rainy Domingo/Domenica/Sunday/Sonntag/Dimanche....

QUINTA SLEF: *How shall we begin? Just before we turned on the tape
recorder, you said, "Art that's of consequence has always been a poeth-
ical wager." You've been talking and writing about "poethics" for quite
a while, but, before we get into that, why "wager"? What's that about?*
JOAN RETALLACK: When you make a wager you stake something that
matters on an uncertain outcome. It's a conscious, strategic risk. Of
course we're taking risks every moment of our lives, but most of the
time we can't think of it that way. We'd become paralyzed with fear. It
may sound dramatic, but it's actually a truism that every time I choose
to do something or persist in some sort of behavior, I'm risking my life
for whatever needs, desires, impulses, habits, values...lurk in that be-
havior, whether or not I have a grip on the implications. There's no
avoiding it. Life—motion, change—is inherently risky. Why not take
risks for what we care about most?

QS: *Why not indeed? But, to be faux-Socratic, you've just said that's
what we're doing anyway. Don't we always try for what we think
is best?*

JR: Not necessarily. It's seldom that clear. Apart from the obvious question, best for whom?—the individual? the community?—a good deal of what's done in the world comes out of the sense that what's best is really impossible. Might as well do the next or third best or—out of overwhelming frustration, anger, despair—the worst possible thing—just get it over with, destroy the field of possibilities that never seems to yield justice or solace or satisfaction! In art—particularly avant-garde art—this is what critics label "nihilism." I personally think it's rare in the arts. Artists want to make things. Their energy tends to be constructive. Of course I'm postponing the question of effect. Even if I want to act positively, what I think is best may be off the mark from even my own subsequent point of view. The future, that is, the present, is complex and uncertain.

QS: *Then what hope is there? We're all shooting in the dark.*
JR: Yes, if we're Platonists or Kantians or religious fundamentalists we're shooting for transcendence into a realm unknowable by the senses; if we're dadaists or Buddhists we're letting things happen; if we're pragmatists we're betting on an outcome by means of logics and intuitions that come from experience in the world as we find it. Radical unknowability is the only constant.

QS: *That's a daunting view if part of your program is ethical or political.*
JR: It's daunting if your primary concern is control. What we need is a robustly nuanced reasonableness, one that can operate in an atmosphere of uncertainty, that gives us the courage to forge on, to launch our hopes into the unknown—the future—by engaging positively with otherness and unintelligibility.

QS: *I don't see the logic in that. I would think it would be precisely the other way around—to engage now with the little certainty we can muster. At least we'd have the best chance of charting some kind of predictable trajectory.*
JR: Well, that's the probabilistic approach of the sciences. I think it's just what we have to relinquish in the arts—that illusion of predictable trajectories. Think of how narrow a trajectory must be in order for it to remain predictable. An obsession with the predictable is what leads people to confuse ethics with censorship in relation to the arts. What we need is dubious prototypes of difficult processes. Long-range inquiries and exercises of imagination that are an entirely contingent praxis of constructively reasoned agency.

QS: *Dubious?! (laughter) Reasoned agency?! I thought implicit in your use of wager would be the foregrounding of chance—that the language of intentionality can never provide an adequate description of any act. Mustn't the artist, as artist, act out of intuition and imagination more than reason?*

JR: Yes, yes, of course. The major role of chance, and change, in our world is precisely why intuition and imagination are so important to a reasoned agency. This is a synergy, not a dichotomy. To act at all we need to pick up on so many cues that are not part of what we're explicitly taught to notice. The kind of agency that has a chance of mattering in today's world can thrive *only* in a culture of acknowledged complexity, *only* in contexts of long-range collaborative projects that bring together multiple modes of engagement—intuition, imagination, cognition... . The more complex things are, the less certain the outcome but also the more room for the play of the mind, for inventing ourselves out of the mess.

QS: *So one could say that making something of complexity is our only chance. Does it work the other way around? Making something of chance is the only complexity?*

JR: Hmm. I like surprising symmetries, but...hmm. You know it's amazing how constrained and victimized people feel in affluent cultures brimming with advanced technologies and electronics designed, as McLuhan pointed out, to give greater scope to our nervous system. Electronics links us in a global neocortex, yet the model for agency remains one of rugged individual willpower. I think we get into those typically postmodern conundrums of the "prison house of language" or the "prison house of power relations" when we puzzle about how the individual speech act fits into social-construction theories of language. Analyzing the individual act to discern signs of free will, given the degree of our interconnectedness, is bound to be discouraging. The apotheosis of this may have been the analytic philosopher A. I. Melden's book *Free Action*, in which he interrogates, for over two hundred pages, the meaning of the act of raising one's arm.[1]

QS: *That appeals to the Occam in me.*

JR: Oh yes I loved it. British analytic philosophy is the next best thing after Lewis Carroll. The peculiarly context-free thought experiment is wonderfully, uselessly tonic. Wittgenstein suggests a remedy by positing the vague, ubiquitous "form of life," context of all contexts that

give meaning to language games, but even he in Oxbridge Philo fashion didn't flesh this out.

QS: *But to return to one-armed elegance for a moment, what does Melden conclude?*

JR: As I remember it, he concludes with what could be the starting point of a much shorter book—the question whether so and so raised *his* arm voluntarily is ultimately too complex to understand since there are so many difficult matters of social context that the author cannot treat in such a study. Ethical analysis that foregrounds isolated acts of individual will always fail when real life floods in and muddies the logic. So the possibility of effective human agency can't depend on such arguments.

QS: *So, ethical agency is embedded in values that inform long-range projects that engage with a complex world as well as indirect and unpredictable ways in which this work might affect the cultural climate.*

JR: Precisely. Beautifully put!

QS: *Hmm, interesting, but—to play devil's advocate—aren't things complicated enough already? Isn't that why artists and humanists and scientists alike have for millennia sought means of simplifying in the service of clarification, one might even say, of sanity? For example, why further complicate an already complex term like poetics—which ten out of ten people are fuzzy about anyway—by adding an accursed Aitch?*

JR: Quinta, my dear friend, life complicates us. Whether we like it or not. There's no turning away from that if one is to live in relationship with the circumstances of real life.

QS: *Wait a minute! I must stop you there. I've noticed that you use the word real with abandon. I must say I find this highly suspect. What isn't real? Or, to put it another way, what does the adjective real add when you speak of "real life"? Remember how Kant discounted St. Anselm's proof of the existence of God? He showed that "real" is not an attribute. You can logically prove that a being "than which nothing greater can be conceived" can be conceived, but you can't prove that it's real. Real adds no content to a description.*

JR: I've wondered about this myself. Isn't *real* simply adding emphasis, like underscoring or italics, or an irritating redundancy? But aren't terms like *naturalism, realism, everyday life* always historical in import? They come up at times when people are trying to revise old

habits of thought, to bring new conceptualizations into vocabularies and logics. I think *real* began to creep into my aesthetic vocabulary when I started distinguishing between "*complex* realism" and other artifices of realism whose stylistic telos is radical simplification. I couldn't help but notice that those traditions in the arts called "realism" and "naturalism" were at least as removed from our experiences of reality and nature as any other aesthetic artifice. The elevation of simplicity as an explicit value in aesthetics followed articulations of scientific method from Occam's razor to Descartes's "clear and distinct ideas" to the values of modern laboratory sciences.

QS: *Interestingly, minimalist work—which is pared down in conceptually strategic ways—has a very complex aesthetic relation to everyday life.*

JR: Yes! But the whole methodological landscape has been changing since the beginning of the twentieth century with the introduction of the constituting observer. Sciences of complexity have altered our sense of the "essential" simplicity and rationality of all things. There is still pattern, but it's in dynamic interaction with an enormous field of unpredictable elements. Chaos theory has brought turbulence and chance into the foreground of how we understand the conditions in which we actually live. I suppose that's what it comes down to for me, *real* means connected with everyday life as we experience it. This is why I've always thought John Dewey's *Art as Experience* is the heart of his entire philosophy—of his ethics, politics, and pedagogy.

QS: *But what does all that necessarily have to do with art?*

JR: Certain kinds of art help us to live with nourishment and pleasure in the real world, connect us with it in ways nothing else can, by shifting our attention to formally framed material conditions in ingenious ways. I'm thinking now not only of minimalism but of what Duchamp and Cage taught us about the link between art and the nature of attention. This relates to Dewey's argument about the urgency of connecting with our sensory environment if we—the species so prone to abstraction and estrangement—are to avoid a kind of living death. Just as importantly, the word *real* took on further meaning for my working poethics when I discovered D. W. Winnicott's useful distinction between fantasy and imagination. Winnicott played a major role in psychoanalysis with his contributions to object relations theory, but his most important contribution from the point of view of aesthetics is his theory of play.[2] He argues, and shows in case studies

from his practice, that the ability to play, that is, engage with the material world outside our minds via the active imagination, *is* our way of participating in the real. This is very different from the inward trajectory and stasis of fantasy. One might say that for Winnicott the "real" *is* what we sense via the play of the individual and cultural imagination. And this play of the imagination is crucial to a "life worth living" from childhood on. So, above all, adults need to continue cultivating their capacity for play. You see this capacity in those engaged in invention and exploration, whatever their field. It's why such people have often been called "child-like." This imaginative vitality, this connectedness with the world, is present in anyone who thrives on curiosity, puzzling, conjecturing. Dewey points out that the passionate auto mechanic is experiencing the same play of the mind brought on by connectedness to material form as the aesthete. To avoid imaginative engagement with material complexity as our popular culture tends to do is to live in a fantasy world.

QS: *Let's return to poetics.*
JR: When did we leave?

QS: *Well, I'm not as sure of all this as you are. Life may necessarily complicate us, but it doesn't follow that the inverse proposition is the case—that we should complicate life. Again, I ask you, why the accursed "Aitch"?*
JR: A poetics can take you only so far without an *h*. If you're to embrace complex life on earth, if you can no longer pretend that all things are fundamentally simple or elegant, a poetics thickened by an *h* launches an exploration of art's significance *as*, not just *about*, a form of living in the real world. That *as* is not a simile; it's an ethos. Hence the *h*. What I'm working on is quite explicitly a poethics of a complex realism.[3] I suppose also that I want to suggest a "po"-ethos to replace the enervating "post"-ethos we're stalled in at the moment. With the situation we find ourselves in—unprecedented, accelerating complexity, more and more porous borders—neither art nor theory can afford to remove itself from the new configurations of the contemporary.

QS: *You mean you think we're not at the end of history and art and the history of art and the art of history after all?*
JR: Not only are we not at the end of history or art, except as perversely defined to end rather than undergo paradigmatic changes, but we're at a threshold of untold possibilities. What thinkers like

Fukiyama and Danto are saying is that we're at the end of certain
things as we've practiced them in the past. This is true of every era
that experiences sudden or rapid change—look at Hellenic Greece,
look at the European renaissance. Philosophy changed rapidly and
radically in the fifth century B.C.E. and has many times since. Science
changed radically in the seventeenth century. Deterministic chaos, frac-
tal geometries give us new images by redefining relationships between
order and disorder, pattern and unpredictability, the finite and the
infinite. For instance, if space-time is to be understood as fractal
surface (a scalar complexity) rather than an archaeological accretion
(time's vertical monument to sticky molecules), then dynamic equilib-
ria can replace the double-ended arrow of depth and transcendence as
working trope. This has immense implications for the way we think
about history and aesthetics.

QS: *You've pointed out elsewhere that it was said of Galileo that he
wasn't doing science, of Mandelbrot that he wasn't a mathematician,
of Wittgenstein that he wasn't a philosopher, of Joyce that he wasn't a
novelist, of Gertrude Stein that she wasn't a poet, of Duchamp that he
wasn't an artist, of John Cage that he wasn't composing music.*
JR: Yes, what they have in common is that they redefined the bound-
aries of their disciplines in relation to experiences that lay outside
generic definitions. What we have instead of ends is exciting new
ways of continuing, new ways of conceiving the relation between
the discipline and the extradisciplinary experience, new recognitions
of the degree to which these projects are complicated by their posi-
tions in multiply intersecting and overlapping sociopolitical and cul-
tural constellations. We know (or perhaps just temporarily think)
that there are no universally and absolutely legitimate uberviews.
Without that illusion, without the authority of what we've called
metanarratives, we can only compose our projects as I think we ac-
tually always have: in relation to the contingencies of cultural
climates and microclimates. This doesn't mean our projects are no
longer informed by history. They're not vacant of meaning because
we've admitted their historical contingency. If anything they're more
meaningful in navigating a sense of the contemporary under princi-
ples of uncertainty, incompleteness, turbulent complexity. I want to
say to artists, and particularly poets, Resist pressures to regress,
deny, escape, transcend. Pop culture and religion do that well
enough on their own. If we're going to continue to make

meaningful, sensually nourishing forms in the twenty-first century, art must thrive as a mode of engaged living in *medias* mess.

QS: *Do I detect a soapbox somewhere in the room? "Mess"...as in Beckett's "The form must let the mess in"?*
JR: Yes, or in John Cage's version, Let the mess shine in! I'm glad that you recognize *mess* as a key technical term! There's also Gertrude Stein's sense of the writer making her way through the mess of the contemporary. Of necessity never entirely knowing what she's doing because to write out of her own time she must work with material that is not yet formed into recognizable patterns. Unlike the classics, the contemporary has not yet been classified. She, like Picasso, uses the word *ugliness* as well as mess. Picasso said, Anything new is ugly. This is always a by-product of a truly experimental aesthetic, to move into unaestheticized territory. Definitions of the beautiful are tied to previous forms. The end of beauty has been lamented, too, of late. Have you seen all those articles in the *New York Times* about composers who are finally restoring beauty to music after the Shönbergian-Cagean debacle? What this means is they are mastering mechanics of stimulus-response similar to those of pop and mass cultures, rolling out tried-and-true methods of eliciting "Ah, how beautiful!" from the audience. In music this means things like sensitive adagios ripening toward thundering crescendos, etc. I and some others think of the music of John Cage as beautiful, think of much of the poetry associated with the label "Language" as beautiful. But this sense of beauty draws on a very different value context—a different poethics, if you will—from the music of Brahms or the poetry of Gerard Manley Hopkins or Emily Dickinson. Not to deny the beauty in all that. Of course it's beautiful.

QS: *Most people think Cage and so-called (or not) Language poets have really made a mess of things, in the negative sense of mess.*
JR: And why is that? It's because the work is jarringly, disarmingly, disorientingly unfamiliar. Like most of the art and science characteristic of the twentieth century—that could only be a product of the twentieth century—it has defamiliarized certain ways of seeing reality while offering others. Theories of "defamiliarization" are very familiar at this point. What is not so well understood is how the positive material of avant-garde or innovative or new (choose the term that offends you least) art remains invisible to the person whose primary experience is persistently that of the *absence* of the familiar rather than the *presence* of the new.

QS: *Is it the desire, the need, for certainty?*
JR: It is absolutely necessary to be certain of certain things—that $1 + 1$
$= 2$, that a black hole won't emerge out of the dusty corner of this room.
To import certainty to other areas of life requires varying degrees of de-
nial and/or oversimplification. Some of that is necessary too. But if your
question is, how can we notice and make new patterns that meaningfully,
pleasurably connect us to the exigencies of life in this complicated, often
frightening, and not so brave new world?, the project requires all kinds
of things: tolerance for ambiguity; willingness to move forward with un-
certainty; willing suspension of both belief and disbelief; willingness to
wade purposefully, playfully out into the mess.

QS: *Sounds unsettling, sounds downright icky.*
JR: Well yes. It is that, particularly if by "icky" you mean anxiety
laden. Working in the noise of the mess, the cacophony of intersecting
cultures, polylingualisms, competing sociopolitical valences and
vectors, the omnipresent electronic intimacy with global intentions,
needs, desires we don't understand—the relentlessly unintelligible. All
this brings on—to ennoble it a bit—something like Kierkegaardian
dread. But to some degree or another this is the work of living in our
world that we are all doing anyway whether we like it or not. It's the
raison d'être for that whole category of endeavors we call "work,"
isn't it? Without the action of time, without change, without thermo-
dynamics and entropy and chaos, work wouldn't be necessary. We'd
be smiling serenely in homeostasis.

QS: *I'm not sure this generic endorsement of work gets us very far.
Work, after all, takes place in many ways—repairs to existing forms,
restoration, conservation, replication, as well as analysis, critical evalu-
ation, modification, invention. It's not all based on noticing
obsolescence and creating new forms.*
JR: You're right. Yes, there are many examples of this range in poetry.
One could—to identify only the extremes—think of "New Formalists"
as conservators, "Language Poets" as inventors. The former risk being
called irrelevant fuddy-duddies; the latter, destroyers of all that is true
poetry. I'll make no secret of it—it's the inventors who interest me
most, those in the past as well as the present. Not only in the arts, but
in every discipline. They give us the energy to be present despite the
frightening aspects of the mess. They give us the chance to experience
the grace of memory in motion.

QS: *Sounds brave, but is it really "new"? This is a perennially contested idea and for good reason. Can there really be invention or are we always just tweaking what already exists?*
JR: Of course *new* never means ex nihilo. It means *ex perturbatio, ex confusio rerum*—or, in the vernacular of this room, *medias mess*. Out of the teeming multiplicity comes a new sense of pattern. And that pattern, if it's to be useful, hasn't bypassed uncertainty and unintelligibility.

QS: *This brings to mind Italo Calvino. He loved Carlo Emilio Gadda's novel* That Awful Mess on the Via Merulana[4] *I think for reasons similar to what you're talking about. Do you remember his Norton lectures—published as* Six Memos for the Next Millennium? *He admired Gadda for writing that uses "multiplicity" as a way of knowing the world.*
JR: What I like so much about Calvino is that he makes it clear that giving pleasure, entertainment, is as high a priority as any other.

QS: *Yes, the lectures are entirely about the characteristics of novels he takes pleasure in.*
JR: Pleasure, yes, but I want also to think for a moment about entertainment. In our world, where we are suddenly discovering that we all have "Attention Deficit Disorder," ADDition is supposed to replace the "higher" mathematics of multiplication. The expression "entertainment value" is pervasively used to justify simplistic fare in all the media. The assumption is that a homogeneous mass audience wants first and foremost to be entertained. Well of course we do. But what does that really mean? The word *entertain* means to hold the attention. There's no question that this must be the first principle of any work that's to have impact. The question is how attention is held, how our assumptions about "attention spans" change and why, how attention is trained by the culture. Our informal and institutionalized cultural pedagogies shape—quantitatively and qualitatively—our geometries of attention.

QS: *Well to some extent, but we also know at this point that people really do have different intelligences.*
JR: Differences in learning styles and preferences need to be respected. But I think I'm asking another question: are we systematically discouraged from engaging in sustained projects that can give us the cumulative pleasures of a meaningful challenge as well as the capacity for ef-

fective agency? Has, in fact, "investment" in this kind of "time-consuming" experience come to be seen as threatening to the necessarily shortsighted goals of a consumer culture whose profit margins are based on constantly changing appetites for instant gratification? Yes, I'm positing a kind of blind conspiracy (as opposed to conspiracy with a centralized intelligence) linking consumer desires to fantasy (the internal world of insatiable illusion) rather than imagination.

QS: *So you want to posit imagination as a function of the active intelligence that to a significant extent shapes its own world rather than absorbing prefabrications.*

JR: Exactly. If we're transfixed by gimmicks that prey on our tendency to sink to the occasion of fantasy's innocuous pleasures, this is not so much attention as capitulation. But this passivity has been naturalized by our consumer ethos. It's thought to be natural to want to sleep one's way through life. I don't think it's "natural" at all to scratch only the media-induced itch, to become flaccid and twitchily reactive.

QS: *You seem to be condemning the entertainment value of mass culture entirely. I'm not sure I disagree, but is fantasy life always so sleazy? You make it sound like a virtually vegetative, masturbatory state!*

JR: I couldn't have put it better!

QS: *Can't fantasy play a role in conceiving new patterns? The child psychoanalyst Bruno Bettelheim placed enormous value on daydreaming—another name for fantasy—in transitional spaces like hallways and secret hideouts so that children would have imaginative space to call their own. He felt this is where artistic ability was nourished.*

JR: I'll refrain from an ad hominem attack on Bettelheim, whom I once read with great interest, but I do think his conflation of fantasy and imagination comes straight out of the worst elisions of the German romantic tradition. His *Uses of Enchantment* makes important points about stories as previews of life's brutalities without critiquing the way in which the Grimm fairy tale can render that brutality oddly acceptable. Fantasy turns its gaze inward, backward, toward the auto-erogenous zones. It's consolation or titillation cordoned off from "real" implications. This has been its chief defense in relation to pornography for instance—that it has no implications for "real life" and is therefore harmless. But that it lacks "real" implications doesn't prevent real consequences. The real fills the vacuum in grotesque

ways. I wonder if all those traditions in German culture that seemed
not to have touched ground—philosophical idealism, mythology, fairy
tales, transcendental romanticism—helped leave the ground open for
holocaust. Ideals of purity, all transcendent idealisms, the noumenal
telos, magical thinking of the sort that informs the logics of myths and
fairy tales are fantasy systems with built-in protections from an ethos
of responsibility to a real world. Fantasy is of course a real phenome-
non, but the mechanism of its style is arranged precisely to deny the
reality of its consequences. I wonder if this comes out of despair. I
wonder whether there is a dystopian assumption among those who
produce fantasy literatures that this world is too irredeemable to merit
attention.

QS: *That's an alarmingly strong statement!*
JR: Yes it is. It alarms me too.

QS: *You sound too certain about the cultural context of the Nazi holo-
caust, of causal connections in what was, if nothing else, a vastly
overdetermined event.*
JR: No, you're right, of course. It was overdetermined. It was a
horrendous collision of elements—some with a contemporary contin-
gency that had very little to do with long-standing cultural traditions,
some that had a lot to do with them, for example, with pedagogical
traditions of compliance as well as the things I mentioned earlier. No,
I'm not as certain as I sound. It's something I, like many others,
continually puzzle over because it's a paradigmatic conundrum of rela-
tions between culture and terror.

QS: *But how do you use thoughts like these in relation to contempo-
rary thought and art without beginning to think of moralistic
opprobrium—thou shall not write fairy tales!*
JR: No, you can't do that. That kind of authoritarian certainty comes
from thinking in terms of easily identifiable, isolatable, cause-effect se-
quences: the mechanics of billiard ball *a* hits billiard ball *b* causing sit-
uation *c*. I would rather think in terms of more complex environmen-
tal models, of atmospheres or climates teeming with variables of
circumstance, habit, opinion, value....This is actually a meteorologi-
cal model that brings one to consider the broad cultural ethos rather
than moral isolates. So what does one do in the turbulent weather of
contemporary societies, global cultures? What does one do if one
hopes to help in some way?

QS: *Yes, that's the question, but I must say the meteorological model only makes things more nebulous for me.*

JR: Yes. The sky darkens. What can you do but take cover? Not even the pathetic fallacy to call on. There's no direct link between the unfolding of the storm and what you want to happen next in the story of your life. Things are out of control.

QS: *OK, cut to the cultural storm.*

JR: There's been a continuum from the popular culture of the early part of the twentieth century to the mass culture of today that has become increasingly fantasy bound, increasingly dependent on the fantasy logics of a consumer-centered me-ethos. You know as well as I do that to make something that disturbs fantasy logic is to ensure that it won't sell. Whether or not something sells is the sole criterion of value throughout most of our society. In a sales-driven faux high culture, novels are more and more written by committee. Agents and editors advise the author on how to shape the book to please the affluent zip codes where the bookstore chains thrive. What little poetry gets reviewed is relentlessly self-obsessed narrative snippets placed between wide margins. A recent review praised a poet's "powerful," "bitter" memories of her father as "perfectly accessible." No challenge here to the fantasy that it's a small world after all.

QS: *Do I detect a strain of bitterness in your feelings about this?*

JR: I hope not. Actually, I really think not, as Descartes said just before he disappeared. Willful simplemindedness is no fun. Ah, yes/no, no bitterness there.

QS: *Let's get back to the "prison house of culture." The power differential right now between economic "bottom-line" motivations and the few voices articulating alternative values seems overwhelming. I don't mean to be crass, but with the picture you're presenting of the state of our culture—and of course it's all globally interconnected, this consumer-driven ethos—how can it possibly help in any way at all to make the subtle lettristic gesture of thickening poetics with an h?*

JR: Ah, glad you asked! This revives my spirits. I like the way you put it—"thickening *poetics* with an *h*." Precisely! As you know, I love and often cite John Cage's essay "History of Experimental Music in the United States." I love it because it directly links aesthetic questions with an ethos of a historical need for experiment. Cage talks about choosing to do not just any experiment but what one thinks needs to

be done. Why? Why—if there are, in principle, no limits to possibility, and art most importantly operates in order to open up the future—why concern oneself with history at all? Cage's answer: "In order to thicken the plot." And then he goes on to say, "All those interpenetrations which seem at first glance to be hellish—history, for instance...are to be espoused."[5]

QS: *"Espoused." Peculiar word, espoused. But, yes, I see the relevance to what you've been saying about possibilities inherent in complexity. However, doesn't this beg the question of what is needed? How can one even think in such terms in the midst of a tidal wave?*
JR: And not just one tidal wave: tidal waves of market-driven goods, tidal waves of information, tidal waves of intercultural noise. What we are talking about is utter chaos. And that's what can give us an inkling of orientation. Every chaotic system is a dynamic, rather fragile equilibrium of order and disorder, pattern and unpredictable detail, all extremely sensitive to initial conditions, to any change of any variable. To enter an *h* into this turbulent system is to change an initial condition in albeit a cultural microclimate. But the fragile contingency of the larger pattern means that even such a small change could have an increasing effect.

QS: *The butterfly effect seems too gossamer to pin one's hopes on.*
JR: Yes it does, doesn't it. And yet, the effect can be quite real. We know this from history. The example that's always trotted out is the assassination of the archduke Ferdinand in Sarajevo—the event whose effects were magnified by other coincidental events into the first great European war. One could say, Well if old Ferdi hadn't gotten his, something else would have done it; and of course that's probably true. It's precisely the point that anything might have done it and that there was no way to predict the outcome.

QS: *Your example also implies that one can't know whether the effect, if it does indeed lead to major changes, will be positive or negative. Whoever shot Ferdinand may well have thought he was doing something for the greater good.*
JR: True, your overall logic is sound, but there's something about the ethos of the act itself, in that case the act of murder, that might lead one to feel it would be unlikely to have a positive effect. An equally passionate act that embodied respect for life, a connectedness to the larger social fabric, might have fared differently. In fact, to return to

our earlier discussion, assassinations often pop right out of the fantasy lives of "loners," no?

QS: *Hmm. They also come out of the thick plots of terrorist groups. But then there's the question of ethos. Let's get back to literature, the proper domain of thickened plots. In fact let's get back to Calvino. I'm thinking about his vision of what he calls the possibility of a "hyper-novel." He's advocating a literature that's not an idealization but a method of knowing the complex, messy world imaginatively. And what's interesting is how commodius that literature can be. His exemplar, Gadda, like James Joyce, can use anything and everything, so to speak, given what Calvino refers to as his "complicated epistemology."*

JR: Yes, let's look at the text: "Gadda developed a style to match his complicated epistemology, in that it superimposes various levels of language, high and low, and uses the most varied vocabulary.... Gadda throws the whole of himself onto the page he is writing, with all his anxieties and obsessions, so that often the outline is lost while the details proliferate and fill up the whole picture. What is supposed to be a detective novel is left without a solution."[6] This, by the way, also happens to Gertrude Stein in her only attempt at a detective novel. Her obsession with language wins out over the trajectory of the detective genre in *Blood on the Dining Room Floor*.[7] To this reader's delight!

QS: *Of course!*

JR: Of course. In fact, the generic detective fiction or sci-fi novel or thriller is a closed system, a fantasy world, designed to be incommunicado with the immense world we move through in everyday life. Listen to this—detective fiction could never do this: "In one of Gadda's novels, the least thing is seen as the center of a network of relationships...multiplying the details so that the descriptions and digressions become infinite." Ah, the scalar detail of a fractal poetics! "Whatever the starting point, the matter in hand spreads out and out encompassing ever vaster horizons, and if it were permitted to go on further and further in every direction it would end by embracing the entire universe."[8]

QS: *And the magnification—your butterfly effect.*

JR: Thickened with an ethos of valuing the random confluences in everyday life. Notice how Calvino sees Gadda effecting this complexity, this outward trajectory. The novel is, after all, like poetry, made of language. The making of language (poesis) into a complex form that has

the character (ethos) of living in the author's contemporary experience
of the world is the poethics of Gadda's work. Calvino describes it,
without of course naming it as a poethics, as Gadda's "Deliberate
Disharmony." It enacts a contemporary epistemology by assuming
that any knowledge of things in this world must confront "a
convergence of infinite relationships, past and future, real or
possible—demand[ing] that everything should be precisely named, de-
scribed and located in space and time. He does this by exploiting the
semantic potential of words, of all the varieties of verbal and syntacti-
cal forms with their connotations and tones, together with the often
comic effects created by their juxtapositions."[9] Sounds like a walk
through Manhattan or any other great metropolis to me.

QS: *This reminds me of the anthropologist Clifford Geertz's notion of
"thick description."*
JR: Yes, very thick description. So thick it moves beyond description as
an attempt to bring forms of extratextual reality (odd juxtapositions,
cross purposes, etc.) into textual reality. Which is what Geertz is fasci-
nated by as an ethnographer, how to "be there" in a text, how to create
a "world in a text." In the extreme, which in art is always better than
the mean, it becomes a question of language that is itself a form of life
in the Wittgensteinian sense, a textual form of life informed by the ex-
tratextual contexts in which it lives, and which it changes. Calvino
quotes Gadda as saying—in line with quantum physics—"To know is
to insert something into what is real, and hence to distort reality."[10]

QS: *Distort has negative overtones. It feels more violent than the effect
of the observer in quantum physics.*
JR: Oh I don't know. Think of Schrödinger's poor cat, equally dead
and alive in the box of his thought-experiment. With all the violence
around us one could become too frightened to embark at all. It's nec-
essary to find ways to navigate the turbulence, to practice the art of
staying in motion in a world that is always threatening to stun us into
stasis. Imagination can rise to an occasion. It can use the surface
tension of the tidal wave rather than being pulled into the undertow.
This is what makes life exhilarating.

QS: *Sounds wet and romantic to me!*
JR: Ow, that stings! No! Not romantic! Well, all right, I admit to it,
just a bit, because what I'm talking about involves passion. But there's

a crucial difference. I'm advocating a greatness of passion, not a passion for greatness. Stereotypical romanticism, the idealist strain, was not about being tossed in the messy turbulence; it was about climbing the statuesque profile of a snow-covered peak—an Alp, a giant frozen custard, a blond Brünnhilde—to identify that larger-than-life profile with one's own genius. I know, it's so easy to bash German idealism. It would be a cheap trick if it were not still such a strong part of "Western Civ."

QS: *So the idea is to rise to the occasion, not above it.*
JR: Connect with it and create textual realities with their own "structural integrities"—to use a Bucky Fuller term—as viable forms of life with more resonance than reference. This is what the best poetry can make happen on the page. To rise above the occasion is to miss it. The occasion in today's world is an enormous, intricate entanglement of people and events. Calvino was excited by the possibilities of a "hypernovel" because it doesn't say "things are complex" but is itself a complex system that embodies a method of knowing how to operate in that "impossible" situation, how to take oneself beyond one self's single-point perspective.

QS: *Calvino ends his essay—con brio—on just that note: "Think what it would be to have a work conceived from outside the self, a work that would let us escape the limited perspective of the individual ego, not only to enter into selves like our own but to give speech to that which has no language, to the bird perching on the edge of the gutter, to the tree in spring and the tree in fall, to stone, to cement, to plastic" (124).*
JR: Ah, I love "to plastic." This is not—with its gutters and cement—to be mistaken for a pastoral vision.

QS: *Then he invokes Ovid, whom I know has been important to you. "Was this not perhaps what Ovid was aiming at, when he wrote about the continuity of forms? And what Lucretius was aiming at when he identified himself with that nature common to each and every thing?" (124). Lovely, isn't it?*
JR: Yes, it speaks to the arts that restore lost continuities between us and the rest of the world. And one can argue that the reason art has always been so critical to our species is that we are in constant need of reconnecting our senses to the sensible world. But art is also full of disjunctions, deliberate disharmonies. To speak of po*ethics* is to foreground this whole range of reassurances *and* dissonances, as values

and epistemologies, embedded in writing/reading as way of living in the world.

QS: *O.K., I have to say this. I'm afraid I'm still not convinced that "poetics" without the h won't do the very same job.*

JR: Thank you for your candor. Let me come at this from a different direction. Poetics without an *h* has primarily to do with questions of style. Style is the manner in which your experience has understood, assimilated, imprinted you. How it has transformed you in its Transylvanian cultural laboratories, focusing, even magnifying, the currents that have fed your intellectual energy, passing them on "stepped up," reenergized, but not swerving them into unforeseen collisions that produce new possibilities, that might even blow out a few old fuses. At this point, preswerve, but feeling a distinct surge of power, you exclaim, Ah, I've found myself as a writer! Actually your poetics has you in *its* grip.

QS: *This brings to mind something that Sartre said—that without our intervention, the language just goes on speaking itself. I think Sartre said that.*

JR: Something like that. But, yes, that's it. You are being led; you cannot breathe fully. You are in its grip. The grip of what you know you should do. Your style is identified; it has become your obligation to the culture. You are doomed to execute it and then to reenact the fatalism of that execution over and over again. The reward is that no one will dispute that you are a poet. Your poethical work begins when you no longer wish to shape materials (words, visual elements, sounds) into legitimate progeny of your own poetics. When you are released from filling in the delimiting forms. This swerve, of course, comes about only as the result of a wrenching crisis. I don't mean to be dramatic, but you might not survive it. At least, not as a poet. You may at this point pick up some other line of work. If you persist, the patterns in your work may become more flexible, permeable, conversational, exploratory. This is a radical shift. It will change your sense of the relation of your language to "the mess"—the world beyond the page, everyday life and death. And this will in turn affect the world of the page—the formal intersections of historical and momentary fragments, formal intersections of space-time with linguistic forms of life, recovery and loss, silence and art. I think Francis Ponge was getting at something like this when he wrote in *Pour un Malherbe*, "In order for a text to expect in any way to render an account of reality of the concrete world (or the spiritual one), it must first attain reality in its own

world, the textual one."[11] But before you can begin to attempt this
you must face the fact that your present project is insufficient, that it
has not moved toward the unintelligibilities of the developing contem-
porary. You see this kind of change in the work of some poets and not
others.

QS: *There's a widespread feeling that unintelligibility has no place in
poetry, that it makes the work inaccessible in flagrant avant-disregard
for its audience.*
JR: I like that, "avant-disregard." It's a good joke because it accurately
reflects a common opinion. But it's not true. The language of one's con-
temporary moment is a complex barometer of all sorts of crosscurrents
that are affecting us, that we are sensing, that fill us with energy and
breath, anxiety and terror, but that we cannot yet bring into discernible
form. I once heard a scientist who loves poetry say that the language of
science and the language of poetry have in common that they are both
natural languages under stress. The complexity of the world, in which
language lives and develops and evolves, forms every word into a chord
conveying many many things at once—some of them contradictory.
Those chords strike us on many levels—sensual, intuitive, intellectual.
And there's so much that we experience in the silence before, during,
after, even *within* words. The poet must work with all of that. It's as
unknown and challenging as exploring any wilderness or frontier.

QS: *We are getting farther and farther from Aristotle's* Poetics.
JR: Oh, you noticed! Yes, Aristotle, who has cast the most enduring
shadow over the course of academic poetics, quite artificially divided
everything up into what he took to be thoroughly comprehensible dis-
ciplines—theory, practice, ethics, politics, poetry. Poethical poets,
whether or not they have themselves used the *h*, enact the complex dy-
namics that crisscross through these boundaries. The model is no
longer one of city- or nation-states of knowledge, each with separate
allegiances and consequences, testy about property rights and owner-
ship, but instead the more global patterns of ecology, environmental-
ism, biorealism, the complex modelings of the nonlinear sciences,
chaos theory. You can see this now with more and more poets using
multiple languages in their work—not as quotation but as lively inter-
section, conversation.

QS: *OK, I confess I'm confused. One's poetics must inevitably be
formed by one's personal experience—by the strange and problematic*

*intersections of self, family, society that are unique experiences for
each of us. But you claim that it's only the culture at large, and partic-
ularly the academy, that "understands" this as form.*

JR: Yes, "understandards," one might awkwardly say. The form that is
visible *as* form at any given cultural moment is what has already been
assimilated into the academy. So the teaching in graduate programs of
those "great innovators" of the past goes on almost entirely in an
atmosphere of invisible contemporaries. And the implicit fallacy that is
transmitted, say to the MFA student in "creative writing," is that if
you are going to succeed in the cautious world of poetry prizes and es-
tablishment publication and professional advancement, your work
must closely resemble a legitimated model. In the poetry of aboutness
the only thing that need change is what it's about: the marvels of *my*
sensitive, free associative response to seeing the first flower of spring.
The models in most writing practice courses, in interesting contrast to
those in scientific practice, rarely include the innovators. But even
when they are included, the modeling paradigm is off base. Innovative
poetry is most instructive to the writer, not as product but in its man-
ner of operation. Every "great" innovator was acutely aware of chang-
ing circumstances and forms of her or his own times and had to devise
a distinctive writing procedure to accommodate them. It's in this sense
that authentically innovative work is consciously poethical. It vitally
engages with the forms of life that create its contemporary context—
the sciences, the arts, the politics, the sounds and textures of everyday
life, the urgent questions and disruptions of the times. It's these factors
that make it different from earlier work and for a time unrecogniz-
able—to all but a few—as significant extension or transgression of ex-
isting genres. For the work to become poethical it seems it must risk a
period of invisibility, unintelligibility. This happened with Stein, Joyce,
Beckett, Wittgenstein, Cage. It's happening as we speak to some of our
most brilliant contemporary poets. For a poethical development to
occur, I think the language—the aural and visual forms, the grammar,
the vocabulary—must precisely escape, in a radical way, the control of
the poet. It must fly from the poet, like Zeno's arrow, in an imperiled,
imperiling trajectory subject to cultural weather, chance, vagaries of all
kinds beyond the poet's intentionality, out of zones of current intelligi-
bility.

QS: *Like Zeno's arrow! This might sound rather daring except that
Zeno's arrow didn't move. It remained motionless in the air.*

JR: Quite right! Until new language—a new philosophy, a new mathematics—came along to release it from false arrest. Chaos theory, fractal geometry, helps now to release Stein's or Cage's work into the culture. In fact at any given historical moment all of Zeno's laws against motion may be relevant to the reactions of academies and critical establishments. It takes a major conceptual shift—the very one that the art itself may be previewing. It seems to happen more easily in the visual arts. The figure-ground shift that we see in impressionist studies of the refraction of light into color, the figure-ground shift in the study of light in quantum physics—these become received by cultural eye and brain in ways less problematic than Joyce's foregrounding of linguistic refractions in *Finnegans Wake*. I wonder why.

QS: *I don't know, but I think that's true. For instance, the shift that occurred in the art critical world for Duchamp's "readymades" to become art prepares the way for Duchamp's and Cage's belief that the work of art is completed by the viewer. For the viewer to make this contribution to the meaning of the work, the culture must have already gone partway.*

JR: Yes, back to Zeno. The problem in one of the paradoxes is how that poor stalled athlete is trying to get from one side of the stadium to the other, but must first go halfway, and half of that, and half of that...and so on in infinite regress. In the contemporary aesthetic environment that problem need never arise. The poet never has to go the whole way, doesn't have to complete the transit of meaning all alone—

QS: *Is met partway by the reader.*

JR: In fact the artist *shouldn't* attempt to go the whole distance. As many have said, one way or another, the work should not explain but show itself. There's nothing more stimulating than a formally evident invitation to the reader to realize the work for her- or himself. There's always *at least* a dual perspective, that of poet and reader, two very different starting points of equal importance, mediated by worlds of experience in between—the vast diffusion and noise of the whole culture.

QS: *Gregory Bateson said in* Steps to an Ecology of Mind, *"All that is not information, not redundancy, not form and not restraints—is noise, the only possible source of new patterns."*[12]

JR: It's the infinite messiness of that noise that gives each of us the chance to invent our own life patterns. New poetries are filled with noise, with surface indeterminacy. The moving principle of reading po-

etry is a function of the degree of indeterminacy in the text. It cannot
be an argument.

QS: *Not an argument? Of course not. Who's saying it is!?*
JR: Well there's a long-standing, very entrenched aesthetic of
persuasion, isn't there? In which the reader must be *made* to feel what
the author felt, must be *convinced* of the author's omniscient perspec-
tive, must come to *believe* in the characters and the point (singular) of
view—at least within the microcosm of the work—and be edified and
inspired (filled with the author's breath) by it. The reader's activity is
not one of participatory invention but of figuring out. Figuring out
what the author as master creator means. One of my students recently
said, Truth is stranger than fiction because fiction has to make sense.
This applies to the lyric fictions of the I-poem as much as the *Ich-
roman*. It all has to make internally consistent, persuasive sense.

QS: *Oh yes, I recall that you wrote somewhere that the ubiquitous
three- or four- or five-stanza lyric poem mimics those exemplar
arguments in modal logic. Final epiphany equals logical conclusion.*
JR: Both are guiding the mind toward an outburst of certitude—cogni-
tive and/or emotional. And, of course, I'm speaking of an aesthetic
whose guiding principle remains verisimilitude, what I think of as the
"unnatural realisms." They have nothing at all to do with the
complexities, the multiple logics of nature, of everyday experience;
they are instead highly stylized, simple, and elegant conventions of
"realism" or lyric "truth." Everything depends on the audience's sus-
pension of disbelief—believe me, there's a lot to suspend!—coupled
with a rhetoric of persuasion. Nature, the natural, is caricatured and
called lifelike. There's no attempt to imitate nature in her manner of
operation. The actual model is the rhetorician in his manner of convic-
tion. Aristotle wasn't in a position to know this, so he separated the
Rhetoric and the *Poetics* into two books, even though the position of
the tragic spectator is clearly the same in both instances.

QS: *Surely you jest!*
JR: Surely not! Not at all. The terms of the *Rhetoric*—*ethos, logos,
pathos*—are engaged in the same asymmetrical relation between writer
and reader, targeting the same imaginative coefficient in the audience
as *verisimilitude*, the major term of the *Poetics*. Both want to
cognitively convince the audience while manipulating their emotions.

QS: *You define the terms of an art entirely in terms of the position of the audience?*
JR: Yes.

QS: *"Yes"? Is that it?*
JR: Well, I think about the forms of life the artist brings into the work and then the completion of the artist's part of the work as resulting in a kind of "score" for the reader or viewer. I wonder about the poethics of the kind of realization it invites. These kinds of thoughts, it seems to me, lead to the possibility of a contextual criticism based on poethical analysis, rather than judgment.

QS: *What would that look like?*
JR: Glad you asked. I just happen to have with me a document that can be read into the record. It came about in the course of an epistolary conversation with a young poet who was, in a series of quasi manifestos, defending the continuing relevance of older forms like the sonnet and villanelle against what he took to be a devaluing of them by certain Language poets. This was to my mind a poethical matter. I wrote this:

> The term "Poethics," as I see it, has two working uses:
>
> a) Analytic: Every form, old or new, has its poethical matrices and consequences. We can ask—after or while locating our questions within a value context—What are they? Are they useful to us? (Whichever "us" is inquiring: "world us" or I and my friends who are charting a working po-ethics.) Do they seem to be constructive or destructive given the articulation of our value context?
>
> b) Normative: as a descriptive term denoting what one takes to be the best uses of a positively constructive imagination in relation to contemporary conditions as they intersect with history.
>
> All of the above is most importantly not about manifestos but about in-vestigating the construction of specific texts. The ways in which language works can be compared among texts. The extent to which the analysis is comparative will, I think, determine the scope of its relevance. Manifestos are energizing because they're not fair. They're a call to action, not mindful exploration. In the rush to battle, the soldier doesn't question the ethical basis of the war. The manifesto is a call to arms whose form of life is to end conversation, not continue it. It festers in all of us who are passionate about what we are doing and it's difficult to redirect that passion into a useful form of exploration cum conversation, but I think we need to try.

Here endeth reply to young poet.

QS: *We haven't talked about the poethical implications of your own work.*

JR: I'm not sure I can do that. Although I sometimes know what I think I'm trying to do, I also know my perspective has a lot to do with what helps me continue on. Whether in, say, using language in new ways we change the grammar of the way we are together, I suppose I feel, as Cage put it, I don't know, but I can try. That's the force of the poethical wager.

QS: *That's how this conversation came about in the first place. We were going to talk about your so-called poethical wager. How did that notion come to you? Was it from Cage?*

JR: The word *poethics* is related to Cage, to how I've been understanding his aesthetic framework for sometime. I invented this term in the late 1980s to characterize his aesthetic of making art that models how we want to live. It was used as the topic for a panel at a 1992 symposium on Cage at Stanford. But the idea of the poethical "wager" is something that came to me during an "experimental vegetarian barbecue" at my house with the poets Tina Darragh and Peter Inman. The conversation was, in part, about how we could choose to go on working in the culturally isolated field of experimental poetry when the whole world seemed to be going to hell all around us. All three of us have had activist backgrounds—civil rights, antiwar. Peter is currently a labor negotiator for his union at the Library of Congress. So the question arises, given the troubles of our society in the world right now, shouldn't we be devoting ourselves entirely to *direct* social action rather than the "luxury" of poetry? I think this is an intermittent question for many of us, and it's—I find it—a bracing one.

QS: *Well, how did you answer it?*

JR: I can't speak for Peter and Tina, of course, but my answer is poethical and certainly a form of "we don't know, but we can try." My idea, which may be a patent rationalization, is that the world situation is so complexly interrelational from weather to neural networks to all forms of culture, there are so many variables, that large-scale or even modestly scaled predictive accuracy is impossible. Certainly when you get down to the level of individual agency, the effects of any one person's actions or work, particularly from the partial and myopic perspective of that individual herself, are quite mysterious. This means, I think, that each person has to make decisions based on prescription rather than prediction. This is a common distinction in the field of

ethics. They have very different logics. You might prescribe, in an aes-
thetic context, that your own action will be based on your conscious
framework of values, knowing that you can't predict the effect this
will have on your audience, much less the world situation. You can
hope that it will have a positive effect, as you construe it, but you cer-
tainly can't know. This hope would seem particularly far-fetched when
the size of your readership might be fifty to a hundred people, if that!

QS: *Such considerations lead to accusations of the exclusivity and self-
indulgence of the avant-garde.*
JR: Exactly. So, even given that one doesn't *choose* to have such a
small audience, how does one reply to that possibility with regard to
one's own work? It strikes me that since the work of any generation is
adding to the initial conditions of generations to come, one obviously
tries to add positive, even constructive, initial conditions. And, of
course, one isn't in it alone. I feel the work I do is part of a cluster of
aesthetic projects that involves many other artists as well.

QS: *So there are many butterflies!*
JR: Yes, we're all in effect choosing to be part of one family or genus
of Lepidopteron or another—a highly decorative, lightweight species
that might seem almost like a biological whim, but of course, we
know it has a very active place in nature. And that any individual, for
reasons entirely unknown qua qua qua, could shift some ecological
pattern—in a way noticeable or not to us, the "observant species." In
other words, all one can do is take what is actually, in these terms, a
very realistic, if improbable, chance that one's contribution might be
useful. So that's it, the long and the short of it—my view of
progressive action within a paradigm of chaos. I was explaining this to
Peter and Tina, and Peter said, that sounds sort of like Pascal's wager.
I hadn't thought of it that way, but of course he's right. I find it an in-
teresting comparison. Pascal was himself trying to figure out how to
proceed in the midst of potentially crippling uncertainty. And his
thinking was naturally couched in terms of his involvement with prob-
ability theory—tossing the binary God coin for a fifty-fifty chance of
heads or tails. Now we can envision many more variables and
possibilities. Although I admit I always thought Pascal's wager some-
what cynical, I've loved the spirit of, You must wager. This is not vol-
untary; you are embarked. I think that precisely describes our
condition. Each era works with its own scientific and mathematical
models, its own understanding of the nature of things. We now have

complexity theory. The poethical wager is just that we do our utmost to understand our contemporary position and then act on the chance that our work may be at least as effective as any other initial condition in the intertwining trajectories of pattern and chance. There's no certainty. One could, as Cage said, make matters worse. But to make this wager is at least to step out into the weather of our times.

QS: *What a good idea!*
JR: Yes, enough of this. Let's go for a walk.

Wager as Essay

The word *Versuch,* attempt or essay...thought's utopian
vision of hitting the bullseye is united with consciousness of
its own fallibility and provisional character.

<div align="right">Theodor Adorno, "The Essay as Form"</div>

I'm looking for *The Great Utopia.* Do you still have it
in stock?
No, but we have *The Rape of Utopia* in stock.

<div align="right">Conversation overheard at
Guggenheim Museum shop</div>

I

The poet Tina Darragh has written some of the shortest, best essays I
know. Piet Mondrian could write one in a title: "The Arts and the Beauty
of our Tangible Surroundings," "Down with Traditional Harmony!,"
"The Evolution of Humanity Is the Evolution of Art."[1] The prose that
follows is almost superfluous. On their own the titles exert aphoristic
power. An aphorism is a sudden essay. Darragh's book of what one could
call poetic essays, *a(gain)²st the odds,* contains formal experiments with a
new kind of narrative poetry and ends with "three manifestos." I don't
wish to be contentious, but they are not manifestos. They are riddled with
interrogatives of the sort the manifesto can't tolerate. Each—"The Best of
Intentions," "Error Message," "Don't Face Off the Fractals (Revis-
ited)"—is three or four pages long and, like John Cage's essays, articu-
lated in part by its spacing on the page. "The Best of Intentions" has this:

> While following this line of questioning, I am consoled by the existence of
> the random function as an ordering principle. We think of "random" as
> "helter-skelter," but as a programming concept it is used to define parame-
> ters within which the direction of diversity is productive.
>
> ...
>
> It's a matter of becoming accustomed to this new mode of organization.
>
> ...
>
> If poetry can be thought of as having a role to play in our culture, one as-
> pect of the job would be to make this random function—as a process, as an

organizing agent—visible, tactile, part of our sense of the world. We know we can do it.[2]

The random function exercised by the writer's/reader's mind is the operating principle of the essay as form. One might ask how to understand forms whose pleasure it is to violate or exceed generic expectations. Perhaps the point is not understanding at all, at least not in the sense of grasping. Essays, like poems and philosophical meditations, should elude our grasp just because their business is to approach the liminal spectrum of near-unintelligibility—immediate experience complicating what we thought we knew. In this case "to write" means to engage in a probative, speculative projection of the often surprising vectors of words as they graze the circumstances of ongoing life. "To read" means to live with the text over the real time of everyday life so it can enter into conversation with other life projects. Forms that move the imagination out of bounds toward pungent transgressions, piquant unintelligibilities intrude into our tangible surroundings. They maintain an irritating presence, pleasurable or not, as radically unfinished thought. They give the reader real work to do. If the essay is a worthwhile wager, it is about startling the mind into action when much is at stake and intelligibility is poor.

Which is to say, the best essay is a puzzle. What's a reader to think when in the course of reading Montaigne's "Of the Power of Imagination" ("A strong imagination creates the event," etc.) she comes on a section on sexual impotence? "People are right to notice the unruly liberty of this member, obtruding so importunately when we have no use for it, and failing so importunately when we have the most use for it, and struggling for mastery so imperiously with our will, refusing with so much pride and obstinacy our solicitations, both mental and manual."[3] Is Montaigne conflating penis and pen? For such flagrant erratics the term *belles lettres* is much too prim.

The history of opinion on the essay is as full of disgust as admiration. Samuel Johnson evokes gastrointestinal disorders gone to the head: "A loose sally of the mind; an irregular undigested piece; not a regular and orderly composition."[4] A century before, Francis Bacon had referred to his own essays as "dispersed meditations." Addison, of Spectator fame, remarked on "the Wildness of those Compositions that go by the Names of Essays." The Petit Larousse—keeper of Montaigne's *langue* if not his *parole*—denotes *essais* as first drafts or *"titres de certains ouvrages qui ne prétendent pas épuiser un sujet."* Think of the degree to

which prose styles with built-in grammars of persuasion service the pretense of exhausting the subject. If one avoids this pretense, if the subject is questionable or constantly shifting or densely complex, there is the risk of frustrating the reader who has been trained by the cultural marketplace to expect attractively packaged exhaustion. Every element of style is saying, *Don't worry, there's nothing more to it than this*. If this is called "essay," it's a misnomer.

Despite increasingly efficient exhaustion, or perhaps in dialogue with it, the tradition of the exploratory essay thrives in its improbable universe. If in times of rampant fundamentalism complex thought is a political act, then the essay is at least a poethical wager. The most happily adulterated essays continue to enact attempts, experiments that promise less about outcome than about possibilities noticed in the activity of exploration itself. I value the poethics of "wild" poet-essayists like Tina Darragh, Rosmarie Waldrop, Charles Bernstein, Leslie Scalapino as they, in conspiracy with their exigent and excessive times, reinvent the form to require collaboration with an ardent reader. Since a genre lives first in its composition and then in its realization by those who "perform" it (I take writing and reading to be equally performative acts), the essay text, like the poem, like the musical score, is nothing other than notations for performance. If the tentativeness implied by the word *essay* is its primary identifying principle, its traces in the text embody the directed random function we call subjectivity.

Early readers of Montaigne noticed the subjective investment his essays enact and invite. Pascal wrote, "It is not in Montaigne, but in myself that I find all that I see in him"; and Emerson, "It seemed to me as if I myself had written the book."[5] Montaigne's essaying was, in fact, of the nature of lively idiosyncratic, contingent, and digressive conversations with absent friends, a moving play of the senses, intertwining intellectual history and everyday life with rhetorical gestures (countless interrogatives, for example) implying the presence of an interlocutor. And the invention of this form was itself circumstantial. According to Donald Frame, Montaigne only started writing essays after the death of a close friend whose conversation he sorely missed.[6] This reaching out of text toward reader (Wittgenstein's notes have the same effect) foregrounds the limitations of the writer, the fact that the richer the matters at hand the more the writer needs the help of an intelligent, informed, interested reader. Difficult texts, those that are difficult because of the proportions of what the writer is attempting to take on, have this qual-

ity of appealing vulnerability. Rather than pushing the reader away, they suggest collaboration. I wonder if the great sacred texts in every culture, those that enlist whole communities of readers as commentators and interpreters over vast stretches of time, don't all have this quality of being unfinished, unfinishable, posing enough puzzles for generations to live with.

Such enigmatic texts can be fetishized into static orthodoxies, but they also inspire active reading traditions—for example, the commentaries on the *I Ching;* the Talmudic tradition of Midrash; the role of marginalia in early humanist reading;[7] the persistently disparate, even contradictory, readings of Dickinson, Heidegger, Pound, Stein, Wittgenstein that nonetheless spawn communities of avid conversationalists. These are scenes of reading as poesis—a materially based making of the text into something of use, positioning it phrase by phrase (the conversational ritual of the quote) in complex—often interrogative—relation to one's projects. From the nineteenth century on, reading as a more passive reception of the text seems to have become widespread. This is in coincidence with the rise of a narcissistic myth of author as genius that demands an audience stunned into submission by its own comparative insufficiency. Barbara Stafford is eloquent on this historical turning point in her book *Artful Science: Enlightenment Entertainment and the Eclipse of Visual Education,* a remarkable account of playfully active learning in the eighteenth century:

> If it is true that present-day neoromantic artists focus more and more on themselves and reach out less and less to their audiences, then nineteenth-century developments offer no consolation. Rather it was in the eighteenth century's demonstration of pleasurable learning that aspects of personal experience were put at the service of a public beyond the borders of the narcissistic self. The activity of attractively making knowledge visible not only kept the performer going, but engaged the viewer to constructively play along.[8]

We are left with three, sometimes intermixed, currents—text as didactic silencer, fantasy enthraller, interlocutor. (Where do Internet texts fall?) With the decline of the amateur intellectual and the Enlightenment ideal of the mind flourishing in thought experiment and other kinds of imaginative play, active reading is prey to the academy's chronic ambivalence between authority and novel thought. But there is also the displacement of private pleasure from cultural work that is part of our obsession with the advancement of self as the sole point of a career—the career of one's emotions, desires, gratifications measuring success or

failure in relation to one's power to become publicly conspicuous and, of course, to consume. The highly rewarded entrepreneurial strategy of forging ahead with an air of mastery no-matter-what spawns impatience for the point or gist. This is the economy of generically busy expertise. It must detach itself from values that encourage the necessarily inefficient, methodically haphazard inquiry characteristic of actually living with ideas.

Who in today's world has the luxury of Montaigne's practice of writing as it negotiates the linguistic distance not only between the invention of self and the presence of the other, between culturally informed consciousness and idiosyncratic inventions of genre, but in open invitation to daily contingencies? Who can afford not to do this? Montaigne cultivates sentences that admit unsteadiness while finding a moving balance in disequilibrium. This is the way every interpermeable life system works—in dynamic, vertiginous flux—finding its patterns in contingent motion. He writes in "Of Repentance":

> I cannot keep my subject still. It goes along befuddled and staggering, with a natural drunkenness. I take it in this condition, just as it is at the moment I give my attention to it. I do not portray being: I portray passing. Not the passing from one age to another...but from day to day, from minute to minute. My history needs to be adapted to the moment. I may presently change, not only by chance, but also by intention. This is a record of various and changeable occurrences, and of irresolute and, when it so befalls, contradictory ideas; whether I am different myself, or whether I take hold of my subjects in different circumstances and aspects....If my mind could gain a firm footing, I would not make essays, I would make decisions; but it is always in apprenticeship and on trial. (Montaigne, *Complete Essays*, 610–11)

Lacking a final coherence, the necessary incompleteness of an intelligence respectful of its own complexity leaves room for the reader to bring other elements into the mix. If one trusts that intelligence, one is drawn back to it by the seduction of a further glimpse, a new angle, a new view from the strange topography one has already helped form with the circumstantial evidence of one's own tropisms and reflections. Each return of the reader, inevitably changed by intervening experience, further elaborates the conversational matrix that has formed around the text—its charged history. (This could be a defense of a canon.) The essay, like the best of any art, is nourished over time by the transformative passage through it of all those exotic interlocutors bearing gifts and explosives.

The field of potential within the essay lies in the active zones between believing and doubting. (Congealed belief, or doubt, produces tracts.) This is why the essay in its best uses can be the most important exploratory tool of humanistic thought. Its active middle term is a particular kind of play with and of ideas—the play of minds in pursuit of both pleasure and meaning, the pleasure of *making* meaning. Or, perhaps more accurately, the pleasure of composing meaning at (and out of) the limits of the kind of knowledge that is possible only with language. It's interesting that a Frenchman brought the modern possibilities of this form into such high profile. French is a language at play (often ironically) with its own severe limits. Notice also the Paris-based OuLiPo— Ouvroir de la Littérature Potentielle (Workshop for potential literature)—that thrives on constraints. For centuries the well-guarded, relatively small French vocabulary (about one-fifth the expanse of English) necessitated cultivating an ingeniously permutative semantic field laced with strategic ambiguity and multivalent implication.

In France there has also been, at least since the sixteenth century, a strongly imprinted national competition between institutional belief and radical doubt. French writing has been the scene of an obsessively disciplined and exclusionary culture along with a playful, transgeneric one. Can one read the history of French philosophy in this light from the Encyclopedists, Pascal, Descartes, Voltaire, Rousseau to Derrida, Kristeva, and Baudrillard? (See ":RE:THINKING:LITERARY:FEMINISM:" in this volume for thoughts on why they mostly happen to be men.) The play of intellect and imagination that characterizes French prose styles is a model of the poesis of curiosity that constantly flirts with a resistance to authority.[9] It exists in the transitional space between individual and tradition, subjective experience and larger reality, as well as that scintillating spectrum of "in-between" that haunts all binaries. We can learn from playful forms in the humanities, sciences, mathematics, and the arts—scenes of intellectual, imaginative, sensual thought experiments—that we need not get stuck at either end of the dichotomous structures we're so prone to ritually enact. The intelligently informed playful imagination makes it possible to experience binaries as magnetic poles that form productive limiting conditions of vast fields of cultural energy, that is, cultural playgrounds.

I find myself continually drawn to the writing of D. W. Winnicott, the British psychoanalyst who charted "transitional objects," "transitional space," and "transitional phenomena" in his thinking about the way in which play negotiates zones between personal experience and shared re-

alities.[10] He emphasizes throughout his work the precarious, experimental nature of play. The collection of essays *Playing and Reality* is a stylistically awkward, intellectually and imaginatively lucid, conceptually suggestive collection of notes, case studies, and theory that help one think about the kinds of values the essay enacts. Winnicott's "location of cultural experience" is precisely where I situate the essay as wager:

> Here, then is my main statement; I am claiming:
>
> 1. The place where cultural experience is located is in the *potential space* between the individual and the environment (originally the object). The same can be said of playing. Cultural experience begins with creative living first manifested in play.
>
> 2. For every individual the use of this space is determined by *life experiences....*
>
> 3. ...This potential space is at the interplay between there being nothing but me and there being objects and phenomena outside omnipotent control.[11]

With the high stakes involved in appearances of control and completion (careers, money, respect), forms that refuse these illusions are necessary to retrieve space for creative living from a culture blindly driving toward total regulation of the imagination. According to Winnicott play is "inherently exciting and precarious" just because it is the moment in which the near-hallucinatory imagination—so skilled at seeing the expected pattern with even the sparsest cues—must intersect with both shared and contingent reality. It's the moment that divides imagination from the stillborn internalizations of fantasy. By occupying the mind with hallucinatory belief, fantasy breaks the connection with the dissonant cues of the sensory world to celebrate the solace of isolated subjectivity. What opens up the active principle of imagination is believing and doubting, equally suspended in poesis—invention that works only in conversation with the material world. What's at stake is one's zest for life, what happiness may be possible given fortunate circumstances. Winnicott puts it this way:

> It is creative apperception more than anything else that makes the individual feel that life is worth living. Contrasted with this is a relationship to external reality that is one of compliance, the world and its details being recognized but only as something to be fitted in with or demanding adaptation. Compliance carries with it a sense of futility for the individual and is associated with the idea that nothing matters and that life is not worth living. In a tantalizing way many individuals have experienced just enough of creative living to recognize that for most of their time they are living uncreatively, as if caught up in the creativity of someone else, or of a machine.

> The second way of living in the world is recognized as illness in psychiatric terms. In some way or other our theory includes a belief that living creatively is a healthy state.... [T]he general attitude of our society and the philosophic atmosphere of the age in which we happen to live contribute to this view. We might not have held this view elsewhere and in another age. (Winnicott, *Playing and Reality,* 65)

Winnicott conscientiously negotiates the dichotomies of his own culture: ideals of creativity versus pressures to conform.

Theodor Adorno wrote as one who had experienced the havoc of what many have characterized as the Ur-Kultur of compliance impossibly linked to a chronic adulation of creative genius. It turned out that since total compliance is anathema to creativity, and the compliance of the majority of citizens was obligatory, creativity had to be the inexplicable exception. Hence the myth of Genius as the mysterious anomaly of the great, transcendent soul. In such an atmosphere the manifest lack of mastery in the essay might be construed as a potent subversion.

Almost four centuries after Montaigne, Adorno is thinking about these matters in "The Essay as Form."[12] (Oddly, he neither mentions Montaigne nor the French term for the genre.) The German word for essay, *Versuch,* has "search" *(suche)*—seeking, tracking—embedded in it. *Versuch* is an experimental seeking whose writing—act and trace—accommodates clear directionalities and peculiar contingencies. For Adorno the essay is above all the discursive form that confounds the dangers of ideology and entrenched thought. It is part of the aesthetic project he championed all his life: upsetting ideological strangleholds by means of forms that resist the commodification of nefarious marketplaces of ideas and images. Great art—and this includes the art of the essay—reveals what ideology conceals. Essay writing must take place in the tentative and transitional space-time that is always in between the publicly entrenched vocabularies and grammars of official thought and the writer's engagement with temporal processes. The goal is to resist all those standards that create what Adorno calls the "illusion of intelligibility."[13]

In his *Aesthetic Theory* Adorno scorns the way in which the cultural consumer is served by conjoined promises of intelligibility and possession.[14] He is in fact skeptical of the truth value of anything contaminated by official thought and its self-serving strategies of interpretation. In discussing the discourse surrounding art with socially established value, he writes, "What everybody takes to be intelligible is in fact not intelligible at all.... When something becomes too familiar it stops making sense. What is immediately accessible is bound to be lifeless."[15] This

is of course part of an argument for the "defamiliarizing" role of art: "If one perceives art as anything other than strange, one does not perceive it at all."[16] One is instead perceiving yet another iteration of official thought (what Gertrude Stein referred to as the already classified). The question becomes how thought can hope to escape the pervasive, high-pressure marketing of faux-intelligibility, what one might call the argument of the habitus—Bourdieu's useful term for the nexus of internally reinforced customs and ideas that create the prevailing climate of opinion in every culture.[17] Adorno writes,

> The word *Versuch,* attempt or essay, in which thought's utopian vision of hitting the bullseye is united with consciousness of its own fallibility and provisional character, indicates, as do most historically surviving terminologies, something about the form, something to be taken all the more seriously in that it takes place not systematically but rather as a characteristic of *an intention groping its way*... There is both truth and untruth in the discomfort this procedure arouses, the feeling that it could continue on arbitrarily. Truth, because the essay does not in fact come to a conclusion and displays its own inability to do so as a parody of its own a priori. The essay is then saddled with the blame for something for which forms that erase all trace of arbitrariness are actually responsible...emancipation from the compulsion of identity gives the essay something that eludes official thought—a moment of something inextinguishable, of indelible color....Hence the essay's innermost formal law is heresy. Through violations of the orthodoxy of thought, something in the object becomes visible which it is orthodoxy's secret and objective aim to keep invisible [italics mine]. (*Notes to Literature,* 1:16–17)

It's remarkable that "an intention groping its way"—full of desire for discernible form but driven by questions rather than certitude—can gather enough courage to welcome the play of the indeterminate, the grace of the swerve, the conceptual metaphysick of coincidence, the po-ethical integrity of a self-prescriptive rather than wholly predictive agency. The love/fear of one's own will toward utopian perfection or of one's own impotence, the anxiety in this groping might at any moment tip that fragile equilibrium toward hysterical mastery or manic exhaustion of the subject. Adorno has often been criticized for his "pessimism." I see him as exercising enormous moral spirit in his work to find forms (both for his own writing and in the arts of others) that could generate constructive energy despite history's default habits of destruction. I think the aphoristic essay is for him the chief instrument of a working optimism.

Adorno's essay chooses to negotiate transitional spaces in a culture that has yielded a very particular set of dichotomies. If in French culture

these spaces are bounded by extremes of establishment rigor versus
playful skepticism or irony, in German philosophical traditions one
finds the "genius" of Systematics *as* Romanticism, Romantic Mastery
as Transcendence, Transcendence *as* Beauty. (Think of Kant's fateful an-
alytic hubris, so beautiful in its categorical imperative toward the
beauty of the categorical.) What might be irresolvably dichotomous
elsewhere becomes fused in romantic idealism creating an idea of will
that reflects the strength of the philosopher's intellectual bonding agent.
The strength of this tradition, the systematized romanticism of ideas
that become policies, depends on protection from empirical interrup-
tion. It is an internally unassailable, a priori fiat of absolute purity.

Is this why the essay for Adorno is shot through with the dangers of
heresy? Does that drive its turn toward parody?[18] Adorno's tone is often
one of bitter irony, a much heavier form of play, if play at all. Parody de-
rives the energy of its self-reflexive trajectories from a sense of entrap-
ment that produces alternating currents of anger and despair. It lacks the
buoyancy and surprise of more optimistic forms of play. These differ-
ences have never observed unadulterated genealogies or national bor-
ders, but they do seem to have to do with divergent projects. The utopian
sense of a possible use, or even invention of, transitional zones as the free
space of unrealized possibilities (for example, as alternative or counter-
cultures) is quite different from projects of resistance and subversion
where the power of the status quo is perceived to be so great it constrains
the imagination from envisioning new territories. The light and fluid
transitional zones of play are scarce where dichotomies either appear to
be terminally irresolvable or are read as two sides of the same coin.

Adorno, in the black light of Hitler's debacle, helped along by those
fraternal twins, systematics and romanticism, and their mirror images,
mastery and transcendence, often chose to write, like Nietzsche, apho-
ristically. His attempts to construct a working optimism out of a dia-
logue of reason and despair found its most viable possibilities in the
idea of the essay as a kind of Epicurean clinamen, a swerve away from
the grim determination of official thought. This swerve cannot be legi-
ble in grammars of the status quo. It must occur in its unpredicted con-
tingency as a moment of something inextinguishably strange unless it is
so vastly overdetermined it has already become part of a paradigm shift.
The essayist, by virtue of peculiar means, may project new geometries
of attention, oblique vectors ricocheting between authoritative generic
poles, describing unforeseen patterns. Writer and reader wander in lush

untranslatability, surveying new territory as they go. Or that's how a near-utopian account of the essay as form might go.

2

To get lost in the writing can be a way out of officially charted territory. Gertrude Stein says this, enacts this emphatically in her own essays—to act out of one's unprecedented contemporariness is to be able to tolerate, even enjoy, not knowing where one is going even in sustained forays. Stein's essays—in a tradition that continues through John Cage, Rosmarie Waldrop, Leslie Scalapino, and others—literally compose (live) their way through the necessary uncertainty that transforms language according to one's sense of the active principles of change in one's time. This is to enter the event of literature (as writer/reader) most directly as a "form of life" in Wittgenstein's sense. The language game of the exploratory experimental essay is in dynamic intercourse with the cultural contexts that form the developing rims of one's social world. If one sees change as the very definition of temporality, then the poesis of living that change is one in which the action of time *is* the action of composition. Stein puts it this way in "Composition As Explanation":

> It is understood by this time that everything is the same except composition and time, composition and the time of the composition and the time in the composition.... The composition is the thing seen by every one living in the living they are doing, they are the composing of the composition that at the time they are living is the composition of the time in which they are living. It is that that makes living a thing they are doing. Nothing else is different, of that almost any one can be certain. The time when and the time of and the time in that composition is the natural phenomena of that composition and of that perhaps every one can be certain. No one thinks these things when they are making when they are creating what is the composition, naturally no one thinks, that is no one formulates until what is to be formulated has been made.[19]

Stein's explanation of composition *as* explanation is a fortuitous elucidation of just how the essay can elude official thought. The act of composition in the writing is radically preformulaic. Official thought has no existence except as formula. The essayist in Stein's world is creating her composition in the transitional zones of the contemporary as unclassified[20] temporal space. This is one way of understanding her phrase "continuous present." In the poethics of an experimental activ-

ity with contemporary "use" as the guiding value, one must always have the courage of "an intention groping its way." Stein again:

> There was a groping for using everything and there was a groping for a continuous present....Having naturally done this I naturally was a little troubled with it when I read it....[W]hen I reread it myself I lost myself in it again. (499)

> Each period of living differs from any other period of living not in the way life is but in the way life is conducted and that authentically speaking is composition. After life has been conducted in a certain way everybody knows it but nobody knows it, little by little, nobody knows it as long as nobody knows it. Any one creating the composition in the arts does not know it either, they are conducting life and that makes their composition what it is, it makes their work compose as it does....And now to begin as if to begin. Composition is not there, it is going to be there and we are here. (498)

> Nothing changes except composition the composition and the time of and the time in the composition. (502)

It is in the act of composing, and only in composing, that one notices and arranges memory; fully lives in, makes something of one's contemporary experience. This has to do with the fact that being where one is—in the present as it is continuing to complicate history—is the one thing we are certain to not understand in advance. (Or perhaps we understand nothing *in advance*.) It takes everything we think we know along with everything noisily/silently unknowable to form the patterns that will eventually give visibility and meaning to things.

Gertrude Stein likes to give an unfolding map (now I am here, doing this, having just done that as I move on to do this, which is not that...) of the process of getting lost as she gropes and relishes her way through what Montaigne called the "changeable occurrences and contradictory ideas" of lived dailiness. In this way and through the use of repetition she presents a bounded pattern of indeterminacy. When John Cage wrote his "Lecture on Nothing," he had clearly learned from his reading of Stein that this principle could be applied to musical composition and language:

Here we are now		at the beginning	of the
eleventh unit	of the fourth large part	of this talk.	
More and more		I have the feeling	that we are getting
nowhere.	Slowly	,	as the talk goes on
,	we are getting	nowhere	and that is a pleasure
.	It is not irritating	to be where one is	. It is
only irritating	to think one would like	to be somewhere else.[21]	

Cage's essays (like all his other compositions) are experiments in forms of living one's life that are ways of not wanting to be anywhere other than where one is. In this sense they, like Stein's essays, enact a concrete utopianism that is not futuristic but is embodied in the composing moment of the contemporary. Poet and novelist Rosmarie Waldrop, also interested in the implications of contingency, makes her skepticism about utopian thinking, idealism, and certainty frankly manifest in "Alarms and Excursions," an essay form she invents for the "impossible" topic of politics and poetic form.[22] In the opening paragraph of the essay she explains her form:

> "Alarums and excursions" is an Elizabethan stage term for off-stage noise and commotion which interrupts the main action. This phrase kept running through my head while I tried to think about [the] topic because all that occurred were doubts, complications and distractions. So I decided to circle around this mysterious interaction of private and public that is poetry with theses (things I believe or *would like* to believe), alarms (doubts), and excursions into quotes, examples, etc. I numbered the theses to give an illusion of progression which will only make their contradictions more obvious.[23]

Despite all the precautions against it, this essay does in fact turn out to be a kind of utopian enactment—a playful movement through the safety zone the essay genre provides, constructing something instructive out of the inability to make decisions (like Montaigne) or to conclude (like Adorno) or to make a systematic whole out of the notes (like Wittgenstein) while rearranging the residue of history in an unmistakably contemporary manner (like Stein and Cage). Waldrop's essay charts itself into existence so that she and the reader can at least maintain an illusion of not having gotten entirely lost in radical uncertainty. This is an interestingly Cartesian method, except that God will never appear to save the day and neither will that inflated punctum Q.E.D. The essay demonstrates the impossibility of demonstrating the relation between poetics and social forms.

Poet-essayist Leslie Scalapino, whose most urgent concerns inhabit a region where poetics and politics are inseparable, interestingly does not, will not, cannot operate in this way. She is perhaps our most Steinian contemporary essayist. Her form is frank in its poethos of surface unintelligibility as textual eros and new semantic geometry. The reader must map Scalapino's intellectual-imaginative sensorium by attending to odd edges in the language, poking the mind into its logical interstices. This is to explore moving principles in the palpable temporality that is an act of writing/reading. One in fact apprehends Scalapino *in the act* of writ-

ing a linguistic erotics whose mystery is its compelling lucidity. Her essays evoke multiple senses of time, intersections of poetics and politics—a long history of con/texts, a recent past full of local excess and global abuse displayed in the fragile surface tension of the present disappearing/reappearing unevenly at the speed of sound and light.

Scalapino acts on her own knowledge that "we don't have words at all," that "the text is erotic not simply by withholding" but insofar as it touches "the rim of occurring." How can language, with its densely freighted etymologies and indebtedness to institutional inertias, do such a thing? Scalapino (as essayist as poet) achieves the shimmering moment of words as forms of life through a transmission that does not attempt, or pretend, to pin things down, what she calls "writing on rim." It is this very incompleteness that brings words to life by sending them into the world as one locus of energy in an intercourse that is dependent on the seductive attraction and creation of the other. It can only happen in the context of a euphoric textual love. Here are some examples of Scalapino's writing on writing on the rim of occurring, from her book of essays on the work of selected contemporary poets, *Objects in the Terrifying Tense Longing from Taking Place:*[24]

> If the writing is on ("seeing") something that's real, it keeps disappearing as the occurrence, as the occurrence does. The comparison of the image to the living object is occurrence as rim of observation, in the comparison of these texts. One is seeing their observation of the object, as an image, to see.
>
> In the reality which is created by a writing, to narrow to the outlines of its form is utter scrutiny, is real. (1)
>
> If we ourselves are objects in the terrifying tense, our writing reflects the object of oneself. It reflects back the object seen through "their" eyes to "them." (66)
>
> Now not as "doctrine," one can't cleave to or be "masculine" "tradition" which is non-existent as we're together floating with real individuals. This is the only love. There is no separation between essay and poetry. (67)

For Scalapino "the form is the occurrence," and this is a contemporary enactment of Stein's composing of a contemporary time as the thing seen. Here are some passages from Scalapino's long poem *New Time,*[25] which, like the work of Tina Darragh, exemplifies an investigative poetics that conflates essay and poem:

> bud—outside—but which is fully open—because outside of one as occurring lightly
>
> a "burst" that's from one being returned to oneself—after one being away (outside). the outside is one's awareness

*

The writing is not narrative "telling" the story or stories of events. Rather it is movements, a *movement* that was a "real" event where all is fictional as phenomena. So history is scrutinized by phenomena, observed as minute, particular—and thus "fictive" as haphazard moving.

Biography that is not "completed/whole" "a life," poems, fictions, not-illustrating, are not an early form, undeveloped narrative, but as mere movements are subject to scrutiny by phenomena, are "the life's" construction *per se.* (11–12)

Scalapino's poetics of exploration along the horizon (rim) of writing (occurrence), that is, writing the rim (history) into occurrence, is experiment not in the scientific sense of tracking highly probable hypotheses but in complex wagers of luminous improbabilities moving through negative space, the constantly shifting remainders left by familiar logics. Poethical wagers are most important, operate most crucially, where existing cultural structures create inverse and distorted relations between what is desirable (just) and what is desired (drawn by seductions of power). Scalapino's work is urgently ethical, concerned as much about social injustice and the U.S. tropism toward war as the always failed attempt to invent an honest subjectivity. Her sense of the real is a double-ended telescoping of awareness in relation to language as it gives on what Kant called the "empirical self." From *Objects:* "In so far as I noticed myself trying to change or avert reality by the writing, I had to recognize that motive, note where it's occurring, which is fantasy" (73); "The current culture is produced in one as one's inner self" (74). The middle spaces, where new work can be done, is found in the gaps left by geometries of intelligibility that both create and cordon off subjective and historical silences. What is the poethics of a wager on silence? In Scalapino's case it's a wager on meaning that can only be created between zones of intelligibility. In this realm of exploratory poetics one must count it one of life's significant projects to develop linguistic intuitions that are unintelligAbilities.

Wallace Stevens wrote to a friend, "people ought to like poetry the way a child likes snow."[26] Here's a sample of his "Snow Man":

One must have a mind of winter...
For the listener, who listens in the snow,
And, nothing himself, beholds
Nothing that is not there and the nothing that is.[27]

Lines in another Stevens poem, "Snow and Stars," could have been written for a child's ear: "The grackles sing avant the spring / Most spiss—oh! Yes, most spissantly" (*Collected Poems*, 133). The "mind of winter" is a mind's eye's ear primed to enter and explore gaps normally erased by the syntactical momentum that functions as speed-set glue in every grammar. The child's synesthetic awarenesses of language have not yet been arrested. Although they lack capacities for complex thought, children recognize the dicey urgency in the off-logics of Mother Goose or Lewis Carroll. Is this literature so nourishing in its strangeness just because its humor is not about trivial things, does not try to erase difficulty? The instances of violence in M. Goose are in the hundreds; *Alice in Wonderland*, like much of the best children's literature is about terrifying events. To become an adult in our culture (which for most of us means to become compliantly productive) is, as Winnicott argues, to be increasingly disabled for the kinds of humorous and dire, purposeful play that creates geometries of attention revelatory of silences in the terrifying tenses that elude official grammars.

The essayist takes up the child's project but under difficult conditions—an irrecoverable innocence, a realization that the cultural stakes are always too high. Every essay, like every poem that is a poethical wager, creates a working ethos of attempting—to the utmost—the improbable. It must be simultaneously grave and light, taking perverse pleasure in a curious precision that illuminates its own defeat. The poethical form awkwardly, if good-humoredly, nods to its limitations as it beckons toward the reader for help. A collaborative making of meaning is its only redemption. In coformations of material agency some "we" just might create projects for a viable contemporary despite the generic impossibility of the task. This is why the extrageneric, experimental instrument of the essay may be indispensable to the collaborative project of our humanity. The interesting question is not whether "I am" teetering but real on the rim of my writing, nor even whether "I think" a "therefore" contains any glue. It's whether, in improbably writing out of the "I am" into the thought experiment that begins with "Let's imagine," that strangely playful cognition will find the filaments of other minds.

Blue Notes
on the Know Ledge

What is the metaphysics of the ontology of the physics of the neuro-physiology of the epistemology of blue? How many ways could I you s/he they we reshuffle the order of these fun-house nouns? Blue-tipped blue light distance signifiling past slide rule's blue shift. A Western poetics of blue *(Is* pink the navy blue of India?) is blind sighted at an intersection of the optics of blue (peripheral vision and distance) the paradoxical psychology of blue (religious hope and historical sadness) the epistemology of blue (peripheral vision and cognitive distance). Linea, punctus, circulus, sanctus, sanctus..... blue

B.I

One's first impression of Giotto's painting is of a colored substance, rather than form or architecture; one is struck by...the color blue. Such a blue takes hold of the viewer at the extreme limit of visual perception. In fact, Johannes Purkinje's law states that in dim light, short wave-lengths prevail over long ones; thus, before sunrise, blue is the first color to appear. Under these conditions, one perceives the color blue through the rods of the retina's periphery (the serrated margin).

Julia Kristeva, "Giotto's Joy," *Desire in Language*

Q&A

Q: *WHAT'S THE QUESTION?*
A: Gertrude Stein.

Q: *How will we ever escape the prison house of language?*
A: Through our unintelligAbilities.

Q: *What?*
A: What?

B.2
And in the best United States way there is a pistol hanging low to shoot
man and the sky in the best United States way, and the pistol is I know a
dark steel-blue pistol. And so I know everything I know.

<div align="right">

Gertrude Stein, "I Came and Here I Am" (1935),
How Writing Is Written

</div>

BUT FIRST AND YET
How can the I that claims ownership of the consciousness in this sen-
tence not be disingenuous? How can it not be disingenuous to bypass
that I in a sleek little stylistic coupe of One (I plural) or We (I plural)?
There's much to be said right now for a stupefyingly global We as in
Who the hell do We think We are?—not the We of kingdom, phylum,
class, order, genus, race, ethnicity, nation, culture but yes, of species, un-
intelligible as that may seem. One asks, Can We really do without "one,"
I write in this dangerously dated language. Top down open to weather
(we aether), the stately We motors through urban and suburban word-
scapes, letters reconfiguring razor blue shadows. Drive-by shooting eyes
cast shadows of their own on scene after scene of the revenge of the real.
Scattershot puncta, vanishing points, traffic lights signaling the grammar
of the blues. Even if I decline ammo amass a mat (philosophical cat on):
Whose mat? What mat? What matters? Taking in and over word's eyes'
view's apostrophized possession's and omission's blue-light district of a
war/peace binary-torn world what will become of US 'n THEM as vis-
ceral dichotomy's epistemological burlesque show now or later still? Can
an epistemology of blue know ledge find a way through this maze?

> If knowing as we know it now has nothing to do with objectivity, universal-
> ity, absolute certainty; if a sense of certainty is no more (or less) than
> personally situated belief in the viability of a cultural matrix, then the ques-
> tion of knowledge arises only when one is in the precarious position of
> needing to act out of *conviction*. In that need one is proven guilty, one is
> convinced. To know: a matter of taking one's bearings from spatial, tempo-
> ral, material cues in order to capitulate or move on. The approach toward
> the know ledge is an urgent, strange, self-implicating gathering of the senses.
>
> Genre Tallique, *GLANCES: An Unwritten Book*

The breeze is stiff out here on the know ledge. Wind whistling *In Our Ears*. Or in *Absence:*

B.3
Out of a sudden
the alphabet wonders what it should do.
Paper feels useless,
colours lose hue
while all musical notes perform only in blue.

> Tom Raworth, *Clean & Well Lit*

B.4
If, for instance, you were ordered to paint a particular shade of blue called "Prussian Blue," you might have to use a table to lead you from the word "Prussian Blue" to a sample of the colour, which would serve you as your copy.

> Wittgenstein, *The Blue Book*

To know is either a pedestrian act—carrying the sample of Prussian Blue across the room to make the match *(Shhhh, cup your hands, light that blue-tip now!)*—or throw of dice across complex kinetic, gravitational, electromagnetic, strong/weak nuclear fields. This is only, or not only, a matter of phot-on glue-on snap-on put-on perceptions or a great nineteenth-century poem or the mechanization of the world picture from Galileo's falling bodies to Tosca after Tosca littering the ground beneath the ledge, literally literaerialy literarially tossed off ledge by romantic crescendo, singing all the way down. A moving principle? Can you locate three points from which to obtain a navigational fix as s/he launches into wild blue wonder? Of course falling is easy of course. The hard question is, how many dotted lines need intersect before an I or a You or a multiple We can achieve the zigzag interplay of reciprocal alterity? Dunno. Carrying the sample of blue across the room to

B.5
She is education history. She. Is water written lament. And cool education written blue. A literate blue. A literate yellow. And arrogance she. Speaks. Forgetting. The first Brazil. Is yellow and so speaking yellow as blue as writing. Lament. Yellow and blue. Slip. The negative. Bury the negative. Growing written water. And arrogance. But first. The oversight.

> Carla Harryman, "Dimblue," *In the Mode Of*

make the match, light the match light sucked in more directions than any rubber sheet geometry can chart, blue nose flattened against blue wall invisibility. Does the leap of knowledge after the fact of just what was that fact take more courage than the leap of faith before? Fact totem. This is perhaps better explained not as act of suicide but of sui generis *memento vivere* remembering with a jump-start that after all those falls of the fact one must move with a knowing scramble toward another ledge. The thought gives me vertigo. Out there with the pigeons it seems only an either/or retreat or some sort of perilous leap is possible. To remain immobile, if one hasn't lost one's senses, is an act of terrible faith rather than terrible knowledge.

> ...but [all this] would perhaps frighten you until you might learn to believe in the reality of that which you believe only in the form of poetry
>
> Søren Kierkegaard, *Either/Or*

There, Stolid, Still, St.

Simeon Stylites on top a pole in the desert for a quarter century, knowing what he believes? I on the other hand and foot in mouth want to know/want to not-know simultaneously. In this I often retreat with all other anarchic "I"s from the I that claims to know to the We that thinks and supposes: Descartes's retreat from *je sais* to the decent anonymity of *cogito*—case in point. The I can always return in time for disclaimers. I might disclaim knowledge altogether, modestly indulge only in opinion or belief. But *to know* holds out the possibility of that ledge. The seduction of that radiant edge of legibility. Singing the radiant blue edge of invention I count on forms of possibility whose probability is statistically insignificant. Here we are again, swerving across dim blue coordinates of blue desert.

B.6
It is a lie that it has gotten worse. And it is a lie that it has gotten better. It is the same. Rounding the desert is the same as rounding the pond. No one is there but rounding but lining. If history were made by a series resting. Yet there are many arguments for the contrary. Although voices disappear as fast as the contemporary arrogance taken as history can obliterate them. Though music contradicts. She. She. He. He. The child sings. And contradicts. She brings preference to history.

> Carla Harryman, "Dimblue," *In the Mode Of*

Here's a nice rub: To undertake the imaginative, cognitive act of know-ing—as distinct from remembering or believing—may enlarge ego to in-clude world. Belief after all the afters of all those falls of ALL enjoys a certain I-solation. I-solace. A *Transbluesency*:

B.7
in The Glass
Enclosure

of the essential
Transbluesency

We dreamt Paradise
w/you
Naima

Savoying
Balue Bolivared

in black Night
Indigo

> Amiri Baraka,
> "Wise, Why's, Y'S"

B.8
The mood of the blues is difficult to assess. It can be sad, funny or desper-ate, but never satisfied or content. Unless correctly understood, it is possi-ble to assume that the singer is out of tune.

> Anon, *The World of Music*

Is the act of knowing that carries one to the know ledge a poethical act, an attempt to develop viable, rather than virtual, forms of life? There is no peripheral vision in cyberspace. What acts of knowing are spiritually pragmatist acts—less about remembering than creating usable pasts?

B.9
Look at that blue, you said, detaching the color from the sky as if it were a membrane. A mutilation you constantly sharpen your language for. I had wanted to begin slowly because, whether in the direction of silence or things have a way of happening, you must not watch as the devil picks your shadow off the ground. Nor the scar lines on your body. Raw sky. If everybody said, I know what pain is, could we not set clocks by the violent weather sweeping down from the north? Lesions of language. The strained conditions of colored ink. Or perhaps it is a misunderstanding to peel back skin in order to bare the mechanics of the mirage.

> Rosmarie Waldrop, "Inserting the Mirror,"
> *The Reproduction of Profiles*

Peel back skin?
Bag-o-blud, sack-o-semen, clotted DNA: dense vascularization of post-
partum language, vast fluid medium holding us, our historarias in sus-
pension, a hemorrhaging We. A thoroughly disgusting act, this attempt
to navigate the viscous silences—all the body fluids, all the unintelligi-
bilities collecting, improbably enough, into a parthenogenic I.

Could the feminine (what do women want? etc.) as we don't understand
it in the intercourse of culture be nothing more or less than the fluid
drive zone of unintelligibility? Is the feminine—in its male and female
versions—the permanent clinamen from the canon's fixed trajectory?
The swerve into wild blue blunders that makes them less persuasive,
makes them really reel, reel back for missing instant replay? Is it only
the simpleminded realisms, the death-dealing fantasies that betray us all
in *riverrun, past Eve and Adam's swerve of shore?*

If the unintelligible/indeterminate is itself the locus of the swerve, then
what is to be the pedagogy of the impressed? *Ego ergo summa wrestler
theologica.* In the postcogito *triste topique* blue-note world—where dis-
tinctions between knowledge and belief, knowing and feeling, image
and reality have lost their l'edge—in the electronic intimacy of a

 post toasties *cogito* blue funk
exploding cartoon ¡¿NOW!? our world's smallness and introversion of
depleted categories can create more surface tension than internal com-
bustion, or is it the other way around? Here we are folks up to our fool
necks in unintelligibility. Are we foolhardy enough yet to become
Global Village Idiots? asks the global village idiot.

> B.10
> *Memnoir* 1
> screens loaded with blanks bruise blue skies rash sunset eyes elide gun and
> index finger she smartly slam(ed) the car door in black and white her high
> heels click(ed) across the concrete floor in the underground garage bomb
> and rose burst into bloom how to tell the story now without telling lies you
> can't you can only leave it alone or complicate it beyond belief

The muteness and the mess in certain unintelligibilities form an ellipti-
cal silence of what we're not noticing. *It* notices *us* as we distract our-
selves, perfecting the match of the color samples. The compound I of the
graffiti-producing insect in the brain is studying hard to become the

complex I who can write in the midst of any noise, can write her way out of any noise. Right this way folks, through that tacky vulgate at the end of the peace-torn hood to shortcircuited particlewavelength blue pair-o-dice lost. In other words

Memnoir 2

coming out of the movie theater the world the world is bright too bright gnomic present tense tensile everything happening at once the world is full of its own mute history the fatality of reflection the fatality of nature and culture the fatality of the German sciences of Kultur the fatality of i.e. mute history remaining mute the fatality of of the preposition reaching out to its object even as it e.g. it slips away

the preceding is much too or not sentimental enough to accommodate the experience of the child is fatally wounded i.e. the house is a mess the streets are littered with trash the lawns are littered with trash the grass is dying shrubs are pruned to look like gum drops grass is mown to look like Astroturf replaces the grass up the stairs of the stoop onto the porch into the house the noise is incessant the grass is broken the broken glass is littered with people I have a confession to make I have not answered my mail my telephone my email my calling my God my country my conscience my desire to

If P then Q, but not necessarily A:

If some apocryphally ecstatic pre-Socratics' acknowledgment of the physical world involved an ethos of knowing as transitive, paradoxical, revelatory act—knowing in the form of poetry—then those wily presocs are with us still as yet another "other." The Socratic and Baconian deployment of Knowledge as manipulative, appropriative power can be tempered with a retrospective view or two: Socrates always played the feminine to Plato's masculine; Bacon spoke of the human mind as "no dry light." "Now" it seems that "then" the world was simpleminded and naïve and good-natured and vulnerable enough to submit as it was being broken down into glistening parts.

I hold myself more gravely responsible for what I think I know (and even, in culpable negligence, for what I know I don't know) than for what I know I (merely?) believe. Is there too much backing off from primary experience in the preceding sentence? There is the possibility of innocence in misguided belief but there is no locution "misguided knowledge." Believing flows out of habits of reverence, trust, faith, hygiene, equilibrium, symmetry—tidy, nostalgic virtues with occasional

catastrophic consequences. Knowing (no guarantees against catastrophe there either) can have the largesse and futurity of an engagement—an actively conscious looking, outward acknowledgment, toward and with. (Some might like to think—I among them?—the knowing that leads to atrocities is merely firmly held belief. But actually it may all depend on the definitional rules of the language game, or the culture of the habitus. What's the best source of hope if that's the case?) It has also the potential of the ecstasy of alterity, conceptually standing outside oneself as other while the ecstacy of belief is one of orgasmic fusion. Hence (since p then q) it is only the know ledge that situates one for the possibility of reciprocal alterity as *know* breaks off from *ledge* and leaves a column of cold blue air suspended in cold blue air. Gale force of utter contingency. Gales o laughtair, as someone famous may have said.

B.11
Memnoir 3
i.e. all this and more with the ontological thickness of a scratch and win sheet

look see the red blue yellow green space at the watering hole hear the animals slurp see the animals roll in the mud witness the archeological trace of some thing less visible than a zoological park the mother the father stiff in Sunday best the insistent curiosity of the child the timing the timing is all that is off

it is that that is the problem with the timing that it is always off while it can not be off at all

B.12
 —où n'avoir plus égard qu'au ciel bleu
L'oiseau qui le survole en sens inverse de l'écriture
Nous rappelle au concret, et sa contradiction
 —now only attentive to the blue sky.
The bird that flies over it opposite to the act of writing
Recalls us to the fact, and its contradiction

 Francis Ponge (trans. Serge Gavronsky), "Le Pré"

Thin blue air in the exhilaration of "I know"—of course always in a context, on a ledge, on a scaffold, always with something at stake. That rare moment of "I know," always precarious. The scaffold always shaky. Then too there is the sinister assertion.

If P then Q, but not the right A:

Jeanne d'Arc, for instance, placed on scaffold during her trial, then burned at the stake for—what? It's generally thought to have been a matter of belief, but I wonder if it was that she was seen to have abandoned belief for knowledge. Her claim to have come to know certain things independently of the church's apostrophic authority was intolerable—not only independent knowledge but the blue radiance of knowledge withheld:

> Asked if she knew beforehand that she would be wounded, she answered that she did indeed, and she had told her king so; but notwithstanding she would not give up her work.... She said she knows many things which do not concern the trial, and there is no need to tell them.
>
> W. P. Barrett, *The Trial of Jeanne d'Arc*

"Jeanne believes lightly and affirms rashly," wrote the Faculty of Theology at the University of Paris in their judgments, noting the presence of "rash and presumptuous affirmations [and] assertions," as well as the heretically erroneous "opinion," which had already usurped belief. Belief may be inadvertently misguided, but affirmations and assertions of knowledge seem to involve will. Much more, then, is at stake. The Holy Faculty recognized quite clearly Jeanne's position on the know ledge: how being there leads one, inappropriately, to act.

> Regarding article the eighth, we observe a pusillanimity verging on despair and by interpretation on suicide; a rash and presumptuous assertion concerning the remission of a sin; and an erroneous opinion in the said woman concerning man's free will.
>
> W. P. Barrett, *The Trial of Jeanne d'Arc*

TRIAL DEFINITION: Consciously poethical poetry: a rash and presumptuous affirmation and assertion—affirmation of form, assertion of meaning withheld, affirmation and assertion of silent unintelledgeabilities—a strangely potent agency.

B.13

Somebody says, "The first time." Is the only time. Speaking it.
Is water. She. Or education. Preference....And one mind could not
exchange for another mind only history....Does delicious silence
hear delicious silence written?...Breaking slip. Is education. The
contemporaneous oversight. Blue for cool. Water for cool. Yellow for
speech. Having a contemporary absence.

Carla Harryman, "Dimblue," *In the Mode Of*

The status of what we call knowledge (as well as what we claim to not know) has always had an ethical, if not moral, dimension, i.e., is tied to use and value. Even on a semantic level, the words we claim to know well enough to tag with definitions and add to dictionaries are inextricably linked to value. As J. L. Austin wrote in his 1956 essay, "A Plea for Excuses": "Our common stock of words embodies all the distinctions men *[sic]* have found *worth* drawing, and the connexions they have found *worth* marking, in the lifetimes of many generations" (130 [italics mine]).

Language is attached to practice and to interests—what the heterogeneous, homoerogenous "we" that establishes usage cares about at particular moments in history. The language of knowing (as distinct from believing, and remembering) is tied to what we care about *now* and intend to value in the future. One does not know outdated science, one knows (now) "about" it. That the word *now* inhabits the English word *know* seems a sweet accident. The ancient etymology (Indo-European root) of *know* is tied to sensory data, what is perceived in the continuous present of the senses. (Something Gertrude Stein seemed to know most acutely.) Out of which flows a poethics of knowing: Curiosity, the desire to k'now our cognitive future tense—what may be present but unaccounted for in our moving principles. (*Curiositas:* curiously medieval sin.) Curiosity, a discipline of attention turned toward humorous shifts in perspective, those that might give us a chance to find newly productive silences in the noise of culture. On the know ledge, on the verge of awareness, in the mIdst of unintelligIbility, there's room for accident and possibility: in medias race of the orderly fall of atoms, there comes the Eve of the swerve.

B.14
The proportion of accident in my picture of the world falls with the rain. Sometimes, at night, diluted air. You told me that the poorer houses down by the river still mark the level of the flood, but the world divides into facts like surprised wanderers disheveled by a sudden wind. When you stopped preparing quotes from the ancient misogynists it was clear that you would soon forget my street.

 Rosmarie Waldrop, "Facts,"
 The Reproduction of Profiles

B.15
 we are parting with description
 termed blue may be perfectly blue

goats do have damp noses
 that test and now I dine drinking with
 others

<div align="right">Lyn Hejinian, Writing Is an Aid to Memory</div>

TH'OUGHT EXPERIMENT 4-F

First and despite all this and that a modest attempt, as a child of bad-for-us Bacon, to isolate a prototype: just what would a systematic attempt to know something really fundamental look like? Would it, for instance, more closely resemble an attempt *at* or *on* a life? In 1939 a British philosopher, G. E. Moore, wanted to put an end to what Immanuel Kant had termed a philosophical scandal, viz., "that the existence of things outside of us...must be accepted merely on *faith,* and that, if anyone thinks good to doubt their existence, we are unable to counter his [*sic?* maybe not] doubts by any satisfactory proof." [Quoted by Moore from Kant's preface to the second edition of his *Critique of Pure Reason.*] Moore's attempt to rectify this matter is a signal moment in the annals horribilis of philosophical desperation. In his "Proof of the External World," a paper read to the British Academy November 22, 1939, two months after Hitler's invasion of Poland and the British and French declaration of war on Germany, Moore reasoned that he had to prove "that there are some things to be met with in space," and that these things are "*logically independent*" of any act(s) of perception at any given time(s).

Moore devised an intellectual magic act, a famous (in philosophical circles) sleight of hand as follows: "I can prove now, for instance, that two human hands exist. How? By holding up my two hands, and saying, as I make a certain gesture with the right hand, 'Here is one hand,' and adding, as I make a certain gesture with the left, 'and here is another.' " (To which Wittgenstein replied, "Stop! If you do know that *here is one hand,* we'll grant you all the rest.") Meanwhile across the channel Nazis were making certain gestures of their own. Just what those "certain gestures" of Moore's were, given the grave ontological insecurity that brought them on, one can only guess. We do know that Moore, claiming he could similarly prove the existence of soap bubbles, sheets of paper, shoes, socks, and "thousands of different things," took his ipso facto performance on the road, bestowing external existence on numerous things with that certain gesture in

one academic hall after another. Moore's own *cogito* (along with the Catholic Mass) might have done better to remain in Latin:

> I think, therefore, that in the case of all kinds of "things," which are such that if there is a pair of things, both of which are of one of these kinds, or a pair of things one of which is of one of them and one of them of another, then it will follow at once that there are some things to be met with in space....
>
> <div align="right">"Proof of an External World" [1]</div>

What a coincidence! The index fingers of Michelangelo's God and Adam, pointing each other into existence, come to mind. There is a notorious (in philosophical circles) instance of Moore's having made that "certain gesture" at a window in a midwestern university hall in the United States, thereby declaring it ontologically sound, only to discover that the "window" was itself a certain gesture—a pair of drapes mounted on a blank wall to give a window "effect." This was a source of great embarrassment and hilarity. Did a twinge of doubt about the enterprise of proving the existence of the external world flit through a blue-gray neuron in Moore's mind?

How, that is, does one get oneself into such odd predicaments in the first place? How odd, that is, that so many "ones" have become so illustrious trying to extract minds from shiny little boxes. Descartes, Kant, Berkeley, Wittgenstein—to name a few. How is one to understand such radical doubt about all that lies beyond the carefully limned circumference of the self-perceived self?

> 24. The idealist's question would be something like: "What right have I not to doubt the existence of my hands?" (And to that the answer can't be: I know that they exist.) But someone who asks such a question is overlooking the fact that a doubt about existence only works in a language-game.
>
> <div align="right">Wittgenstein, *On Certainty*</div>

And what of that antidote "I know"? And of this need to make "certain" gestures? Just what is it that Kant, Moore, you, I most fervently need or desire to say "I know" about? Or, perhaps more to the point, what is the point beyond the act of pointing? Of marking territory in thin blue air?—Pointillists wave, pointing the way to a picnic by the river.

I am catapulted by the image of substitution of image for thing (drape signifying window, for instance) into more recent insecurities.

Jean Baudrillard and other roundabout neo-Platonists claim we are awash in a rising sea of cheap imitations, the closest thing to reality we've got, no dry ground of viably rooted referents anywhere in sight. This may be no less formidable a magic trick than Moore's *Voilà!*

TERRORTORIES OF TERRA INCOGNITA

When the map covers the whole territory, then something like a principle of reality disappears.... [T]he latter equals making the human race unreal, or...reversing it into a hyper reality of simulation...where everyone comes to witness him*[sic]*self (really his *[sic]* own death) in the gaze of the future.

Jean Baudrillard, *Simulations*

AND NOW FOR SOMETHING NOT COMPLETELY DIFFERENT

If it were no longer a question of setting truth against illusion, but of perceiving the prevalent illusion as truer than truth? If no other behavior were possible but to learn, ironically, to disappear? If there were no more fractures, no more vanishing lines, no more lines of rupture, but only a surface that is full and continuous, surface without depth, without interruption? And if all this were neither exciting, nor despairing—but fatal?

Jean Baudrillard, *The Ecstasy of Communication*

Logically, except perhaps in fractal terms, there can be no surface without depth (or death?) except along the depth-consuming Möbius strip of capitalist desire. In your irony, J.B., you've sprung neither the metaphysical nor the sociopolitical trap. Irony is an intellectual holograph emerging out of the glare of surface energies, unable to function in other dimensions. This is because it depends on a negatively humorous packaging of the phenomenon under siege. The problem with irony as critique is that the glamour of the packaging ensures the persistence of the ironized object in the culture. Packaging that comes to be mistaken for the object because we're too besotted with its shiny surfaces to unwrap it.

What?

If the vitality of our cultural morphology only makes sense in the fractal complexities of historical space-time, Flatland with its plane geometries of irony, misogyny and denial won't work. The symbolic is always such a flatland in its relation to the complex real. In a fractal relation between art and life—that is, art as fractal form of life—an infinitely in-

vaginated surface of linguistic and cultural coastlines, interconversant edges of past/present/future, gives us, if not depth, then the charged and airy volume of living matter.

Plato taught a certain "us" how to be ironic. (Socrates, actually, if you wish to distinguish between Edgar Bergen and Charlie McCarthy in charming drag.) How to argue in place while seeming with acrobatic esprit to wander questing far and wide. How to revere knowledge as artifact of a mythic past captured by a captivating, specular I. How to detach the specimen of "you" from the mind's I only to pin it to the exhibition mat. (Ah, how convenient to dismiss the sheer otherness of the world apart from the spectral male-order I in the Platonic catalog.) Of course the form or word or image is detached from the referent—the world is a second-rate trompe-l'oeil to the transcendent a priorI mind's-eye-real, mind's-I-deal. The word pales at his view as Racine's Phèdre pales at the sight of young Hippolyte. Perhaps for Baudrillard, the not quite out neo-Platonist, artifice—word, image, medium—must create the illusion of a plenum to materially deny that it is—like all embodiment—an entropic fall from its own transcendent form. It is symbol, i.e., memento morI, degraded refrain in search of, if not justification, the seamless whorIzon.

B.16
 It takes a horizontal
world to prop
the blueness of the sky. I
cannot lay a foundation, but must
build on one.

 Keith Waldrop, *Water Marks*

PACKED PARENTHESIS SPEEDS BY, SPEWING EXHAUST
(There is, of course, no denying the disappearance of the object. Food and shelter and persons disappear daily in all the "trouble spots" on our globe. Yet there are those who obscenely resist an aesthetic of disappearance—Other Ness monsters making frightening noises in the dark, Intifadas of various kinds, bloated bodies bobbing up in rivers and streams, shuffling homeless impeding our progress on city streets, female bodies refusing cultural erasure, discounted peoples blowing up symbols of their discontent. Street in Manhattan, street in Jerusalem,

Belfast, Calcutta, Kabul, Baghdad converge toward vanishing point on horizon of socially constructed probability.)

REMEMBRANCE OF PAST PAST

G. E. Moore: I certainly *did* at the moment know that which I expressed by the combination of certain gestures with saying the words "There is one hand and here is another" [italics mine].

G. E. Moore: I *did, then,* just now, give a proof that there were *then* external objects; and obviously, if I *did,* I could *then* have given many other proofs of the same sort that there *were* external objects *then*...[italics mine].[2]

> That history *is,* rather than *was* is not clear enough. None of us tends to think that way. (Do we act that way?) Well-sharpened wordswords in the tiny castle on storybook hill fight off glassy essences and absolutisms. Do we have to give up on knowing? Perhaps not. Perhaps, only "know" has that pre-post-eros flying buttressed l'edge from which, while taking our bearings, we can breathe in the cool blue air of alterity. Most importantly to know implies its opposite, a form of epistemological respect for the other. But the really operative term (the too oft-excluded middle) between believing and doubting is play. Play—in Winnicott's terms of imaginative invention—is a material interaction with the world beyond the pale of subjectivity. Requiring lightness, it gives the lie to possessive claims and assertions. Intellectual-imaginative play may be our most productively energetic form of knowing.
>
> Anon

The light of the Enlightenment was not to be blue—not full of misplaced and otherwise abused objects, displaced spectators, short-wave blurred edges of historical lament. It was to be the white light that as we know, but cannot see except refractively, contains the entire spectrum—the light of programmatic optimism: Utopian light. The light of hope, with its dependence on undependable pleasant surprises is, on another hand-to-mouth, blue. It arises out of a strangely luminous pessimism, late in the day. Blue light to be perceived as light at all requires an oblique angle of vision, an averting of the eyes from the glare of our cultural foreground toward the silent periphery that is our future. Blue—last and first color visible at twilight.

B.17
now that the line has reabsorbed
the trajectory

 crossing over
 determines the divergence of angle,
 blue out of which
 the spot as well
 (loss)

<div align="right">Anne-Marie Albiach, "(opposition : I)," <i>État</i></div>

MIRACLE-WHIPPED PLAY

Scene: Sparsely Furnished Know Ledge
in Any Euro-American City

V. Woolf: Had I been born, said Bernard, not knowing that one word
follows another I might have been, who knows, perhaps anything.
As it is, finding sequences everywhere, I cannot bear the pressure of
solitude. When I cannot see words curling like rings of smoke
around me I am in darkness—I am nothing.[3]

J. Cage: When I am not working I sometimes think I know something.
When I am working I discover that I know nothing at all.

G. Tallique: To know, if our knowledge is not to kill us or others, is it-
self the urgent necessity to unknow, to move on to the next ledge.

POP-UP SELF-QUIZ

<div align="center">How do we know our names?</div>

When my friends, Faith and John, moved to Kalamazoo, their neigh-
bors introduced themselves as George and Isolde; "But," they said,
"just call us Butch and Gidget."

<div align="center">How do we know what it means?</div>

After Descartes's five-year-old daughter died, he wrote a treatise on
rainbows.

<div align="center">Or, e.g.,</div>

Do I know that when the Allied tanks rolled into Paris, Braque and Pi-
casso took credit for their "cubist" camouflage?
Do I know that to economize, the Nazis arranged excursion fares with
the railroads for those they were sending to the camps?
Do I know that blue is one of the psychological primary hues, evoked in

the normal observer by radiant energy of a wavelength of approximately 475 nanometers?

E.G., or,

G' L' A' N' C' E' S'

Ah **G** apostrophe the halocutionary arts! she talked Like an angle **A** apostrophe angel already turning blue from separation error in cerulean blue of blue happy blue face blue domed Skies.
That is,
Gee, excuse me but Like is there any angel **A** apostrophe difference at all between the Madames B'ovary and B'utterfly in the face of all that **N** apostrophe now is and has been known to be known in the **C** apostrophe c'anonic C'atastophe of *Il n'y avait pas de suite dans ses idées* she's incoherent! Yes No she's not and yet she was paradoxically or not enough among the first to disappear in those short wave-lengths at dusk the past tense makes her tense too blue from seeing distance he said in the turbid atmosphere of the many apostrophes between the EEE!s that she and he have in common and the final **S**. Her note reads: I do all workhouse I do charge razonable rate.

Or, e.g.,
Is the exclamation, "that's amazing!" one we only use when we think we know "that"?
Or, to put it another way, is there an epistemologically significant difference between saying it's amazing that Judith holds such and such an opinion, on the one hand, and it's amazing that Judith holds Holofernes' head in the other?

B.18
age of earth and us all chattering
a sentence or character
suddenly

steps out to seek for truth fails
falls

into a stream of ink Sequence
trails off....
seconds forgeries engender
(are blue) or blacker

Susan Howe, *Pythagorean Silence*

POSTERIOR ANALYTIC POSTLEWD

Can any clot of we in this age of excruciating posteriority
HELP?
CLICK ON **HELP**

Error Message: To be or not to be is not the question.
In the melancholic engulfment of world by self's I-mage can I find the
humorous energy to swerve my eyes toward others? Can I write myself
out of a package deal &/or a self-entrancing looking-glass world of
irony shrines, or the subjective plenum where horizon collapses into
subject's ingrown smile? How to move outward when the terrain out-
side the door is so treacherous? This is not a question peculiar to our
terrorist now; it is a perennial question. How to shift the purview of
that philosophically exhausted *gaze?*

> B.19
> Blue, Blue got up, got up and fell.
> Sharp, Thin Whistled and shoved, but didn't get through.
> From every corner came a humming
>
> Wassily Kandinsky, *Sounds*

In this *what's wrong* picture the eyes are not first-person pronouns, the
eyes can acknowledge the distance of an other without ravishing her,
the eyes give onto flight and passage as well as reflection, the eyes do not
seek the saturated spectrum of the sublime. The eyes caress what they
cannot create. The eyes caress what they cannot touch or hold.

Poethics of the Improbable

Rosmarie Waldrop and the Uses of Form

The future is in the swerve.
Anon

Back in a medium of German, my mother's Northern variety,
not the softer "Fränkisch" I had grown up with, memories
flooded. I started a novel, *The Hanky of Pippin's Daughter.*
It began with portraits of my parents, but quickly became a
way of trying to understand, to explore, at least obliquely,
the Nazi period, the shadow of the past—and the blurred
borders of fact, fabrication, tradition, experience, memory.
Rosmarie Waldrop, *Contemporary*
Authors Autobiographical Series

I don't even have thoughts, I say, I have methods that make
language think, take over and me by the hand. Into sense or
offense, syntax stretched across rules, relations of force, fluid
the dip of the plumb line, the pull of eyes. What if the mother
didn't censor the child's looking? Didn't wipe the slate clean?
Would the child know from the start that there are no white
pages, that we always write over a text already there? No be-
ginnings. All unrepentant middle.
Rosmarie Waldrop, *A Form of Taking It All*

Rosmarie Waldrop, whose reputation in this country and in Europe is
primarily that of poet and translator, has written two novels that are
gravely, playfully situated in that "unrepentant middle." They are
works of compound attention, permeability, and generous humor—the
kind of humor that renovates medieval notions of temperamental fluidi-
ties into piquant conceptual shifts. *The Hanky of Pippin's Daughter*

(1986) writes over and through textual contusions, surface tensions, odd autobiographical particulars of a small-town German family's life during Nazi rule. *A Form of Taking It All* opens the novel's pagescape to topologically redistribute historical figures—political and scientific— in discursive gaps whose space-time coordinates yield to the new physics even as they evoke the irredeemable legacy of the European conquest of the Americas. In this book quasi-autobiographical characters and personae enact a quantum comedy of manners with figures and grounds and relativities of historical complementarity.

Waldrop composes the cultural flotsam and jetsam out of which we fabricate memory into shifting mosaics whose energy derives from interactions of textual particles (captions, lists, anecdotal fragments, descriptive glimpses... "data" of various, humorous sorts) and narrative/speculative waves that raise questions about our relation to art, science, politics, history. The moving principle in both her novels is transgeneric, a textual graphics of prose and poetic intersections—cultural invention in intercourse with historical crime. The effect is photo-electric, illuminating a contemporary poethics of the formally investigative novel with, given the urgent matters addressed, an improbable lightness of form.

As "twentieth-century" writers and thinkers we have continued to live in the shadow of a nineteenth-century narrative dictum: affix one unit of prose to the next with the uberglue of interpretive transition. That this rule has been so spectacularly transgressed—Stein, Dorothy Richardson, Woolf, Joyce, Beckett, Calvino, Queneau, Sorrentino, Perec...—may mislead us into thinking that novels experimenting with *other* logics—associative, collage, paratactic, recursive, procedural, permutative...—are numerous. In fact, the scene of the novel is dominated by hundreds of thousands of securely coupled units (sentences, paragraphs, chapters) hurtling like locomotives toward the metaengineered marvels that configure the architectonics of romantic profundity—psychologically and philosophically penetrating tunnels, epiphanic climaxes, mirror-image vanishing points.

Nineteenth-century mechanics, in philosophy and literature as well as in science and technology, exploited the power of continuous, contiguous piston-driven momentum toward the transfer of godlike qualities (overarching wisdom and judgment, omnipotence, omniscience) to "man" as author. Twentieth-century, "feminine," gaps and collisions and sensible uncertainties set off alarms, ruptured the nineteenth-century illusion of controlled historical continuity. The intellectual tragicomedy

of the Gödelian aftermath has been staged as a dramatic inventory of cultural logics—theological, historical, aesthetic—whose unmoved movers have been, with heavily theorized ceremony, pronounced dead. All the while poets and theorists of complexity have been cavorting in delight as they engage in newly energized explorations.

Complexity—the network of indeterminacies it spawns—is the condition of our freedom. That freedom, insofar as it is exercised as imaginative agency, thrives in long-term projects, like Waldrop's novels, that reconfigure patterns of thought and imagination. (I wonder if human agency—in contrast to human rights—can at this point in our self-conscious cultural undertakings be usefully modeled by isolated instances of "free choice.") This is why, with all the disruptions and anxieties of an age of uncertainty, we are seeing a renaissance of literary and scientific invention brought about by the peculiar twenty-first-century dialogue of questions and forms. Things are much more interesting than warmed-over narratives of decline and fall would have it. Where once we thought exclusively in terms of linear developments, with very few first-class tickets or window seats available for the ride, we now notice proliferating opportunities in fractal surfaces—the extraordinary number of detailed contact points that compose the cultural coastline. Draining the "profound depths" of symbolist metaphysics has presented us with the infinite potential of recombinatory, chance-determined play. On the historical surface, whose geometries are more about topological stretches and folds and global networks than developmental chains, it is not surprising that Waldrop's work with the form of the novel resembles *Tristram Shandy* more than *The Magic Mountain* or *Buddenbrooks*. Most important, her novels are imaginative, material inquiries into our contemporary conditions. On this matter of timeliness Gertrude Stein set, many times over, both the modernist and postmodernist scenes: "The whole business of writing is the question of living [one's] contemporariness....The thing that is important is that nobody knows what the contemporariness is. In other words, they don't know where they are going, but they are on their way" ("How Writing Is Written," 151).

If logical systems are, as Gödel tells us, inherently incomplete; if mass *is* energy, particle *is* wave, space *is* time, and vice versa; if natural and cultural histories *are* chaotic; if complex surfaces *are* fractal (allowing infinite detail to exist within finite space-time delineations)—then the question arises, What is implied about the forms with which we attempt to make meaning of our experience? The answer has not detached itself

from the known literary universe. Waldrop, writing within historical residues *and* attentively out of her own times, explores patterned currents of discontinuous motility and porousness that are all historical residue. But this fluid topography enacts a refusal to stop the event with descriptive certainty. In her prose-poetic spatial manipulations there is such a vigorous widening of the investigative impulse that single-point perspective becomes a reversed current flowing right off the page into the ongoing puzzle of contemporaneity. The opening prose poem in Waldrop's *The Reproduction of Profiles* (1987) articulates a reimagining of aesthetic truth patterns:

> I had inferred from pictures that the world was real and therefore paused, for who knows what will happen if we talk truth while climbing the stairs. In fact, I was afraid of following the picture to where it reaches right out into reality, laid against it like a ruler. I thought I would die if my name didn't touch me, or only with its very end, leaving the inside open to so many feelers like chance rain pouring down from the clouds. You laughed and told everybody that I had mistaken the Tower of Babel for Noah in his Drunkenness. ("Facts," 5)

In the perverse annals of recapitulation one could say that childhood has always foreshadowed the way in which we lost our (purported) grip on things in the twentieth century. Childhood, in the calmest of eras, is a scintillating scene of absurd and terrifying disproportions. *Alice in Wonderland* or any random selection of fairy tales can be read as instruction manuals for negotiating the speed and glare of associative light as it obliterates the boundary between stable figure and quaking ground. Does the dangerous passage into the dotted-line equilibrium we call adulthood ever end on a personal or historical level? A major source of the practice of storytelling seems to come from the need, first as children, to hear stories that contain the terror, that seduce one in as night tourist only to skillfully deliver us into the daylight on the other side of a door clearly marked THE END. (Yes, dear, don't worry, the nightmare does stop. Mommy/Daddy/your author will see to that.) There is as well the crucial impulse to tell one's own story, to exercise for oneself the power to fashion a version of reality that can be exited intact.

Now we think we know that the stories we tell tell us as well. This dialogic rhythm forms whole cultures. The panoptical novel reflects and abets a culture of docile bodies, hierarchical power, politically conscripted detail. The romantic and brutal and precise folktales collected by the Brothers Grimm cannot be without some connection to the ro-

mantic and brutal and precise fantasies that Hitler and his myth-manu-
facturing cronies visited on Europe.

Rosmarie Waldrop spent her childhood and adolescence in Nazi and
postwar Germany. She was not a designated victim. Her family was not
Jewish, gypsy, communist. As far as I know, no one close to her circle
was homosexual. Nonetheless, as a child growing into a sense of her
world, she had to contend with the pervasive effects of rampant para-
noia, systematic deceit, unjustifiable certainties, rumor, betrayal that
formed the atmosphere of Hitler's Germany, as well as with the logical
schisms, absences, and terrors associated with any war zone. Bombing
raids on the Bavarian town where she lived, Kitzingen-am-Main,
brought one's ultimate vulnerability home. Waldrop is the first to say
that amid the bizarre tensions of a family with its own peculiar psy-
chodramas attempting normal life in the context of a major entry into
the catalog of human-constructed hells, there were consolations: her
piano, recordings of her favorite music, books, friendship.

The Hanky of Pippin's Daughter was the product of a long-standing
"impossible" desire to transform the disequilibrium of ordinary life pat-
terns and Nazi nightmare into a novel. What this finally meant in prac-
tical terms was eight years of struggling to find a form, an agon between
the vanishing points of irredeemably nasty memories and the complex
necessity for what I can only see as poethical courage—the nerve to re-
sist packaging unruly materials in the nineteenth-century conventions
of novel as written by God in possession of a world that makes sense.

Waldrop's own statement about *Hanky* is revealing: "The drive to
know our own story moves us to see through it and touch the violence
inherent in the mechanism itself."[1] That violence is, in part, the refusal
of the material to conform to the palliative gestures of an existing deco-
rum. The contemporary paradox of storytelling is that the disturbance
that becomes the "drive to know our own story" must enter the *form it-
self* thereby making the desired knowledge impossible. Samuel Beckett
is interesting on the story as form:

> What am I doing, talking, having my figments talk, it can only be me.
> Spells of silence too, when I listen, and hear the local sounds, the world
> sounds, see what an effort I make, to be reasonable. There's my life, why
> not, it is one, if you like, if you must, I don't say no, this evening. There has
> to be one, it seems, once there is speech, no need of a story, a story is not
> compulsory, just a life, that's the mistake I made, one of the mistakes, to
> have wanted a story for myself, whereas life alone is enough. ("Texts for
> Nothing 4")

Oddly or not, this may constitute a functional either/or—"story *or* life" rather than "story *of* life." If one chooses story of/over life, one chooses the consolation prize of an understanding that removes one from uncertainties and disruptions of extratextual worlds; one is put at rest. The objective is a kind of "moment of inertia," a parameter useful in describing the rotational motion of rigid (inorganic) bodies. The urgent knowledge that erupts onto the page and into the form sends one into the swerving, turbulent patterns of life principles—the messiness and loveliness of ecological interdependence, synergy, exchange, chance. This is what John Cage meant by art that imitates not nature but her processes—processes that render us cheerfully and tragically inconsolable. I suspect it is precisely Beckett's refusal to be consoled (a rejection of sentimentality) that allowed him to "go on." When Waldrop says she doesn't have thoughts but that she has methods that make language think, she is referring to a similar movement away from grammars of inertia. Waldrop turns her own restlessness and anxiety of insufficiency into a navigational project, a poetics of formal choices that throw text into motion as life processes themselves. This has to do with material energies of language—vocabularies, syntaxes, juxtapositional dynamics, interpretive coordinates. Since their first publication by Station Hill Press in 1986 and 1990, respectively, both *The Hanky of Pippin's Daughter* and *A Form of Taking It All* have more or less fallen off the edge of a generically flat literary world, in which anything venturing outside certain well-defined conventions tends to remain all but invisible. (They have recently been reprinted in one volume by Northwestern University Press.)

In his 1958 essay "History of Experimental Music in the United States" John Cage wrote that in the midst of "all those interpenetrations which seem at first glance to be hellish—history, for instance...one does not then make just any experiment but does what must be done" (*Silence*, 68). Of course, we all must decide for ourselves "what must be done." The urgency of a perceived necessity, even in a universe so brilliantly perforated by chance, is what connects experiment with passion. A passion of working through, transfiguring, the materials of one's times can involve all that the word *passion* implies—"suffering" (undergoing, enduring) but also the way in which the register of emotions, from anguish to dread to humor and joy, turns our intellectual and imaginative inventions into richly suggestive humanist prisms. What distinguishes this from sentimentality is the realism and courage involved in a gamut of feelings that makes us permeable to dire intercourse with our world, with others, in the form of love, anger, desire, lust, competitiveness, friendship, the rush-

ing conceptual tumult of shared humor. (Sentimentality, on the other hand, is protective of a closed-down self, hermetically self-serving, in retreat from real consequences.) It is just this that separates the truly consequential experiments in the arts from pro forma imitations.

Rosmarie Waldrop humorously illuminates the emotionally charged character of experiment in her 1990 essay "Alarms and Excursions":

> In the early stages of my writing all the poems were about my mother and my relation to her. Rereading them a bit later, I decided I had to get out of this obsession. This is when I started to make collages. I would take a novel and decide to take one or two words from every page. The poems were still about my mother. So I realized that you don't have to worry about the contents: your preoccupations will get into the poem no matter what. Tzara ends his recipe for making a chance poem by cutting out words from the newspapers and tossing them in a hat: "The poem will resemble you." (55)

The remarkable coincidence of experimental results with what one most cares about happens only when the active consciousness of the experimenter precipitates an urgency of choice, one that cannot help but affect the shape of the indeterminate elements. The moral is that in the hands of the poethically innovative artist we need not fear dissociative or denatured or depersonalized forms. Waldrop began an autobiographical statement for a literary reference book with John Cage's credo: poetry is having nothing to say and saying it; we possess nothing. What this can mean is bringing disparate linguistic units into a patterned synergy that will unavoidably emanate from the writer's being in the world, that has tangible sources but also honors the active intelligence of the reader precisely to the extent that it eschews ownership or authority over the way in which it is construed. The text is sent out into the world in reciprocal dialogue with its other.

In *Hanky* there is a captioned framing, a paratactic pace that serially interweaves the personal anecdotal, the journalistic documentary, the epistolary, the philosophical, the helplessly humorous with a quest for meaning that is neither pretentious nor falsely modest given Waldrop's acknowledged remove from the worst horrors of Nazism. She arrives at this strategic nexus, one could say, in order to depart from it not as victim but as composer of a novel that, under the pressure of the grotesque horror of Nazism, transmogrifies into a kind of linguistic comic strip. This book could in fact be fruitfully read together with Art Spiegelman's *Maus*, volume 1 of which was also published in 1986. It does with language some of what Spiegelman does with the visual conventions of cartooning. Waldrop and Spiegelman are writing about their parents' rela-

tion to Nazism from an intimate remove that, although differently situated, leads both to transgress and exceed the scope of the conventional novel in their material engagements with impossible material. Spiegelman's humor erupts out of his relationship with his father, whose irritating quirks may or may not be the result of victimization. A similarly important questioning of the limits of victim status is what makes humor possible in Waldrop's account.

Waldrop's "strip" has features of Möbius as it traces the process (not necessarily progress) of moving from personal narrative to narrative persona. In discarding the self-justifying strategies and sentimentalities of certain kinds of novelistic prose—prose that never undermines the power of the narrator even within the conventions of "unreliability," she has literally turned the uses of her language inside out and in again. This leaves us with that paradox of all consciously postmodern fictions—that of the acknowledged lie of acknowledging the lie that is the sinister engine of selectivity in all forms. Spiegelman's *Maus: A Survivor's Tale* begins with the humor of its own title and the problematic of its first caption, *My Father Bleeds History.* The first caption in Waldrop's humorously titled *Hanky* is "LAST SEASON'S BESTSELLER WAS GREED." Both novels sort through dubious legacies of parents who are simultaneously trapped/free agents in/of their cultures. Humor is located in conceptual shifts between "trapped/free" playing out in *Hanky* as "Jewish/Aryan" in linked "Franz/Josef" figures of the mother's "Lover/Father."

To Theodor Adorno's despairing sense that after Auschwitz it would no longer be possible to write poetry, Waldrop says Edmond Jabès replied, "I saw that we must write. But we cannot write like before." Waldrop, close friend as well as translator of Jabès, has enacted this realization in her own work. Adorno himself attempted to moderate his poetic pessimism (at one point saying it is only *lyric* poetry that is barbaric after Auschwitz) to the very end of his life. The challenging means to a reinvention of possibility was already apparent in his *Minima Moralia,* written during and immediately after World War II: "There is no longer beauty or consolation except in the gaze falling on horror, withstanding it, and in unalleviated consciousness of negativity, holding fast to the possibility of what is better."[2]

This raises—in a manner both stark and energetic—the life and death urgency of questions of literary form as we navigate through the range of joys and catastrophes and commonplaces and shades of anomie of our violent times—the unexpurgatable mess of lived history. Imaginative structures orient and initiate our intuitions as we confront the con-

gealed givens that can stop breath and hope. Some forms point toward what is yet fluid, what is possible; others encapsulate the brutality, rendering it somehow palatable. By the last vanishing point punctum at the end of the last beautifully constructed paragraph of the nineteenth-century well-made novel even the holocaust can acquire a lyrical dimension, not unlike that assisted by sound-track violins in a Spielberg movie. One must question the consequences of conventions that protect the formal dynamics of art from the awkwardness of its subject matter. This is the reassuring—market-friendly—production of innocuousness: the misleading solace of work too timid to disturb the logic of the universe in which the violence continues to occur.

We are always writing through the impossibility of *after*. This chronic, dispiriting condition can grind imagination to a halt or send it tooling in nostalgic circles. The most vital of our new writing addresses our need to stay in motion via the disparate and humorous logics of inventing and reinventing our contemporaneity. Such a process must always take place in acknowledgment of the fact that the materials of invention are nothing other than historical detritus. All the more reason to affirm a poethics of the improbable—our perennial challenge, the heart of an engaged optimism.

The Experimental Feminine

Attention Deficit Disorder is for the moment our ubiquitous
cultural disease. What brings art to life, what makes life—
even the most difficult life—worth living, is a quality of
sustained attention.

> K. Callater, *Reports from Teerts Egdir: The Other Book*

Attention (chronically) scattered manages to find patterns of
caring in the debris of the (chronically) interrupted life. Life
that's (chronically) life—isn't that what's meant by the femi-
nine?

> Genre Tallique, *GLANCES: An Unwritten Book*

I

Molière might have gotten it (almost) right were he around today: yes,
poetry is certainly all that is not prose and vice versa. (Although there is
prose poetry.) Feminine is all that is not masculine and vice versa. (Al-
though there are feminine men and masculine women.) Art is all that is
not business as usual and vice versa. (Although there is the art market.)
The experimental feminine is all that is not business as usual and vice
versa. No qualifiers here. Can the same be said of experimental poetry?
Yes, to the extent that one identifies it with the experimental feminine.
Wait. What?

2

Of course we know that biologically female-male traits are on a contin-
uum in humans unlike other animals, which tend to be terminally ei-
ther/or. But female and male don't necessarily correspond to what one

means by the cultural terms *feminine* and *masculine*. Those terms function in our culture more like an agonistic yin-yang.

3

Why is discomfort with experiment in the arts so persistent and widespread? Unlike attitudes toward science, the relation between innovation and tradition in aesthetic projects has been troubling since at least the nineteenth-century identification of an avant-garde. One could say there are conservative tendencies built into any habitus, but to the extent that modernity defines itself through its ongoing experiments in thought and living, every crisis of conservation versus transfiguration should present an opportunity to make new meaning.

Which is to say, experiment and tradition should, in an ideal world, form the dialogic energy that creates vital cultures. In fact nothing of interest happens without this synergy, which is not to say that it's business as usual. Our Western cultural image resembles a brain with a severed corpus callosum—each side functionally innocent of the other. Did an evil surgery occur while we were all asleep in one fairy tale or another? One side happily thinks everything is simple; the other side unhappily thinks everything is complex. In this chronic bifurcation a potentially collaborative "we" is missing the fact that complex dynamics aren't monsters lurking in forests, threatening the simple pleasures of blue skies. They are the forest. They are the blue skies. They are our entire natural-cultural environment. They may indeed consume us, but this is only a grim certainty if we don't embrace them with respect and understanding. Since Mandelbrot presented us with computer models of the fractal geometry of nature, we have recognized the beauty in forms of chaos, which is inherently fractal. It was apparent before, in turbulent romantic landscapes, but not yet identified as global dynamic principle. Perhaps our dysfunction, at this point, has less to do with a paucity of intellectual and aesthetic evidence than the lingering wounds of Occam's razor regularly sharpened by market logics. Chaos theorists may tell us that things are not as simple as we'd like them to be, but can we afford to believe that?

It's well known that scientists, in what has been a characteristically masculine enterprise, strategically ask only answerable questions. This is the reason for their great success, carefully defining the progress they make within parameters that tend to exclude the messiness of everyday

life.[1] Speculation directed toward a frank unintelligible and complex unknown are a waste of time when one needs quantifiable results, not to say well-funded budgets. Despite this (luckily!) there are accidental discoveries, swerves of intuition that bring on shifts of perspective. But scientific logics of discovery aren't going to help us make bridges between the complex nature of reality and the extreme sport of everyday life. Or the complex realisms of today's experimental arts.

The playful improbabilities of thought experiments in the arts are only strangely germane. Like inquiry in the sciences, they start from questions and guesses and put variables in motion to see what happens (note the entire opus of Gertrude Stein or John Cage) but they are more wager than legitimate experimental design because—in the most exciting instances—results are radically unpredictable, radically incompressible into summaries and rationales. Feminine dyslogic—the need to operate outside official logics—is essential because official logics exist to erase any need to operate outside official logics, that is, the feminine. If this seems circular it's because it is. The habitus tends to be self-reinforcing. What is unintelligible within the rules of intelligibility of an institution is either invisible or threatening. The masculine is most intelligible in its need to prove that it isn't feminine—pliant, forgiving, polylogical. These are traits that have characterized the need to maintain immediate connections with others; they are also an aggressive affirmation of life principles whose beauty lies in independence from institutional necessities of abstraction, estrangement, tunnel vision, programmatic depression. Helen in Euripides' *Trojan Women* says to Menelaus, "Your first acts are arguments of terror to come."[2] The arguments of terror have followed an inexorable internal logic century after century for millennia. They would seem to be as incontrovertible as the direction of history itself were it not for the improbable feminine swerve that can shift the scene from one logic to others whose path is less obvious. Why feminine? Not because men can't do it, viz., Einstein, Joyce, Mandelbrot, et al.

Remember Athena, the *dea ex machina* (written into the tragedy by male playwrights) and other eloquently persuasive feminine logics in the long arguments of Masculine-Feminine (that is, Apollonian-Dionysian) that constituted Ancient Greek culture.[3] The larger than Life/Death composite Greek, whose early fate-driven exploits and later turn toward rationalism the Western we has worshiped equally, engages in loutish campaigns to destroy the barbarian other. That the Homer-Plato-Aristotle nexus is the founder of a Western canon that, until recently, managed to erase otherness made it difficult, until recently, to see

Troy as just one of many ancient Bosnias or that Aristotle's student
Alexander the Great can be compared—in his campaigns to crush "bar-
barians" under the stamp of the Hellenic uberculture—to any other im-
perialistic killing tyrant. Yet what the poet Rosmarie Waldrop has
called "the ancient misogynists"[4] have oddly among them the play-
wright Euripides, who, in his apparent disdain for some of the founding
myths of his own times, articulated dramatic pleas for an ethics of peace
that were voiced by female characters.

In fact, most of the psychological power (and implicit social cri-
tique?) of Euripides' plays derives from the role of the antagonistic Fem-
inine in Greek culture. This, in dialogue with the brutal arguments of
the Masculine. One can read Nietzsche's exploration of the Apollonian-
Dionysian agon in *The Birth of Tragedy*, his own reading of Euripides'
Bacchae ("The Bacchic, or Dionysian, Women") in M-F terms. In Eu-
ripides' *Suppliant Women*, as well as the two *Iphigenias, Electra, The
Phoenician Women, The Bacchae, The Medea, Helen, Hecuba, Andro-
mache, The Trojan Women*…, the scale and range of the Feminine is
enormous as site of impassioned alternatives—sometimes laced with
irony—to logics of a purely masculine power.

Albeit, there is no pretty picture—women do great domestic harm, men
cut a broader social swath, although it remains in the arena of family and
tribal lineage. But the logic is confoundingly complex, and this is useful—
a puzzle that reminds one of the conceptual work we still need to do. The
women of Athens who choose to follow F-Dionysus against M-official
codes are not sold as slaves, as Pentheus (spokesman for the law of the fa-
ther) threatens in the beginning of the play, but end up literally dismantling
him. The female character who is the instrument of this murder is Agave.
She has proudly abandoned her F-loom to undertake the M-hunt. In tak-
ing on the Masculine ethos in her opposition to Masculine repression, she
inadvertently takes revenge on her own son, Pentheus. The bitterest irony
of all is that the women feel they have outdone the men, killing without
weapons and armor: Agave has torn apart her son's body with her bare
hands. There's no way to identify Euripides' opinion of all this. Among
other hindrances is the fact that a large part of the end of the play is miss-
ing. But there is more than a textual lacuna. What we don't know about
Greek culture, it's remove from the schooling of our own intuitions, has
made all the literature a richly productive Rorschach exercise.

In reading and rereading the *Bacchae*, what continues to fascinate me
is that the divergent logics of Masculine-Feminine, Apollonian-Dionysian
have equal power. Nietzsche recognizes this. In his interpretive exegesis

neither Apollo nor Dionysus is victor; the agon must go on. The vital dynamism comes from the destabilizing Feminine principle that makes it necessary to constantly reestablish—with highly charged energy—the threatened equilibrium. Some classicists have faulted Euripides for the very "feminine" traits that Montaigne identifies with the moving principles of the essay—incoherence and inconsistency. Those unsteady states can be transvalued into strategic disequilibria necessary in the attempt to find one's way—poetically or essayistically—through culturally unintelligible unprecedented times, whether that be fifth century B.C.E. or third millennium C.E. The culturally productive M-F agon of ancient Greece turns out to have been a chaotic system, a dynamic equilibrium of order and disorder, on its way to local extinction in the Peloponnesian wars. But many of its patterns remain in the agon of our own times. It's interesting that the particular angle of the averted feminine gaze seen on the Hellenic vase, called *aidos*—demonstration of respect, modesty, and submission in the presence of a powerful man—is present today in a feminine geometry of attention to one's place in relation to a potential locus of desire. It can be enacted by a man, a shy boy, a girl, a woman.

4

The Feminine has been invidiously understood as weak, indeterminate, contingent, fuzzy thinking. At least until it came to be selectively valued—in computer technology and the complex sciences. In literature, to work in acknowledgment of the limits of logics, to break through to less intelligible forms, has been an act of poethical courage. The investigative methods of Stein, Woolf, Joyce, Beckett, Pound, Cage, Oulipeans, and Language poets are dedicated to expanding the fields of linguistic projects. Ironically, it's been particularly courageous for women to work in the territory of the Feminine, insofar as it can be called distracted, interrupted, cluttered, out of control. The question hovers in the culture: Does a woman do this only because she is so incapacitated by gendered life circumstances that she can do nothing else? In fact, the suggestive, humorous juxtapositions that emerge out of the disarray (which is of course the habitat of the male of the species as well) can, when they enter the work, demonstrate that there are many more logics of connection, distinction, and value than are dreamt of in our Aristotelian or Cartesian philosophies. Rosmarie Waldrop and Ann Lauterbach have notably explored juxtapositional logics in essays literally made out of counterpositioned, contrapuntal meditations and quotations.[5] The fundamental

fact is that the Feminine chaos of the juggled life or the exploding novel or the experimental essay or the Feminine silence of the minimalist experimental work, meditatively finding its way, is always bounded by patterns of dual-gendered human interest.

Imagine the vital work of making our contemporary space-time livable—promising!—without the dynamic disequilibrium of our energetic binaries (even Buddhism would not exist without the starting point of ego vs. world) past and future, Feminine and Masculine. Or rather, what would attempts to act on stereotypically hypertrophied Feminine or Masculine alone look like? F: sentimental irresponsibility? M: rigid, defensive tribal and national identities, ungiving hierarchical principles, concentrated authority, reflexive aggression in a repetition compulsion that overrides desires for peace? The latter, which I've admittedly strung out because I think it creates the worst of the conditions in which we actually live, is a generically "heroic" ideal that puts action first, nationalist plot development above all. Total erasure, brute conquest of the unintelligible other—as in what made Alexander (and now America) Great—may be entirely compelling if you've had no training in the richness of ambiguity or the choreography of contingent ideas reconfiguring their relations in motion. Of course, unadulterated by reason, all this can bring on "New Age" vapidities. But this may be a fate not worse than the memento mori of the progeny of Aristotelian logic, which remain eternally fixed in delusions of universal absolutes and therefore empty of useful meaning. To wit, Wittgenstein's remark, "But in fact all propositions of logic say the same thing, to wit nothing."[6]

Could it be that to know history—or anything else for that matter—too well is to fatally reinscribe its logical outline in self-fulfilling prophesies as well as narrative accounts? The familiar grammars of the narrative outline are empty forms that offer no resistance to the onrush of habitual responses. In the linked mechanisms of destruction and nostalgia the past—like Homer's Penelope—is desired as hermetically knowable, reliable, sealed in mythic form as locus of return whose QED is repetition. This is fantasy knowledge resolutely unavailable to reality checks. The fixed image of the Venerated Feminine, the fixed image of the Virgin Mary, Goethe's Eternal Feminine offer untroubled Edenic memory traces free of the logical excess that is curiosity. (How long did *curiositas* remain a sin in the Christian church?)[7] The time before She became curious must go on in the image of the domestic world as Eden. A masculine romantic reimagining of the ideal object (but not mechanism) of memory as woman—mother, wife, lover—source of one's being,

above all dependably there, embraces the need to burrow into creamy respite from a world whose turbulence resists fixing. We may think we're beyond all this now in our postfeminist self-images, but the sexual politics that drives the nuclear family is hard for young women to resist.

Another possibility?—the experimental feminine shaping history conceived not as fateful adumbration, but as dynamic coastline where past and present meet in the transformative rim of our recombinatory poesis. Epicurus is one candidate for patron saint of the experimental feminine. The philosopher Hans Blumenberg has this to say about the Epicurean way around certain dichotomies:

> [For] Epicurus...the chaos of the atomic vortices has a reassuring dependability that surpasses the guarantees traditionally provided by the gods....Epicurus makes current once again the Greeks' authentic concept of nature which they conceived of as...a mode of processes that proceed from themselves, of their own accord. The demiurge, the unmoved mover, the "world reason" had replaced this concept of nature with a supposedly more dependable factor, which allowed the world to be interpreted according to the model of the intentional product of human action. The crucial fact is that Epicurus was able to eliminate and exclude from human consciousness this god laden with care for the world...only by building into the world process certain "constants," by making chaos into a sort of "ideal disorder" and thus, as Kant reproaches the "shameless" Epicurus, "really [deriving] reason from unreason."[8]

What's the difference between the unintelligible world of the Feminine and the knowable ideal of the Masculine? Counter to common wisdom, I want to assert that one (F) is a challenge, the other (M) a mystique. To the extent that the Feminine is forced into service as consolation for the loss of meaning within the emptiness of logics of "world reason," the energy of a productively conversational M-F is lost to culture.

Desires to escape the world's chaos are understandable, but there's no real escape hatch in nostalgia. It's a temporary sedative at best. The past is not an exotic vacation spot arrived at in conceptual time machines. If I decide I want to visit the past, I walk out into the day, locate a book, a dig, a film, some sort of archive, or I stay home and prowl the Internet. History is nothing other than the infinitely intricate present that surrounds us—the panoply of residues and effects, accidental and chosen—that adorn and litter the landscape of our desires. The arts of nostalgia, including the Homeric ones, operate in that material field, adding to the debris that covers over the problem of the repetition compulsion designed to erase anxieties of futurity but that ironically recre-

ates all the things (from the past) we fear most: wars of sovereignty, chatteling of women, racism.... One might call these things the fringe maleffects of attempts to live by fantasy logics—those in particular of fundamentalism, domination, and nostalgia.

In the usual allocation of conceptual labor the fantasy past (Penelope) is Feminine, and history (Odysseus) is Masculine. Let's imagine another version. Is it that the probable is Masculine, the improbable Feminine, but the swerve that brings on possibility must become hermaphrodite, androgyne, mongrel, cyborg, queer, lovely freak, the unintelligibility that reveals life continuing as continuing surprise? Are there piquant unintelligibilities that draw curiosity toward possibility? Eve is the prototype of the Experimental Feminine. Her inquisitiveness, her desire to try something new, frees the virtual couple from their virtual paradise. A new complex realist story has been ready to begin for a very long time.

Experiments in every discipline are born out of the unanswered questions, the unfulfilled improbabilities, of the past but also out of the radically unintelligible nature of the contemporary, out of being—now, more and more—in unprecedented positions from which we—any "we," any "one"—must reinvent the terms of engagement and move on. Tradition gives us navigational coordinates, but topographies are changing even as we pick up our instruments to determine where we are, have been, might have been.... Who we are, might be, is every bit as much in flux. It's common to think of identities and traditions as useful limiting structures, points of departure from the known. But epistemological reality principles, like all others, shrivel without the dicey pleasures of interpermeability, motion, susceptibility to chance occurrences. Isn't it more fruitful to think of Identity and Tradition in ongoing, transformative conversation with a changing world? Dynamic systems models like fractal (cultural) coastlines or cultural DNA shift attention from narrow defensible borders to broad interactions among material, formal principles and possibility.

5

A structure is simply an inside and an outside.

Buckminster Fuller,
conversation with the author

Experiment—with its carefully structured invitation to surprise—is the paradigmatic interrogative conversation between the insistent intelligible and the silent unintelligible, intention and chance, structure and

process. In an aesthetic context the question is always a tripartite composition—of material, form, and meaning (what has been made of possibility). What twentieth-century innovative artists came to see is that the form that the experiment takes is not preliminary to the answer, not preliminary to the creation of the art object. It *is* the answer. It *is* the art. Just as the essay is not the result of the investigation, it is the investigation going on in writing that, in the radical mode of any lively thought, does not, at any given point, know entirely where it's going. This means that its openness to its inability to conclude, its refusal to know, rather than to sense, suspect, consider, theorize, contemplate, hypothesize, conjecture, wager... forms it as an experience of being in the world where uncertain and unpredictable life principles (in contrast to prescriptive rules) always exceed the scope of logical inference or imagination. This is the moving principle of the essay, which is distinctly feminine in its violations of masculine orthodoxy, the rule-bound "law of the fathers" that some feminist theorists have unfortunately mistaken as the only principles we have.

Any truly contemporary art is experimental because to be actively engaged with one's contemporariness is to be in conversation with the unintelligible. Too often critics who would be the first to agree that nothing can be created ex nihilo reflexively dismiss these conversations as spurning tradition. Although every generation faces problems unknown to previous ones, artists are artists because they have loved the work of artists before them; they spend their lives in conversation with the dead as well as the living, as well as with what they know they don't know in both terror and wonder. The present is what we, in the urgency of the unprecedented, with the pressures of rapid-fire transformations all around us, make of the past; and of course it's what the past has made of us. The contemporary is no more or less than a further complication of history that makes experiment, as critical dialogue with history, the poethical enactment of optimism. It asks, despite pressures to hunker down and minimize risks, What's possible? It's amazing/It's not surprising how unsettling that question can be.

Our default survival modes create awkward contradictions. Change is a defining principle of life; it's also a signal of peril. Resistance to change is an important defense; inflexible hunkering down is death. Not surprising that so much of our thought is dichotomous. It's hard to resolve such exigent contraries. Wittgenstein's ladder can never be abandoned. The stock of conceptual puzzles will never run out. We'll always have to rethink the perennial sticking points at the construction sites of our hu-

manity. That, in fact, *is* the construction site—conceptual minefield bracketed by our all-time, top-ten or so binary hits: e.g., Masculine-Feminine, Determinism-Freedom, Order-Disorder.[9] These three examples are dynamically interrelated principles, differential nonequations, integral to what I'm calling the "experimental feminine."

One way to think of them is in terms of Buckminster Fuller's elegantly minimalist definition of structure. Each term in these contesting binaries is the outside of the other's inside: each an alternative and/or complementary and/or argumentative and/or critical and/or destructive logic in relation to the other. The problem this poses for ordinary discourse is that we have the same kind of trouble seeing an inside and an outside simultaneously that we have seeing both vase and profiles in Edgar Rubin's famous ambiguous figure. This means we habitually feel we must rank or choose between the terms of a binary. (Which is figure, which ground? If both are figure, which is dominant?) But in fact, these terms (as terms) describe only the most easily identifiable limits at either end of a sinuous, moving range of nuanced possibilities.

It's a difficult conceptual shift to go from freeze-frame contraries, staked out at oppositional extremes, to the idea of a dynamic continuum, even though that continuum is the field in which we live. In fact we do see the ambiguous figure of the fused binary M-F as constantly shifting, and we must interpret and reinterpret the visual cues around us in fluid recognition/creation of changing patterns. The speaker at a conference on identity asks, Why do binaries keep returning even after they've been deconstructed? My provisional answer is that they are in agonistic definitional relation to one another. You can't have one without the other. You can't have either without both. Masculine-Feminine, Rational-Irrational...are terms that locate limiting conditions for a very complex range of mixes and possibilities that wiggle, slip, slide, elide, combine, recombine, morph, mongrelize. Binaries play the social role of bracketing the noise, the silences, the messy misfits we don't have the cultural energy or angle of vision to attend to.

This is finally the problem we have with all ambiguous figures—from profile/vase/profile to homosexuals (in Spanish, *los ambiguos*), mongrels, of every kind. We want clear and coherent, clean and well-lit stories. Perhaps sometimes, as Page duBois puts it in her discussion of Euripides' questioning of the motive of the story, to stop pain.[10] The narrative impulse is to make things right. And there is also the impatience that cures its restlessness in a fixed gaze with enough depth of field to locate a vanishing point and no more. This is a picture of settled,

singular images, fixed ratios. (How many drops of blood or hormones tip the balance, shift the whole scene toward irremediable otherness?) All the while we know (or should know) that absolute determination of ratios in living systems is impossible. They're always changing.

Some aesthetic forms fix; others engender flux. Of course, this isn't a static opposition either. Most do both in different degrees. Any work of art can be explored as a foregrounding, one way or another, of this problematic. Our minds are too dynamic to stop the flow of definitions and distinctions. Artists best demonstrate this by performative, rather than descriptive means. (Euripides' irresolute treatment of the Feminine is a case in point.) Gertrude Stein, a mater of ambiguities, had a lifelong preoccupation with the problem of description. She had no interest in fixing her poetic gaze. Like the cubists and gestalt psychologists (and, for that matter, biologists) she found life/art principles in motility. It is the first characteristic of the form of life that is her writing. Her implicit theory of description is not one of pointed linguistic skewer but of fluidly dynamic perceptual field. In "An Acquaintance with Description" Stein writes:

> She said she did not believe in there having there having been there having been there having been there before. Refusing to turn away.
> A description refusing to turn away a description.
> ...An acquaintance with description or what is the difference between not what is the difference between not an acquaintance in description. An acquaintance in description. First a sea gull looking into the grain in order to look into the grain it must be flying as if it were looking at the grain.
> ...This comes to be a choice and we are the only choosers.[11]

6

It was a pleasure to find the *New York Times* dance critic Anna Kisselgoff discussing an actively permeable global discourse between experiment and tradition—another ambiguous figure?—in her review of the October 1999 International New Dance Festival in Montreal:

> How can one remain inspired by tradition but break free of its clichés as a creative artist?...The emergence of experimental African choreographers is not exclusively a 1990's phenomenon....By the same token...well known European choreographers [like] Mathilde Monnier...use African dancers in pieces stemming from their visits to Africa, reveal[ing] how much two-way traffic is in progress....The choreographers Seydou Boro and Salia Sanou from Burkina Faso, as well as Gnapa Béatrice Kombé of the stunning

Tchétché female troupe from the Ivory Coast, have studied or danced with Ms. Monnier in Montpellier, France. Since Ms. Monnier's mentor was the American teacher Viola Farber, once Merce Cunningham's partner, the line of descent and influences is more complex than first apparent.[12]

The longer one looks, the more complex everything becomes; but how long can one expect anyone to sustain attention? Everyone knows how hard it is these days. Perhaps it was hard in those days too, but the consequences of inattention are multiplied at higher speeds, in greater congestion. The mind more than ever needs to make meaningful patterns out of the purposeful play of its own motions in and out of sync with the motions of the rest of the world. It also needs to know how to be very still, to find and listen to the silences, the emerging patterns in all the noise. In those silences, those unintelligibilities, lie the forms of our futures. Why do I say this? Because what is intelligible is already the past. As Stein puts it in "Composition As Explanation," classics are "what having become past is classified."[13] Silence and unintelligibility are the loci of immanent futurity. We require the discipline of attention that one notices in the play of healthy children or, indeed, in the high-wired, experimental choreography of a Merce Cunningham (working with bodies) or a John Cage (working with sounds and words and visual matter) or a Gertrude Stein (working with words and ideas).

I've just gone backward in time for most of my examples. That path is habitual. It's harder to sense how what's currently going on fits into concepts of a developing contemporary. This is why, in a poethics of experiment, I've added an aitch to *poetics*. I think of that aitch itself as a feminizing, adulterating of the word/world as brought to us by the paradigmatic Aristotle. Perhaps I should call this transgressive lettristic feminine principle the "Scarlet Aitch."

The Scarlet Aitch

Twenty-Six Notes
on the Experimental Feminine

> The dissociation defense was giving way to an acceptance of
> bisexuality as a quality of the unit or total self. I saw that I
> was dealing with what could be called a *pure female element*.
> At first it surprised me that I could reach this only by looking
> at the material presented by a male patient.
> > D. W. Winnicott, *Playing and Reality*

> Chance is always a relative term. The swerve out of one system
> enters the logic of another. Can't you see, Alice, as long as cul-
> tures and their artifacts are identified by internally consistent
> logics, as long as identity itself is identified as an internally
> consistent logic, the feminine will be the constant clinamen.
> > Genre Tallique, *GLANCES: An Unwritten Book*

1. Differential Loquations:

 Hey, it's not the end of history, it's just the end of Hegel. (Anon.)

 It's not the angel of history, it's the angle of attention.
 (K. Callater)

 The world's not ending, it's just becoming incomprehensible. (*Washington
 Post*, March 12, 1999)

 In a culture of strategic simple-mindedness relishing complexity is a politi-
 cal act. (S. M. Quant, *Manual for Desperate Times*)

2. Phallogocentrism, the latest term for a double-ended rationalist telos:
What's not coming from the Father must be tending toward Him. (Fast-
track from Hegel to Lacan.)[1] This is a dream from which we can
awaken. I engage in projects that enact my preferences—reciprocal al-
terities, the polylogical perverse. Does this mean an ethics of individual

will set against currents of cultural ethos? No. I think it's a different reading of cultural ethos.

3. The rationalist telos has got to go, but a constructive myth of progressive social conscience may still be our best hope. (Is it possible to know it's a myth and still believe in it?) We've been calling the crisis of character that cumulative self-consciousness inflicts on us "postmodernism." The communal optic nerve affixed to that *post* affixed to *modern* is useful in scoping memory and desire. Is a confusing, embarrassing sense of postness the trial we must make our way through in order to arrive at new visions of possibility? None of this would be a problem if we were satisfied with the cultural work we'd already done; if any of the various *we*s had constructed a world beaming with kindness and justice.

4. Meanwhile (did I wait too long to say this?) with all the noisy deconstruction going on, the ironic critiques, the chronic and tic-like irreverences, the continual exposures of presullied classical thought, history's not ending, civilization's not ending, art's not ending, nature's not ending. Things are just becoming more complicated, less intelligible. (One can define any moment in history as the further complication of what preceded it.) This is exactly as it should be. In the sciences, intelligibility is a sign that the current paradigm is still functioning. If the horrors of the twentieth century are to be taken as a challenge to our humanist conceptual frameworks, it's clear that many of our social paradigms have been working against us. In the arts and humanities untroubled intelligibility is a sign of denial. The ways in which we understand the ongoing history of our values are subject to more constant upheaval than the ways in which we understand atoms and stars. Accelerating change over the twentieth century caused no greater stress than to the processes of making meaning in everyday life. Popular culture, with its market-driven values and stereotypes, has created an imagistic plenum in an opportunistic vacuum, but there have also come to be "everyday life" poetics in aesthetic thought not fueled by fantasy—neither idealized nor nostalgic. Refreshing, given the need for continuous reorientation to the dailiness of culture—its accidents and intentions, its F and M trajectories, its intractable messiness.

5. In culture, as Tallique puts it, *chance* is a relative term. The swerve out of one system rapidly enters the logic of another. We can't remain estranged from chance as though it would leave us to our own devices.

6. I've often used this quote from Francis Ponge: "In order for a text to expect in any way to render an account of reality of the concrete world (or the spiritual one), it must first attain reality in its own world, the textual one."[2] I'm thinking now it may be more useful to construe the realism in texts not so much as accounts *of* but in fractal relation *to* extratextual reality. Texts (or any other aesthetic realization) may exist as illuminated details, fractal elaborations along the natural-cultural coastline. So Ponge's point is still crucial: literature is not a shadow world; we are not condemned to languish at a remove from the real in Plato's cave or in the social constructionist's "prison house of language." To critically essay into the world of poetry is to explore the nature of textual realities as they engage us in specific and energetic *material* forms of life.

7. If poethics is a lived pattern of conscious and unconscious values, its contested habits of being are performed in literature as lettristic-phonemic practices. These ventures foreground the parts of our human agency exercised by means of configuring words—words that incorporate and transform experiences of mind, society, and nature at increasingly busy linguistic intersections. Poetry, as chronically blurred genre, can demonstrate just how busy by operating simultaneously from multiple perspectives, in multiple dimensions, in multiple languages that draw on the inherent ambiguities, cross-references, polyglot intercultural vectors of all languages in today's electronically intimate world. Poetry, particularly authentically contemporary poetry (that which could only have been written in its own time), is polyglossia in motion. The poethics that comes out of the postmodern crisis is in programmatic dissonance with simplistic thinking and ideals of purity.

8. How odd, for instance, to speak of a pure female element. Those things that are identified as pure (absolute, objective, essential, ideal, innocent, chaste, generic...) are thought—when thought is farthest from experience—to exist in the clearest imaginative air. In reality they muddle through netherworlds in conceptual drag. What brings the snap of the real back into the picture is to acknowledge, like D. W. Winnicott, that the pure female element is seen only through the lens of the male and vice versa.

9. Masculine and Feminine have long been agonistically defined. In the Möbius comic strip that seems to be our cultural default mode, irra-

tional Feminine is the swerve (or swish) away from stolid Masculine rationalism; Masculine is heroic resistance to the Feminine. But, in the tumult of the heroic urge, it betrays its own rational principle. (Think of Odysseus and the mess of Troy, Odysseus erectus tied to the mast as yet another ship glides by yet another pack of Sirens.) Perhaps there's some good news in this. That it's an agonistic, dynamical attractive/repellent system means that it's fluid. It can quiver if not quake at the slightest provocation. Its patterns are subject to startling rearrangement.

We speak of a static binary. But are those tensely positioned pairs ever really so still? The Feminine and Masculine are much more convincing as migratory principles that in principle can work in any body, can be engaged by any one in multivariable proportions. Among other things, this means women/men don't have to parody or subvert or steal power from one another to liberate the self because the other is already part of the self. Acknowledged or not, each of us carries—as inoculation and disease—an internally embedded reciprocal alterity.

10. One principle of nonreciprocal alterity is that the invisible *other* casting a shadow on every *other* marked as *other* is the self. To know this self is like knowing the earth only as its shadow casts the moon into eclipse. The Feminine, as it negotiates cultural arrangements in material dialogue with the pattern-bounded unpredictability of everyday life, is chronically foregrounded as ostensive other. That is, as the conductor, rather than connoisseur, of chaos.

11. A more hackneyed (realistic?) view: Masculine and Feminine principles are the internal combustion systems of male and female bodies staging agonistic drag races on the cultural Möbius strip. The carnage is terrible. Sexual drag-race history repeats itself as tragedy pupating, mutating into farce that is tragedy/farce/tragedy...ad nauseam. The relation looks suspiciously like profile/vase/profile. One can't ask in such circumstances whether M or F, tragedy or farce, profiles or vase occupies the privileged position. The visibility (intelligibility) of each depends entirely on the other.

12. When, in certain experimental arts, Feminine and Masculine are released from oppositional sexual politics into an active aesthetic of transient principles, coming and going as needed for the project at hand, generously available to both men and women, they engender a dynamic disequilibrium of the sort that's so productive in the rest of nature. It

may be that Male is to culture as Female is to nature only in the culture of Nature *versus* Culture. Could Feminine-Masculine as interdynamic principles nourish a culture of reciprocal alterity?

13. And what of that Scarlet Aitch?—aitch with enough texture to thicken a plot called *poethics*—poetics pregnant with street noises (silences), feminine strains (stains) (contagions), the thickened plots of communitarian ethics. The concrete fact of aitch is this: *A* with an *itch* is hitched in aural marriage to the class-indexical letter *H*. This humorous phoneme has of course had a primary function in the social drama of British—and, to some extent, American—class divisions. It marks the scene of a paradigmatic intersection of language and social destiny. The Scarlet *A* marks a different sort of paradigm, where the catastrophic swerve out of one's destiny is read as female, the energetic swerve within it as male.

14. What would it mean to say that all poets are feminine,[3] all *As* scarlet? The *A* that starts up the alphabet that starts up the poet adulterates everything with a lettristic fall from unity. The mess of multiplicity, of infinite combinatorics, has begun.

15. The *A* for adultery is indelibly linked to Hawthorne's Hester Prynne in American lit. and moviegoing cultures. I use this emblematic junction box, charged with unacceptability, impurity, the crimes and punishments legislated by law-of-the-father fundamentalist cultures (where the Feminine is always the polluting element and greatest threat) to situate my concerns with poetry and ethics in a poesis/po*ethos* of lettristic play.

16. Lettristic play operates illegally, strictly on the diagonal, the glancing tangential, transgressing left-right regulations, right angles of history, institutional rights to dictate meaningful grammars. It streaks through official texts, illuminating subtexts and subliminal noises as letters swerve, collide, coagulate in the wound—the scar in scarlet—the scars of historical/etymological silences.

17. By means of poethical concerns (explicit or not) with making forms of life out of language, and vice versa, the language aesthetic becomes a disclosure (or disclaimer) of values that embed it in one's cultural dispositions and silences. A poethics of the Feminine fall (swerve), transfiguration and apotheosis of *A*, takes place (here) within a lettristic geometry of attention.

18. Interestingly, Hawthorne's narrator explained his interest in Hester Prynne as an accident, a quite specific swerve of attention that occurs as he is poking about in an old storage room in the Salem Custom-House, scene of what he characterizes as a patriarchy of permanent inspection:[4]

> One idle and rainy day, it was my fortune to make a discovery of some little interest. Poking and burrowing into the heaped-up rubbish in the corner... glancing...with...half-reluctant interest...I chanced to lay my hand on a small package....There was something about it that quickened an instinctive curiosity....[T]he object that most drew my attention, in the mysterious package, was a certain affair of fine red cloth, much worn and faded.[5]

This event opens up a new angle in his geometry of attention that one could label clinamen of consciousness—taking him from despised world of official respectability to daring poethics of a novel. The embroidered A on the tattered piece of cloth leads Hawthorne to what many critics have called a confused, ambiguous (in my view, admirably complex) examination of a woman whose vision somehow exceeds the legislated hermeticism of seventeenth-century New England. Hester enacts a remarkable transvaluation of values—lettristically sited—that improbably illuminates a shameful A into icon of pride and grace, an A that might stand for *Angel*[6] or *Adulteress,* depending on one's angle of vision.

19. Lettristic bonds, valences, contagions are angles of realization afforded by the accidents of intellectual and biological alphabets. The letter as letter is a charged vector of transmission, as in "to send a letter" through the chaotic geometries and postal contingencies of everyday life. Letter *A,* Messenger Angle of attention creating countless Alpha bets as it spirals through the thick medium of historical silence. Messenger Angles of connection navigate helical wagers of DNA. In English the first letter of the alphabet moonlights as indefinite article and comes from the Indo-European root *oino,* meaning "one." (Of course, there literally cannot be a one without an other.) Is there anything to be made of the fact that the starting points of our lettristic and numerical combinatory systems are cognate? Do they really have entirely different logics? In our geometries, algebras, differential equations, combinatorics of every sort, we choreograph our attention even as our ideas are choreographed by delicately indiscreet symbols full of the poetry of transgressive relationship in our fractal brains. How gracefully strange, as the mathematician Brian Rotman points out:

Claiming symbols as artificial romanticizes mathematics as a mysterious
and ineffable species of "pure," i.e. linguistically untainted, thought. The
history of mathematics is impossible to tell except as an ongoing and highly
complex interaction between writing (symbols, notations, diagrams,
formalisms) and thinking/imagining (ideas, concepts, intuitions, arguments,
narratives). In mathematics, language far from being neutral or inert is al-
ways inseparable from and frequently constitutive of the very objects,
abstractions and relations it (subsequently) is seen to be "describing."[7]

20. The scarlet A as first integer of transfiguration in a Purist society—and
in the life of a disgruntled customhouse worker—becomes public sign and
ritual instrument of Hester's Assumption into the possibility of a higher
social vision. (Additional lettristic accidents: in the English liturgical cal-
endar A indicates Annunciation and Ascension.) From the point of view of
a culture freighted with masculinist fears of feminine contagion Hester is
the quintessentially feminine ambiguous (conceptually fluid) poethical
figure. The A marks an Archimedean point where the idea of adultery no
longer fixes identity into stigmatized object but becomes lever for a swerve
into the gratuitous utopianism of a liminally conceived contemporary:
"her firm belief that, at some brighter period, when the world should have
grown ripe for it, in Heaven's own time, a new truth would be revealed, in
order to establish the whole relation between man and woman on a surer
ground of mutual happiness" (Hawthorne, *Scarlet Letter*, 177).

21. The illuminated A is material sign of Hester Prynne as poethical cli-
namen, the experimental feminine incarnate. In her verge toward the
rocky coastline of a contemporary reconfiguration of virtue Hester is
ejected out of a logic inescapable on its own grounds—the Puritan patri-
archal logic in which the figure of the independent woman negates mas-
culine principle as final moral arbiter. As character and as feminine prin-
ciple Hester seems to become a clinamen for Hawthorne's narrator
himself, releasing him from what Winnicott would have identified as de-
pressed and bitter compliance, the (autobiographical) state Hawthorne
is (in the introduction to the book) brooding about at the scene of his un-
happy employment, the customhouse. That is the scene of the A striking
Hawthorne with the heat of its "other" history: "I happened to place it
on my breast.... It seemed to me, then, that I experienced a sensation not
altogether physical, yet almost so, as of a burning heart; and as if the let-
ter were not of red cloth, but red-hot iron" (25).

22. An illuminated letter is always a clinamen, sending the reader for a moment into visual logics. (Any letter is illuminated by sustained attention to its graphic presence.) The ethos of Hester Prynne is one that embodies intersecting angles as lettristically improved angels of chance and attention. They collide and transfigure in a feminine principle that makes change possible even within punitive logics of a social structure erected in specific terror of all that is conceived as feminine, all dynamic, destabilizing fluidities.

23. The experience of A, or F or M, is always contingent, although their long histories render them anything but arbitrary. These angled marks, linguistic levers, are a function of the range of forms our cultures have played out in their sexual and familial politics. This last tends to be enacted in stereotypically stripped, oppositional gender roles, but the dynamic exchange, the folding in of new materials that gives the reinvention of forms their lively possibility, never stops.

24. Adulterations can bring on new angles (angels in geometries of attention) of improbable grace. Perhaps angels of history are of some use with their wing-dinged vectors after all. (Mathematicians once thought of vectors as angel flight patterns.)[8] (A) Alice plummeting into Wonderland or (B) gliding through suddenly airy molecules to Looking Glass world. Swerves occur all the time; Alices and Icaruses fling themselves into uncanny trajectories through cultural space. One might sense this emotionally, but for it to come usefully into consciousness, to effect structural change, it must enter our less stable lettristic logics—our poetries, our poethical analyses.

25. Can one say that the Feminine (wherever it may find itself—in woman, man, hermaphrodite) is the experimental principle that projects its vision outside limiting structures?[9] The active "Experimental Feminine" is a necessary update to Goethe's passive "Eternal Feminine." His is just one of many static visions that reassuringly place the Feminine in cultural mausoleums constructed on the outskirts of the Masculine state.

26. Can't you see, Alice, as long as all that complicates systems, thickens plots, diverges from invested trajectories and story lines is persistently feared and devalued, the Feminine will be the constant clinamen?

:RE:THINKING:
LITERARY:FEMINISM:

(three essays onto shaky grounds)

I PICTURE THEORIES

She moves slowly. Her movements are made gradual, dull, made to extend from inside her, the woman, her, the wife, her walk weighted full to the ground. Stillness that follows when she closes the door. She cannot disturb the atmosphere....

Upon seeing her you know how it was for her. You know how it might have been. You recline, you lapse, you fall, you see before you what you have seen before. Repeated, without your even knowing it. It is you standing there. It is you waiting outside in the summer day. It is you waiting and knowing to wait. How to. Wait. It is you walking a few steps before the man who walks behind you. It is you in the silence through the pines, the hills, who walks exactly three steps behind her. It is you in the silence. His silence all around the unspoken the unheard, the apprenticeship to silence. Observed for so long and not ending. Not immediately. Not soon. Continuing. Contained. Muteness. Speech less ness.

Theresa Hak Kyung Cha, *Dictee,* 104, 106*

In our silence, out of docile bodies and silent minds—out of multiple silences more and more audible—we've constructed theories and accounts of a historical endurance and power we call "women's silence." This is only one of many silences to which an increasingly heterogeneous and problematic *we* is attending after modernism's figure/ground shaking "now." Isn't it, come to think of it, curious that the twentieth-

*Italics mine in all poetry block quotes.

century project of conceptual reorientation came so often to silence? There are Wittgenstein's aphoristic and Beckett's elliptical silences, Gertrude Stein's silences of depunctuation and repetition, Kristeva's semiotic silences, John Cage's resounding silences filled with ambient noise; Anne-Marie Albiach's, Rosmarie Waldrop's, Hannah Weiner's, Susan Howe's, Lyn Hejinian's, Nicole Brossard's, Tina Darragh's, Charles Bernstein's, Diane Ward's, Leslie Scalapino's, Tom Raworth's, Bruce Andrews's, Rod Smith's, Carla Harryman's, Peter Inman's, Theresa Hak Kyung Cha's...poethical silences of countersyntactic and divested forms; as well as testimonies and sacrifices of silence we associate with names like Virginia Woolf, Tillie Olsen, Sylvia Plath, Audre Lorde, Adrienne Rich....(The cultural silences that befall radical difference will prolong the obscurity of some of the names I've listed.)

What we've learned from this coincidence of silences (as venerable and portentous as a siege of herons or a murder of crows) is that silence itself is nothing more or less than what lies outside the radius of interest and comprehension at any given time. We hear, that is, with culturally attuned ears. The angles of our geometries of attention are periodically adjusted, sometimes radically reoriented. This century's formal investigations into experiences of silence have meant opening up previously inaccessible or unacknowledged or forbidden territory, where the very act of attending entails a figure/ground shift. We continue to be startled by Cage's discovery that silence is not empty at all but densely, richly, disturbingly full. Full of just those things we had not, until "now," been ready or able to notice; or reluctantly noticing, had dismissed as nonsense or noise. The long postponements of acknowledgment that constitute our cultural silences are not only accidental oversights. They are also indications of just how threatening to surface composure and cultural self-image the articulation of silence can be.

Not an accident, but certainly an intriguing coincidence to discover the force of silence at precisely this cacophonous moment on the Western Civ time line. A moment of accelerated technological momentum hell-bent on drowning out silence in every form once and for all, stuffing information into every crack. This is no paradox. All those probes and antennas, satellite dishes and cellular phones are designed to make the experience of limit and respite we have called silence as conceptually irrecoverable as the romantic idea of wilderness. And yet cognitive/intuitive frontiers remain. If silence was formerly what we weren't ready to hear, silence is currently what is audible but unintelligible. The realm of the unintelligible is the permanent frontier—that

which lies outside the scope of the culturally preconceived—just where we need to operate in our invention of new forms of life drawing on the power of the feminine.[1]

What is currently most prominently audible/intelligible is, as Judith Butler pointed out in *Gender Trouble*, a trap.[2] It is a world authored in the image of Rational/Universal Man—Homo Protoregulator studding a clear and distinct (Cartesian) prose with *man's* randy, generic pronouns. (Slipping back—do you notice?—after a brief, PC interlude.) We have been presented with a subtle and treacherous "text" declaring itself generic and normative starting point—homogenius, monolithic, active, authoritative—just as Moses brought it down from the mountain; i.e., masculine. In *Gender Trouble* Butler sees the generic feminine as *sub*text, either *sub*jugated or *sub*versive (*reactive*) to *the* master narrative. But we must be cautious about the consequences of such a view. If one defines feminine power only as the power of *sub*version, one is valorizing the predominance of the masculine "version." We might note with unsettling, extraliterary logic that if the subversion of rape is seduction, then seduction is an implicit legitimation of rape.

In the unnaturally constructed choreography of cultural survival, the text, as rational, imperial, constitutive fabric, has been understood as logically prior, defining the terms of the intelligible. For Judith Butler, who implicitly accepts the normative status of the "intelligible," and therefore the constraints of this binary textual code, to make "gender trouble" is to act up as subtext: that is, to perform *sub*-versions: parody, pastiche, ironic mirrorings, deconstructive replications. Doing this, she believes, exposes the arbitrariness of the phallogocentric text. But this prescription for a performative feminine subtext doesn't spring the binary trap. On the contrary, it reinforces it by positing its referential stability and by ignoring strong traditions of multivariant feminine texts. To make real gender trouble is to make genre trouble. Not to parody, but to open up explorations into forms of *un*intelligibility (unintelliga-bility?) as transgeneric feminine frontier.

Textual traditions that have enacted and explored modes culturally labeled Feminine have oddly—or, as we shall note, not so oddly—been practiced until recently more by men than by women. *Gender Trouble*, in its strong argument for the social contingency of traits (and bodies) labeled feminine/masculine, can help prepare us for a radical rethinking of the occurrence of the feminine in culture. Feminine textual traditions have had tumultuous histories of appropriation and rejection by women and men alike in the long, topiary hedgemony of masculinist values dis-

guised as natural forms. It's been suggested by Luce Irigaray and others that "the" feminine is perhaps nothing other than a plural—all that conspires against monolithic, monotonal, monolinear, *uni*verses. Complexities and messes that overflow constrictions of "the" have been labeled variously over the centuries but most strongly identified with the feminine. As alternative principle, it is, importantly, the transgressive term in an ongoing Western cultural dialectic between established order and new possibility. We may smart from raw awareness of the invidiously destructive M/F binary, but its internal collisions and combustions have yielded constructively complex and paradoxical forms—mastery, *matery*, and strange powers yet to be named. Our best possibilities lie in texts/altertexts where the so-called feminine and masculine take migratory, paradoxical, and surprising swerves to the enrichment of both, /n/either, and all else that lies along fields of limitless nuance. This is not a vision of androgyny but of range. The collision with limiting principles that shut down possibility, like "I am a man; I must write like a man," lead to interesting swerves. For example, the French poet Dominique Fourcade likes to declare that as poet he is a woman: "toutes les poètes sont des femmes."[3]

To the extent that such swerves have been abhorred, they've been identified as feminine whether or not they've been declared as such. When valued they've been almost entirely incorporated into the myth of dis- or e-ruptive male genius. In the romantic tradition the strong male poet is inspired by a female muse, a pointedly external feminine element. But as far back as one looks it's there. Even prior to Sappho's acknowledgment of male poets as her precursors or Plato's incorporation of the feminine Socratic rationalist. In Homer, as well as in the mythic sources of Attic drama, one finds the paradoxical and ambivalent linking of the feminine with both the yielding and the threatening.

From the end of the nineteenth century to the present the exploding genre (if not gender) project has been located in what is called "experimental" or "avant-garde" traditions. Because of the masculinist bias of establishment literary traditions, these labels have often been applied pejoratively to connote the threat of unintelligibility. Perhaps one of the most remarkable things about our present time is that women are finally powerful enough sociopolitically to undertake the risks of this feminine challenge in their own texts.

A realistic optimism, not just for the feminine but for the complex human, lies in forms that engage the dynamics of multiplicity (three and more). In acknowledgment of difference, yes, but, more important, in

generating a proliferation of possibility beyond invidious dualisms. The same global and space information technologies that are disembarrassing us of the illusion of other as absence are schooling us in multidirectional coincidence (a pattern, coincidentally, related to Carol Gilligan's web image of characteristic female thinking) as a connective principle at least as forceful as monodirectional (hierarchical) cause-effect. In a high-tech scientific era recognizing both complexity and the constituting presence of chance in nature, we may be rediscovering that coincidence, everything at any given moment happening at once, presents the most remarkable challenge in our teeming, electronically intimate global village.

It happens that this has been the condition of women's experience for as long as our histories recount and imply. An interesting coincidence, yes/no?, that what Western culture has tended to label feminine (forms characterized by silence, empty and full; multiple, associative, nonhierarchical logics; open and materially contingent processes; etc.) may well be more relevant to the complex reality we are coming to see as our world than the narrowly hierarchical logics that produced the rationalist dreamwork of civilization and its misogynist discontents. I wonder if we may find in the collision of radically destabilizing institutions and emerging feminine forms the energy to make something unprecedentedly, poethically generous of our complex future?

Let's essay into this seismic zone and explore some odd logics in the literary disposition of women's silence.

She is education history. She. Is water written lament. And cool education written blue. A literate blue. A literate yellow. And arrogance she. Speaks. Forgetting. The first Brazil. Is yellow and so speaking yellow as blue as writing. Lament. Yellow and blue. Slip. The negative. Bury the negative. Growing written water. And arrogance. But first. The oversight.
 Carla Harryman, "Dimblue," *In the Mode Of,* 7

FROM IMMANENT TO EMINENT DOMAIN?

First an oversight: Anglo-American (and to some extent French) feminist thought has tended to support a women's literature of expressive voice and depictive visual metaphor. This has been promoted as the only way to explore the domain of women's silence—of what can and cannot be spoken or heard in a male-dominated world. Linguistic as/like snapshots are meant to reveal the truth of women's condition through the startling disclosures of poetic images. The project is to record our present experience and expose undeveloped images from our

long period of cultural latency. In female captivity narratives the si-
lences hiss in the mind's ear with all the *pressures* visited upon us. We
have been op*pressed*, sup*pressed*, re*pressed*, de*pressed*, com*pressed*—
even im*pressed* to the point of participating in our own belittling scorn.

The picture theory of female liberation proceeds on the Enlightenment
belief that bringing things to light is ipso facto therapeutic. Visibility is
also construed as a political force that progressively reconfigures con-
sciousness, making it possible to act out of the immanent power of our
endurance. Self-projected images of our disenfranchisement should, given
the promise of Enlightenment-based psychotherapies, generate the emo-
tional power to claim our rightful domain. The only way out of invisible
and mute oppression is to turn up the lights and shatter the silence with
voices that have earned the right to name the particulars of the oppres-
sion, to envision the conditions of empowerment.

The major problem with this picture may be that it's just that—a pic-
ture theory depending on a kind of verisimilitude that draws images
from life to present them as (like) replicas in the text. The poetries
whose energies come largely from pointing to the state of the world out-
side the text enact only limited life principles within the language itself.
The desire to be immediately and easily understood dictates reverent
uses of the very constructions that contain the injustice. To depict may
be to trigger an image in the mind's eye/I, but does it reconfigure the
grounds for major conceptual change?

[Working Note: It's been assumed in a culture that ties knowledge and
freedom to self-empowerment that the power of women, like that of ev-
eryone else, lies conceptually in the right to self-definition, politically in
the right to self-determination. Add the two together, divide by "I," and
you get self-expression, yes/no? It's been part of the chronic dis-ease of
women in our society that self-definition was for so long understood as
a private matter. Thus, women who daily played the role of domestic or
office servant or otherwise diminutive person (often with little-girl body
language and undescended voices) seized on first-person forms—di-
aries, journals, confessional poetry, autobiographies, and autobio-
graphical novels—all genres where the scope doesn't have to exceed
firsthand and/or self-knowledge. This is the field for self-definition as
self-expression.

Suppose we think of self-determination in art as invention, where the
power lies in creating not just a self but language games and forms of life
that draw on public knowledge and exploration of otherness, thereby re-

forming by their very *active* presence the public sphere in which they operate? This might be seen as the realm of imagination that plays in the arena of the world, as opposed to fantasy—that recedes into the envelope of the mind I-solate, I-solace.[4] This would mean that the power of women lies not in expressing what has heretofore been stoppered within our cramped domain (scene of our silence) but in a radical reorientation that may explode the notion of domain as proprietor's home, body, self to substitute the energetic principle of poethical form—socioaesthetic values to live *by* rather than under, within, or through.

Proposal for a healthy politics of identity: to demand the right to work on one's subject position rather than to live out its destiny.]

NOW PICTURING ONLY TWO SIDES OF A PICTURE THEORY OF THE PICTURE THEORY OF LITERARY FEMINISM (THERE ARE MANY MORE)

> "When meaning (what we take to be significant) is pictured as a picture we can talk about its undeveloped negative" (Michelle de Certaigne). We have had a sense that whatever was pictured was real, that proof of existence lay in a discreetly finite set of attributes rather than the mess of limitless process. We thought that what was undeveloped, that is, all that failed to be stop-timed into manageable freeze-frame units, remained or became a negative. Our idea of development as calculated leap from one snap-shot to the next must undergo scrutiny.
>
> Genre Tallique, *GLANCES: An Unwritten Book*, 13

It has been a general practice to evaluate feminist writing in terms of its developed and underdeveloped images of women—to praise poets like Adrienne Rich, Marge Piercy, Audre Lorde, Sharon Olds...for the courage of their content—the way in which their writing exposes previously unexposed negatives, i.e., female experiences persistently devalued, suppressed, repressed in a world dominated by male logics and values. The image is of a strong female poet creating strong metaphoric pictures to fuel desires for liberation. But another instance of devaluing—to my mind equally destructive in its implications—must be discussed. The dark side of the Enlightened feminist literary establishment has been the way in which women writers whose projects are dedicated to something other than therapeutic exposures have been treated. They are lumped together with male writers who produce "inaccessible" texts and dismissed. The situation is uncomfortably familiar. It looks

very much like a replica of the standard patriarchal treatment of non-conforming women.

The picture theory of meaning has roots going back to Plato and Aristotle but comes to us most recently from turn-of-the-century Positivist sources. It presumes that a meaningful picture is instantly legible because of its this = that correspondence to a fully available, intelligible reality. A picture is an implicative instance of hard data as it's defined within the deductive genealogy of the reigning metaphysic. Put simply (there's no other way), reality is as internally consistent and coherent as any rational man (no feminine disruptions in logic or tone admitted) and is clearly classifiable (no blurred genres). Craig Owens, in his essay "The Discourse of Others: Feminists and Postmodernism," writes, "Recent analyses of the 'enunciative apparatus' of visual representation—its poles of emission and reception—confirm, the representational systems of the West admit only one vision—that of the constitutive male subject—or, rather, they posit the subject of representation as absolutely centered, unitary, masculine" (58). This is surely a model we must question for a feminist enterprise.

> *Only the women were placing bets.*
>
> *From instinct and from memory I try to reconstruct nothing. From memory, I broach the subject. And that cannot be from childhood. Only from ecstasy, from a fall, from words. Or from the body differently. Emergency cell like body at its ultimate, without its knowledge, the tongue will tell it.*
>
> *When Florence Dérive entered the Hôtel de l'Institut, Montréal, 1980 on rue St. Denis. Snatches of sentences inside. At the registration desk. It was night. Since* Finnegans Wake. *It was night. Itinerant, Florence Dérive such a woman. Brain— — — — — — — — — — — — — — — — — —*
> *— — — memory. The night, numbers and letters.*
>
> *Florence Dérive sometimes repeats a certain number of gestures that continue to exist as writing and each time she dis/places ardour and meaning...*
> Nicole Brossard, "The Ordinary," *Picture Theory,* 13

Brossard's theory as practice moves us away from picturing. The language is not a static mirroring. It does not attempt to transport intact images from writer's life to reader as spectator. The disjunctive syntax, the depunctuated grammar, like that of Cha and Harryman, send ripples through any image that might be forming, keep it moving in the mind. This is not a scene of instant recognition. It's about the pleasures of active engagement. We are invited to participate in uses[5] of language in the generative dark of a Finnegans waking night.

A picture-book universe reveals little about the dark side of any-thing—neither conceptual frameworks nor the moon. Picturing presup-poses recognizable foregrounded figures—preconfigured into genus, gender, genre—frontally visible units. It reinforces the authority of es-tablished conceptual frameworks, of what can be seen through cultur-ally grounded lenses. There can be no dark, noisy silence of a *Finnegans Wake* in a picture-book universe—nor can there be the work of Cha, Harryman, Brossard. Theirs is a literature precisely dedicated to what cannot be illustrated, mediated, filtered by words at a remove from their objects.

The ideal poetry of depiction is a series of images strung together in rhythmically unbroken sequences that appear to reveal rather than con-struct a world. Designed to create a plenum, to saturate the mind with verisimilitude, the impression must be that there's no other logically possible world and that there's nothing left to say. The admiring re-viewer uses words like *skillfully crafted, deftly polished, absorbing, con-vincing, lacks nothing*. Meanwhile, the reader is not any more spurred to imaginative agency than one who has just reviewed an airtight logi-cal proof. Why act when all the work has quite clearly been done? If ex-istence is nothing more than a set of attributes, then "worlds" can be created than which nothing other can be conceived. This is the theolog-ical principle of the omnipotent author free of cognitive entropy, and play.

All this is about as far from real life in *medias* mess as we can get. Could it be that contrary to received opinion, a literature of attributes may not directly empower us to make a joyful, troublesome, gender/genre exploding noise? It certainly may confirm, console, support, jus-tify, reveal, inform, and—what sounds most active—inspire... but what does inspiration mean? Literally to be filled with someone else's breath. This secondhand air depletes energy for much of anything other than fantasy identifications with idealized models. Does this nurture a self-image that feels potent and positive? It may, but I question its value for imaginative practice.

Women have for centuries been subjected to images—from literary and romance novels to romantic poetry to movie and fashion magazines. Mostly we've been left with a damaged self-image—a feeling of invidious comparison, incompetence, inadequacy, paralysis. No sense—except through buying products—of how to get from here (flawed self) to there (idealized image). This romantic mechanism—confusion with an ideal-ized other—is, in its updated forms, central to the media value of glam-

our. As any TV producer knows, the image locks in the viewer's gaze and desire. It's a strategy of built-in seduction and persuasion, and betrayal. The remainder in the experience of being transfixed by images is the reader/viewer herself—left in a quiescent fantasy state, entertaining after-images, and afterthoughts, rather than engaging in active, alternative constructions (for example, by means of playfully indeterminate forms) that can materially reconfigure a form of life. Could it be that any medium whose chief function it is to impress images on us may be prolonging our cultural latency (our passivication) rather than deconstructing it?

I think one must question Images of Women literary theories in this light.[6] The extent to which they are founded on positivist or naïve realist epistemologies is revealed by their insistence on full disclosure or accessibility. We are in constant need of revising the connect-the-dots constellations we call our worlds. Luckily they're not ontologically glued to an unchanging backdrop. Nonetheless the metaphor of mirroring a stable truth, as brought to us in Aristotle's *Poetics,* still carries enormous weight.[7] It's seen in mainstream literatures as providing unassailable grounds for cultural understanding and political analysis even when the very notion of grounds has become so philosophically shaky no one would knowingly choose to secure anything to it. It's my feeling that women should be particularly suspicious of mirrors. The retrograde looking-glass world we've been encouraged to inhabit harbors a cultural black hole reflected as benign beauty mark. It's actually an ominous vanishing point.

Interestingly, ironically, the same theories that have destabilized the principles of realist epistemologies and literatures—and are thereby taken by many feminist theoreticians as inimical to women's causes—are responsible for the politically vital, postmodern notions of difference and decentered multiculturalism (the fall of "the" metanarrative) that release the power of the feminine from the status of a subtext. The valorization of realist grounding and accessibility produces the unintended effect of maintaining women as credulous readers in the passive state.[8]

> I know that the amorous scene has already been viewed and consumed in several of its strategies, I know that, I know that, repeated, it determines the opening and the vanishing point of all affirmation.
>
> Nicole Brossard, "Perspective," *Picture Theory,* 41

What comes of light that is secondhand (moon goddesses and worship?), written words destined to come *after*—after the fact, after the

fall of the fact (from Platonic forms or the biblical grace of not needing curiosity), after thought, after image (Baudrillard's vanishing point), and of course, in Harold Bloom's Freuding frenzy, after every other writer's *after*? One would think Bloom's romantic image of the male writer in an agon of belatedness might be exotic or irrelevant for those of us to whom language appears devoid of precedents created in the image of woman, low on *mater*pieces. Instead many of us have found it enviable—a condition to emulate. Hence the effort to establish a rival, mirror-image women's canon.

This ambition attempts to remedy the frightening absence of the feminine in history. The cultural memory embedded in all those language games where women have had little if any power has indeed felt like a negative—a sense of the absent (m)other, where the prototypical other is woman, where in fact the assumption into culture of the male child is coterminus with an emotional dropping of the *m* from *mother*. So Alicia Ostriker's poignant title for an emblematic book on "The Emergence of Women's Poetry in America," is *Stealing the Language*. It strikes a familiar, inauspicious note. Since Ostriker (who represents what may be the majority view among literary feminists) takes it as conceded that language has not been woman's domain, she concludes that we must pilfer and loot among its male-inscribed artifacts. As in Judith Butler's account of the eminent domain of phallogocentrism, our most active/aggressive role is limited to subversion. We can defiantly expose ourselves as strong women in the pictures we make with *their* language, embed these pictures in forceful stories, and create a new mythology portraying women as heroic models, but this is always done in full cognizance of the degree to which we remain exiles in a foreign tongue. In her final chapter, "Thieves of Language: Women Poets and Revisionist Mythology," Ostriker writes,

Women writers have always tried to steal the language. Among poets more than novelists, the thefts have been filching from the servants' quarters. When Elaine Marks surveys the Écriture féminine movement in Paris, she observes that in its manifestos of desire "to destroy the male hegemony" over language, "the rage is all the more intense because the writers see themselves as prisoners of the discourse they despise. But is it possible," she asks, "to break out?" Does there exist, as a *subterranean* current *below* the surface structure of male-oriented language, a specifically female language, a "mother tongue"?...[A] number of empirical studies in America seem to confirm that insofar as speech is "feminine," its strength is limited to evoking *sub*jective sensation and interpersonal responsiveness; it is not in other respects perceived as authoritative; it does not command men's respect. The

question of whether a female language, separate but equal to male
language, either actually exists or can (or should) be created, awaits further
research into the past and further gynocentric writing in the present.

Stealing the Language, 211 (italics mine)

The contemporary women writers Ostriker valorizes have followed
Anne Sexton and Sylvia Plath from a uniquely anguished "I" to an in-
structively, communally victimized "We"—representing a solidarity of
defiant images that unfortunately remain unresolvable, and therefore
inactive, in the alien chemistry of patriarchal language. (Is it because
what has in the past been characterized as feminine language has not
been authoritative, i.e., respected by men, that Ostriker so summarily
passes over its possibilities?) This leaves the structural trap of the "phal-
logocentric" language undisturbed. Since images created by women do
not impress male linguistic arbiters, these images cannot really enter,
much less transform, the language. Yet they are all we are "allowed" or,
to use Ostriker's image, all that is detachable enough to be "filched." In
Ostriker's Steinbergian languagescape of deeded real estate and Mens-
Club "pride of lions" architectural improvements, we might snatch a
"flower," "branch," or "bone" from the masculine metanarrative. Or,
better yet, an assertively female vocabulary list—"womb," "breast,"
"vagina," "menses." But not a dynamic principle. Not a grammar or
syntax to live by. Sure, says the (male) architect or contractor, you can
do what you like as long as you don't fool with anything structural.[9]

If this picture of total, male, linguistic hegemony were actually the
case, one might indeed be inclined to agree that all we can do is make
the best of what we can get away with by theft or subversion. But the
humiliation implicit in this image is startling. More disturbing than its
dismal picture of gender politics is the questionable picture of lan-
guage/culture itself—one that shares Judith Butler's image, after Freud-
Lacan/Foucault/Rich, of culture as inescapably male: "That the power
regimes of heterosexism and phallogocentrism seek to augment them-
selves through a constant repetition of their logic, their metaphysic, and
their naturalized ontologies does not imply that repetition itself ought
to be stopped—as if it could be....[T]he crucial question emerges: What
kind of subversive repetition might call into question the regulatory
practice of identity itself?" (Butler, *Gender Trouble*, 32).

What Ostriker calls for in the face of the seemingly insurmountable
obstacles to "owning" "the" language is the manufacture of bigger and
better (heroic) female images, turning the "project of defining a female
self" into a construction site for a full-fledged, woman-centered mythol-

ogy—a male hegemonic form Ostriker thinks we can renovate to represent women authoritatively in the public domain. The project is yet another subversion of image into mirror-image. It swallows Bloom's self-expressive "strong poet" ethos whole: "Where women write strongly as women, it is clear that their intention is to subvert and transform the life and literature they inherit....[R]evisionist mythmaking in women's poetry is a means of redefining both woman and culture" (Ostriker, 211).

Transforming a life is not the same as redecorating a poem or house with stolen or even legitimately acquired accessories. I fear this is a desperate and futile attempt in a world text that constructs the feminine itself as domesticated ornament/image rather than publicly effective, active principle. To the extent that Ostriker fails to link the feminine with dynamic processes already in the language, she condemns the female writer to lurk in the subjective (private), subterranean, subaltern world of subversive self-definition. What is most useful to us now—images of the female or enactments of the feminine?[10]

[Working Note: Is the following a useful distinction?

A use theory of meaning, one that locates the making of meaning in a collaborative engagement with interdynamically developing forms rather than in the interpretation of a fossil signified allows exploration of the medium of language itself and thus the invention of new grammars in which subject-object, master-mater relations become fluid. The picture theory, on the other hand, valorizes the prototypical *it*. *It* exists only in obeisance to processes outside *it*self, processes that unlike the *it* are not compressible into single units. To counteract this dichotomous relation between art object as *it* and nature as process, John Cage pledges to imitate not nature but its manner of operation. This results in art that is not a picture but a moving form of life.]

FIG. I

I feel you climbing toward me
your cleated bootsoles leaving their geometric bite
colossally embossed on microscopic crystals
as when I trailed you in the Caucasus
Now I am further
ahead than either of us dreamed anyone would be
I have become
the white snow packed like asphalt by the wind
the women I love lightly flung against the mountain
that blue sky

our frozen eyes unribboned through the storm
we could have stitched that blueness together like a quilt

(4–5)

This is the third stanza of Adrienne Rich's "Phantasia for Elvira
Shatayev." In an epigraph Rich explains that Shatayev was the "leader
of a women's climbing team, all of whom died in a storm on Lenin Peak,
August 1974. Later Shatayev's husband found and buried the bodies."
The "I" of the poem is the voice of Shatayev addressing her husband.
The poem ends,

In the diary torn from my fingers I had written:
What does love mean
what does it mean "to survive"
A cable of blue fire ropes our bodies
burning together in the snow We will not live
to settle for less We have dreamed of this
all of our lives

(6)

It's easy to equate this ill-fated, heroic (inspiring?) expedition with a
search for the cognitive, emotional, social domain of woman. Shatayev,
who in the past trailed behind her husband's assault on Mounts "Blank"
(we can imagine him planting flags on countless geological bulges, nam-
ing them *his*), has now achieved what might be seen as the ultimate claim
to eminent domain. She has, along with her companions, become part of
the mountain. But more important, she has become an in situ, literal
symbol of the monumental: image frozen onto the side of a mountain
like the faces at Mt. Rushmore. I mean to foreground the seeming con-
tradiction of the symbolically literal. The logical torque here is related to
the conjunction of this romantic/heroic scene with the language of
women's self-help manuals—"we will not...settle for less" and the lan-
guage of unrealized fantasy—"we have dreamed of this all of our lives."
The poem contains the entire range from immanent to eminent (as mod-
eled by worldwide machismo) domain. But the symbolically literal is not
the literal itself. Like all symbolism it stands "in place of."
 What does it mean to be inspired by a poem like this, with its finished
surface and romantic fatalism, to be literally filled with its breath? Sec-
ondhand breath is no more appealing to me than secondhand light. I
would rather conspire (active voice) than be inspired (passive voice). To
conspire (to breathe together) is to participate in the construction of a

living aesthetic event. But this requires a different kind of form—one not so authoritatively intelligible, one that otherwise enacts a continuing articulation of silence.

I chose to look at "Phantasia for Elvira Shatayev" because, like so much of Adrienne Rich's poetry, it has touched a wide audience. It was written during a time when her work—poetry and essays—helped fuel an important stage of the women's movement in the United States. Its passionate, collective self-expression (voices renting the silence of forbidden dreams) may indeed move a reader. But what does it mean to "be moved" (passive voice) by the kind of language game that forms this poem? This is a significantly different dynamic from that of a poetic language game whose unfinished surface requires the reader to behave as fully empowered participant. Think—as Wittgenstein did—of a chess game in which "to move" (active voice), to calculate and imagine, is to collaboratively develop (albeit under constraints) the future configuration in which one lives. The project is not so much to understand what is meant as to create meaning and possibility through one's conversational intervention in the pattern.

The didactic implication embedded in the sort of literature that the current pantheon of received feminist writers represents directs the reader toward the subjectivity of empathetic identification and away from autonomous, critical production. The prompt for female reader as writer (from Ostriker and Butler, as well as Rich et al.) is, after all, toward repetition with a difference. This is replication of a value structure that fetishizes heroics, where lyrical forms mimic logical proofs, where the reward is a conclusion that is a predetermined epiphany that is rewarded by a society left untroubled in its assumptions. The alternative is experiments that generate a proliferation of formal possibilities, possibilities that have, incidentally, much less to do with territory, ownership, and rights (all important issues in extraliterary arenas such as courts of law) than with the invention of poethical forms of life. Repetition with a difference may just not be different enough.

What's most interesting about the section from Theresa Hak Kyung Cha's *Dictee* ("ERATO Love Poetry") quoted at the beginning of this essay is not the picture Cha presents but the active disclosure of her language. The poem seems at first glance to be solidly within the tradition of "images of women" lit., but it presents constructive problems for this kind of reading. One notices, for instance, the unusual way the text is printed in the book, in an interaction of facing pages that only when folded together fill all the space. They are negative mirror images of one

another: where one is blank the other is imprinted and vice versa. The act of closing the book, of folding these empty and full spaces into one another becomes an erotic act, alerting readers to the intimate and odd cohabitations of words and words, ink and paper. But this is no easy sexual union, since one knows—although there's the mystery in not actually being able to see—that this text will never be one. When the book is closed the interfacing type will always face in opposite directions.

Roland Barthes wrote of the "lover's discourse" always implicit in words: *"Language is a skin: I rub my language against the other. It is as if I had words instead of fingers, or fingers at the tip of my words"* (Barthes, *A Lover's Discourse*, 73 [italics mine]); yet Cha's language touches only the emptiness of the other (opposite) page. That this text is designed to interpolate itself into emptiness/silence—to let emptiness/silence in—gives it remarkable breath: possibilities of in- and exhalation for writer and reader alike. I'd like to suggest that it is a woman's feminine text (denying any redundancy) that implicitly acknowledges/creates the possibility of other/additional/simultaneous texts. This is a model significantly different from Bloom's competitive "anxiety of influence." It opens up a distinction between the need to imprint/impress one's mark (image) on the other and an invitation to the others' discourse as necessary to an always collaborative making of meaning. Collaboration with the reader is unnecessary only when meaning is being reported rather than made.

Like the relationship between facing pages, "she" and "he" in ERATO articulate the silence between them by syntactic stops and starts. But this blurred genre (prose-poetry, investigation-artifact) blurs gender as well. S/he is silence. The feminist enactment of this text does not depend on its being politically correct. Its discourse is the experimental feminine in process—complex and partial. The confluence of languages (French, English, Korean) with multiple forms (translations, translation lessons, letters, biblical passages, documents, photographs, charts, movie stills, handwritten text; lyrical, prose, permutative writing...) brings *Dictee* into the multiple performance dimensions that characterize everyday life. I agree with Asian American feminist critics who say (some in praise, some in disappointment) that Cha's work doesn't support racial, ethnic, or gender identity politics. The complexity of *Dictee* confounds the reductionist coherence that logics of identity require. It is poethically investigative in the surprising juxtapositions of its parts. These are parts whose interactions create a fluid and productively indeterminate form of life as text, in the irresolvable abundance of their in-

tersecting lines of play, in their grammatical/syntactical, particle-wave interruptions. Cha's poetry is not the reflection of a finished project or a mind that is "made up." It is the permeable membrane of a living organism.

A CONFLUENCE OF SILENCES:

> We forget that we must always return to zero in order to pass from one word to the next.
>
> John Cage, *For the Birds*

> Don't *for heaven's sake*, be afraid of talking nonsense! But you must pay attention to your nonsense.
>
> Ludwig Wittgenstein, *Culture and Value*

> Probable probably is the most that they can say.
>
> Gertrude Stein, *How To Write*

Nicole Brossard's, Theresa Hak Kyung Cha's, Carla Harryman's words, the spaces between them, lead us to a prospect—an overview, not oversight—of the medium of language itself—the medium with which we must become so intimate and at home that we stop worrying about ownership and legitimacy (asserting rights of domain) and start using it for the sort of experiment and invention that brings us into transformative interaction with the worlds that languages betroth[11] and create. What I want to suggest, after Judith Butler, is that to make really productive and useful gender/genre trouble is not to repeat old forms with a difference (parodic or not) but to open up radical explorations into silence—the currently unintelligible in which some sense of our future may be detected.

The question then is not how to exit our silence. Not how we move from immanent to eminent domain. Not how to raise our voices loud enough to be heard in the legitimate (intelligible) theater of patriarchal culture. We already know how to do this: by reflecting the values of established, male-dominated power structures. Instead, let's think of how we can amplify the knowledge of/in our silence, our not so much *non*-sense as additional or other sense, our *im*probabilities, our unintelligabilities...in order to create new forms of intelligibility that are resonant with our values. This is where our feminist project overlaps with Wittgenstein's, Beckett's, Stein's, Cage's. And with contemporary women writers working in largely unrecognized traditions in formal transgression of gender/genre markers.

They are at this very moment making palpable sense of unintelligibles in their art.[12] And that sense is a breath of fresh air. It strives to avoid the eternal return to hermetic traps in old forms of life tainted by the systematic devaluation of feminine forms. New intelligibilities have been much ignored because what is validated as intelligible, what makes easily accessible sense—what is prized and rewarded[13]—is indeed repetition/replication of the structures supporting the aesthetic establishment currently enjoying the privileges of legitimacy, which are (it's all tediously circular!) the rewards of legibility.

Codes of intelligibility rationalize values that derive their force from the extent to which they are constructed and defended in terror of the experimental and the feminine.

NOWFORSOMETHINGNOTCOMPLETELYDIFFERENTNOWF

II FRENCH FREUD FEMINISM?

> What can "feminist" writing possibly mean? Images of the female as persons, strong and weak, admirable and despicable occur in the writing of both men and women. These images, pictures, vignettes, no matter how "progressive" the narrative in which they are embedded, cannot be said to constitute either feminine or feminist writing. Only form—stylistic enactment (aesthetic behavior)—can be feminine. What society has called feminine forms have always been available to both men and women in art as well as life. Feminist writing occurs only when female writers use feminine forms.... At precisely that moment of enactment, feminism as polemic disappears: the female writer has entered the world of the living.
>
> Genre Tallique, GLANCES: An Unwritten Book

The use of this quote is not intended to bolster what follows with authority. (Who is Genre Tallique anyway!?) It may indeed be that too much authority has vested the rhetorics of feminist theory. And with just that patriarchal charge we seek to escape.[14] Consider the French-Freud-Lacan-plex staging trans-Oedipal love or death masquerades with some of the best and brightest of the intellectual daughters. Positioning feminist theory in gendered *post*ness at the very moment it should be inventing itself anew. Not that I claim freedom from what Tallique has called *cette Électrecution*—her ironic term for the sinister cauterizing of the presumed gender wound that invites the feminine to remain transfixed at the mirror stage or in the pre-Oedipal eros inter-

ruptus of *écriture féminine*, "writing one's body." (No problem if body includes mind.)

To be conscious of twentieth-century humanist theory is inevitably to find psychoanalytic narratives winding their *strasse*s and *rue*s through one's mind. In the impacted setting of the psychoanalytic "family romance," where one's cultural space is delimited by the narrative outline of a nineteenth-century authorial parentage and "name of the father" imprimatur, understanding leans toward a very curious vanishing point.[15] In the Freudian master narrative the vanishing point is tagged "resistance" or "denial." Because it punctuates the farthest reach of the authorial point of view, it is anything but innocuous. It lies in wait for bounders and transgressors. Try to pass beyond it—you will either disappear or return home to father, chastened and docile. The at-large vanishing point for women is simply this: to the extent that we venture onto the post-Oedipal playing field of culture, or the sexual politics of the unreconstructed family constellation, our every role, every move is defined by the "law of the father" in search of good wife and mother. This is another installment in the fictive creation of the "eternal feminine" within what Judith Butler calls the "heterosexual matrix":

> I use the term *heterosexual matrix* ... to designate that grid of cultural intelligibility through which bodies, genders, and desires are naturalized. I am drawing from Monique Wittig's notion of the "heterosexual contract" and, to a lesser extent, on Adrienne Rich's notion of "compulsory heterosexuality" to characterize a hegemonic discursive/epistemic model of gender intelligibility that assumes that for bodies to cohere and make sense there must be a stable sex expressed through a stable gender (masculine expresses male, feminine expresses female) that is oppositionally and hierarchically defined through the compulsory practice of heterosexuality.
>
> *Gender Trouble*, 151

Beyond the vanishing point lie shocking scenes: exposed negatives reveal a domimatrix with polymorphous perverse appetites and ambitions wreaking havoc in the popular maxiseries, "Civilization and Miss Content." For Freud "poly" *without invidious comparison* is always safely and emblematically pre-Oedipal:[16] an immature psychological grammar in which subject has not yet targeted an appropriate object. What has occurred for women in this grim fairy tale is something akin to emotional clitorectomy. The little girl's assumed complicity in the patriarchal construction of the "eternal feminine" means that she must simultaneously valorize and relinquish her femaleness as agent and object of desire. The rich polymorphous text of early female experience is

thereby reduced to threatening subtext—source of guilt, confusion, self-loathing, enervation....When little girls are asked to stop desiring the feminine and instead to affect it (boys are put in an equivalent position with respect to the masculine), they are no longer exploring vibrant performative gender/genre possibility but scurrying toward its underexposed images. This regression is astonishingly called maturation in the psychoanalytic fairy tale. Can we imagine instead a scenario in which maturing, gaining power in one's culture (medium of growth) is to actively (disruptively) participate in one's own gender/genre construction by choosing among the multiple logics of a complex, pragmatic realism, rather than passively receiving the imprint of a distilled, idealized, fully commodified (and phallicized) symbolic? To what extent have women been complicit in the substitution of the image of the female for the transgressive experimental feminine?

Freud was above all else a great prose stylist. The literary paradigm of psychoanalytic persuasion and plausibility is, as Freud ruefully/pridefully admitted, the novella.[17] Bettelheim, in *The Uses of Enchantment,* finds his writing close to the narrative symbolic structures of German fairy tales. What this form entails is a persuasive grammar that gathers force from a particular kind of analogical and metaphorical thinking—one that presumes that the "as/like" and "stands for" relation yields "deeply" significant meaning. A structure in which symbolic codes stabilize an economy of equivalences and equilibria is one in which circularly reinforcing logics can even maintain an uberphallus as the equivalent of an entire system. But the symbolic is not the only logical or associative order of meaning. There is metonymy, as well as metaphor; there are complex dynamic systems and fluidly interactive models, as well as equivalences. The phallus, like the romantic genius and strong poet and symbolic logic it props up, has got to go; the penis may get on quite well without it.

Meanwhile there are other compelling forces in Freud's narrative style. It operates very skillfully as an Aristotelian rhetoric of persuasion. In the psychoanalytic narrative the rhetorical *ethos* (appeal to respect for the author's character) has been that of courageous patriarchal genius; *pathos* (appeal to our emotions) that of deeply, aesthetically sensitive patriarchal genius; *logos* (appeal to our respect for reason) that of rationally masterful, historically knowledgeable, patriarchal genius.[18] It is the confluence of these characteristics in Freud's and, with a different flavor, Lacan's prose that vested the protopsychoanalytic narrative with authority (Ostriker's major concern) and intelligibility (Butler's). Is

there room for an "experimental feminine" here or for the spirit of postmodern eclecticism, much less for the invention of new rules? Luce Irigaray was actually expelled from Lacan's seminar when she deviated—rather minimally, as it turns out—from his views.

In this "progressive" cultural tragedy (drama of the inevitable) we are forever children shaped by the authorial tyranny of the father. Sons carry on the name, the law, the primary text. Daughters dress up in costumes tagged Electra, Jocasta, Iphegenia, Clytemnestra, Medea. Like all disenfranchised peoples, the daughters can submit or self-destruct. We can rebel, displace, deconstruct, subvert but only in the ongoing *sub*text that is our purported destiny. We cannot author our own play.

This model is only plausible if one narrows the field of vision to the rules of nineteenth-century metarhetorical perspective as syntactic impulsion toward the father, hugging the logomotive track in self-fulfilling linguistic fatalism. With the female Lucifer, Luce Irigaray, comes a different light, voice, text only to return as the redepressed. Isn't this all too familiar? Don't we have to consider that to replicate this particular psychoanalytic model[19] in feminist theory is to perpetuate an exclusionary and suffocating grammar in which to make sense, to be authoritative or intelligible, is to underwrite one's subjugation to a system whose very grounding is scorn for the feminine? The feminine as negative image of the cultural construction of the masculine is distrusted in its openness to multiple—sensual as well as rational—logics. In conceding "the" symbolic order to the long shadow of the name of the father we will remain audience to the shadow theater of Plato's misogynist cave. Why then the voluntary subjection of feminist theoreticians to the tawdry outcome of this narrative line?

Oddly, interestingly, the defensive desire for our own grounding has had the paradoxical effect of making us, as literary feminists, resistant to the use of feminine forms, which (in any era) are neither authoritative nor intelligible by current establishment standards. This, I think is the terminus of a theoretical line whose narrative is constructed on restrictive *pre* and *post* axes: pre- and postcultural, pre- and post-Oedipal, pre- and postgenital—ignoring the complex, polymorphous, exploded-cartoon contemporaneity of all active thinking experience. In the still-silent film the proverbial preverbal heroine is still tied to the tracks, silently screaming. She *will* be run over by the Hegelian-Freudian-Lacanian logomotive because there are no other tracks on the set, no sidelines or margins from which the possibility of liberation beckons, no topological warps or additional dimensions in the flatland

narrativescape, no choice of vanishing points. Most important, there are no alternatives to finding herself in this position to begin with. The possibility of plural possibilities is excluded by the marked singularity of the theory-ordained probable.

[Working quote: "The critical task for feminism is not to establish a point of view outside of constructed identities; that conceit is the construction of an epistemological model that would disavow its own cultural location.... The critical task is, rather, to locate strategies of subversive repetition" (Butler, *Gender Trouble*, 147).]

So in a recent remake of this classic Western the woman tied to the tracks may be a feminist who can theorize, parodize, ironize her position but not escape.[20] The movie is shot not in some flimsily constructed studio but on location—*the* cultural location. This is the repetition compulsion of *Gender Trouble,* in which the scripted response to entrapment in narrowly binary, essentialist gender identities is the parodic overacting of the silent scream. (In fact a good deal of hyperfeminine social behavior—with its characteristic costumes and gestures—may be just this.) The disruptively audible—if not immediately intelligible—swerve of real gender/genre trouble is possible only if we recognize what has been the continual constituting presence of feminine forms in language. This is the implicit condition of all vitally resonant literatures. The Hegelian-Freudian-Lacanian logomotive is only one among many trains of thought entering into the messy polylectics, polylogues that create the live culture of our language.

What I'm looking for then is a polymorphous perversely startling point from which can spring the possibility of a feminist poethics—aesthetic practice that reveals, in the course of its enactment, the powers of feminine poethics in female hands. Hands freed from holding mirror/speculum to exemplary images of an immaculately (or disgracefully) conceived feminine. This is not to disavow the necessary sociopolitical analysis of boundaries that have confined women's lives or the legal work still needed to secure women's rights. But the aesthetic project is at a juncture where the radii of possibilities (and improbabilities) must reach beyond the mirror stage.

The room inside me has disappeared. At night, when all is quiet, I no longer hear the pictures shifting on the walls when I walk fast. Only the pump in the basement. I wonder whether the space has folded in on itself like a tautology, or been colonized. You think the wine has washed it out,

and it's true that the mirror tilted at a reckless angle. I still have the floor
plan with measurements, but now that nothing corresponds to it I can only
take it as part of the emptiness I try to cover up with writing. To know my
blind spot. I have always wanted to dilate my landscape for the piano and
the long labor of losing the self. Though I am too nearsighted for clouds. If
I had lived a different image.

Rosmarie Waldrop, "Inserting the Mirror,"
The Reproduction of Profiles, 71

We know, with the help of Foucault, Judith Butler, and others that
the power to make useful meaning (OE *mænan*—to mean/to moan) of
one's historical experience does not lie in accepting the outline of one's
"nature" narrated therein. Hope for the categorically oppressed lies in
constructionist readings that expose the contingency of those very cate-
gories. These are not most helpful as regressive justifications of one's
complicity in a degraded status or in generically pumped up self-esteem.
(The palliative strategies of victimhood.) The powerful project is the in-
vention of a polymorphous future. To move from the simple harmonics
of moans (whether of pain or *jouissance*) to a polyphony of exploratory
means, from narrative therapy to linguistic experiment, from a picture
to a use theory of meaning is to open meaning to radical revision in the
act of multiple language games and new forms of life.

Is it plausible to think of the possibilities of a literary feminism in this
way? If it is, then perhaps the sense of entrapment in a language-culture
with a predetermined power structure and coercive symbolic coherence
can be superseded. Perhaps we can cancel our *ad nauseam* encores as
ambiguously smiling, subtextual female repressed. Perhaps we can as-
sume the active textual project of entertaining multiple, complex possi-
bilities/improbabilities/unintelligabilities in our languages and lives.
There are of course obstacles. Chief among them has been the picture
theory of gender that lodges the feminine exclusively in female bodies.
In attempting to identify a strong feminine tradition in literature the
search for ancestors has been limited to writers who enacted a restricted
symbolic code and who could retroactively pass the Olympic commit-
tee's hormonal assay as F.

The most interesting thing about our "different voices" may be that
feminine modes of thinking, as they are currently located and described,
are, with respect to masculine modes, radically and robustly asymmet-
rical. Not *post* but *extra*. The fertile excess of culture nurtured in the
playing field of complexity. The feminine is culturally constructed as

commodious, accommodating, generous, multiple—in its role as alternative to the masculine, nonabsolutist, nonhierarchical. In not precluding otherness, the feminine, as dia- or polylectical force that is always the paradigmatic other, leaves us with the humorous prospect that the only thing excluded in principle from the feminine is not the masculine but principles of exclusion themselves.

NOTES FROM A CONSTRUCTION SITE
(figures grow shifty, grounds grow slippery)

Gender/genre is pure experiment. Every boundary construction is a gamble, a dare, a hypothetical with consequences. That most have chosen to repeat old experiments does not logically negate the possibility of new forms.... There are energetic experimental traditions in our culture. It's in their direction our lucky glance falls. Glance, yes. I refuse the word "gaze." The gaze turns self and other to stone. The glance is light in the gossamer breeze of chance, *un coup de dés*, inviting the unexpected.

Genre Tallique, *GLANCES: An Unwritten Book*

Gérard Depardieu: [Catherine Deneuve], certain people think you're cold. You're simply direct, frank and unambiguous. People think you're serene and organized: I've never seen anyone so disordered or so capricious with money and belongings....You are stronger, more responsible, more armored than male actors. You are less vulnerable, and doubtless this is the paradox of real femininity. Catherine Deneuve is the man I'd like to be.

Catherine Deneuve: For a woman, I'm quite masculine, you know, in the relations I have toward people, men. All of them, I don't make much difference. And I think it's the way I'm quite straightforward, you know, and he can love me as a man. I understood what [Depardieu] meant, you know, because he has a very feminine quality and I have a masculine quality. I don't try to charm, I have quite strong and straight relations with people. In film it's different. In films you are a character and woman, much more woman than me.

Henry Allen: She doesn't charm. She doesn't have to, with that face: It seems like an aesthetic principle she totes on her shoulders like a jar of water. You find yourself watching her rather than listening to her. The jawline is so long, the face is so *big*. You find yourself trying to make her smile, to arouse her interest. Not like Tom Sawyer walking a fence for Becky Thatcher, but more like a geisha girl entertaining a Japanese businessman. You try to intrigue this woman who does not try to intrigue you. You begin to see what Depardieu meant. You are the woman and she is the man.

Henry Allen, "Deneuve's Masculine Mystique"

In its binary dialectic Feminine/Masculine is the Western Yin/Yang—
as ubiquitous and unstable, contradictory and paradoxical as any dual-
istic principle appealed to for explanations of everything. Depardieu,
Deneuve, Allen are caught in a language game that must tag every move
M or F. They are, here, on this stage, daring players. But there's still no
sign of a form of life that can support polymorphous persons whose
moves are not self-classifications but experiments in a world of uncom-
pressible possibility. Does such radical possibility exist? If we abandon
the notion of the cultural dynamic as predominantly phallic in a fixed
symbolic, can we move toward a new paradigm of culture as *poethical*
process, where the primary engagement takes place in transformative
interactions with the *material* presence of heterogeneous bodies and
forms? In fleeing a narrowly constructed Ken and Barbie essentialism,
can responsively playful social construction broaden the field of
genre/gender and spring us from the mind of that bourgeois gentil-
homme for whom all that is not x is y (M, F) and vice subversa?

III GENRE TROUBLE

THE EXPERIMENTAL FEMININE

I know that it is simplistic. And it is wrong. When one does not recede to
the oversight of the western philosophical tradition. But when visa versa?
Overseeing the recession of it? I speak my mind or not without receding. In
this case memory is a negative. Repetition and jargon.

Carla Harryman, "Dimblue," *In the Mode Of,* 12

We need to recognize the strangeness of what we thought we recognized.
The only reliable mirrors are in the fun house.

Dita Fröller, *New Old World Marvels*

The feminine has for some time located the open and receptive, the materi-
ally and contextually inventive. Men, like Joyce, Pound, and Duchamp,
could be feminine in their art, but not their life. Women could be feminine
in their life, but not their art. Gertrude Stein, playing the role of scienti-
fically trained investigator and cultivating the demeanor of a Roman
emperor, was uniquely positioned to explore the experimental feminine.

Genre Tallique, *GLANCES: An Unwritten Book*

WHAT!?
First. An oversight.

The experimental feminine draws us *on*

(long) after *Goethe, Freud, Lacan*

Here's a curious thing. If, as good social constructionists (neither cultural essentialists nor biologists), we note current identifications of the feminine—that it is open, diffuse, multiple, complex, decentered, filled with silence, fragmented, incorporating difference and the other (Hélène Cixous, Luce Irigaray, et al.); undefinable, subversive, transgressive, questioning, dissolving identity while promoting ethical integrity (Julia Kristeva, Judith Butler, et al.); *materially* and contextually pragmatic, employing nonhierarchical and nonrationalist associative logics—"web-like" connective patterns (Carol Gilligan); self and other interrupted, tentative, open/interrogative (Sally McConnell-Ginet, Mary Field Belenky, et al.); marginal, metonymic, juxtapositional, destabilizing, heterogeneous, discontinuous,...(Genre Tallique, Craig Owens, Page duBois, Janet Wolff, et al.)[21]—and now if we look for enactments of these modes in the formal strategies of literature, we find, first, that from the late nineteenth century on they show up most often in experimental or avant-garde traditions and, second, that although these modes relate more closely to the life experiences of women, they have been *until recently* chiefly utilized by male artists.

> you will have a little voice it will be barely audible you will whisper in his ear you will have a little life you will whisper it in his ear it will be different quite different quite a different music you'll see a little like Pim a little life music but in your mouth it will be new to you[22]

This writing, clear precursor to Harryman, Cha, and others in an experimental feminine tradition, is from Samuel Beckett's depunctuated prose poem *How It Is*. We writers who wish to explore/enact the feminine beyond the punctum of a masculinist vanishing point are always looking for ancestors. Well, oddly enough, here's one—in, on, out of silence:

> twenty years a hundred years not a sound and I listen not a gleam and I strain my eyes four hundred times my only season I clasp the sack closer to me a tin clinks first respite very first from the silence of this black sap

How It Is (24–25)

And here's another:

> riverrun, past Eve and Adam's, from swerve of shore to bend of bay, brings us by a commodius vicus of recirculation...

You know the rest. Beckett and Joyce fleeing their patrimony—the law (the grammar) of the Irish father—for the exile of the (m)other tongue.......................

How is it that men come to enact the feminine?

Following logics of the social construction of gender, can't it quite easily turn out that many of our ancestors in a strong tradition of foregrounding feminine processes in writing (which can be traced at least as far back as *Tristram Shandy* in the English novel and Rimbaud's *Illuminations* in poetry) are men? This is merely ironic, not paradoxical. How it is if we skirt the essentialist M/F trap. The power of feminine forms—not the least of which is the power to deconstruct an institutionalized masculine—was almost exclusively claimed by men until the latter half of the twentieth century because women did not have the social power to claim it as well. The power of the feminine is simultaneously admired and despised. By definition it trespasses on forbidden or uncharted territory. Hence, it's been only those who have had, first, the social backing and, then, the po-ethical courage (or naïveté) to risk ostracism by the academy who have felt able to take on the challenge. (Or who took on the challenge and were not heard from thereafter.) Until relatively recently women have not had the social (public) power and cultural standing to take such risks without almost certainly disappearing beyond emotional and socially constructed vanishing points. We could extend Virginia Woolf's thought experiment, imagining what would have become of Shakespeare's sister and all her hypothetical progeny, to think of lost female literary revolutionaries—the ones who were told early on that they had missed the point, the ones never heard from (in feminine forms) again.[23]

So, alongside Gertrude Stein, Dorothy Richardson, Djuna Barnes, and (midcareer) Virginia Woolf, there is the much longer list of men: Andrey Beley (of *Symphony*), the Russian Futurists Velimir Khlebnikov and Alexei Kruchenykh, Apollinaire, Artaud, Rimbaud, Mallarmé, Marinetti, Cocteau, Tzara, Jarry, Schwitters, Breton, Raymond Queneau, Georges Perec, Sterne, Whitman, Joyce, Beckett, Pound, the Eliot-Pound collaboration in *The Wasteland*, W. C. Williams, Zukofsky, the Louis-Celia Zukofsky collaboration in the *Catullus*, "A"-24, etc., Jackson Mac Low, Ian Hamilton Finlay, Augusto de Campos, Bob Cobbing...William Burroughs *(The Exterminator)*, Gilbert Sorrentino, David Antin, Walter Abish....The list, of course, could go on and on.

There are only three women among seventy-seven writers represented in Emmett Williams's *Anthology of Concrete Poetry*, three women of twenty-three writers in Eugene Wildman's *Experiments in*

Prose. In Marjorie Perloff's *The Poetics of Indeterminacy* Gertrude Stein is the only female poet represented in a lineage spanning the period from Rimbaud's *Illuminations* (1871) to John Cage. (Perloff, of course, has since written on many of the contemporary women poets who bring this tradition into the present.) Hugh Kenner includes no women in *The Pound Era* except for a slighting reference to H. D. On the whole these books are not complicit with mainstream anthologies and criticism in *overlooking* women (at least not before the late 1960s, early 1970s). Women were not in fact very much present (except as handmaidens, models, muses, wives, midwives, and mistresses) in the experimental literary world until the advent of "Language"-associated poetries in the 1970s (where, incidentally, for the first time, not only the "single" woman but the wife and/or mother *is* the experimental poet).[24] Two recent "Language" anthologies have quite different M/F ratios, with women constituting roughly a third of the poets in each. In Ron Silliman's *In the American Tree* twelve out of forty poets are women; seven of twenty poets are women in Douglas Messerli's *"Language" Poetries.*[25] A book by Ann Vickery, *Leaving Lines of Gender: A Feminist Genealogy of Language Writing,* traces the omnipresence and enormous power of women in the Language movement. Her book is essential for understanding the feminine nature of this (almost entirely male impresarioed) entry into the American experimental tradition. It's become evident since the last two anthologies came out that their M/F ratios inadequately represent the unprecedentedly large presence of women in the new poetry movements in this country.

However, most women writers were (and are still) writing in styles with mainstream or established genealogies (the confessional, multigenerational New York schools, the new-old I-lyric idyll...) acceptable to the masculinized academy—writing within the standardized stock of poetic genres. Even while espousing a new feminist politics, not forging a new feminine poetics. Woolf, shaken by negative criticism, returned to a conservative (masculine?) style in her last novels after having explored revolutionary feminine forms (indebted to both Dorothy Richardson and James Joyce) in *Jacob's Room* and *The Waves* and having performed that humorous postmodern experiment *Orlando.* Dorothy Richardson was effectively forgotten in the wake of *Ulysses*; Gertrude Stein, the most radically experimental poet of this generation, was ridiculed.

It may seem like a betrayal of the few courageous women who are our clear "feminist" ancestors (Tallique's "female writers who use feminine forms"—Richardson, Woolf, Barnes, Stein, Niedecker, Loy...) to

acknowledge a "feminine" tradition dominated by males. But it's far worse to deny the presence of the feminine in language (as Ostriker and others do) by missing the fact that the feminine has never been exclusively embodied or exercised in female writing. It is, of course, entirely a question of power. All forms of power are seized by those best situated to take advantage of them. For sociopolitical reasons, made painfully clear by the women's movement, women were not until the 1960s in a position to directly exercise the full power of the feminine. Hence its *sub*-versions.

Even in cultures where there has been more respect for feminine forms—for example, in the literatures of romance languages—the power of these forms has been explored mainly by men. Look at France, for example, where Montaigne's untidy, digressive *essais* could become a model for the (male) stars of the academy. Recent French intellectual writing (Cioran, Blanchot, Barthes, Baudrillard) and even the deconstructive movement—despite its strikingly macho surface projections—is strangely feminine. Think of Derrida's self-interruptions, his flirtatious insinuations, his coy ironies, his outrageous feints, his calculatedly playful exclamations and interrogatives. He teases out metaphysical pre- and con-texts with as potent a mix of charm and venom as Bette Davis. Ironically, indeed, in this "masquerade" he performs something like Judith Butler's parodic, subversive function.

Perhaps most characteristic of *Ce sexe qui n'en est pas un* (title of Luce Irigaray's 1977 book) is the tendency of the feminine gender/genre to exceed masculine cultural paradigms in its messiness, multiplicity, and complexity. For the fifth (and, as it turned out, last) of his Harvard lectures *(Six Memos for the Next Millennium)* on the formal qualities he most valued in literature, Italo Calvino begins with a quote from the novel *That Awful Mess on Via Merulana,* by Carlo Emilio Gadda, and then goes on to talk about Gadda's writing and more generally about "multiplicity" as a literary manifestation of imaginative possibility. He does this in terms that are not only at times identical to Carol Gilligan's "web" metaphor for women's' thinking but constitute a virtual catalog of so-called feminine modes of thinking. The italics below are mine:

> I wished to begin with this passage from Gadda because it seems to me an excellent introduction to the subject of my lecture—which is the contemporary novel...as a *network of connections* between the events, the people, and the things of the world....Carlo Emilio Gadda tried all his life to represent the world as a knot, *a tangled skein* of yarn; to represent it without in the least diminishing the *inextricable complexity* or, to put it better, the

simultaneous presence of the most disparate elements that converge to deter-
mine every event....As a writer—thought of as the Italian equivalent to
James Joyce—Gadda developed a style to match his complicated epistemol-
ogy, in that it superimposes *various levels of language, high and low,* and
uses the most *varied vocabulary....* What is supposed to be a detective novel
is left *without a solution.* In a sense, all his novels are *unfinished* or left as
fragments.... [T]he least thing is seen as the center of a *network of relation-
ships* that the writer cannot restrain himself from following, *multiplying the
details* so that his descriptions and *digressions* become infinite....The best
example of this *web radiating out from every object* is the episode of finding
the stolen jewels in chapter nine of *That Awful Mess....* He does this by ex-
ploiting the semantic potential of words, of all the *varieties of verbal and
syntactical forms* with their connotations and tones, together with the often
comic effects created by their *juxtaposition....* Gadda knew that "to know is
to insert something into what is real, and hence to distort reality."

<div align="right">Calvino, Six Memos, 105–8</div>

This is not the language of the "law of the father." What is real here,
is neither abstract principle nor hardcore empirical innocent of theory
but the simultaneity of the whole range in "that awful mess." (Beckett
also valorizes the "mess.") The complex realist mess that intermixes vo-
cabularies, syntactic trajectories, linguistic origins, descriptive worlds,
high and low, plays out formal consequences of foregrounding the ma-
terial presence of language. Strange and humorous swerves occur when
close attention to words reveals peculiar lettristic attractions and ety-
mological energies. Synergistic interactions produce an exploding, mul-
tidimensional figure expanding toward chaos—or by any other name,
the "feminine novel." (Distinct, of course, from the female novel.) This
is a poethical practice that depends on humor in the medieval sense of
shifting fluids—in this case the highly fluid conceptual shifts that are ac-
tivated by close attention to the details of complex systems.

Julia Kristeva locates these fluid humors in what she calls the "semi-
otic" (not to be confused with semiotics), prelinguistic, instinctual, li-
bido-sensual experience of all children. The semiotic, as defined by Kris-
teva, is the fluid, vitalizing source of the (private) pleasures of
jouissance[26] and thus of all that exceeds and circumvents the (public)
grammars of "the law of the father." Interestingly, in *Revolution in Po-
etic Language* Kristeva argues that the pursuit of the good and the eth-
ical are inextricably tied up with a semiotic-based, avant-garde poetic
practice. Having identified poetry with *jouissance* and "revolutionary
laughter," having identified laughter *as* practice, and having quoted
Lautréamont's "truth-in-practice" *as* poetry (217), Kristeva writes, "the

text fulfills its ethical function only when it pluralizes, pulverizes, 'musicates' [truths] which is to say, on the condition that it develop them to the point of laughter" (233). Kristeva feels that the need for poetry of the sort that "pluralizes, pulverizes, 'musicates'" is urgent for all who would act outside the logics of "the machine, colonial expansion, banks, science, Parliament—those positions of mastery that conceal their violence and pretend to be mere neutral legality" (83). The exemplary writers in *Revolution in Poetic Language* are all men: Mallarmé, Bataille, Lautréamont, Joyce. Kristeva's concession to the identification of the semiotic with "woman" is made via Mallarmé, as "prototype" of avant-garde practice. For him, she says, the "semiotic rhythm" is "indifferent to language, enigmatic, and feminine" (29).

This is a beautifully articulated recognition of an avant-garde poetic practice in dialectical agon with the institutionalized masculine "positions of mastery." But Kristeva, like Butler and Ostriker, supports the view that the semiotic (the feminine) cannot directly enter the (phallic/symbolic) linguistic order. For her the semiotic is logically and developmentally "previous" to language. It can only nuance ("musicate") or interrupt language with "semiotic silence." This insidious, and to my mind fatalistic, view in Kristeva's work (accompanied by the heavy breathing of psychoanalytic drive theory) is not only counterproductive as an ethical base of the public/linguistic realm, but it is experientially counterintuitive and logically flawed. The process of acculturation and learning a language is not one that takes place at the abrupt terminus of a neatly sealed off "pre-" period. Language is, for most infants, part of their highly charged sonic environment from the very first moments just after birth. And soon part of their visual world as well. It's just because the learning of language is in rich intercourse with all the multivaried, sensual experiences—the "mess" of early infancy and childhood—that natural languages are such rich instruments, such complex forms of life, full of connotative, multiply associative, extrarational dimensions. This is what makes languages the fluid, vital, permeable, and growing organisms they are. Language has always overflowed the structures and strictures of its own grammars.[27] But even those grammars exceed rationalist caricatures. They are intimately connected with the multivalent experiences of real lives, the forms of life that give all language games their nuanced, often contradictory, meanings. The feminine is in language from the start. It's not a subversion but is intertwined through every dimension of the linguistic—of words, which always strike us like chords on the various levels of our perceptual systems and resonate

from the neocortical to the instinctive limbic. The most pressing question at hand is not only why certain rich dimensions of language have been persistently (invidiously!) identified with the feminine but, much more startlingly, why in some cases they have been theoretically expunged from the realm of the linguistic altogether.

> "I know"—this turgid moment in the mind—has assumed all the consequences of male identity. It must be ejaculated, it must impregnate or destroy the other with its detumescing logics. But wait, let's interrupt the trajectory of this metaphor. Attention to the complex discontinuities of the feminine in language will fill the shortest distance between points with improbable fractal detail.
>
> Genre Tallique, GLANCES: An Unwritten Book

MORE GENRE TROUBLE
MULTIPLICITY, UNINTELLIGIBILITY, POLYLINGUALISM: THE EXPERIMENTAL FEMININE

> What allows our free will to be a meaningful notion is the complexity of the universe or, more precisely, our own complexity.
>
> David Ruelle, Chance and Chaos, 33

> The very complexity of the discursive map that constructs gender appears to hold out the promise of an inadvertent and generative convergence of these discursive and regulatory structures. If the regulatory fictions of sex and gender are themselves multiply contested sites of meaning, then the very multiplicity of their construction holds out the possibility of a disruption of their univocal posturing.
>
> Judith Butler, Gender Trouble, 32

> It is she. It is she again. It is preference. Words in the mind on the ground speaking not writing but history in the air. Yellow. For blue. And yellow. For blue as blue speaking. The first association was arrogance. History and arrogance. Contemporaneity and oversight. Paring of blue and yellow. Slivers of preference and literate. As written history might keep. The cool oversight whose soft leaves water. And later breaking. Slips.
>
> Carla Harryman, "Dimblue," In the Mode Of, 6

Yes, and (long) after (even) Wittgenstein, is it not the blue yellow green time to say, The limits of your language are *not* the limits of my world? Or better yet, It's no more your language than it's my world. And vice versa, with plurals. Ah, the redeeming vice of verse!: to com-

plicate our grammars, to pluralize our languages and worlds. *Verse (OED),* so named from turning to begin another line.

Here, for instance, is a new line:

> "A" was for "ox"
> The first oxygen conversion occurred as an incline, a
> sharp bend as in "wrench". The elements surrounding
> it were strong, physically violent ones—wreck, wrestle,
> wretch—with the exception of "wren". The next major
> activity was "wrinkle", again related to "wrench" with
> the addition of "wind". Wrist action proceeded from
> there—wrist-lock, wrist-pin, wrist-shot, wrist wrestle,
> wristy—preparing us "motor-wise" to write: write our
> own ticket, write-down and write-in.
>
> > Tina Darragh, *on the corner to off the corner,* 5

Here's another:

> "elaborative" to "Eleatic" for "D"
> "Egg" and "oxygen" both contain "edge," with egg's edge
> located at "share" and oxygen's at "shear." The distance
> doubles from one to the other along this line: shar et
> vb farme atim domin numer iz cti porta acio torti
> him sho SHAG low ME L dou sha tio HE min ears cou
> ock metim semb dj
>
> > Tina Darragh *on the corner to off the corner,* 8

And another:

> > We are parting with description
> > termed blue may be perfectly blue
> > goats do have damp noses
> > > that test and now I dine drinking with
> > others
> > adult blue butterfly for a swim with cheerful birds
> > > I suppose we hear a muddle of rhythms in water...
> > > > the streets of traffic are a great success
>
> > Lyn Hejinian (poem 28, *Writing Is an Aid to Memory,*
> > unpaginated edition)

Coming across Carla Harryman's "Dimblue," being sent by it back to *Dictee,* reminded of Brossard, Waldrop, Darragh, Hejinian...the mind is not put at rest. The traffic of this language is noisy and disruptive...full of the formal/verbal articulation of silence. Neither the streets nor these linguistic bodies go docilely to their preconceived vanishing points. This

language does not replicate sciences of perspective as we've known them. Nor does it assume the implied movement toward epiphany/conclusion that lyric syntactical momentum dictates. It matters/maters not so much as expression of gender but as enactment of genre. That is, the complicated moves it makes take it from expression of female experience to Tallique's feminine *as* aesthetic behavior. It does not deny the consequences of its own *material* presence by substantiating (and thereby disappearing into) received, masculinized metanarratives. The *it* that mat/t/ers, that behaves like living matter, is language—the material of the writer connected to poethical forms of life. Nothing can matter without words coming alive—spinning contextual, connective, associative webs that not only apprehend the multidimensional realities of what we care about but enable our variant-radiant intelligences to range toward transformations of the complexities of desire and cultural realization.

There's not room for a CATALOGUE RAISONNÉ of all the writers who are doing just this. But among the *Cygnes. Paroles souvenus. Déjà dit./Vient de dire. Va dire.* (Cha) there are other languages, other worlds:

> Ami minden quand un yes or no je le said
> viens am liebsten hätte ich dich du süsses de
> ez nem baj das weisst du me a favor hogy
> innen se faire croire tous less birds from the
> forest who fly here by mistake als die Wälder
> langsam verschwinden. Minden verschwinden,
> mind your step and woolf. Verschwinden de
> nem innen—je vois de void in front of
> mich—je sens, als ich érzem qu'on aille, aille,
> de vágy a fejem, csak éppen (eben sagte ich
> wie die Wälder verschwinden) I can repeat it
> as a credo so it sinks into our cerveaux und
> wird "embedded" there, mint egy teória
> mathématique, "d'enchâssement" die
> Verankerungstherorie in der Mathematik,
> hogy legalább.

Anne Tardos, *Cat Licked the Garlic*, unpaginated[28]

OUI. JA. YES.
YES. THIS TIME MOLLY BLOOM'S THE AUTHOR.
IT IS SHE. IT IS SHE AGAIN.
After WOOLF'S roominations
After CARLA HARRYMAN'S "DIMBLUE"
After THERESA HAK KYUNG CHA'S *DICTEE*

After TINA DARRAGH'S *off the corner*
After *et al.*
After the fall of *After the Fall of Adam's Eve*

 The most active locus of the exploration and construction of femi-
nine forms in English poetry today is among Language and "other" as-
sociated poets. These poets are both male and female of course, but, if
Genre Tallique is onto something, it is the women among them who—
for the first time in large numbers—are using feminine formal processes
and are thus presenting us with our strongest, most challenging models
of literary feminisms. These poetries, these poethical practices—ironi-
cally marginalized in established feminist circles—*are* the experimental
feminine. In active exploration of multiplicity and unintelligibility this
is the articulation of silence that draws us on.

The Difficulties of
Gertrude Stein, I & II

I WRITERS & READERS — PARTNERS IN CRIME

Here you will learn many things:
How Gertrude Stein Failed to Write
a Proper Detective Novel While Writing
Blood On The Dining Room Floor.
(Was it an accident or was she pushed?)

1

> Do you see, nothing is surprising but a coincidence. A fact is not surprising,
> a coincidence is surprising and that is the reason that crime is surprising.
> There is always a coincidence in a crime.
> There are so many ways in which there is no crime.
> *Blood On The Dining Room Floor*[1]

Here's a coincidence. I've been thinking a lot about these things—coin-
cidence, surprise. The latter as positive aesthetic value. It's one of those
days composed of rushing here and there for reasons instantly erased by
the completion of each task. I turn on my car radio just in time to hear
a woman's voice saying, Complex thought in writing is always surpris-
ing. Does she mean it both ways—complex thought always surprises;
it's surprising to find complex thought in writing? We intuitively know
that everyday life doesn't conform to the simple outlines of well-made
stories. In fact the story as story is radically surprising only to the degree
that it transgresses its own generic expectations. When it really does
this, disrupting the calculated turns of an artful plot, it's instantly rec-
ognized as at least a misdemeanor.

Is there always a coincidence in a crime? Of course, everything is of course coincidence, but the literature that incorporates the kind of co-incidences—the unsettling ones, the dissonant juxtapositions—one notices is surprising and therefore a crime unless/until those dissonances become familiar, naturalized. A densely polyglot world, overflowing with disparate perceptions, intentions, desires, is one in which the kinds of coincidence we call transgressions (border incidents) are more likely to occur. The literatures of high-profile coincidence cause generic border incidents even as they explore the patterns of a complex reality. It's ironic that their dissonant contiguities, juxtapositions, incoherences, permeabilities seem gratuitously haphazard when the extratextual world is so much like that. The formal principles of these literatures raise difficult questions about making meaning in a world whose borders exist primarily to locate scenes of transgression while transgressive fluidities are forming our interconnected realities. It might seem that all this should pose more difficulties for the traditional storyteller as guardian of narrowly sequential logics, logics of identity, narrations of continuity in a world whose vulnerabilities have more to do with contiguity. Contiguity is the spatial dimension of coincidence, and it is the ill-fitting coincidence-contiguity of our reciprocal alterities that continually disrupts longings for the harmonies and smooth transitions of self-assured narrations. If literature is an engagement with possible forms of life—as all language games must be—there are perhaps too many ways in which there is no crime.

This speculation comes as a surprise only because we live in a culture of literary institutions (and markets) that have constituent needs to erase difficulty. But, wait, this is itself beginning to look suspiciously like a story—story of early, middle, or late capitalism reinscribing its brutally fetishized commodification and reification of— If I don't stop the momentum right here and now it might prematurely ejaculate its own conclusion. Stein stops me. Stein writes in her seven-page, four-chapter "Superstitions Of Fred Anneday, Annday, Anday A Novel Of Real Life" (1934): "Do not bother. Do not bother about a story oh do not bother. Inevitably one has to know how a story ends even if it does not."[2]

Virginia Woolf, the great and hesitant storyteller, self-interrupter of stories, thinks about the problem of the story as form in her novel *The Waves*. Throughout, the quasi-character, quasi-narrator Bernard engages in an intermittent, ruminative soliloquy on the relation of lan-

guage to the experience of living one's life. He says, "Had I been
born...not knowing that one word follows another I might have been,
who knows, perhaps anything."[3] This is not a question of the daily
habits and routines necessary to the sane ordering of any life but of the
forms one chooses in one's poesis, the making of forms of life out of
words. If those forms are made in the course of thinking through one's
values, then it's a matter of poethics. I read Bernard as articulating
Woolf's own longing to move as a writer beyond the constrictions of ac-
ceptable forms, a move with which she was never—in her troubled re-
lation to society—entirely comfortable. Here is Bernard's construction
of the problem toward the end of *The Waves*:

> Now to sum up.... Now to explain to you the meaning of my life.... But
> in order to make you understand, to give you my life, I must tell you a
> story—and there are so many, and so many—stories of childhood, stories
> of school, love, marriage, death, and so on; and none of them are true.
> Yet like children we tell each other stories, and to decorate them we make
> up these ridiculous, flamboyant, beautiful phrases. How tired I am of sto-
> ries, how tired I am of phrases that come down so beautifully with all
> their feet on the ground! Also, how I distrust neat designs of life that are
> drawn upon half sheets of notepaper. I begin to long for some little
> language such as lovers use, broken words, inarticulate words, like the
> shuffling of feet on the pavement. I begin to seek some design more in ac-
> cordance with those moments of humiliation and triumph that come now
> and then undeniably. Lying in a ditch on a stormy day, when it has been
> raining, then enormous clouds come marching over the sky, tattered
> clouds, wisps of cloud. What delights me then is the confusion, the
> height, the indifference and the fury. Great clouds always changing, and
> movement; something sulphurous and sinister, bowled up, helter-skelter;
> towering, trailing, broken off, lost, and I forgotten, minute, in a ditch. Of
> story, of design I do not see a trace then.[4]

What does such a literature look like? One that does not deny the
inarticulate, the confusing, the fragmented, the lost, the loss, but instead
brings it into the form? There are many examples in modern and post-
modern poetry, drama, even fiction (although less there). Samuel Beck-
ett searched for a form that would admit what he called "the mess,"
"the chaos": "What I am saying does not mean that there will hence-
forth be no form in art. It only means that there will be new form and
that this form will be of such a type that it admits the chaos and does
not try to say that the chaos is really something else.... [T]o find a form
that accommodates the mess, that is the task of the artist now."[5]

2

Everybody knows everybody.... But not everybody
knows everybody.

<div style="text-align:center">John Upham, Chelsea, Vermont[6]</div>

What about the mess, the chaos, of murder? In the summer of 1933
Mme. Pernollet, the wife of the hotel keeper in the little town of Belley
(near Gertrude Stein's country house), fell from a window onto the
courtyard below. She died five days later. Stein was fascinated by this
event and even went to the funeral. (She and Toklas had stayed in the
Pernollet hotel during the summers of 1924–28.)[7] The whole town was
gossiping; the cause of the death would never become clear. Stein made
a series of attempts to turn an account of this death into a manageable
story, but in the way of all mysteries of ordinary life it resisted neat pack-
aging to the very degree that it was closely inspected. It was in fact the
merest glimpse of an enormous entanglement, and Stein was quite famil-
iar with the intricacies of the town gossip. As Stein scholar Ulla Dydo
puts it, "Notes and revisions in the manuscript of *Blood* show how many
family stories seethe behind the details.... Stein... saw her chance to use
the death and her knowledge of town and crime in a detective story."[8]
 Stein loved detective novels and wanted very much to write one. By
early fall she was trying to put the circumstances of Mme. Pernollet's
death into a generic detective form. Unsatisfied with the way things
were going, she repeatedly tried to tell the story in other ways. By the
end of the year the account had entered three short prose pieces.[9]
 The fact is that Stein could never bring herself to reduce this material
to the conventional form of the detective novel. As much as she desired
another popular publication to follow the success of *The Autobiogra-
phy Of Alice B. Toklas* (1932), she wouldn't (couldn't) take the advice
of her American agent, William A. Bradley, to fix the transitions. As
anyone who has ever taken a high school English class knows, "fix the
transitions" is shorthand for "this makes no sense." *Blood* is indeed not
a story at all but a strangely fragmented, intricately incoherent, humor-
ously tonic meditation on the genre of the murder mystery itself, on the
probable act of an improbable murder, on the murderous microclimates
often found in seemingly innocuous small-town ecosystems. In the
midst of what Stein believed was a failed project, her sense of Mme. Per-
nollet's death would remain full of powerfully oblique implications in-
tersected by ominous and poignant elements of small-town life.[10] The

town that Stein composes in *Blood* foregrounds most strikingly the sadly, dangerously predictable life of the wife.

The genre that supersedes the detective novel in Gertrude Stein's use of the events of Mme. Pernollet's death is a complex-realist text that can play out contradictory and coincidental and unsettling implications in experiments with form—the form of the sentence, the paragraph, the chapter, as well as what Stein humorously referred to as the "novel of real life." The promise of a "real life" novel is heralded in the subtitle of "Fred Anneday" (written some six months later, in the winter of 1934), where a "real life" ambition at first appears to be a passing joke but is actually the object of analysis in a hybrid story-essay about the impossibility of telling stories. The permutative-analytic poetics of *Blood*'s antinarrative logic enacts this kind of analysis. It begins with the very first sentences in chapter 1: "They had a country house. A house in the country is not the same as a country house. This was a country house. They had had one servant, a woman. They had changed to two servants, a man and a woman that is to say husband and wife" (*Blood*, 11).

So the reader at the very outset must either put the book aside in disgust or become complicit in the dual crime that is the fall of the story as story of a fall: the Pernollet clinamen reveals itself in a medley of long-since fallen generic suspects: small-town life, family life, public and household scenes of the sinister life of husband and wife:

> Who remembers a door. Any one who remembers a door can remember a war. He went to the war to be killed in the war because his wife was crazy. She behaved strangely when she went to church. She even behaved strangely when she did not. She played the piano and at the same time put cement between the keys so that they would not sound. You see how easy it is to have cement around. (*Blood*, 47)

The book concludes with this parting gesture toward the detective genre:

> Do you understand anything.
> How do we do.
> Do you remember. It made its impression. Not only which they sew.
> Thank you for anxiously.
> No one is amiss after servants are changed.
> Are they.
> Finis

Yes, of course. Everything always turns out as it should in the world of that particular detective genre where the servant problem remains the

greatest potential crisis. Yet the book ends much too strangely, and with a question—rhetorical or not? *Blood*'s eccentric opening and closing time-space-tone brackets define an in-between semantic zone that D. W. Winnicott would identify as the location of the precarious play necessary to cultural experiment.[11] This intermediate, partially indeterminate territory is scattered with a litany of unanswerable questions punctuated thirteen times by "Lizzie do you understand" in almost ritualistic reference to another unsolved family mystery—the 1892 murder of Lizzie Borden's parents followed by a lengthy trial that had fascinated Stein since her student days at Harvard. In counterpoint to the recurrent questions is the much too insistent phrase "Of course," which appears forty-nine times in this short book with no answers.

> Lizzie do you understand.
> Of course she does.
> Of course you do.
> You could if you wanted to but you always want something else but not that but not that yes. (*Blood,* 79)

That last sentence can be read in as many ways as there can of course be no "of course" at all and yet "of course." Of course it's all a matter of course given the shadow geometries of small-town and family life. But mostly, of course, one can ask all the questions one likes; one can cast them in any direction and address them to whomever one chooses, and of course there can be no reply but one that is entirely empty of information and portent. These are matters to be treated finally as matters in the course of a literary logic that enacts a language game of indisputably warranted nonconclusion. One can quite easily read *Blood On The Dining Room Floor* as simultaneous matter-of-fact deconstruction of the detective genre—beginning with the counter-informative title (there is no blood on the dining room floor in the text)—and demonstration of the experimental novel as play of and on forms.[12] This play is enacted in a number of spatiotemporal ways—for example, the occasional one- or two-sentence chapter that, like Laurence Sterne's comic brevity in *Tristram Shandy,* is just one more destabilizing blow to a reader's generic expectations.

But, someone will protest, couldn't this be just a coincidence of accidents in the making of a poesis? Yes, of course, that's how it always is in our contingent world. But I think I know what they might mean. Something like: Are not Gertrude Stein and Mme. Pernollet sleepwalking toward the precipice hand in hand? Is it perhaps a double suicide?

Does Stein, accustomed to the deliciously private writing process of the unsuccessful writer, want to sabotage the sudden success of *The Autobiography Of Alice B. Toklas?* Or is Stein's habitual writing impulse simply returned to its default mode of arrhythmic tic? That is, is this nothing other than a psychological mystery turning on certain mental conditions of the writer? Yes, of course, possibly, but of greater interest is the complex-real fictive probability that both Pernollet and Stein— each for quite distinct reasons—have been pushed. The crucial question from the perspective of poetics is whether the possible murder of this wife impelled Stein toward an investigative novel very different from the one she set out to write.

Of course, with Oulipean thoroughness all these pairs could be recombined. Whatever answers one might posit or reject it is undeniably clear that Stein makes of the textual world of *Blood* just what a confirmed mystery addict doesn't want—unresolved ambiguities, a proliferation of questions whose very forms, rhetorical and not, are ways of saying, See? We never will understand the why of it; this is how things happen. In fact, Stein's fascination with the psychodrama of husbands and wives, as well as other material in *Blood,* persists well beyond the immediate events of 1933. *The Mother Of Us All,* completed in 1946, the year Stein died, will revisit the role of the wife with psychological queries and conjectures and humor and startling wisdom.

Meanwhile Stein's geometry of attention in *Blood,* rather than being plotted in an intriguing, reassuring Euclidean zigzag route from A to Z, creates a fractal coastline of repetitive/permutative linguistic forms whose semantic shape (following the permeable, fluid dynamic of any coastline) is constantly shifting in the emotional, social, intellectual weather of interpretive space.[13] The novel is a small but complex system that cannot by its own constituting rules arrive at a logical terminus. The directionalities here are about expansion, permutation, change...not reductive stasis. In fact *Blood* can be seen as a radiant ecosystem of unstable grammars, indeterminacy, uncertainty, surprise. The thoroughly embedded crimes of valuing coincidence over strategic plotting, a generic failure, the ruin of closure, no question of answers. Knowing how badly Stein wanted to write a popular detective novel, I cannot see *Blood* as the result of Stein's insufficiency as a storyteller. Certainly not after the indisputable counterexample of *The Autobiography!* And self-sabotage just doesn't ring true. Rather, I want to conjecture that her characteristic practice, the ethos of an investigative poetics, propels her into this culpably poethical position. That she herself later proclaimed her effort a

failure[14] can be misleading in thinking about the value this work actually realizes.

The poetics of any writing that can and must go on without answers, despite the urgency of its subjects, will always be regarded as a failure if systematic narratives of completion are desired. This is the nature of the story that must bypass questions of its own generic entropy to follow its conventionally prescribed schedule. The first requirement of a plot-driven narrative is that it run on time—story time. The detective story may be the most paradigmatic case in point because all of its mechanisms are in the foreground. It operates with the principles of assured closure present in any assembly-line best-seller. If the writer becomes self-conscious about the DOA starting point s/he might well balk. A narrative will fail to meet its generic conditions if the writer is incompetent, yes, but also to the precise extent that it becomes poethical in its vitality. That is, to the extent that it is a truly investigative form of life, it might override its own moment of inertia; it might not be condemned to go in perfect circles. I associate Stein's "failure" to fulfill the conditions of the detective form with other fortunate generic failures: the "failure" of Walter Benjamin's *Arcades* project to come together as a systematic whole, Pound's "failure" to fix the fragmentation of the *Cantos,* and Wittgenstein's (ambivalently) self-proclaimed failure in his introduction to *Philosophical Investigations:*

> It was my intention at first...that the thoughts should proceed from one subject to another in a *natural order* and without breaks. After several unsuccessful attempts to weld my results together into such a whole, I realized that I should never succeed. The best that I could write would never be more than philosophical remarks; my thoughts were soon crippled if I tried to force them on in any single direction against their *natural inclination.—* —And this was, of course, connected with the very *nature* of the investigation. For this compels us to travel over a wide field of thought criss-cross in every direction....I should not like my writing to spare other people the trouble of thinking.[15]

It's interesting to note how Wittgenstein seems to confuse forms of logic (that must always fail to contain life) and forms of life (that must always exceed logics). He is after what is "natural"; but of course the logics of genres, philosophical or literary, although they may become habitual enough to be "naturalized," are constructed. The means of their artifice is always open to revision. Pace Gertrude and Wittgen, remarks can be philosophy can be literature.

In all these cases the authors' sense of failure comes in the wake of generic expectations that cannot be achieved for what I see as poethical reasons: the writing engages difficult, unprecedented forms and questions of one's times and therefore must move out of familiar containment into what—at least for a while—will be experienced, by writer and reader alike, as hopelessly fragmented and—to one degree or another—unintelligible. (It's hard to imagine now, and yet true, that Wittgenstein's work was widely considered unintelligible for decades after its publication.) Such work leaves the reader with the question of what s/he's to do. This is where thinking in terms of a fractal poetics may help.

Fractal models (with their scalar self-similarities and unpredictable variations) bring into the foreground of our attention the large patterns and erratic details, the dynamic equilibrium of order and disorder in complex life systems like weather and coastlines. This is a geometry of nature that has helped us attend more productively to the chaotic processes of complex turbulent phenomena that static and idealized Euclidean models cannot begin to accommodate. I have begun to think of certain forms of art (for example, the post-1940s music of John Cage) as having a fractal relation to the rest of life. They are complex constructions that, among other things, present their material presence as a dynamically indeterminate "coastline" for audiences to explore via their own complex cultural and psychological dispositions. If one acknowledges language itself as a complex life system, the linguistic tensions and instabilities, semantic ruptures, and self-similar variations in a work like *Blood* invite comparison to fractal forms. Can one in fact view *Blood* as fractal model of small-town and family turbulence rather than confused detective novel?

The closer you look at fractal models, or the natural phenomena they describe, the more (self-similar) details you see, the more complex things become. (In Euclidean figures the closer you look, the simpler things get.) I wonder whether the kind of "positive feedback loop" that generates fractal self-similarities and variations—data reentering the system again and again, each time undergoing slight modifications— might be an illuminating way to think about Stein's writing process. Might in fact give some intuitions about how the mind (that is, the fractal neural networks of the brain) produces complex linguistic forms based on repetition and variation. We know that in the case of *Blood*, as with most of her other writing, the product and the process are

almost identical. Stein wrote as words came to her and hardly ever made substantial revisions.

And then there's the particular way the form of any coastline structures an exploration of it. The reader can tramp up and down the shifting coastline of Stein's words looking for the lost object (the victim, the culprit) in vain, day after day not finding it, finding instead a strange constancy in the scene of the absent object, the coastline itself as a pattern-bounded indeterminacy in flux. Even if something as reassuring as a body were to turn up with an explanation tagged to its toe, it could hardly become the focal point of this tidal windblown beach or page. Ocean beach and Steinian page are equally contingent and dynamic zones whose life principle is change. The beach changes in its conversation with the vagaries and variabilities of meteorological elements; the page changes in its conversation with variable epistemologies, grammars, and genres, as well as with the associative elements of a reader's mind as that mind lives within multiple intersecting forms whose rules are neither simple nor readily apparent. All this occurs of course within another strange constancy—the changing cultural climate of the developing contemporary. Luckily, coincidentally, both beach and page are locations of aesthetic wonder. Aesthetic wonder is a source of energy even as one hesitates in the face of unforeseen difficulties.

But, you may be quite legitimately asking, this beach stuff—isn't this (metaphorically speaking) building sand castles on an extended conceit? Surely one knows that language is not really a coastline. Well I'm not so sure it's not. Or rather I sense that languages and coastlines operate with similar kinds of principles. If one thinks of a coastline as just one site of mutually transformative exchange between different kinds of complex dynamical systems, then language as it exists in the active mediation between neural network and world ecosystems is surely such a site. There are specific things one gains in thinking of language in this way, particularly when confronted by literature that won't resolve into simple mimesis or tidy containments and conclusions.

It saves a certain amount of frustration to remember that you will never solve a coastline. You can explore, analyze, describe it, visit it as often as you like for the pleasure of it, picnic on it, swim along it, embark from it. It is of course gloriously noncompressible. Its best description can only be coterminous with itself, with its horizons and skies and weather, with the complex, infinite series of possible encounters anyone might have with it. You cannot sum up or paraphrase a coastline, although you can experience topographical limits. Geographers

call the point on a landscape where certainty about one's bearings begins to rapidly fall off an "edge." The fractal edges of Stein's art make up part of the active coastline—zone of shifting stabilities and instabilities—between culture and the rest of life—the zone of silence that will never be absorbed by culture but can be wondered at from the vantage points of its edges. Some dimensions of the scalar repetitions and variations within a work of art can be internally formulated, but others have to do with the relation of that work to the history of the language-culture, the history of the art itself (in this case to the novel), to other cultural forms, to forms of everyday life and the natural world.

As location of conventional murder mystery, where all must resolve into a single gory punctum—vanishing point of "the body"—Stein's coastal prose is entirely revelatory in its surprising variations. The more you can't find the object you're looking for, the more you're learning about the language coastline itself. "The more you see how the country is the more you do not wonder why they shut the door" ("A Water-fall And A Piano," 31–32). This experience includes that of one's own imaginative cognition, since the system that I am calling fractal is always composed of text in interaction with reader's mind.) To make a "novel of real life"—as distinct from stylistic naturalism—it was necessary to pursue language, with its internal tensions between grammatical logics and radical unintelligibilities, as an active intersection that resists one-to-one correspondence with anything other than its own traffic patterns. Stein was acutely aware, as was John Cage, of the incommensurability of the multiple logics we experience and employ in different parts of our lives. Hence the cluster of questions that will always exist concerning the connection of connections within a work of art to the connections between persons and events and things in daily life. These passages from "The Superstitions Of Fred Anneday, Annday, Anday a Novel of Real Life" examine precisely the same puzzle of poetics that Aristotle and countless others since have worked on—the relation between the unfolding logic of a lived day and the logic of time in literature. Notice the self-similar patterns, the noise, the perturbations as this linguistic system enacts what it's saying about everyday life:

It is not at all confusing to live every day and to meet everyone not at all confusing but to tell any one yes it is confusing even if only telling it to any one how you lived any one day and met everybody all of that day. And now what more can one do than that. And doing more than that is this....
Now I need no reason to wonder if he went to say farewell. But he never did. Fred Anday never said farewell to any one in a day no one ever does

because every one sees every one every day which is a natural way for a day
to be.... Of course no dream is like that because after all there has to be all
day to be like that. And all day is like that. And there cannot be a novel
like that because it is too confusing written down if it is like that so a novel
is like a dream when it is not like that.
 But what is this yes what is this. It is this.[16]

What then is this text one finds in *Blood On The Dining Room
Floor?* It is this. Stein's complex dynamic system enacts on the page her
contemporary mix of Euro-American, lesbian feminine-masculine, sex-
ual-intellectual, visual-linguistic...compound sensibilities. Refusing to
arrest her gaze in the way of detective fiction she keeps it and us in mo-
tion. She must go on, even after the success of *The Autobiography Of
Alice B. Toklas,* with her role of prime suspect in the crime of being a
foreigner in the familiar world that most readers demand. She is, in
other words, the foreigner that every contemporary artist must be.
("Oh dear a foreigner. They did not listen to him be a foreigner"
[*Blood,* 49].) It is this ethos of contemporaneity (most decidedly not
that of the conventional detective novel) that Stein articulates in the ex-
traordinary essay she wrote in 1935, "How Writing Is Written":
"Everybody is contemporary with his [*sic*] period...and the whole
business of writing is the question of living in that contemporari-
ness.... The thing that is important is that nobody knows what the con-
temporariness is. In other words, they don't know where they are going,
but they are on their way."[17]

II READERS & WRITERS — CONSTRUCTING ACCIDENTS

The constructed contingencies of a novel, whether we call them acci-
dents, coincidences, or just events, occur in what we read (in the gram-
matically directed continuity of reading) as linked series. This gives us a
sense of continuous pattern rather than unaccountably sudden or iso-
lated event—a death. When a chapter is no more than a sentence or two
or is, as in *Tristram Shandy,* black or blank, it announces a sudden
death/dearth of what one can know even within the confines of the
novel—a form whose working epistemology has from its inception been
one of authoritative, sweeping, transcendent cognition. Any breakdown
of this illusion in the novel is a wrenching event, like a figure emerging
out of a dark corner with a knife. Here are five sudden chapters in
Blood on The Dining Room Floor quoted in their entirety. I experience
them as edges and bends in the coastline of the book:

READING & WRITING

The difference between reader and writer can be the difference between fantasy and imagination, unless what one is reading demands rewriting. Fantasy creates the illusion that amazing things are happening even as one's body is quite still, docily watching the movie in the mind. One breathes in, breathes out. This gentle breathing is very soothing, the pulse is steady and slow. Imagination can trigger a rapid or irregular pulse, send eyes darting. Frenetic and copious fits of marginalia are not enough. The reader jumps out of her chair, indulges in kinetic perversions—arm waving, forehead grasping, gasps and exclamations, hyperdramatic reading aloud, chaotic pacing. This corporeally risky (best unobserved) reader-response can knock over lamps, disrupt and rearrange the material forms of one's life, make it worth living.

Genre Tallique, *GLANCES:*
An Unwritten Book[18]

Imaginatively living one's contemporariness is a poethical matter. Art can bring us into touch with the concrete particulars of our world in ways that raise questions like John Dewey's in *Art as Experience*—How is this useful in connecting us with (vivifying) ordinary life experiences? Or my own permutations of that—What art forms help us do the work of meeting our historical moment with compassion, in reciprocal alterity with others; bring us into courageous, humorous dialogue with the historically contingent character of the contemporary; draw us into en-

gagements that help us notice and make sense of what's most at stake? Although we know Gertrude Stein, writer, believed "the whole business of writing is the question of living in [one's] contemporariness," she might not want to write when she was reading.

Gertrude Stein, reader:

What are detective stories, well detective stories are what I can read. ("Why I Like Detective Stories," 146)

I used to think that a detective story was soothing because the hero being dead, you begin with the corpse you did not have to take him on and so your mind was free to enjoy yourself, of course there is the detection but nobody really believes in detection, that is what makes the detection so soothing, they try to make you believe in the detection by trying to make you fond of the character that does the detecting, they know if you do not get fond of him you will not believe in the detection, naturally not and you have to believe in it a little or else it will not be soothing. ("Why I Like Detective Stories," 147)

Stein is describing a fantasy ethos, a bubble in which one can float on the surface tension of real time. It provides respite from daily worries and also from writing.

Stein, writer:

I like detecting there are so many things to detect. ("Why I Like Detective Stories," 147)

Suppose or supposing that you had an invitation, suppose some one had been very inviting supposing some one had given him an invitation supposing you had been inviting him to listen to an explanation suppose there had been an explanation supposing you had given an explanation, I can explain visiting. I can explain how it happened accidentally that fortunately no explanation was necessary.

I explain wording and painting and sealing and closing. I explain opening and reasoning and rolling, I was just rolling. What did he say. He said I was not mistaken and yet I had not when he was not prepared for an explanation I had not begun explaining. It is in a way a cause for congratulation. It is in a way cause for congratulation. ("An Elucidation," 434)

Or, to put it another way, Stein doesn't want as a writer to be prematurely dead:

Those who are creating the modern composition authentically are naturally only of importance when they are dead because by that time the modern composition having become past is classified and the description of it is classical. That is the reason why the creator of the new composition in the arts is an outlaw until he is a classic, there is hardly a moment in between

and it is really too bad.... [I]t is very much too bad, it is so very much more exciting and satisfactory for everybody if one can have contemporaries, if all one's contemporaries could be one's contemporaries. ("Composition As Explanation," 496)

This interestingly echoes Stein's teacher William James, who, like all those thinkers most intensely concerned to work against the inertia of the known, was puzzling about the locus of new intuitions and knowledge. I found this passage from *The Will to Believe* quoted in Benoit Mandelbrot's *The Fractal Geometry of Nature*:

The great field for new discoveries...is always the unclassified residuum. Round about the accredited and orderly facts of every science there ever floats a sort of dust-cloud of exceptional observations, of occurrences minute and irregular and seldom met with, which it always proves more easy to ignore than to attend to. The ideal of every science is that of a closed and completed system of truth....Phenomena unclassifiable within the system are paradoxical absurdities, and must be held untrue...—one neglects or denies them with the best of scientific consciences....Any one will renovate his science who will steadily look after the irregular phenomena. And when the science is renewed, its new formulas often have more of the voice of the exception in them than of what were supposed to be the rules. (28)

Stein's enthusiasm for real detecting, for not explaining, is an actively imaginative ethos of an ever "rolling" investigation released from the finalities of explanation or the death—to art—that is brought on by premature classification. This is the poethos that pervades her writing, linking it with her early interests in psychology and physiology. Isn't it a lovely coincidence that Mandelbrot, whose work helps us read Stein, quotes her teacher, William James, who himself wrote about science in a way that describes Stein's attitude toward language and writing—its relation to the unintelligibilities of the contemporary. Stein was no doubt drawn to James and influenced by him because of significant temperamental affinities. The spirit of inquiry in their respective science and art is one of purposeful play.

I want once again to underscore the seriousness of play in culture, how bereft we would be without the improbable capacity for play some of us sustain against all odds. There's an intense need for play when one is in a peculiarly untenable situation like adulthood. Notice that children can be victims of all sorts of horrors, can suffer from poverty, racism, war, invidious identity politics, but they aren't victims *when* they are at play; they are fully realized persons when they are fully con-

centrating on play. Play is the middle term—the active principle—between believing and doubting (antidote to skepticism and cynicism), hating and loving, misery and ecstasy, hope and despair—all those binaries bracketing empty slots that sort us into the insulted and injured and chronically depressed. Detecting is a form of play. It manifests itself in Stein's permutative, investigative writing. But then there's also a need to rest. Here's Stein writing about her favorite detective novelist:

Stein, reader:

Really why Edgar Wallace is so good is that there is no detection. He makes it ordinary and the ordinary because he is genuinely romantic has an extraordinary charm. The girl will always be caught by the villain just before the end and the chase is to end only in one way that is in the rescue and sometime he has to cudgel his brains to find some reason for this capture of the heroine but captured she is and it is a charm.... [O]f course incidentally he writes awfully well he has the gift of writing as Walter Scott had it. ("Why I Like Detective Stories," 148)

Stein, writer:

I tried to write one [a detective story] well not exactly write one because to try is to cry but I did try to write one. It had a good name it was *Blood on the Dining-Room Floor* and it all had to do with that but there was no corpse and the detecting was general, it was all very clear in my head but it did not get natural the trouble was that if it all happened and it all had happened then you had to mix it up with other things that had happened and after all a novel even if it is a detective story ought not to mix up what happened with what has happened, *anything that has happened is exciting exciting enough without any writing, tell it as often as you like but do not write it not as a story.* (ibid. [italics mine])

TIME (OUT?)

To be or not to be continuous? How can this be a real question? Notice how much of the matter of poetics has to do with time. The detective story occurs in its own, urgently hermetic past tense. When the wager of your genre is to maintain the tension of an internal logic, you are always writing in the past tense—about what *has happened* (present perfected by the past, stopped dead). You cannot let what is going on in your daily life enter without rupturing the form. Writing, as Stein practices it, is the moving principle, the literal composing of her daily life as attentive participant in her contemporary moment. She is in her writing process, which is also her life process "on the way...." She cannot know precisely where this will take her writing, only that it must not

stop until she dies. Her last work, the opera *The Mother of Us All*, celebrated Susan B. Anthony, another figure on her way in/out of her time.

Not everyone is contemporary voluntarily. Stein and Stein's Susan B. know that most people choose to live "about forty years behind their time" ("How Writing Is Written," 151). Few can attend to anything truly new until it is no longer new. Stein says in "How Writing Is Written," the contemporary artist is "expressing the time-sense of his contemporaries, but nobody is really interested.... That is really the fact about contemporariness...you will do something which most people won't want to look at" (151). Stein and the Susan B. of *Mother* have only recently arrived within the ken of a large, appreciative audience.[19] The writing practice and the living practice for Stein as contemporary writer are inextricably intertwined and must remain that way despite risks to one's "career."

Stein, writer:

This makes no success because success—who shall, who will, who could, who if they do—nobody changes. (*Blood*, 79)

What happens if one thinks of the temporal not as layers or arrows, or horizons "before and beyond which...," but as consequence and possibility? Why do we notice time? Because things change. Why do we notice change? Because expectations are disrupted. With this in mind might we begin to develop a model of experience (and art as part of that experience) that is fractal, where time is one dimension of an omnidirectional, infinitely detailed, surface continuum? Transformation, produced by accident and praxis—the form of play that is moderated by exigencies of the real—is the moving principle of human time. Not that this makes anything simple. To the contrary, to think this way is to invoke an urgent scene of complex intersections—nonstop traffic, noise, swerves, accident (collision) on accident (serendipitous meeting). Detailed aerial views would reveal one happy or harrowing coincidence after another. There are so many ways in which there *is* a crime.

TIME OUT (OF FOCUS?)

The contemporary is what we're doing with the consequences of the past before they've congealed into history.

Genre Tallique, *GLANCES:
An Unwritten Book*

It's quite clear that a good deal of the culture of any period is designed to reassure the populace that nothing is happening. Stanley Cavell's excellent analysis of TV as palliative pseudomonitor explores one sociocultural logic of this sort.[20] In fact popular programming formats show that nothing significant has changed since the last golden era fit for nostalgia. (This can be signaled by the form even as the characters speak the latest lingo, refer to the most current events. Is the literary equivalent the "new formalism"?) Or, same thing, that the things that are rapidly changing have no effect on core truths.

If one starts, like Gertrude Stein, with the premise that the most valuable writing of any time is that which enacts those times in its language, what—in concrete, material, pragmatic terms—does this really mean? It can mean something about the currency of vocabularies, the ingredients of the linguistic mix, but it inevitably has more to do with formal principles that redirect geometries of attention. The first thing it means for Stein is that she can't operate in the topography of a conventional poem or detective novel. Her poethics precludes conventional (already classified) forms with the one oblique exception (the one that led to her greatest popular success) of writing a biography of herself as autobiography of a persona who *can* write a conventional biography of Gertrude Stein. *The Autobiography Of Alice B. Toklas* can be seen from one of many possible angles as an exercise in Kierkegaardian irony—the pseudonymous narrator writes from a privileged position of disingenuous disclosure that is in fact the closest thing to a "coming out" that Stein could accomplish.

What it means to write one's contemporariness has of course to do with one's material culture but also, and just as important, with one's working epistemology. Stein puzzled a great deal about the relation between memory and knowledge.

> Stein: In my own case, the Twentieth Century, which America created after the Civil War, and which had certain elements, had a definite influence on me. And in *The Making of Americans*...I gradually and slowly found out that there were two things I had to think about; the fact that knowledge is acquired, so to speak, by memory; but that when you know anything, memory doesn't come in. At any moment that you are conscious of knowing anything, memory plays no part. You have the sense of the immediate. ("How Writing Is Written," 155)

Given this highly evolved epistemology, informed by her study of psychology with William James at Harvard and of neurophysiology in her medical studies at Johns Hopkins,[21] Stein realizes that the material forms and synaptic routes her language takes must leave room for what

cannot be said. This presents the possibility of meaning that might be constructed by a reader recombining the elements via different paths and is (we now think we know) how neural networks operate. Stein sees clearly that her writing must differ markedly from those she calls her "forbears...Meredith, Thomas Hardy and so forth." She figures this out in very concrete but always dynamic terms: "To get this present immediacy...I had to use present participles, new constructions of grammar. The grammar-constructions are correct, but they are changed, in order to get this immediacy" ("How Writing Is Written," 155).

Stein cannot write a book entitled *What Is Remembered,* as Toklas can and does, any more than she can write a convincing narrative account of Mme. Pernollet's death. Why not? For one thing, however much she wanted to make an account "natural," she simply couldn't tell a story about what *had happened* (past perfected). She had to make something happen (tensile present) in her own text. The act of writing automatically catapulted her into the conditions of presentness. As reader she may want to be soothed by pseudodetection, but as writer she wants to engage in the actual detection that is the modus operandi of investigative forms. She approaches writing more like a passionate scientist than an audience-conscious artist. She is investigating the "elements" of language. She is using those "certain elements" to construct a kind of fractal model of her experience of the twentieth century: "So I got rid more and more of commas.... [T]he comma was a stumbling block...that is the illustration of...grammar and parts of speech, as parts of daily life as we live it....The other thing I accomplished was getting rid of nouns. In the Twentieth Century you feel like movement" ("How Writing Is Written," 153).

READING
From Epistemological First Principles to First Sentences, A Sampler:
 First a first sentence from Stein's favorite mystery writer:

> Harry the Lancer slouched along Burton Street; he was out of Dartmoor only that Monday, having served twenty-one months short of seven years and the last person he wanted to see was Inspector Long. (Edgar Wallace, *Terrible People,* 1).[22]

Ah, the wholesomeness of a well-made English sentence!

WRITING
Here is the dilemma, in *How To Write:*

Stein: A sentence is an interval during which if there is a difficulty they will do away with it.[23]

And what a poignant predicament to refuse to live in that interval.

Having undertaken never to be renounced never to be diminutive never to be in consequence never to be with and delayed never to be placing it with and because it is an interval it is extremely difficult not to make sense extremely difficult not to make sense extremely difficult not to make sense and excuse.[24]

With a sentence like Wallace's one can begin to appreciate the soothing effect of the stylistically heralded foregone conclusion. The epistemological illusion that knowledge can be complete. It is just that illusion that Gertrude Stein liked so much in murder mysteries. Here's another Edgar Wallace opening, from a novel called *The Mouthpiece,* published posthumously in 1935. (Wallace lived from 1875 to 1932, so the coast was clear in 1933 for Stein to try her own hand at a mystery.):

There might have been occasions when the offices of Stuckey & Stuckey, solicitors, received the ministrations of a charwoman; but, if so, no living soul could testify to this of his own knowledge.[25]

There is of course complete knowledge of incomplete knowledge all around us. This is the prose of foreshadowing, foreordaining what is already known to the writer. Don't worry, he's in control. Relax, just as you relaxed as a child being read to by an adult. The end is in the beginning. Teleology recapitulates epistemology, or is it the other way around? Stein felt very bad about not being able to do this kind of thing. According to Ulla Dydo, after the success of *The Autobiography Of Alice B. Toklas* she discovered how much she enjoyed fame. She had a marvelous time touring America, meeting hundreds (thousands) of delighted readers. She herself was delighted, delighted in all those delighted readers, relishing the delights of finding that she as writer could delight readers. In her attempt to write a generic detective novel did the writing process become fused with the reading process in her mind? Did she wish to satisfy not only her newfound readers but the reader in herself? I think so. I think Stein originally conceived of *Blood on the Dining Room Floor* entirely in terms of writing as reader for readers. But that interval in the sentence, between reader and writer, looms with more difficulty than she anticipates: "It is very early to begin with the end and so this will not be done" (*Blood,* 37).

It seems that as Stein began writing *Blood,* there was a figure-ground shift, a poethical transvaluation of values, in which the author

herself was transformed from reader into writer by that very process
she called living the contemporariness. According to Stein's working
epistemology as writer, at the moment she is conscious of knowing
what she wants to write in this detective story—the account of the
events that had occurred in the summer of 1933—memory recedes into
the background; the foreground is entirely occupied with the immedi-
acy of writing. ("At any moment that you are conscious of knowing
anything, memory plays no part. You have the sense of the immedi-
ate.") It seems that writing as Stein constructs it is an act of knowing
even if she does not know where it will take her. Notice the beat-by-
beat unfolding of linguistic exploration that continues the opening
chapter of *Blood*. She will later say, in her disappointment over what
she had written, "[T]here were corpses but no detecting" ("Why I Like
Detective Stories," 149), but this is certainly not the case. The detect-
ing is there, and the method is Stein's own form of differential analysis
as permutative linguistic inquiry:

> The first husband and wife were Italian. They had a queer way of walking,
> she had a queer way of walking and she made noodles with spinach which
> made them green. He in his way of walking stooped and picked up sticks
> instead of chopping them and he dried the sticks on the stove and the fires
> did not burn.
> The next ones were found on the side of a mountain. She had a queer
> way of walking, he didn't. She had been married before but perhaps not
> only then, at any rate she was soon very sick and is still in a hospital lying
> on a chair and will not live long. He was like a sheep. He was not at all
> silly. He was like a sailor. He had been a waiter. He cried when he was dis-
> appointed and fell down when he was angry.
> The third pair came by train from a long distance and most unexpect-
> edly they had a little child with them. She was a pretty child and went up
> stairs gracefully. He had been an accountant and loved automobiles and
> poetry. He was very quickly certain that a mistake had been made. She
> had lost one kidney and was soon to lose another. They wished all three
> to sleep under a tree but that is unbecoming and dangerous. There was
> fear and indignation everywhere until there was nothing any longer to
> fear. There never had been. (*Blood*, 11–12)

Stein: I did write it, it was such a good detective story but nobody did any
detecting except just conversation so after all it was not a detective story so
finally I concluded that even although Edgar Wallace does almost write de-
tective stories without anybody really doing any detecting on the whole a
detective story has to have [it] if it has not a detective it has to have an end-
ing and my detective story did not have any. ("Why I Like Detective
Stories," 148–49)

Stein is a reader who wants to be soothed, and there is nothing so soothing she says as "crime and ancient history which explains the crime" (ibid., 150). She concludes that Wallace is so satisfying because he uses "the old melodrama machinery and he makes it alive again and…it is much better to make an old thing alive than to invent a new one" (ibid., 149). This is undeniable if one's project is the genre fiction of detection with its systematic extinguishing of variables, its location of the single vanishing point one must create and destroy in generic detective fiction. There is also the exact placement of the interrogative *it* as in Who done *it?* The reader wades two sentences into *Blood* and knows it's generically hopeless. There will never be a luminously prominent *it*, that fictive filament by which every part of the story is evenly lit. With sprightly writing and a homeopathic dose of uncertainty Wallace is undisputed winner of the competition. Is it a cheap shot to point out that forty years or so later he is forgotten and that *Blood* is steadily gaining new readers and is the basis for two new operas? This is a happy story of the delayed, but important, consequences of some poethical forms.

In this story Stein has fallen/risen from her position as reader, enjoying the soothing nature of detection-free detective crime, to move between a poetics of permutation and one of conspicuous incompleteness. Or perhaps this is the same thing since permutations foreground indeterminacy. In this way—through repetitions, microvariations, investigating that is a form of noticing, shifts of perspective, pattern differentia, the relative incompleteness of thought/grammar is played out via enjambment and fragmentation. In contrast to Edgar Wallace, whose hydrodynamical circular flow is designed to dissolve jagged edges and return us to the past, Stein gives us a humorously craggy coastline to explore well into the future.

POP QUIZ
MORE FIRST SENTENCES, from *The Autobiography Of Alice B. Toklas*, by Gertrude Stein and *What Is Remembered*, by Alice B. Toklas. Which is Stein? Please elucidate your answer.

a) I was born and raised in California, where my maternal grandfather had been a pioneer before the state was admitted to the Union. He had bought a gold mine and settled in Jackson, Amador County.

b) I was born in San Francisco, California. I have in consequence always preferred living in a temperate climate, but it is difficult, on the continent of Europe or even in America, to find a temperate climate and live in it.

WHAT STEIN FOUND HERSELF WRITING
What Stein found herself writing in *Blood On The Dining Room Floor* was not generic fiction, not a story at all, but an analysis of town and country stereotypes embedded in the habitus of a particular place-time. An analysis that emerges out of her investigatory poetic language:

> They said nothing happens in the country but there are more changes in a family in the country in five years than in a family in a city and this is natural. If nothing changed in the country there could not be butter and eggs. There have to be changes in the country, there had to be breaking up of families and killing of dogs and spoiling of sons and losing of daughters and killing of mothers and banishing of fathers. Of course there must in the country. And so this makes in the country everything happening in the country. Nothing happens in the city. Everything happens in the country. The city just tells what has happened in the country, it has already happened in the country.
>
> Lizzie do you understand. (*Blood*, 50–51)

Lizzie Borden, under whose sign Stein writes a detective story with no solution, is a key element. As the Episcopal priest John Herbert Gill puts it in his afterword to the 1982 Creative Arts edition of *Blood*:

> Why could her detective story have no ending? Why is there no detecting, even though clues and coincidences abound? It is because it is a story of crimes in which the guilty are not caught or punished. It is not "soothing" the way Gertrude Stein found most crime stories to be. These were true crimes, crimes that stayed in the memory because they were never solved; when there is a solution it is soothing but it is not interesting, we do not remember it. And so we find that page after page...summons the spectre of the patron saint of unsolved crimes in a kind of anguished litany: "Lizzie do you understand Lizzie do you mind." (*Blood*, 88)

Of course there is detecting here, but of another kind. The matter under investigation is not only the kind of crime that produces a corpse. The death of the hotel keeper's wife is only the efficient cause as Stein frames her exploration of the ambiguous and complexly explosive elements of the sexual politics of marriage and small-town family life.

THE MOTHER OF US ALL

Gertrude Stein is not known for her sensitivity toward the position of the wife in a masculinist society. She is in fact known to have had scorn for wives of writers she knew while respecting the intelligence and enjoying the services of her own model wife. Alice B. Toklas was the silent partner who kept house, cooked, and typed and commented on Stein's work. According to Ulla Dydo, Stein was unhappy that homosexual

marriage was not socially legitimated primarily because she would have
liked Alice B. to have taken Stein as her name. She plays on personal
ambivalences and social ambiguities in *The Mother Of Us All*. One of
the many subplots that threads through this opera is that of the
affianced Indiana Elliot, who causes a great uproar when she announces
that she will not take her husband's name, her own name suits her just
fine. At the marriage Susan B. (Anthony) sings,

> What is marriage, is marriage protection or religion, is marriage renunciation
> or abundance, is marriage a stepping-stone or an end. What is marriage.

and later,

> I am not married and the reason why is that I have had to do what I have
> had to do, I have had to be what I have had to be, I could never be one of
> two I could never be two in one as married couples do and can, I am but
> one all one, one and all one, and so I have never been married to any one.[26]

After her marriage to Jo the Loiterer (whose name from the outset has
been tagged as lower class: "Any Loiterer can be accused of loiter-
ing."),[27] Indiana Elliot decides to change her name but wishes to make
it clear that this comes of her own free choice, not from social or mari-
tal pressures.

> *Jo the Loiterer:* She has decided to change her name.
> *Indiana Elliot:* Not because it is his name but it is such a pretty name,
> Indiana Loiterer is such a pretty name.
> *All the Chorus:* She is quite right, Indiana Loiterer is so harmonious, so
> harmonious. Indiana Loiterer is so harmonious.
> Stein, *Last Operas And Plays*, 82

And in the next act,

> *Indiana Elliot:* I am sorry to interrupt so sorry to interrupt but I have a
> great deal to say about marriage....[D]ear Susan B. Anthony was
> never married, how wonderful it is to be never married how wonder-
> ful. I have a great deal to say about marriage.
> *Susan B. Anthony:* It is a puzzle, I am not puzzled but it is a puzzle, if
> there are no children there are no men and women, and if there are
> men and women, it is rather horrible, and if it is rather horrible, then
> there are children.
> Stein, *Last Operas And Plays*, 85

With the illuminating intelligence of Susan B. Anthony the conscious ambivalence and ambiguity is humorously and seriously played out in an irony that is neither bitter nor sinister. After all, how could any woman resist the opportunity to become a Loiterer? The political voice of the chorus changes the terms from aesthetic ("pretty") to social ("harmonious"). All this operates at a different end of the chromatic scale from Stein's *Blood*-chilling writing on the position of wives in general and in particular the wife of the hotel keeper who is so crazy she drives her husband off to fight in the war even though he could have avoided combat conscription. The sinister sociofictive logic of Stein's "our town" prepares one for the probability that the husband has pushed his "crazy" wife to her death in the hotel courtyard. The ominous tone leading up to this event is couched almost entirely in evocations of the isolated and uneventful life led by the hotel keeper's wife. (Or, was it suicide?) The linguistic embodiment of thankless repetitive tasks coheres with generations of feminist writing on the "wife trap" that drives women into depressions that of course drive husbands to affairs, divorce, even murder....

> And all this time she was at home, home at the hotel And was it home. In a way it was and in a way it was not, but any way it was the only home she had.
>
> Every day and every day she had to see that everything came out from where it was put away and that everything again was put away....In that way she passed each day and each day passed away which was a night too....
>
> She cried when she tried but soon she did not try and so she did not cry....She was very gracious and smiled sweetly and every day everything was taken out and every day everything was put away; and sometimes several times during every day and sometimes very often during every day everything was taken out and everything was put away. He was busy every day. That is the way to see a thing, see it from the outside. That makes it clear that nobody is dead yet. They grew richer and richer every day. The four children grew richer and richer in that way. They grew richer and richer. That was the only change every day. (*Blood*, 18)

Thinking about generic differences, the detective novel turns out to be much too linearly driven and constricting for Stein's investigative poetics. The simultaneities of opera as a genre lend themselves to Stein's multiple explorations even as the positive outcome of Susan B. Anthony's work provides the psychic space for a particularly buoyant humor in *Mother*. A sense of the kind of thing that happens in both in-

stances—where the poethical exploration through language must over-
come generic expectations—is particularly well elucidated in Stein's
1926 essay "Composition As Explanation," where she both enacts and
describes how the making of a composition is not to recount what you
already know but to change your way of seeing things (a lesson John
Cage learned in part from Stein): "Nothing changes from generation to
generation except the thing seen and that makes a composition"
("Composition As Explanation," 495).

A POETHICAL WAGER

For Stein, to compose authentically out of one's contemporary situ-
ation is to live in the new time that one is taking part in making through
the act of composition. Unavoidably this is to some significant extent to
not know where you are going, to literally make your way with a poet-
ics whose language leads you to see things in the changed perspective
that only the present (with its new cumulus patterns) offers. But, with-
out contemporary composition/composition of the contemporary—the
living and seeing it literally makes possible—one isn't moving with in-
tegrity and vitality into the new time.

> The composition is the thing seen by every one living in the living they are
> doing, they are the composing of the composition that at the time they are
> living is the composition of the time in which they are living. It is that that
> makes living a thing they are doing. ("Composition As Explanation," 497)

> Each period of living differs from any other period of living not in the way
> life is but in the way life is conducted and that authentically speaking is
> composition. ("Composition As Explanation," 498)

UTOPIA NOW?

This may be the closest Stein comes to an avant-garde utopian vision:
to actually live in one's contemporary world! If it can't happen in ev-
eryday life, then it can first happen in art. But if it can happen in art and
art is a part of one's everyday life, then we are living courageously in our
time. It's funny. Almost too funny for words, but not quite:

> I have often admired her courage
> In having ordered three
> But she was right.
> Of course she was right.
> About this there can be no manner of doubt.
> It gave me pleasure and fear
> But we are here
> And so far further

It has just come to me now to mention this
And I do it.
It is to be remarked that the sun sets
When the sun sets
And that the moon rises
When the moon rises.

"Stanzas in Meditation," V, lii[28]

FOUR ON CAGE

Geometries of Attention

Every philosophy, every narrative, every poem, every piece of
visual art or music organizes our noticing according to its im-
plicit and enacted geometries of attention.

Dita Fröller, *New Old World Marvels*

SILENT

It's a lovely coincidence that *silent* and *listen* are just a lettristic shuffle
apart. Mid-twentieth century, John Cage conceptually and performa-
tively redefined silence in two major pieces, "Lecture on Nothing" (c.
1950), which he called a "structured silence," and the 1952 piano com-
position he referred to as the "silent piece," 4'33". This latter was in
fact the realization of a project begun in 1948 with the working title
"Silent Prayer." The directives in both cases are, Notice where you are,
Look around, *Listen.*

LISTEN

 Listen to what? To the sound, music, poetry in what one has not been
noticing. Silence is ambient, empty noise that as we turn our attention
to it becomes full. This is more complicated than one might think, not
just a matter of swiveling the head. Every structure embodies a geome-
try of attention that renders some things audible/visible and others in-
audible/invisible. Cultures do their orientational work in large part un-
consciously/unintentionally in naturalized figure-ground relations that
appear to be simply the way things are. Habits of perception are
difficult to inspect. Areas of experience unaccountable in the topologi-
cal continuities of culture are no less difficult to locate just because we
know in principle that they must be there.

SILENCE

How to attend to the many silences—aesthetic, historical, social—
that affect everything we think and do? How to use them? This may be
the principal challenge of any contemporary moment. We're confused
enough already, and then there's the present relentlessly rolling in,
vastly overdetermined, further complicating the past. We've only just
glimpsed a pattern, and it's changing before our eyes. What's most char-
acteristically contemporary at any moment is the least recognizable,
least visible, least audible, least intelligible of all that matters. Unintelli-
gibilities of past and present tend to blur into the reassuring and omi-
nous white noise of dailiness. Increasingly ominous, to the degree that
they're persistently ignored.

The question that must be continually addressed, if one is to live in
one's times, is how to invite the most recalcitrant, even hazardous si-
lences into the conversation. This is a complicated figure-ground puzzle
that involves reconfiguring geometries of attention. For Cage, like his
aesthetic and spiritual mentors Marcel Duchamp and D.T. Suzuki, the
transformation of the nature of attention was the key to the construc-
tive transfiguration of experience. Duchamp's working assumption (the
one that brought on both pop and conceptual art) was that any object
can be seen as art. Attention is the necessary and sufficient condition.
The only thing that isn't art is inattention. Suzuki similarly taught that
Zen awareness brings ordinary experience into the field of enlighten-
ment. Intersecting in Cage's consciousness, these insights became a com-
prehensive aesthetic of silence, that is, of heightened attention:

I am here , and there is nothing to say .

 If among you are
those who wish to get somewhere , let them leave at
any moment . What we re-quire is
silence ; but what silence requires
 is that I go on talking
 there are silences and the
words ·make help make the
silences .

 I have nothing to say
 and I am saying it and that is
poetry as I need it .
 This space of time is organized
· We need not fear these silences,—
we may love them .

 "Lecture on Nothing"[1]

Cage's "Lecture on Nothing" uses a rhythmic structure composed of measures meant to be performed as a piece of language music but with "the *rubato* which one uses in everyday speech."[2] It's an effective outline of the new geometry of attention that Cage was developing in the late 1940s and early 1950s and that would formally define all his projects for the rest of his life. Whether hearing "Lecture on Nothing" or seeing it on the page, one is struck by the apertures that are built into the organization of this "space of time." They function to dramatically redirect vectors of noticing—past words, into the silence of pauses, the emptiness of structural description:

> I am here....I am doing this.... [W]e are now here....I go on talking....This is a composed talk...for I am making it...just as I make...a piece of music....How could I...better tell...what structure...is...than simply to...tell...about this,...this talk...which is...contained...within...a space of time....It makes very little... difference...what I say...or even how I say it....You have just... experienced...the structure...of this talk....[3]

The explicit mapping of the space-time of the talk makes it instructively prototypic as experience of silence as poetry/poetry as silence— what we don't normally notice when a lecture wholly occupies the foreground of our consciousness with its densely constructed text. The schematic form of "Lecture on Nothing" affords constant glimpses of the world outside the lecture. It conspires (breathes together) with its own alterity. And this means it is transferable to any other situation, with content composed of any other collection of details. "Lecture on Nothing" of course turns out to contain many delightful, thought-provoking, astonishing things. It's full of beautiful philosophical statements, stories, ideas, surprising references; but its formal gaps, its recursive attention to its own emptiness, foregrounds structure and turns it into a template for noticing similar relationships elsewhere—for example, among words and silence, ideas and experience, what is and is not apparent in other instances of art and of course in the course of everyday life.

This is what geometries do—they organize the vectors of our attention, establish relations between abstract directionalities, insides and outsides, enabling us to notice certain things we could not otherwise. The ancient Egyptians used geometry to locate landmarks buried in mud or displaced by floods. Benoit Mandelbrot noticed that complex natural forms like trees, rivers, and coastlines can be modeled with

Koch and Peano curves, which in turn led him to notice that coastlines
have self-similar infinite detail in finite space. Cage puts it simply and
directly: "Structure without life is dead. But life with-
out/structure is un-seen. "[4] Which is what Gertrude Stein, another
of Cage's aesthetic mentors, meant when she wrote in her 1926 essay
"Composition As Explanation" that the thing seen, if it is new, can only
be seen within the composition. Since the nature of the structure deter-
mines the nature of the seen, how can it be anything other than imper-
ative that we engage in the continual invention of new arts, new artifice
to see/hear the underside of the habitus that clamors to deaf ears, the in-
visible cities that presage our hope and our ruin?

RECIPROCAL ↔ ALTERITIES

What Cage discovered was that the more minimal and permeable the
disciplined process or structure, the more it reveals about the world out-
side its perimeters. With the right orientational vectors, the qualities of
lightness and permeability place it in conversation with its immediate
environment. Like all formally constructed aesthetic experience, art
that lets silence into its composition is, in its own artifice, an invasion
into the conditions of a given space-time. But its relation to that space-
time is, importantly, one of reciprocal alterity rather than erasure or de-
nial. What lies outside its structuring geometries is always the major
area of investigation.

In the late 1940s and early 1950s Cage was working on these ideas,
as always, in collaboration with others—at Black Mountain College, as
well as in New York City—with Merce Cunningham, Buckminster
Fuller, M. C. Richards, and Robert Rauschenberg. Fuller and Richards
shared, to the greatest degree, Cage's social concerns, but it was
Rauschenberg's white paintings (1951–52) that became for him an
iconic example of a minimalist use of materials in maximalist service to
an art of ordinary experience.

Like Cage's 4'33", the white paintings foreground ambient activity
(the visual ambience of light and shadow) wherever they are placed.
What seems at first empty becomes, with attention, so full one cannot
take one's eyes off them. Since the play of light is live, happening at the
moment of one's looking, one doesn't want to miss any delicious nu-
ances. It is like watching the continuous change of light on water. Yes,
it is, and with this realization comes another—that you don't need the
paintings to have this experience. You needed them to show the way—
to stimulate your museum-quality attention—but what has enraptured

you in the museum happens on every surface that refracts light. The geometry of attention inscribed in the art illuminates your visual experience of everyday life just as $4'33''$ amplifies the auditory one. Dance, opera, film, most any performance does both. All this is what Cage's redefinition of silence as ambient noise is about—the act of noticing turns it into sound that is, with a heightened quality of attention, transvalued into music just as one comes into a realization that if this is music, then all of the audible world presents, equally, a musical occasion.

This was not how Cage began. In the 1930s and early 1940s his explorations of silence had been focused on contemplative, even mystical, experiences in which silence in music was valued as a quieting of the mind so that the divine could enter. This was a geometry of the receptive mind/soul characteristic of Indian (Sri Ramakrishna) and medieval Christian (Meister Eckhart) spiritual philosophy. The divine comes from an unspecifiable zone beyond the threshold of ordinary perception. Silence is the clearing of that threshold for its arrival. If one were to draw a diagram, the vectors of attention would be directed off the page toward an implicitly radiant spiritual horizon. The geometry of radiance is omnidirectional, making specificity and focus impossible.

Cage's redefinition of silence shifts it not only from empty receptivity to active, disciplined attention (in which the empty becomes full while remaining empty) but also away from the notion of silence as indicative of absence and longing. The silent that transliterates into "listen" marks the always present possibility of things previously unremarked. From the 1950s on, Cage's new geometry of silence requires a different sort of diagram, one in which events from the ordinary world enter into precisely composed apertures, by chance and intention, filling the foreground with a newly identifiable material presence that, as it comes into audibility/visibility, collapses background and foreground into one. From the 1950s on, the traceries of this geometry are what all of Cage's scores (as well as his visual art) present to the performer-auditor-viewer for realization.

Our legitimated geometries of attention determine the kinds of ambient information we find disturbing or confusing or unintelligible. If postmodern theory has taught us anything, it is that the internal logics and internalized values of cultures frame naturalized prospects that obliterate, miniaturize, or exoticize all things outside their scope. They create horizons of social silence and monodirectional alterity. John Cage's Copernican paradigm shift in aesthetics has direct implications for social and his-

torical silences, as well as for the arts. Just as we now recognize silence not as the absence of sound (physically impossible) but the sound we happen to be ignoring, the white noise of the habitus can be understood as the persistently ignored and devalued, the seeming irrelevant—the irritatingly cacophonous mélange of otherness. Silence/Noise becomes music, voice, object of interest only with a change in ethos that can shift trajectories of noticing. In this sense it is a thoroughly poethical matter.

It is not the romanticized angel of history but the very pragmatic angles of attention that should occupy us. What this implies is that we need to devise projects that in their sustained attention and collaborative scope adjust the distribution of silences, that is, the distribution of value and power. Consciously redirecting our noticing entails cultivating disciplines that are difficult and anxiety laden, as well as tonic and nourishing. To intentionally devise methods of bringing silence into one's work, as Cage did with his selective use of chance operations, is to acknowledge the dire limitations, even the dangers, of relying uncritically on habitual practices, familiar perspectives. This is as much about taking pleasure in intricate strangeness as it is about survival. Can it be that the best way to adjust geometries of attention is to be, like Cage, playfully and purposefully curious? To begin with questions, to undertake every project as an investigation? A new geometry of attention is a new choreography, a new music, a new visual art, a new poetry, a new science, a new mix of genres, that is, a new form of life.

That John Cage found ways to use the fact that pure silence doesn't exist, to redefine silence as sound, and to turn that figure/ground shift into an open window on our world is a major contribution to the health of our uncertainties, the power of constructive curiosity. The worldwide influence of Cage's work has vastly enlarged the field of improbable possibilities.

Silence is in us, a constituent principle of all our habits and perceptions. What we don't know about ourselves in these complex times is equaled only by the radical independence of all that does not reflect our most cherished self-images. Is it that to come to love silence is to finally experience one's own otherness, one's own mongrelism, one's own unintelligibility in playful and grave reciprocity with the rest of the world?

Fig. 1, Ground Zero, Fig. 2

John Cage—May 18, 2005

Zero is always a starting point; in signifying the absence of
one thing it implies the possibility of another.

S. M. Quant, *Manual for Desperate Times*

My computer has accurately noted the date for three years but suddenly dates this essay May 18, 2005. I'm writing it in 1989 to present at a Cage festival outside Washington, D.C.[1] This is a decade prior to Year-2000 concerns that computers unable to read a date beginning with 0 will self-destruct. (Only machines laboriously reprogrammed to be "Y2K compliant" will survive.) Even in ignorance of impossibilities to come, this leap onto my screen of the fifth year of the twenty-first century seems highly improbable. I've adjusted the calendar several times, read the manual several more, but can't fix it. My intention is to have the correct date. My computer, of course, has no intentions. It's electronic networks are designed to function in reliably predictable ways. Any deviation from this, any "glitch," might be an accident of programming but could just as well be brought on by the fact that everything in our world operates in the same electromagnetic field. This interconnectedness makes the climates in which we live subject to vagaries of indoor and outdoor, cultural and natural weather.

By now it's well known that weather is a complex (chaotic) system with sensitive dependence on initial conditions (the "butterfly effect"); so writing on any computer, particularly in a neighborhood with vulnerable wires strung from pole to pole, is to be too intimately connected with the rest of the world. As has always been the case, the pragmatic-mystical union in which we all take part involves maximal

participation with minimal understanding and control. We define this dynamic nexus in different terms now—gods and fates have become many things, including politicians and habitus. But, in the turn from the transcendent to the pragmatic mystical, the geometry of attention can draw puzzles, even in the midst of all the turbulence and chance intersections, into the foreground of the constructive thought experiment.

Thinking of this then and now, when the undeniable, incompressible scale of interconnected life on our planet brings on waves of anxiety, I like the sound and look of C:\WP\CAGE 5.18.2005—the computer file that held this unfolding essay in my old computer. Even as I tried to correct it, it had become part of my imaginative coastline. I say coastline rather than horizon for reasons I discuss elsewhere.[2] I'll just say here that as metaphors of limit and possibility go, the self-referential location (and romance) of horizons interests me less than the dynamic, transformational exchanges between elements that we call coastlines. Horizons seem to be locations of fantasy, coastlines of probative and mutable imagination. More than a decade later I continue to walk along conceptual edges of this essay from starting-point accident to acquired meanings.

Any movement of the mind in relation to a given pattern occurs for the same reason the dense and seemingly random arrangement of stars in the heavens (the celestial coastline) acquired pictorial and mythological meanings for our ancient ancestors. Looking up, they noticed the archetypal connect-the-dots puzzle in the sky. They drew in constellations, colonizing the heavens with artifacts of their interactive, connecting imaginations. Gaps and disjunctions, when we don't suspect them as traps laid by a purportedly hostile avant-garde, tend to give us pleasure. We are the puzzling species. They awaken our associative faculties. Like the artificial intelligence we've created in our own self-image, the human brain seems to have a connection reflex—by means digital or analog, by straight lines or Brownian motion, by predesigned logics or probative intuitions.

It's not surprising that my computer's glitch date is more apt and interesting than May 6, 1989. For one thing, it's easy to associate with "futurist" aspects of Cage's work. Actually his work is, like all vital art, ripe with presentness and permeability to its contemporary condition. It is literally making something of (composing) materials of that condition, inviting us to enter the conversation with concerns of our

own moment. The work presents a coastline of sounds or words or visual marks where mind and aesthetic form interact, subject to conditions of cultural climates. That in turn alters those cultural climates (or microclimates), shifting geometries of attention. This sounds like an analogy with an actual coastal shore that is in dynamic interaction with the changing circumstances of water and air that constantly shift its geometry, but I want to suggest that the dynamic interaction of art and mind (each with its own fractal principles) may actually work similarly to coasts and meteorological elements, not just in a metaphorical relation. If the present is a coastline mediating the turbulent weathers of historicity and futurity, John Cage's decision to explore processes of chaos in his work may seem most strikingly futurist now. But the fact remains—as Gertrude Stein pointed out—that we persist in calling "futurist" (or "nihilist" or "outrageous" or "absurd") those things that address a "now" too complex, too unrecognizable to be immediately understood.

This raises what is perhaps the central issue of the avant-garde—what does one make of change? How does one compose new geometries of attention out of changes that are already taking place? When does one advocate new geometries of attention by literally composing things into view? And then, having done either or both of the above, what is to be made of the work?

Is the degree to which such work is valued governed by laws of something like cultural time-release, akin to those capsules only gradually absorbed by the gut? Another, more familiar, way to ask this question is, Does the truly vital new that Picasso and Stein declared always ugly at its inception always become beautiful over time?

I wonder, for instance, whether in May 2005 a Boston audience will be sufficiently initiated by the general culture's absorption of Cage's working principles—the larger principles of physics and biology and history from which they drew their vitality—to remain attentive throughout his Norton lectures, or *Empty Words* or *Mureau*.[3] These principles, which have to do with accommodating complexity, uncertainty, nonlinear dynamics, randomness, incompleteness, indeterminacy, became known in the twentieth century as characterizing the major movements in physics and mathematics and in the last decades as characteristic elements of what has been called the science of chaos. I'd like to think there's hope for what I value so much, find so beautiful, in Cage's work—the way it brings us into pleasurable contact with

what can be otherwise daunting experiences of the dicey nature of our contemporary world. Since my working conception of hope is nothing more or less than the willingness to be pleasantly surprised, I needn't worry too much about the odds.

I of course can't predict the future reception of Cage's work. It is, was for him, a radical wager. That's a large part of its beauty and moral courage—its inherent poethical stance. But we do tend to assimilate into our formal expectations structures that science has legitimized in its changing models of reality. The new paradigms of complexity in fractal geometry, physics, biology, physiology, and neuroscience have led to a series of figure/ground shifts in which simplicity and complexity redistribute focal and value positions. Although chaos and flux and the inextricable interrelatedness of things form a nexus that has been treated and redefined in every era, was treated philopoetically in pre-Socratic texts, the engine of modern science had been until recently a tunnel-vision pursuit of simplicity and elegance, not only leaving primary aspects of our experience of the world unexplored but casting them into suspect categories of confusion and error. Luckily the gamut of possible foregrounds for the sciences and the arts now includes multiplicity and unpredictability.

Difficult perceptual shifts, new vectors of attention, have defined the province of the avant-garde. (We want profiles; s/he gives us vase; we see nothing but an absence of profiles and declare that there is nothing at all there!) Whatever the intentions of any particular artist at any given moment may have been, the avant-garde event, by definition, connects us with something unprecedented in contemporary experience. When this unprecedented material becomes assimilated, so may the artist. When it does not...Even when the avant-garde impulse seems largely negative, as it did in the post-WWI dada explosion (Ecrasez la bourgeoisie!, etc.), the extent to which that impulse plays itself out in art renders it a constructive making (poesis) of new patterns out of the cultural material (ethos) of the times, thereby opening new fields of possibility to those who (poethically) care to notice.

John Cage has given us two major figure/ground revolutions. Because of his work we are able to hear noise as music. We are also able to hear silence as sound and, more generally, as those presences (natural and cultural) we have not been attending to. This enlargement of the scope of our noticing allows one to understand aesthetic, meditative, and social silences as all having to do with qualities and choices

of attention. But changes in paradigms tend to be resisted. Why is this? Probably because we humans are richly complex creatures not quite in possession of an open-ended neural network coupled antagonistically with a stubborn strain of biological conservatism—hardcore fear of difference—which we, often shortsightedly, identify with survival.

So we as a species produce among and within ourselves agonistic factions like two strains of mathematicians in France—the Bourbaki group, set theorists who some say are as fanatically committed to rigor in numbers as the Académie Française is to purity in letters.[4] They started out to counter the vagaries of Poincaré (beloved by philosophers who claim that rigor is achieved only through loss of meaning), to flush out ambiguity and paradox. The playful humor that led them to cloak themselves in the collective pseudonym "Nicolas Bourbaki" complicates the story along with the fact that their work inspired the OuLiPo writers—Queneau, Perec, Roubaud—who like to play with a poetics of constraints and systematically induced improbability.

Those who see more problems than possibilities in rigid limits argue that all meaning in this richly complex, nonlinear, turbulently chaotic universe rests on a firm foundation of paradox, intriguing ambiguity, and other delightfully troublesome principles. Benoit Mandelbrot, the inventor of fractal geometry, declared something like this to the Bourbaki, who in turn announced that he was obviously no mathematician. (Just as physicist Mitchell Feigenbaum was thought to have abandoned science when he began to spend time on complex nonlinear problems like those of turbulence. And as John Cage was thought by boundary keepers to be operating outside the realm of music when he refused to distinguish between musical and nonmusical sounds.) What Mandelbrot, Feigenbaum, and Cage have in common is that they all turned to the abundant, undisciplined world outside the current boundaries of their professions for the material on which they worked. Mandelbrot took on snowflakes and coastlines and broccoli; Feigenbaum took on clouds and water flow; Cage took on...well Cage took on everything audible on our boom box of a planet. All three seemed to recklessly disdain a certain sacrosanct, impoverished notion of delimiting rigor.

Rigor, as we now know from Gödel, Bertrand Russell, and others, is not secure. It is, ironically, those systems that attempt the greatest rigor—logic, mathematics, linguistics, theoretical physics—that are

capable of generating the most interesting paradoxes, paradoxes that save them, despite themselves, from rigor mortis. Does this mean paradox and rigor (which one might, in certain contexts, transmute into Feminine and Masculine) are the two sides of the Western rationalist coin—our yin and yang so to speak? (Interestingly, leading Eastern philosophies seem to put their complementary principles on the same side of the coin.) Is it the case, then, that as we toss coins or computerized equivalents in chance operations subject to statistical probability, we must always awkwardly, painfully, straddle irresolvable polar extremes? Is this the inevitable outcome of High Noon Western Mind in collision with its own dualisms of world and idea, chaos and order, irrational and rational, noise and culture...all those markers of complex range that, when left uninspected, function automatically as invidious comparisons?

The art we have tended to value most highly, like the ancient rituals and mythologies that spawned it, has given us a sense of coming closer to those things that affect us most deeply *and* that we understand least—a familiar catalog of things that are thought to carry power or omen in our lives: destiny, the gods, human power, family, social conditions, good, evil, love, death—all of which can elicit fascination and terror, fear and trembling, Either-Orness, and even, remarkably, humor. We find it—to focus only on theater—in the drama of ancient Greece, Shakespeare, Strindberg, Ibsen, Beckett....One could trot out several canons—literary, philosophical, and musical, and much that those canons exclude. Is this capacity to take us to the edge of our needs and desires, to the collisions of our humors in a notoriously strange universe in John Cage's work?

Cage credits many teachers with the evolution of his views on art and its relation to the rest of life, among them Gertrude Stein, Erik Satie, László Moholy-Nagy, Arnold Schönberg, Sri Ramakrishna, Ananda Coomaraswamy, D. T. Suzuki, Huang Po, Marcel Duchamp, Buckminster Fuller, Marshall McLuhan, Henry David Thoreau, James Joyce, Robert Rauschenberg, Jasper Johns, Jackson Mac Low, even— toward the end of his life—Wittgenstein. But perhaps the idea most characteristic of his aesthetic, characteristic even in its negative implications, came from Duchamp—that the only thing that is not art is inattention. This may seem glib or facile or simply false until one begins to think of how difficult it really is to calmly, wholly, intensely,

meditatively, contemplatively...attend to anything at all in our distracting world. I think it's for this reason that the "attending arts" of pop culture involve what one might call full-saturation media—movies, video, music—with their blitz effects. These, interestingly, all involve sound tracks—the aural stimuli one literally cannot turn away from within range. If there is art in films, apart from the mass entertainment values of movies, it is in those that refrain from steering the emotional response of the audience with the sound track. Think of the blasting, flooding, drowning of the senses by the previews alone. This, quite calculatedly, is meant to be a Dionysian erasure of any complex monitoring of one's response, making superfluous the conscious structuring of perceptual stimuli. Not necessarily problematic unless it's the only cultural engagement one has. The level of sensory awareness that the arts can invite—buoyed by the surface tension of difficult matters—is part of an engagement with meaning that one might describe as the ongoing humanistic project of contextualizing our senses. When one earnestly turns one's attention to something more strategically demanding than the broadcasting of pop culture, one chooses to live in a volitional mode of transitive prepositions, a form of agency that positions consciousness in conversation with world. To attend *to* is to be present *to*. The word *attend* in English and in French comes from the Latin *attendere,* to stretch toward. The lovely thing about that stretching, its luxuriant and luminous touching of things outside oneself—the grace of it—is that it encompasses the Dionysian along with the ardent rational. There is no necessity for an either/or, as Cage demonstrates.

But, says the exhausted interlocutor, we who might acknowledge the value of stretching toward things outside ourselves, exploring what lies beyond the limits of our "coping," feel too damned besieged. Stretching—mentally as much as physically—is taxing. It takes energy we don't have. The very senses and faculties we might stretch in excess of coping are too fatigued, burned out, dazed, dazzled by the sensory overload of today's world—the condition persistently known as "modern life."

Does it then require the luxury of remove to take on the wager of "high" consciousness proffered by "high" art? Thoreau, in the early nineteenth century, felt overwhelmed by the clamor of society in Concord, hence the need (desire?) to slip away into the woods. Nuns and monks, East and West, have been going into cloisters or onto moun-

taintops for millennia. And then there are all the "back to" movements, presumably to access a simpler life, to get away from the din, to focus, to concentrate, to gain clarity of mind and value. This is also why "high" art, primarily an experience of selective focus (and selective inattention), has traditionally separated itself off from the rest of life—being presented on stages, pedestals, in frames of various sorts, blinds drawn, behind closed doors. Notice all those "highs"—even the drug culture's use of the term has to do with the idea that transcendence (being at a high remove) is the only hope for claiming one's capacity for joy. In the twenty-first century the preponderant view of art is still as transcendent respite from the mess of the quotidian. Or as a mirror reflecting the great soul of the artist, or God, or both in collaboration, or nature undisturbed by urban noise.

It seems over and over again to come down to Idea vs. World: is it no things but in ideas; no ideas but in things; no ideas but in ideas? If we could just get that straight, we might understand a thing or two in this hall of mirrors artfully directed toward/away from love/death, flux/stasis, emotion/reason, the persistently evil/the ephemerally beautiful, the foolish, the ruinous, the sardonic—all in their many guises and manifestations colored by the artist's intention of engaging the emotions and elevating the mind of a gratefully receptive audience. Grateful because the artist has done the work of connecting the dots and directing the mirror toward only the very best constellations. The viewer, excepting scholars and critics whose business it is to fill in silences, is not so grateful toward artists who leave us in the mess, the overflow, the gaps.

This high art of the constellation has no doubt been edifying. We've been edified out of our senses by gods and geniuses, edified beyond belief, edified to the point of desiring only that life emulate an art so removed from life that its imitation would ensconce us finally in the flatland emporium of Plato's immutable forms. One high-mindedly goes to high art as to a high-priced drug, to get a temporary fix. The question is whether high art helps us live in the parts of the world it so brilliantly excludes—the world that's not so tastefully constructed, not so harmonic and orderly, that doesn't seem to have a theme, a consistent voice, a center, that doesn't even have elegantly composed vanishing points.

How can anyone blame aspiring Greats for excluding the insistent cacophonies? They are difficult to work with. They demand and dull

attention simultaneously. If there is a god who created this chaos, that god is clearly an avant-garde artist; that is, no consolation.

John Cage thought that the function of art is to help us pay attention to the magic that comes not from art but from everyday life—to draw closer to the experience, to draw energy precisely from those parts of it we don't understand—its silences. "People," he said, "...have great difficulty paying attention to something they don't understand. I think," he said, "that the division is between understanding and experiencing....Music is about changing the mind—not to understand, but to be aware."[5] The thing we understand least about our world is its random multiplicity, the synchronous occurrence of an infinite number of unrelated events that make up the texture of any given moment of consciousness. The violence that frightens us most is random violence—unpredictable events that alter and even end lives. We have invented and named fates, gods, and principles of universal justice to protect ourselves from the knowledge that we are all fortuitously and perilously subject to the often not so benign butterfly effect. That weather and traffic patterns and the configurations of most of what we see and hear are unpredictably sensitive to initial conditions beyond our imagination. That they are fundamentally nonintentional, have no beginning, middle, denouement, climax, end—except as we compose those things for our own purposes—is a fact of life. That we experience life on multiple perceptual and cognitive levels is a fact of human nature.

John Cage's art acknowledges and works with these facts as its point of departure, its set of initial conditions, themselves—in their radical indeterminacy—sensitively dependent on whatever an audience or viewer or reader brings to them. Cage, who believed that art should imitate, not nature, but "her manner of operation,"[6] invented structures in which many butterfly effects converge to create temporal developments that are chords of multileveled resonances in what he called "anarchic harmony" with ambient noise. This is why he stopped working with traditional forms. Form, he came to think, is the shape of what happens over time when you put a limited set of initial conditions in motion. Cage's compositional processes, in other words, continue within the realization of the piece. They move from his own strictly rule-governed chance operations, based on first principles and values, via a series of compositional questions, to a collaborative complexity, intimately involving performers, to a simultane-

ously bounded and indeterminate field of events involving the audience in its poesis.[7] This is clear in all his music from the late 1950s on, from large-scale compositions like *Musicircus, HPSCHD, Atlas Eclipticalis,* and the *Europeras* to his compositions for solo instruments and throughout the "number" pieces of the final decade of his life.[8] It's also true in his writing. Let's look, for instance, at a page from *Empty Words.* (See Fig. 1.)

Huang Po, who at least in translation does not eschew the notion of understanding, says, "If you wish to understand, know that a sudden comprehension comes when the mind has been purged of all the clutter of conceptual and discriminatory thought-activity. Those who seek the truth by means of intellect and learning only, get further and further away from it."[9] In looking at Fig. 1, then, try to empty the mind of the following conceptual and discriminatory thought activities: This should be a mirror of somebody's mind, preferably a great artist and/or thinker; this should be an artfully directed mirror of reality, preferably revealing graceful patterns and hard-won harmonies. But it seems to be neither. What the hell is it? It's nonsense! I don't understand it! What's the point? What are those weird squiggles? What are they meant to illustrate? I don't get the point! This is ridiculous! I can't figure it out!

Now that you have exploded your rational arsenal, you are at ground zero. Turn to Fig. 2. What do you notice?

For Cage the importance of the return to zero is both the Buddhist ideal of "empty mind," from which fresh perception might spring, and a compositional principle reached not by dadaist or surrealist free association or improvisational action but by strict adherence to carefully considered procedure. In this way his work is related to the OuLiPo group, which also investigates what happens under predetermined constraints. In contrast to the mathematical preoccupations of OuLiPo, the interests and values out of which Cage worked touch on a much broader spectrum—traditions in all the arts, his personal pantheon of influences: Duchamp, Joyce, et al.—as well as an architectural love of space-time volume and grids, to principles of nature and, of course, everyday life. There are countless examples of this last source of ideas. He conceived the idea of *Musicircus,* for instance, while enjoying the human and automobile traffic on a street corner in

Seville. The fact of his fifty-year collaboration with dancer and choreographer Merce Cunningham no doubt shaped his sense of the musical event as physically sited and spatially multidimensional.

Cage's compositions are designed to create open rather than recursive systems. What does *open*—by now a flaccid term—mean: a system whose logics are quite obviously not complete (semantically reinforced and self-identified) within themselves but must be taken up and furthered by the audience. In this way one's consciousness is invited to venture beyond, although not to entirely abandon, its most habitual and intrusive preconceptions and intentions. This probative wandering sets the scene for the Ah Ha! experience not only in Zen and the arts and sciences but in any adventuresome investigation. This is the opposite of transcendence because it asks us to look not at the recursively projective screen of the horizon but at that most difficult of all scenes, what is right before and around us. Attending to one's immediate circumstances is basic to the way all organisms preserve their vitality. The mind need not (indeed, cannot) be entirely emptied of its perceptual structures in order to experience art-life in the way Cage recommends, but those structures must have practiced permeability. One must become vulnerable enough to sensual-conceptual transformation to experience the perverse pleasure of figure/ground shifts in which much more can become figure—figure that is vibrantly real—than we previously had grounds to imagine.

The borders that frame Cage's compositions are semipermeable membranes that participate in dynamic, fluid exchanges with the elements that surround them: ambient sounds, ambient thoughts and emotions, cultural weather. In the case of a composition like *Empty Words,* ambient etymology and spatial intuitions figure in as well. Meaning is a complex system sensitive to the precise, unpredictable mental and emotional, and even appetitive, conditions of each member of the audience, each viewer, each reader. This ever-changing ambient field is what makes stable interpretations a hoax, generally perpetrated to bolster some locus of authority. Art is surely a life system within our material culture; all life systems are dynamic. The biological principle of the semipermeable membrane makes possible the life (motility, development, exchange) of systems—their nourishment and interactive responsiveness. This is as true of our aesthetic and intellec-

tual metabolism as it is of processes that go on in the gut. Art is a form of life.

According to Cage the proper response to art as life is "merely" to delight in it with heightened awareness, to experience the reflexive humor of the figure/ground shift, the wonder of richly improbable conjunctions as the ambient comes into and is shaped by the art. I associate this with the French notion of *jouissance,* a playful erotics of informed sensuality. The figure who will always be known as Cage was himself full of jouissance—a wonderfully polymorphous perverse jouissance. Supposing this is all he has to offer us—his sense of the opportunity to develop a capacity for delight in complex aspects of reality we have a strong tendency to ignore, or deny, or escape in our daily frenzy. Delight in the graceful, anarchic harmonies of nonintentional configurations of sounds and sights in our everyday world. Is this enough?

If it were possible, how could it not be enough! Does this sound glib? Thinking again, in this age of cultural Attention Deficit Disorder, how rare an informed, intense, not to say pleasurable connection with anything in our daily lives can be—the effects that this distractedness has on possibility and aspiration—this role of the arts seems positively urgent. There is strong support for this aesthetic function in the American pragmatist tradition, from Emerson's capacity to notice light in a puddle that makes him "glad to the brink of fear" to John Dewey's *Art as Experience.*[10] Dewey writes,

> To my mind, the trouble with existing theories [of art] is that they start with a ready-made compartmentalization, or from a conception of art that "spiritualizes" it out of connection with the objects of concrete experience.... The nature of the problem [is] that of recovering the continuity of esthetic experience with normal processes of living.... [This must occur because] if the gap between organism and environment is too wide, the creature dies.... Experience in the degree in which it *is* experience is heightened vitality. Instead of signifying being shut up within one's own private feelings and sensations, it signifies active and alert commerce with the world; at its height it signifies complete interpenetration of self and the world of objects and events.[11]

It is the role of art, according to Dewey, to stimulate and maintain our capacities for such interpenetration, such heightened awareness.

This is the pragmatic-mystical ground zero: zone of Cagean silence.

That is, scene of new composition that redefines geometries of attention. It's full, even in its conspicuous absences, of the matter that is always improbably there, that must be attended to if we are to recover our senses and move on. It's not that one loses Fig. 1, or anything else, at ground zero; it's that we gain the possibilities in Fig. 2.

andthe andtwitimmaterialandofcallnot
skyup ytedwawith Just ly theninwhatworn
 thosebrightat poland umly any Coll.
 stem with iseessNo

 wnh lar Iover isense

 w red
 fraghtsso hechow Privet ime ea
my e is formed anwhichthee m
a-thefeetts. Tseeds chuIweeds

oflalltLy theap tley not its us
where bewardlovsberanddeour liarrough
 - edged twen are mismayToxside are new
 theanandston lythantained ket

 eggthe ofis ou The be nd, tha
 pick thirminuteswith
 goldwhatsbr ining ousstbeen it otc.
 e fisha crowththt ple e soon ety

 do Araliaconcentratedvermilion one o
 per notred epleasantlyndlsp w-c a
 ldin spyfewdust
 whilebeingsrichlyAt nn for thweath fas
 cloud een-f e threetthyoungWhy
skimmed much firstsoundis

edis ckly o or ehndc faint ro con ary th
 grsons

 of toand ngp ef-bwinwood
 tto nd. Fe nors
nthsuchg sucaposed

 mhasing notsuited oncovering pinely
 skn rpmera i isat pines ghills

 dryingi above masswith-point and
 grownhighwas ri legsnPI tail
 everynth-isyingr aRiver
ncyfrprimetera gleoenour g oped tmymb sta
a rmhavecutwadb - twotoit havefthe n
 malseelit o flahowcr i ofasockscav e

 on bout ca g ormanyioncioni
 ha Un plates Thetemnote
and thatis oc ber
 ly theberor The miss Brook

andthe andtwitimmaterialandofcallnot
skyup ytedwawith Just ly theninwhatworn
 thosebrightat poland umly any Coll.
 stem with iseessNo

 wnh lar Iover isense

 w red
 fraghtsso hechow Privet ime ea
my e is formed anwhichthee m
a-thefeetts. Tseeds chuIweeds

oflalltLy theap tley not its us
where bewardlowsberanddeour liarrough
 - edged twen are mismayToxside are new
 theanandston lythantained ket

 eggthe ofis ou The be nd, tha
 pick thirminuteswith
 goldwhatsbr ining ousstbeen it otc.
 e fisha crowththt ple e soon ety

 do Araliaconcentratedvermilion one o
 per notred epleasantlyndlsp w-c a
 ldin spyfewdust
 whilebeingsrichlyAt nn for thweath fas
 cloud een-f e threetthyoungWhy
skimmed much firstsoundis

edis ckly o or ehndc faint ro con ary th
 grsons

 of toand ngp ef-bwinwood
 tto nd. Fe nors
nthsuchg sucaposed
 .

 mhasing notsuited oncovering pinely
 skn rpmera i isat pines ghills

 dryingi above masswith-point and
 grownhighwas ri legsnPI tail
 everynth-isyingr aRiver
ncyfrprimetera gleoenour g oped tmymb sta
a rmhavecutwadb - twotoit havefthe n
 malseelit o flahowcr i ofasockscav e

 on bout ca g ormanyioncioni
 ha Un plates Thetemnote
and thatis oc ber
 ly theberor The miss Brook

Fig. 2

Poethics of
a Complex Realism

I

Before his death in 1992 John Cage was a vivid and ubiquitous presence
in the world. In the last year and a half of his life he contributed to and
attended most of the growing number of small to grand scale concerts
and festivals in anticipation of his eightieth birthday—events in Ger-
many, Austria, Spain, Italy, Czechoslovakia, and Switzerland, and
even—although notably fewer—around the United States. He was at
Crown Point Press in San Francisco working on a new series of prints;
at home in New York City producing prodigious quantities of music, as
well as language compositions, including a new "Writing Through" of
Ulysses ("Muoyce II"); editing the film *One¹¹* (premiered in Frankfurt,
September 20, 1992); consulting with performers, festival directors, ed-
itors, publishers, copyists, curators, art dealers; responding to inter-
viewers; responding to requests for information; answering the con-
stantly ringing phone; answering mail from young artists seeking advice
("I feel I should respond because I don't teach.");[1] writing letters of rec-
ommendation; shopping for food; cooking; inventing and collecting
recipes; administering a botanical loft with close to two hundred plants;
playing chess; enjoying friends...and always thinking about what he
was doing and why, questioning what else or other might be possible—
what new questions could be asked.

In this continual process of doing—the composing, writing, visual practices, even the cooking—was a highly developed discipline of attention to detail, a meditative inquiry into specifics: spatial-temporal-material specifics; that is, the particulars of an inquiry into aesthetic possibility where we understand *aesthetic* to locate the interaction between the probing, structuring mind and the sensory correlates of our modes of perception.

For John Cage the significance of art lay not in the production of artifacts but in the making of meaning as an active collaboration with medium, performers, and audience. So the scores and texts and visual art that John Cage left behind will always be work that has yet to be done. Work to be engaged in by a participatory audience, viewer, reader at a specific intersection of material, place, and time occasioned by a performance, an exhibition, a screening, or the presence of a text. One way to think of this is that what we call the work of John Cage exists entirely in the form of a collection of scores—visual and auditory notations—music (on the page and in performance), texts, drawings, prints, and paintings, that are invitations to realization (to use the musical term for performance) of our aesthetic potential in a poethics of everyday life. In this way Cage's work—as well as our continuing collaboration with Cage—unfolds within the American pragmatist tradition characterized by the aesthetic theory of the philosopher John Dewey. The theories of John Dewey were influential in the formation of Black Mountain College—a brief but significant catalytic scene of the new aesthetic that John Cage, Merce Cunningham, and Robert Rauschenberg (with important contributions from Buckminster Fuller) were pioneering. Dewey was a friend of the chief founder of the college, John Andrews Rice, and became a member of its advisory board in 1935.[2] Dewey wrote in *Art as Experience* that the chief problem for artists and theoreticians is

that of recovering the continuity of esthetic experience with normal processes of living. The understanding of art and of its role in civilization is not furthered by setting out with eulogies of it nor by occupying ourselves exclusively at the outset with great works of art recognized as such. The comprehension which theory essays will be arrived at by a detour; by going back to experience of the common or mill run of things to discover the esthetic quality such experience possesses. Theory can start with and from acknowledged works of art only when the esthetic is already compartmentalized, or only when works of art are set in a niche apart instead of being celebrations, recognized as such, of the things of ordinary experience. Even a crude experience, if authentically an experience, is more fit to give a clue

to the intrinsic nature of esthetic experience than is an object already set
apart from any other mode of experience. Following this clue we can
discover how the work of art develops and accentuates what is characteris-
tically valuable in things of everyday enjoyment.... To my mind, the trou-
ble with existing theories is that they start from a ready-made compart-
mentalization, or from a conception of art that "spiritualizes" it out of
connection with the objects of concrete experience.... A conception of fine
art that sets out from its connection with discovered qualities of ordinary
experience will be able to indicate the factors and forces that favor the nor-
mal development of common human activities into matters of artistic value.
(10–11)

II

Art as Experience / Theory as Practice

What could be a more ordinary part of everyday life than weather?
Weather is just that state of the atmosphere at a given place and time
characterized by specific variables such as temperature, moisture, pres-
sure; presence or absence of rain, hail, snow, lightning, thunder, ice, fog,
etc.; quantity of sunshine; wind velocity (violence or gentleness of
winds)—any condition of the atmosphere subject to variables and vicis-
situdes, which is of course every condition of the atmosphere.

WHETHER WEATHER

John Cage: "I am willing to give myself over to the weather. I like to think
of my music as weather, as part of the weather."[3]

New York City, July 17, 1992—the Summergarden Concert Series in
the Museum of Modern Art Sculpture Garden. Two pieces by John
Cage are to be performed: One[8]—"53 flexible time brackets with single
sounds produced on 1, 2, 3, or 4 strings" of the cello; and ASLSP—a
piece for solo piano to be played "as slow as possible."[4] All of the con-
certs in this series are held outdoors; no arrangements are made for
moving them inside. In the event of inclement weather they are simply
to be cancelled.

All day on this particular day in the New York metropolitan area it
has been on the verge of rain. All day, as others have worried, John
Cage has relished the "whetherness" of weather—not knowing until the
last moment whether the concert will go on, and even after it begins, be-
cause of continued uncertain weather throughout, knowing that each
moment of the concert might be the last. Twice during the performance
uniformed museum employees—whose poised readiness (like Wimble-

don ball runners) has clearly embodied "whether"—advance on the loudspeakers and amplifiers to rush them inside; but the weather holds, so we remain in the mi/d/st of "whether," on the edge of rain. Each sound that comes from the cello, as well as the silence (ambient sound) of extranotational possibility, is savored as the gift it would of course be anyway but here, given the particular atmospheric circumstances, is thrown into relief. Cage's only concern has been that the musicians be paid whether or not they can perform.

It is the nature of performance to be fraught with "whethers" anything could go right or wrong at any time. And in this, even as it strives for certainty and precision, it both replicates and operates within the constancy of life's variability. The conditions of performance with its inherent risks provide a congenial vehicle for Cage's work with chance, so much so that all his "nonperformance" art is fundamentally performative in its requirement of audience-interactive processes—active listening and viewing—to complete its meaning.

This evening, the probability of rain has necessitated wrapping the piano in heavy sheets of industrial plastic. Black garbage bags shroud the six loudspeakers mounted on tall metal stands. Near Picasso's bronze goat the sound man crouches with his bank of amplifiers under dense foliage of a small tree in which a single bird sings loudly and persistently. A billowy plastic tent is erected over the cellist, Michael Bach, as he is tuning up. For the duration of the cello piece—43'30"—the translucent plastic will be articulated by gusty breezes sending pools of accumulated mist into randomly intersecting rivulets just above the head of the cellist. This tent, improvised by necessity of weather's "whether," becomes as much a part of this performance of One^8 as the Mineko Grimmer sculpture (also making the operations of chance visually available) has become a part of One^6.[5] Both the traceries of this light drizzle and the sounds of One^8 are the results of chance operations—those of nature, and those of John Cage imitating nature's processes, understanding nature's processes to involve (as they always do) an interaction between chance and selection. This is, in other words, not the ineffable romantic mist; it is the fully present, complex realist mi/d/st of an actual weather system with immediate, rather than transcendent, consequences. If it is to have transcendent meaning, it is the poethical work of the audience to make that meaning—the responsibility of imaginative collaboration that this kind of art requires. It is the work of the composer (or artist of any kind) only to create the occasion for the making of meaning.

To review this concert is then most appropriately to give a kind of retrospective weather report: The weather system in the garden at MOMA from 7:30 P.M. to 9 P.M., July 14, 1992, was complex and engaging. It consisted of layers of traffic sounds, sirens, airplane motors; a palpably silent, diagonally pulsing mist; rivulet readout; bird aria; and solo cello. In the second part of the concert the cello part was replaced by solo piano, played by Michael Torre with somewhat excessive brio.

Weather was the medium in which this concert took place. It was also its form. Michael Bach in his transparent weather tent played a music of w(h)e(a)ther distinguished by the fortuitous coming together at this particular time, in this particular place of a number of verging and converging paths of sensory variables. The cello part was realized both as one set of variables among many and as the structuring event that, despite its own fundamental contingency, created the bounded pattern bringing other elements into auditory and visual focus. All of this on the edge of coming and going without a trace, nothing to remember after each sound (mostly, due to chance operations, richly resonant chords) has been played. There is none of the periodicity, the rhythmic or melodic line developed in music to counteract the fact that it is the most transitory of all media—the medium bound to time, the medium of vanishing and change.

> John Dewey: "The eye and ear complement one another. The eye gives the *scene* in which things go *on* and on which changes are projected—leaving it still a scene even amid tumult and turmoil. The ear...brings home to us changes as changes." (*Art as Experience*, 236)
>
> Søren Kierkegaard: "Music has time as its element, but it gains no permanent place in it; its significance lies in its constant vanishing in time; it emits sound in time, but at once vanishes, and has no permanence." (*Either/Or*, 2:139)

John Cage's music is both faithful to and revelatory of these characteristics of its medium. There is nothing to take home with us in the way of a tune or beat to arrest time's erasures. Yet there is no sense of loss. On the contrary, there is the memory of something much richer and more complex than a rhythmic line—the memory of fully awakened and surprised sensibilities, sensibilities initiated into the possibility of a fuller presence in the world beyond the concert—Dewey's art as experience/experience as art. Having been so totally and delightfully suspended in both weather (including the urban weather of traffic sounds) and "whether," we could attend to the extraordinary grace notes of am-

bient possibility, the range of contingent detail that teems about us. What makes Cage's aesthetic so important is how often we're annoyed, confused, dismayed, frustrated by ambient circumstance.

Take time, for instance. Our perception of time is bound up with feelings of inadequacy: Will we be ready on time? Will we *ever* be ready? And loss: So much is no longer possible, gone, past, forgotten. Art can exploit our susceptibility to these feelings by sweetening them with nostalgia. This helps us deny the experience of time rather than exploring it in a way that might help us live more honestly, courageously, humorously, even serenely with it. In fact, time comes into our attention only intermittently, usually because of anxiety: Is it early? Are we late? Is it *too* late?

The performance of *One⁸* began when and where we all were—in *medias* race in New York City, world capital of the accelerated clock. For some of us the familiar, jittery experience of time may have been accentuated by the knowledge that it can be difficult to know precisely when a Cage concert has begun. But a generic source of anxiety in any time art is that a fragmentation of continuity seems to destroy stable context. By contrast, spatial arts provide, whatever their visual disjunctions may be, a reassuringly constant ground. For one to relish Cage's work, certain kinds of conceptual shifts have to transform the figure-ground relations of one's attention. In *One⁸* there are many long pauses during which Michael Bach, for technical reasons, might change bows.[6] As Bach began to play, this listener found that time was being reconfigured from silence interrupted by sound, to sound interrupted by silence, to sounds and silence coming into equal value, equalizing the medium in which the listener resides. The meditative dignity of the music had invoked a state of attentive calm in which time had become audible, constant, palpable, friendly, and habitable—as fully habitable as space—even as it was disappearing without a trace.

III

"Lecture on the Weather"

> Theodor Adorno: "The greatness of works of art lies solely in their power to let those things be heard which ideology conceals."[7]

Does ideology conceal weather? It certainly attempts to conceal "whether," alternatives, and they usually come only in twos. In considering anything beyond that—complexities of three and more...not to

say the infinite possibilities of "weather"—ideology becomes simply an engine of obscurantism and denial.

> John Cage: "Our political structures no longer fit the circumstances of our lives. Outside the bankrupt cities we live in Megalopolis which has no geographical limits. Wilderness is global park. I dedicate this work to the U.S.A. that it may become just another part of the world, no more, no less.
> "...Chance operations...are a means...of silencing the ego so that the rest of the world has a chance to enter into the ego's own experience" (preface to "Lecture on the Weather," 1975 [*Empty Words*, 5])

> "The idea was that if we could listen we could bring about some kind of change." (Remarks by John Cage after 1989 performance of "Lecture on the Weather," Strathmore Hall, CageFest, Rockville, Maryland)

John Cage's performance piece "Lecture on the Weather" can be seen as a paradigmatic case of his working aesthetic: twelve performers simultaneously read texts taken by chance operations from Henry David Thoreau's *Journal, Essay on Civil Disobedience,* and *Walden.* The pacing of each reading is variable within a set of specific time brackets. This creates periods of silence. Tapes of wind, rain, and thunder are played. A film flashes "lightning"—negatives of Thoreau sketches—over the performance area. The performance is, of course, not *about* weather; it *is* weather.[8] Like all weather—state of the atmosphere at a given time and place—this piece is sensitive to initial conditions; thus it is significantly different every time it is performed.

Weather Report: At the May 5, 1989, CageFest at Strathmore Hall, Rockville, Maryland, doors were open to the outside where a storm began to be audible and visible (thunder and lightning and then torrential rain) at about the same time as the storm was beginning inside in John Cage's "Lecture on the Weather." This had the interesting effect of eradicating the distinction between inside and outside. The meteorological display over Strathmore Hall was continuous with that going on in the room, where Cage's more gentle storm included the weather of predetermined and coincidental conjunctions of sound and voice variables—words, ideas, and silences that form the complex systems of sociopolitical climates.

> John Cage: "I thought the resultant complex would help to change our present intellectual climate." (*Empty Words*, 3)

That particular weather system on the evening of May 5, 1989, could be called "'Lecture on the Weather' with Weather." It assumed its particular and variable character because of the kind of permeable bound-

aries—between inside and outside the piece itself—that characterize all of Cage's compositions. The silences, the layered and intermittent simultaneities make it possible to admit other variables. In this case, first the sound of (outdoor) rain, then thunder, and finally lightning—meteorological traffic—with its flashing lights, collisions, and swerves.[9] In principle, and in fact, nothing audible or visible to the audience would have been excluded from the domain of the performance, although we might not think all possibilities desirable. In accordance with Cage's cherished idea of interpenetration and nonobstruction (one of the three "whispered truths" of Buddhism, and in consonance with Cage's quest for "anarchic harmony") anything interrupting or obstructing the performance would have been undesirable. As with all of Cage's compositions (at least from the 1960s on) this performance was intended to model an ideal state of anarchy—voluntary cooperation within interpenetrating and nonobstructive complexity.

What was being heard that night was indeed what ideology, with its myths of simplicity, usually conceals—that complexity, perhaps even chaos (and I'm referring here to the current image of chaos as pattern-bounded unpredictability), is not only with us, but it may be—if we can accept and work with it rather than against it—a source of energy for optimism.

IV

"*World Us*"

<div style="text-align:center">

our picture that's now Visibly
dEveloping
is woRld us
world citizenshiP
will nOt occur
as a Political initiative
it will be reqUired by the economics
of an expLoding
industriAl world

</div>

<div style="text-align:center">(John Cage, "Overpopulation and Art," 33)</div>

A multifarious, noisy, exploding-globe-cartoon "we" has careened over the psychological threshold of a new century, new millennium. "We" are saturated by media, in- and ill-formed by immaculately conceived factoids, deficient in knowledge of the most elemental things. How

to get along with each other, for instance, in the mi/d/st of dizzyingly increased complexity. Within that "we" of course are many ones and others whose investigations have modeled promising and nourishing and even productive forms of life. None has yet or will ever save the world, if only because the world is not a "the" to be saved, but there is work that allows us to live in cultural atmospheres of heightened possibility.

The work of John Cage with sound and visual media, as well as with the medium of language—*medium* not in the sense of the surface looking-glass imagery of mass media but as elemental and permeating conditions of life—enacts a peculiarly American model of possibility. What I like to think of as Cage's avant-pragmatism is a philosophical and aesthetic realism, disruptive of certain individual and institutional habits of mind while concretely revelatory of the odd and always interesting intersections of whether (chance and choice) and weather (concrete variables).

It's interesting to think of John Cage and Edward Lorenz, an MIT meteorologist,[10] as two characteristically American thinkers and inventors—both working in ways made possible by new computer technologies, both working—theoretically and pragmatically—on complex systems that form the conditions of our daily lives. At the start of his chapter on Lorenz's work on modeling weather systems, "The Butterfly Effect," in *Chaos: Making a New Science,* James Gleick quotes the late physicist, Richard Feynman: "Physicists like to think that all you have to do is say, these are the conditions, now what happens next?"[11] This is in fact what Lorenz did for the mathematical descriptive dynamics of weather systems, developing a set of differential equations into which initial conditions (e.g., directions of air flows in the atmosphere) could be fed and then doing a computer run of their interactions to see what kinds of patterns unfolded. It could also describe Cage's approach to compositions in which initial conditions (e.g., sound sources, pitch, timbre, amplitude, and duration) are fed into the variable slots of a random-number generator program that replicates the operations of chance in the *I Ching* (a program called *ic,* with a time values specific version called *tic*)[12] and then asks the computer to determine how the score (which will initiate the performative music system) is to be notated. Because Cage's scores always incorporate significant elements of indeterminacy, each performance of his music, like each performance of the weather, has a built-in difference of initial conditions whose variations can produce major changes in the system that unfolds.[13] This phenomenon, popularly called the butterfly effect, is characteristic of temporally evolving, nonlinear systems that are descriptively noncompressible and subject to pattern-bounded unpre-

dictability. In the complex sciences only dynamical systems whose descriptions have all these characteristics—such as weather and other forms of liquid and gaseous turbulence—fall under the rubric "deterministic chaos." It's interesting that the nature of the *interplay* of order and disorder has been significant enough in the history of ideas to require perennial updating.

Is it meaningful to say that what Lorenz has done for the butterfly effect in science, John Cage, with his music of weather and his aesthetic paradigm of deterministic randomness, has done in the arts?[14] Both can be seen as having worked in the Pythagorean tradition, where number reflects the relations between elements in nature. In music, as Pythagoras pointed out, this is number made audible; in computer modeling it's number made visible. Both Cage and Lorenz developed models for allowing numbers to enact the random elements in nature's processes. But the scientist and the artist diverge in interesting ways. Whereas Lorenz and his colleagues have been primarily interested in finding the orderly patterns in chaos by creating self-contained models that generate broadly repetitive forms delimiting local randomness, Cage, working as a composer in a field that has been dominated by self-contained repetitive forms, was most interested in the nonperiodic aspects of chaos—the local unpredictabilities.

The music makes this available to our attention in the space-time, materially delimited experience of the play of randomness Cage referred to as "chance." The music operates with the kind of chaos that permeates ordinary life as its forms develop in the dynamic interaction between unpredictable details in the atmosphere of its performative realization and the ordering minds of the audience. This structuring of what Cage himself called chaos was in accord with his pledge to imitate not nature but "her manner of operation." The active processes of natural systems are always in dialogue with, informed by the selective forces and random events in their environment. We know that this is what makes change possible. Edward Lorenz and John Cage, sharing a love of weather's changeability and an elegant pragmatics of investigative invention, broadened the field of possibility in science and art to include active models of what had until relatively recently been considered inappropriate or unwieldy objects of anything but metaphysical speculation.

From the start Cage's work in the arts was based in collaborations and material conversations with other artists and their work. In music the central collaboration was with dancer-choreographer and life partner, Merce Cunningham. In textual compositions the first great poetic

influence came from the work of Gertrude Stein, but direct language sources were most notably James Joyce and Henry David Thoreau. The textures of Cage's language compositions are, in their receptive maximalism, Joycean. Cage celebrated the detailed commotion of life even as he drew serenity from calming disciplines of attention that come to us from the East and humor from the conceptual shifts that are the legacy of Dada and Duchamp. Cage's oeuvre is European, Asian, and quintessentially American in its cultural pluralism. Its fundamental value of usefulness and its generous acceptance of chaos characterize it as a complex-realist aesthetic and a poethics of everyday life.

Not all is well and good in everyday life as America has come to market it. It is painfully clear to most reasonable people that if we are to avoid global ruin, the United States can no longer serve as a model for the lifestyle to which the rest of the world aspires. Robert Smithson seems to have been right in suggesting that other cultures have fallen into ruin but that our specialty has been to rise into it.[15] This is undeniable in the production of strip malls and megacommodities, but it may also afford an insight into a particular kind of art production. To the extent that our aesthetic endeavors have been aimed at creating edifices that stand upright and apart from their surroundings, to be admired rather than used, they are indeed prone to ruin and the nostalgia that fetishizes it. Work that is not continually redefined by use, conversed with, absorbed into the life around it is work that doesn't breathe, that has, as Cage put it, "become art" rather than a form of life. Becoming art (to stock the art market) is what recent Western aesthetics has been all about, posited on the very gap between art and everyday life that gallery owners and transcendental theorists revere and John Dewey and John Cage have disavowed. Long before specters of ecological disaster had reconstituted our sense of the fragility of our future, Dewey wrote, "Recovering the continuity of aesthetic experience with normal processes of living must occur... [for] if the gap between organism and environment is too wide, the creature dies" (*Art as Experience,* 19)

In an age of increasingly mediated reality where the object is losing in the competition with its simulation (see complete works of Baudrillard), where in fact reductive simulation has become a form of political life, where dichotomies of life/death, good/evil, external/internal, true/false, real/artificial have been the warp and woof in the weaving of synthetic textual "realisms," anxiety about what is left out of our imaginative constructions is warranted. Given that they shape our sense of what the future holds, they had better be commodious. They had better

be friendly to complexity, difference, otherness.... They had better help us live in our world.

v

> Overheard at art opening: "I like art; it's better than looking in the mirror."
>
> David Ruelle: "...what allows our free will to be a meaningful notion is the complexity of the universe." (*Chance and Chaos*, 33)

Pothooks

Suppose one wants to live by a principle one is trying to articulate. In this case the principle of "poethics," a practice in which ethics and aesthetics come together to characterize a particular form of life, in this case admitting—that is, acknowledging and valuing—complexity. I am writing an essay on John Cage—living inside and outside that present participle, "writing," for a number of months, piling on other present participles like "puzzling," "exploring," "questioning" what this idea, this practice of a Cagean poethics could mean; beginning with "Suppose one wants to live by a principle...." That is, beginning with a hypothetical. "Thetical," not "ethical;" not yet. My problem, in part, is just that—getting from the conceptual zone of the "thetical" to the pragmatics of the "ethical," both descriptively and prescriptively, discursively and formally, in order to enact, not just write about, a poethics. When, toward the end of this writing process, I activate my Spell Check, it stops at every instance of the word *poethics,* flashes "WORD NOT FOUND," and suggests that I must mean *pothooks.* Maybe I do. Maybe my computer has found the fast track thetical to ethical as John Dewey's "common or mill run," in this case, kitchen functional.

This is so crudely arbitrary, so epistemologically unsavory it's irresistible. It would surely take heavy theoretical machinery to justify, if indeed justification is appropriate at this point. It might even require an argument. Argument is considered epistemologically more respectable than accident even when it is accident that brings it on and accident that remains when it's finished. We might try something like one of those arguments so popular in the Middle Ages to prove the existence of God. These logical structures are still available to us—minus the unwieldy referent—as models of high rationalism. So the justification of the coincidence of pothooks and poethics might go like this: "If John Cage's lifework is a prototype of a contemporary poethics, and John Cage's life-

work included cooking,[16] (insert a few intermediate "if-thens")—we
without doubt arrive at a "therefore" that reads: A Cagean poethics is
something you can hang your pot on. Q.E.D. There are many instruc-
tion manuals that will tell one how to do this odd exercise with flair. It
can be very reassuring that the swerve off one track is merely the occa-
sion for locking onto another—forgetting for a moment, or for as long
as one can, the dizzying, empty space between them. This is all conge-
nial if one wants to remain in a single-track logical mode.

If, on the other hand, one wants to see what's going on outside
such structures, if one wants to see the world while exploring the
coincidence of poethics and pothooks, there are multiple logics at our
disposal—multiple ways of connecting multiple and disparate
things—deciding what can be included, how much surprise can be
tolerated, what comes next. Although, since identifying instruction
manuals for these modes poses a whole new set of problems (Would
a book of Zen Koans work? Any of Cage's books? A book of optical
illusions?), it can't be denied that to ignore the call to "pothooks"
would, if not simplify things, at least not complicate them further
than it already has. John Cage himself has cited Thoreau's injunction,
"Simplify, simplify." To do that we could notice that a pothook is a
kind of concrete interrogative; that a Cagean poethics is based on
questions; that both are forms of receptivity—as is the act of listen-
ing. This is not to discover deep structure but to make meaning firmly
grounded—as meaning always is—in tentative fragility, the circum-
stantial, the arbitrary.

> John Cage: "In Sevilla on a street corner I noticed the multiplicity of
> simultaneous visual and audible events all going together in one's
> experience and producing enjoyment. It was the beginning for me of
> theater and Circus."[17]

If one is to experience at least as much enjoyment writing an essay as
one can have standing on a street corner in Seville (or anywhere else for
that matter), that essay, or poem, or any other work of art for that mat-
ter *should* be a complex intersection of intention and nonintention, pat-
tern and surprise. These are the conditions of every form of life. So,
"pothooks" stays in the poethics of this essay. This choice leaves me
with less time and more to do. Or perhaps it's the other way around.

John Cage has said, "We have all the time in the world."[18] I don't un-
derstand this. It's a puzzle I carry around in the nature of a koan.

Professor Chance

John Cage: "I feel very friendly toward chaos."[19]

David Ruelle: "*Chance* and *randomness* did not look like very promising topics for precise investigation, and were in fact shunned by many early scientists. Yet they play now a central role in our understanding of the nature of things."[20]

David Ruelle is a mathematical physicist who in 1971, along with Floris Takens, wrote a paper entitled "On the Nature of Turbulence."[21] It was one of the early articles in the current round of chaos theory. There is, as N. Katherine Hayles has pointed out in her book *Chaos Bound*, a long history of redefining chaos.[22] Every age has its particular fascination with chaos as origin, Armageddon, and, somewhere in between, possibility. The Ruelle and Takens paper describes how in certain chemical reactions, a dynamic field involving a great deal of indeterminacy is bounded by what they called a "strange attractor" pattern. Until then, the observation of turbulence in chemical reactions, because it involved nonperiodic motion, was taken to signal not a complex phenomenon of great interest but the failure of the experiment.[23] That is, the working decision, or methodological choice—in consonance with a scientific paradigm exclusively legitimizing simplicity and predictability—was to ignore it. Ruelle, in fact, tells the story, in a chapter called "Chaos: A New Paradigm," of how a scientist who had done pioneering work on periodic motion in chemical reactions, for whom "On the Nature of Turbulence," with its description of nonperiodic oscillations, should presumably have been the next step, dismissed this work out of hand. In one of life's amusing little ironies, the name of this scientist who was so uneasy about the idea that chance could enter into deterministic systems just happened to be Briton Chance.[24]

Our truth fictions, our truth functions, and (somewhere in between) our political structures no longer fit the quantitative and qualitative transmogrification of the circumstances of our lives. They are not strange enough, nor commodious enough, to enact the complex realism we need to negotiate with grace in order to flourish in the world as we find it. We find ourselves, for instance, in the midst of a scene of accelerating information complexity, nourished by the proliferation of sophisticated feedback loops. More information, as we should all know by now, does not necessarily mean greater knowledge or meaning.

The quest, as always in the sciences, is for efficiency; in the case of information, for efficient transmission. The simpler the system or the message generating the information, the more compressible the information will be—for example, wrds whch r stll ndrstndbl wth vwlls rmvd, or linguistic messages that can be transmitted in "gists," summaries, or paraphrases. These systems are compressible because they contain a great deal of redundancy and, in the case of paraphrasable literature, meaning supported by familiarity with the *kind* of message being transmitted where nothing formally or semantically new is being said. This means that truly new, formally complex literature, music, art of any kind (particularly that art characterized by indeterminacy) is far less compressible than the art of the "mainstream." (The mainstream is the one stream one *can* step in twice.) Another way to put this is that truly contemporary work, as semiotic system, contains less internal redundancy and is less redundant than other systems in its genre. In the arts and the humanities, resistance to compressibility is of positive value because the quest is for richness of meaning and thus higher levels of complexity. For the more adventuresome among us this implies significantly new perspectives of the sort that only become available through formal innovation.

In the 1960s John Cage wrote a text for one of his visits to the Sogetsu Art Center in Japan. It included this version of his much quoted homage to the Indian philosopher Ananda Coomaraswamy: "I have for many years accepted, and I still do, the doctrine about Art, occidental and oriental, set forth by Ananda K. Coomaraswamy in his book *The Transformation of Nature in Art,* that the function of Art is to imitate Nature in her manner of operation" (*Year from Monday,* 31). Cage often repeated this statement, and it is well known as one of his working principles. What immediately follows in this version (composed for a Japanese audience) has been given less attention: "Our understanding of 'her manner of operation' changes according to advances in the sciences." To understand more about the "manner of operation" of Cage's work, it is useful to review what theorists working in the nonlinear sciences are telling us about complex systems in nature—including the human brain, thought, and cultural experience: that they are pattern-bounded systems characterized by infinitely complex unpredictability. "What we now call chaos is a time evolution [of these complex systems] with sensitive dependence on initial condition," writes David Ruelle.[25] These systems are all characterized by noncompressibility of information—to "describe" them, you must literally replicate them.

This revolutionary paradigm in the sciences parallels Cage's revolutionary aesthetic paradigm. If we think of Cage's work after the late 1940s, when he began to incorporate indeterminacy and chance operations into his compositions, we see scores that begin to exhibit deterministic randomness (those generated by means of the *I Ching*—early on, when Cage was tossing coins, and later when he was using the *ic* and *tic* computer programs). "Deterministic randomness" simply means, like "deterministic chaos," that there is a mixture of determined (by Nature, God, or Cage) elements and chance. Certain complex deterministic systems produce nonperiodic behavior. The combination of intention and chance has often, oddly, been pointed out as a contradiction in Cage, as though his manner of operation, unlike Nature's, had to employ one principle alone. Rather than a contradiction, it can be seen as a deeply productive paradox yielding music that is a dynamical system including, to use the physicist James Yorke's characterization, wild disorder embedded in stable structure.

Starting with the same score and introducing slight changes in initial conditions (different settings, instruments, performers, the same performers in a different mood), most of Cage's post-1950s compositions yield radically different realizations. "Lecture on the Weather" may in fact be subject to the amplification of difference characteristic of chaotic systems (see note 14) since its dependence on simultaneous readings leads to greater and greater divergence of textual coincidence. Sensitivity to initial conditions may in fact be seen as part of the poethical force of Cage's work—that it places anarchic value in the freedom of all elements—including those of media, performers, ambience, and audience—to contribute qualities of their own nature to the nonobstructive interpenetration that forms the complex texture of the realization. In this way Cage's art is a living practice rather than simulation or mimesis. It is art *as* the very life experience it draws our attention to. Cage as artist is helping us redefine and revalue chaos in the vital, immediate context of art as circumstance of everyday life.

John Cage's art, as a poethical form of life characterized by the values of complex realism, makes the intricate complexity of intersecting order and accident (where order includes, but also is larger than, human intentionality) known to us, through forms that structure participatory attention of the sort that can admit and even delight in turbulence while allowing us, as active audience, to make meaning. To feel friendly toward chaos, as John Cage and David Ruelle do, should be to engage in practices that don't betray it with simple fictions. Both aesthetic and sci-

entific paradigms must engender experiments that acquaint us fruitfully and usefully with the conditions of our world rather than bringing on, through denial or neglect, what Jacques Lacan called the "revenge of the real." We, global we, are painfully familiar with the revenge of the real as the grim panoply of wars, civil revolts, famines, social and economic and environmental injuries, catastrophes, and upheavals might continually remind us. Could holocausts and environmental degradations find such enabling conditions if we were able to give more courageous (honest) attention to the implications of complex systems as they unfold?

The very idea of deterministic chaos is, of course, itself a kind of fiction—or at least a very potent metaphor—as are all visualizable scientific paradigms. Mathematically, chaos theory is an idealized model of phenomena (weather, for instance) whose occurrences in "real life" are a good deal messier than on a computer screen. So to claim that Cage's work parallels in important ways the scientific modeling of complex systems, and that it furnishes us with an aesthetic paradigm that helps us make sense of and live with chaos—both natural and human-made weather (with economics and politics as examples of sociological "weather")—is to say that Cage's work reveals to us—in pleasurable and useful ways—complex, pattern-bounded, noncompressible, non-paraphrasable unpredictability. Like the work of the scientist, it offers us ingeniously framed lenses with which to attend to the most significant and troubling aspects of the world as we find it in the twenty-first century.

As Thomas Kuhn and other historians and philosophers of science have pointed out, it's no accident that the history of science has paralleled the history of other imaginative forms and ideas. During transitional periods in the development of thought, highly charged questions are omnipresent. The assumptions in every part of life, in every discipline, are under review, subject to reinvention.[26] Certain metaphors and models (like the Copernican reconfiguring, or relativity, or chaos) begin to structure thinking across disciplines. The artistic imaginative construction often anticipates the scientific one. John Cage was modeling complex systems and even fractal forms in his compositions two decades before the publication of Mandelbrot's *The Fractal Geometry of Nature* and the full-blown emergence of the "complex sciences" in the 1980s. As Cage would probably have said, "It was in the air." We are all working on the problems of how to live in our world.

Cagestan as World Model?

> Douglas Hofstadter: "...what actually *does* determine history is a lot of things that are *in effect* random, from the point of view of any less-than-omniscient being."[27]

In the seminar notes to John Cage's 1988–89 Charles Eliot Norton Lectures at Harvard—an extended "lecture-poem" entitled *I–VI*—Cage says, "We could make a piece of music in which we would be willing to live...a representation of a society in which you would be willing to live." At a concert at the National Academy of Sciences (Washington, D.C.) in November of 1991, when a member of the audience asked Cage what idea was behind the composition of a piece called *Two⁴*—for violin and piano—Cage replied, "I used the idea of thirty minutes." The audience laughed and waited. Cage said nothing more.

The idea of thirty minutes—like the idea of *4′33″* or any other time period for that matter—is actually quite extraordinary. (All of Cage's compositions in the last decade of his life were in fact structured in terms of "time brackets.")[28] At the start of the next thirty minutes we could ask any question we like. We could ask, for instance, Will we make it into the future? If in the course of the next thirty minutes we do indeed find ourselves making it into the future, as we are in fact finding ourselves doing right now, we could say, Look! Look around! Listen! Here we are! We made it into the future! Now we can see and hear what the future is like. So *this* is the future! Here we are in the future of the world, of America, of this crowded intersection in Manhattan or the Bronx or Denver or San Francisco or Pittsboro, N.C., or the coastal low country of Georgia or the southwestern desert or the Adirondack Mountains. What's there to notice? Noisy streets. Birds, insects, trees, flowers, this slightly chilly breeze....

If someone—not omniscient but omnipotent—turned up the volume on the whole planet right now, we would notice the music of "world us." It would not be by the same composer who brought us the Music of the Spheres. We would hear pots clanking on their hooks, a professor of chance sneezing into her handkerchief, children laughing, crying, car engines starting and stalling, monkeys screeching in rain forests, rain falling, rain forests falling, bombs exploding, car radios blaring, radio static crackling, astronomers coughing in their cold perches, hundreds of languages, thousands of dialects and accents, singing, praying...guns firing, fire crackling, water rushing, food frying, innumerable mammalian

species chewing, snorting, wheezing, buildings crumbling, sirens wailing, horns honking, geese honking, cars and waves crashing, broth boiling...thunder...wind...the noise of weather and lectures on the weather....

Meanwhile, as I sit in another space-time frame writing this essay on my computer, my file name—of which I am reminded every time I save—has gradually undergone a conceptual shift in my mind—from Cage-Stan (for Stanford University, where I delivered an early draft of this essay as a lecture) to Cagestan—a boundryless region that hasn't been much in the news, although it has for sometime been the scene of revolutionary manifestos (intentional and nonintentional). Let's spend a few minutes with the idea of thirty minutes (or any designated time frame) in Cagestan to see if it *is* a world in which we'd be willing to live. It will be the world as we hardly know it because there's been geometrically increasing complexity and arithmetic flight from complexity in our everyday lives. If complexity is the source of our freedom, it's also the source of our terror. We live in a culture so driven to desperate simplifications that it's given over most of its thought processes to the most facile imagery of mass media. It's this flight that has produced the media event that is our 30-second politics, our frantic inability to tolerate the intricacies of what we take to be time-*consuming* matters. Interesting shift—from *using* to *consuming* time.

Can we deny that we need to change, that we can't continue on this, now admittedly, life-threatening, world-threatening course? Certainly we can. We can deny anything, including that there *is* a world independent of our minds and egos. Western philosophers, for whom dichotomous insides and outsides have held a particular piquancy, have put in a lot of time and hard work trying to prove the existence of the external world. To move into the semantically messy world of poetry during such attempts would of course be taken as a failure of the thought experiment. But even with the poets locked out of the room the world eludes proof of its existence. It seems it's too complex for linear if-then strategies, even of the sort within the lyric poem that serves up the autopiloted mini-epiphany as its conclusion. There's too much centrifugal noise to permit this kind of concentration (as in frozen concentrate) without loss of a great expanse of experience and meaning. Some of our time—whether thirty minutes or even thirty seconds—might be better spent in attempts at constructive engagements with the pandemonium. (It's always there, blaring outside the closed door, waiting to disorient us.)

Any formal structure draws us outside ourselves, beyond personal expressive logics. Things as simple as meter, rhyme, abab patterns pull us in directions having to do with material structures of the language. Such forms are the barest start in the exploration of the multiple logics (lettristic, phonemic, semantic...) within a natural language and the forms of life that give it vitality. Chance operations and structural indeterminacies pull the work of the composer, writer, auditor, reader toward the kinds of events and relationships characteristic of richly complex systems. It's a leap of some kind of aesthetic faith to go from simple patterns of bone/stone, heart/art to the disorienting surfaces of language generated by complex procedural principles incorporating chance and intention. A question of poetics/poethics is whether these procedures bring language uses into more constructive association with the turbulent patterns of weather, ambient noise, cultural climates that daily affect our lives.

VI

The Poethical Practice of Admitting Complexity

John Cage: "People have great difficulty paying attention to what they do not understand."[29]

Let's start with a relatively simple example of complexity by looking at "(untitled)," (X, 117).

(UNTITLED)

```
            if you exi ted
            becauSe
            we mIght go on as before
but since you don't we wi'Ll
            mak
            changE
            our miNds
            anar hic
so that we Can
            d to        let it be
        convertEnjoy the chaos/that you are./
                    stet
```

It's immediately obvious that this text is problematic in terms of a simple left-right, left-right, top-to-bottom, linear reading. For one thing, it's not clear whether this is a poem consisting of seven lines (combining lines with crossed-out words and words overhead, ignoring

stet, and honoring the seven capitalized letters of the mesostic string, S I L E N C E, as indicators of the number of lines in the poem) or whether the presence of the crossed-out words on the page, along with the word *stet*—not handwritten as a proofer's mark but typed like all the other words in the poem—indicates that this is actually a twelve-line poem. This is an interesting "whether"—posing two alternatives that, because of their equal material presence on the page, render the poem a kind of ambiguous figure, like Edgar Rubin's Profile/Vase/Profile. As with all ambiguous figures there seems at first glance to be a kind of terminal either/or complementarity. It's conceptually/visually impossible to take in both possibilities at the same time, since each one is in part constituted by the functional absence of the other. This is the dualism of a "whether" system, one—in this case—that would seem to be interestingly irresolvable, demonstrating the powerful role of the reader/observer to determine the way in which at any given time it's to be read.

But, one might ask, is it really irresolvable? Can't we determine a single, correct way to read it by weighing the evidence in favor of the author's intention? Can't we, that is, simply see the crossed-out words as corrections, the *stet* as an indication of a change of mind (decision to restore "that"), and be done with it? In this case we might clean up the text and render it thus:

```
(R-1)           if you exiSted
                    we mIght go on as before
          but since you don't we'Ll
                    makE
                    our miNds
                    anarChic
                convertEd to the chaos/let it be that you are/
```

The problem with this is that it's so easy. Clearly the author could have done it himself. What's crucial (interesting) is that he didn't. He chose to publish the poem with the crossed-out words and the *stet* as part of the text. So just reading what isn't crossed out as "the corrected version" won't work. If we're interested in intentions, it's not plausible to suppose John Cage wanted the reader to ignore what he might with no trouble have left out.

But let's be extra careful. Plausibly or not, let's suppose this was in fact what he had intended. Suppose he had written a note saying to his readers something like, "I didn't have time to retype this; just ignore the crossed-out words and the 'stet.' They're really not supposed to be in the corrected version of this poem." Surely we couldn't take this seriously. No time to

retype? It would have taken only a bit more time than writing the note. We have to view this as a joke or an additional text to puzzle over. And, of course, even if we were inclined to take it seriously, it would have been a serious miscalculation on his part. The reader can't ignore crossed-out words any more than the viewer can fail to notice the crossed-out Mona Lisa of a contemporary artist, or the "Erased de Kooning" of Robert Rauschenberg. If anything, being crossed out or partially erased makes things more noticeable than they would have been otherwise.

So the version, as printed, must be taken as the text—what is materially present to us, as readers, on the page. What this text means to us will have to be at least as complicated as the "whether" reading above. But it need not necessarily be taken as an ambiguous figure.

John Cage has in fact said in conversation that this poem went through several changes, all on the same sheet of paper, and was published as a typed version of the handwritten copy in order to retain its history and give it the dimension of time. He then read it aloud as it appears in R-1 above.[30] Does this solve our problem of how to read it?

Knowing this fact about the author's intentions will no doubt influence what we notice when we go back to the published text. It does tell us something about how the poem was written. It tells us little about how to read it. History that ends up on a page no longer exists in the past. It has only a present and a future. It is, in effect, a score to be realized by the reader. It's past may be something we know *about* it; but that is only part of what it *is*.

Taken as a score—a notation that gives us c/l/ues for a range of possible readings—we might start experimenting aloud:

1) We could read it, line by line, in sequence, exactly as presented on the page. (Perhaps whispering the crossed-out parts.)

```
(R-2)                    if you exi ted
                          becauSe
                         we mIght go on as before
        but since you don't we wi'Ll
                          mak
                          changE
                         our miNds
                         anar hic
        so that we Can
                             d to          let it be
                 convertEnjoy the chaos/that you are./
                             stet
```

In doing this, some lovely things happen. The first line becomes, "if you exited." The first three lines, "if you exited/becauSe/we might go on as before." If the "you" being addressed is SILENCE—the silent noun/title/addressee in the mesostic string—then it would indeed exit if we went on as before, not noticing it. This reading makes as much sense as one we might make of, "if you exiSted/we might go on as before." What prevents us from seeing it (and any other like it) as an additional rather than an alternative reading? The only thing that would silence these multiple readings would be ideology—ideology valuing simplicity and the idea of a single, "correct" meaning, one truth. Harking back to Adorno, let's assume that this is a better piece of art than would satisfy an ideologue and admit as many meanings, as much complexity as we notice.

2) We could omit crossed-out sections altogether—reading single letters as phonemes, or reading letters that have lost their words *as* letters—the return to being alphabetic isolates rather than parts of syllables:

```
(R-3)          if you exi ted
                          S
                   we mIght go on as before
but since you don't we 'Ll
                   mak
                    E
               our miNds
               anar hic
                    C
                 d to          let it be
             convertE     the chaos/   you are/
                              stet
```

This gives us, for instance, "E/our miNds" (where E can be associated with energy) and "convertE the chaos" (a permutation of Einstein's formula?) and "stet" as echo of "let it be" all addressed to the silent "you" embedded in the text. And, as they say in catalogs, Much More!

3) We could, as mentioned before, decide to read only lines with mesostic letters. This presents us with three more possibilities:

 a) read what isn't crossed out

 b) read what is crossed out

 c) read a & b somehow combined

4) We could notice—and try to make available in our reading—
other complicating details: for example, "I" as first-person
pronoun in "mIght," "stet" read out as proofer's mark ("let
stand as set"), the way in which the word *change* is being
changed before our eyes, etc.

5) We might notice, additionally, the fractal symmetries in the poem:
How the tension between the vertical and horizontal, present in
every mesostic (that is, the pull to read it both ways), dynamically
structures the poem as a whole, and then is replicated in the verti-
cal-horizontal tension between pairs of lines (where the
"overhead" line needs something from below to complete it and
vice versa), with individual letters, like the *S*, which seem to
belong in both vertical and horizontal axes, and which on their
own have (as all letters—usually unremarked—do) both vertical
and horizontal graphic elements. All this, of course, is also instan-
tiated in the very act of reading with the vertical-horizontal chore-
ography that often makes glimpsed (vertical, diagonal, and dog-
legged) connections available despite energy expended on barring
them from conscious cognition. Of course, like the crossed-out
words in this poem, these aberrant connections/conjunctions can
never be entirely ignored. They must in fact form one of the
strange and interesting associative, peripherally received, sublimi-
nal subtexts in our common reading experience.

There are many more ways to "realize" this deceptively small
poem. We have moved from "whether" to, if not a full-blown re-
gional weather system, at least a very complex and fascinating mi-
croclimate. With nonetheless macroclimatic implications about how
much ideology (institutionalized habit) can silence not only in the act
of reading but about the nature of silence itself and our choices in re-
lation to it. John Cage has said about his working methods, "Com-
posing this way changes me, rather than expresses me."[31] It's an en-
tirely poethical approach—one that allows invention, humor and
surprise, changes of mind and quality of attention. This kind of per-
formative engagement (as realization on the musical model) with text
as dynamic complex system is a poethics of response available to au-
dience-participants in all the arts.

I want to suggest then that this poetry (and this kind of reading)
functions within a poethics of complex realism where active processes
of mutability and multiplicity are valued over simpler, more stable illu-
sions of expressive clarity. Change actively, continually destabilizes the

poem, thwarting *the* "correct" reading, thwarting any sure sense of return to the author's ego-bound, prior intentions. All, it seems, that it makes sense to do is to notice what we find on the page and experience the multiple directions—the multiple lettristic, phonemic, syllabic, syntactic, semantic, and graphic trajectories—in which it takes us. What is found on the page is enough. It has arrived there full of Cage's conversational ethos, his enactment of art as public interlocutor.

As with the systems described and modeled in the nonlinear sciences, it's not that there is *less* structure but that the structure is one of greater complexity since it's in a richly dynamic relationship with larger areas of indeterminacy. It's not the case with silence that there's no sound, or less sound, but that the range of what's audible depends on the angle of our attention. It's not the case that with indeterminacy there's no meaning but that the ranges of meaning, the connections we notice and construct, undergo transformation as we rise to the occasion of actively reading and rereading the text. The scope and focus and force of our attentive engagement is altered as we take on the discipline of more active noticing/inventing that the unfinished, irregular (fractal?) surfaces of indeterminacy invite.

D. W. Winnicott's distinction between fantasy and imagination comes to mind once again. Fantasy is the passive, self-enclosed mode nursed by nostalgically, tidily manipulative forms. Imagination is an active reaching out to the energy and consequence in the order/mess/order of the real world. It must literally take chances, playing with the concrete hypothetical, the experimental "what if." It's the fruitful act of play as exploration and reciprocal transformation—a poethics of interrogative dialogues with material reality. (All of Cage's work began with, was propelled by questions. Questions about his medium and about the spiritual and social dimensions of his art.) Imaginative play is the child's experimental framework for learning how to live (with excitement and pleasure) among others in a world of real consequences of accident and design. As adults we stop playing at our (and the world's) peril. A poethical engagement with a work like "(untitled)" returns us to the fullest exercise of our senses as we explore its graphic and linguistic implications. We—text and reader—grow and change together.

If we, with difficulty and delectation, attend to the possibilities in what we do not understand, that is, if we can move into a collaborative future admitting with constantly developing disciplines of attention the constantly changing world at large, then we can't "go on as before."

The poethics of this poem invites a practice of reading that enacts a tolerance for ambiguity and a delight in complex possibility. Imagine what might happen if such a practice were to become widespread. Cage believed that such an eventuality (Here Comes Everybody listening to everybody else) could have real social consequences—that it could, as he said, change the political climate. An ethics, even a poethics, is not a politics, so this question is very much at large. At large is precisely where we need to be.

UNCAGED WORDS

John Cage in Dialogue with Chance

We forget that we must always return to zero
in order to pass from one word to the next.
 John Cage[1]

FROM ZERO TO THREE IN LESS THAN TWO MILLENNIA

Sunyata [emptiness] is formless, but it is the fountain-
head of all possibilities.
 Tosu, ninth century A.D.

 Art is either a complaint or
 kinD of thing
 uncallEd for in
 A
 just as gooD
 is that it's very fragMented ' in
 is **A**'
 iNvolved
 arT is either
 the question of whAt is a
 worK won't
 bE'
 else my experience of life is thAt
 Splitting'the idea of
 the real thing i liKe what i see
and the idea of air in breathing in and oUt
 Like my work to have some vivid indication of
 a Large
 City and the traffic there

 John Cage, *Art Is Either a Complaint or Do Something Else*

Note: All italicized passages are quotes from John Cage.

FIRST
THE RETURN TO ZERO

can take playce in many wayes. *(Opening doors so that anything can go through.)*[2] It might be brought on by linguistic or lettristic or graphic oddments that slow the skimming glance, inviting a kind of meditative awakening to the material text. Calling attention to the arbitrary splendore of grammaticall forms & enigmaticall epithetes as "the sun at noon illustrates all shadows" (to recall Sir Thomas Browne and invoke past as "other"), we might notice that it's become difficult to ignore the rank contingency—word by strangely delicious word—of what seemed only a moment ago to make necessary, sufficient, and relentless sense. That is, a startling departure in spelling or a rupture in syntactic momentum can bring into relief how all words might be other wise. (When to "thInk" requires Ink.) Or better or worse yet, how words might or might not be more or less wise than we think, since it's so hard to think without them just as they/we are—vis-à-vis, tête-à-tête, foot-in-mouth... "uncallEd for...Splitting' the idea of /the real" in this Large City of language with its fragmented traffic.... just as it's always been.

At the moment of any disruption of habit (grammar or traffic) a generic question can arise: Might it be possible to move through our lives in other ways, guided by other processes and structures, perceiving connections, even constellations lost to our habitual grammars, seeing the side streets, getting lost and discovering something new? In a new mode of moving and noticing will we be enacting, to some degree, slight or grand, a different kind of humanity? Can we really move so quickly from one word to one world to the next? Should we, in light of 20th C linguistic theory (Saussure, Whorf, Wittgenstein, etc.), simply conflate the two into wor/l/d ? This may be the poethical question implicit in John Cage's return to zero—a question of the relation between the structures of our language, our art, and our forms of life.

The writing below, both despite and because of its occasional unexpected shifts, makes a clear statement against the illusion of possession by identification that underpins the logic of depicting—whether graphically or linguistically. All the modes we find in books that implicate the world in a conspiracy of "and then of course" are designed to relieve the uncertainty of anything new (unrecognizable) under the reflected light of the moon.

 itS
 shaPe
 And
 coloR
 exActly
what you've Seen
 in bookS
 make It
 eaSy

 to reCognize
 the fiRst
 tIme
 you See it
 we Possess it
 thAt

 iS to say
 before we Put
 hAnds on it
this is not poetRy
 which is hAving
 nothing to Say
 at the Same
 tIme
 Saying it

 onCe
 we'Re
 In
 the foreSt nothing else
 recognition Puts
 in one's heAd

 a certain Sense
 of accomPlishment
 thAt leads
 away fRom poetry
 Away
 from uSe
 towardS
 possessIon law and order
and then of courSe

 John Cage, "Mushrooms *et Variationes*"[3]

But this language doesn't radically breach "the law and order" of a linguistically based logical sequence. There is no necessity for the reader to go beyond an appreciation of what is being said about a poetics of "useful" defamiliarization and enact its principles. This language has not achieved the form of poetry it implies: that formal structure, in a movement away from "possessIon law and order," must look more like Cage's *Empty Words,* with its fragmentation and reorientation of all linguistic units, or like the beginning of *Art Is Either a Complaint or Do Something Else.* Notice the continuation of its exploration of new associations between parts of speech—in a sense, freeing the "Ions" from "possessIon" and allowing new exchanges to take place:

space being represented in it my work feeds Upon itself i think it is a

play oR

placE

tO be'

liFe is

accustoMed to thinking

it's verY

Form[4]

Buckminster Fuller used to say the most important thing to remember about structure is that it is an inside and an outside. Given this, it's worth worrying about our insider's tendency to take the walls and ceilings for everything there is. We have known—and forgotten this—many times in many ways from Plato's cave to Whorf's snowscape. And "now," is this not what we may be doing with language identified as *the* paradigmatic human structure? Whorf informed us that we don't see anything that isn't prefigured in our vocabularies, and Wittgenstein moved us from "the world is all that is the case" to "the limits of my language are the limits of my world," although he himself never believed that, except to mean "my social world." The number of times this latter has been quoted with all its problematic implications rival's McDonald's astonishing hamburger statistics when corrected for the mean deviation between hamburgers and ideas.

WHICH MEANS IT'S BECOME

a staple assumption in the haute demi-monde of theory that epistemology is now nothing more or less than a subset of language theory. We'd better start looking for the outside fast, before all the oxygen gets used up.

This is not to say that it's possible by violent claustrophobic reaction to throw down the goggles of our virtual textualities and wander innocent abroad. It does indeed seem logically impossible (at least by certain well-known principles of noncontradiction) to stand entirely, or even largely, outside the structures of our language. Nothing prevents us, though, from exercising multiple and hyper logics in certain high-risk aesthetic enterprises that create in their disjunctions with our metanarratives, apertures/gaps/grounds-zero, glimpses of other possibilities, other logically improbable worlds. This formal rupture—opening out to a complex reality—characterizes the avant-pragmatism of John Cage's art.

THE RETURN TO ZERO
IN OTHER WORDS

can be seen as a way to touch on dormant possibilities of language, particularly when it intersects with the understructured mess, the overlying chaos we all know/forget so well—"Real-Life," not to be confused with "Real-Lemon," a brand name.

> What I am saying does not mean that there will henceforth be no form in art. It only means that there will be new form, and that this form will be of such a type that it admits the chaos and does not try to say that the chaos is really something else. The form and the chaos remain separate. The latter is not reduced to the former. That is why the form itself becomes a preoccupation, because it exists as a problem separate from the material it accommodates. To find a form that accommodates the mess, that is the task of the artist now. (Samuel Beckett)[5]

The moment of zero is the pause or gasp for breath, the caesura, before/after the old order/ing system overtakes and closes down limitless space-time. It is the rest stop, the silence, between negative and positive integers of past and future. Given the force of our now (compellingly theorized) contemporaneous past, we may well need an active time-zero to experience any present at all. This is important because without a vital present it's hard to see how the future can be anything other than a thing of the past.

OR

we might think bidirectionally

of both possibility and recovery.

Recovering, for instance, in *medias* mess of our violent world, the sorrow embedded in anger, whose root, *angr,* was Old Norse for grief. [Indo European root, *angh-,* spawning angst, anguish, angina (a narrowing).] Can the return to the sense of that absent *e*—to zero in the spelling of *ang-r*—acquaint us with the sad conditions of our own rage? Help us notice something we've been overlooking in the familiarity (invisibility) of how we name the causes of riot, rebellion, murder, massacre, war...? What would it take, what would it mean, to develop a consciousness of language that allowed us to inspect the charged bonds, the ions, in our obsession with possessIon, or to hear the silent *e*—the grief in our anger—as a return to zero?

WALDEN III?

One is unity. Two is double, duality, and three is the rest. When you've come to the word three, you have three million—it's the same thing as three. (Marcel Duchamp)

When, after a 1989 performance of *Lecture on the Weather,* John Cage was asked by a member of the audience what the performers were saying, he explained that they were reading passages from Thoreau's work *(Walden, The Journals,* and the *Essay on Civil Disobedience)* and went on to say that he used these statements because, *through the circumstances of our history we have gotten to the point where we can no longer hear them. And that's how we act with regard to the best of our past.*[6]

It may seem that our uses of language have always been overwhelmingly occupied with memory, with telling ourselves more and more stories, gathering more and more factoids for our collective consciousness—of late, culturally mutated into microchip archive. So much so that we forget the zero-sum fact that knowing is itself a forgetting. Forgetting the other sides of structures, for instance; forgetting to surprise ourselves into entertaining the currently inconceivable; forgetting to pass from one world to the next, not as sci-fi adventure but in order to envision things better than what we have resigned and habituated ourselves to. This is enormously difficult. It sometimes takes what at first glance may seem to be cruel and unusual artifice.

Due to N.O. Brown's remark that syntax is the arrangement of the army, and Thoreau's that when he heard a sentence he heard feet marching, I became devoted to nonsyntactical "demilitarized" language. I spent well over a year writing Empty Words, *a transition from a language without*

*sentences (having only phrases, words, syllables, and letters) to a
"language" having only letters and silence (music). (Empty Words, 133)*

*Language free of syntax [James Joyce'S "sintalks"]: demilitarization of lan-
guage.... Full words: words free of specific function. Noun is verbs is adjec-
tive, adverb. What can be done with the English language? Use it as mate-
rial. Material of five kinds: letters, syllables, words, phrases, sentences.
(Empty Words, 11)*

This is of course Cage's method in all the arts: locate the elements of
the medium, set them interacting with one another in a process that
frees them as much as possible from artist's intentions via chance oper-
ations, all the while maintaining the specific integrity, even gravity, of
their material presence within the urgency of the historical context.

*Empty words. Take one lesson and then take a vacation. Out of your mind,
live in the woods. Uncultivated gift. (Empty Words, 11)*

But it's not as simple as "the return to nature" once seemed. Nature
as we think we know it now is itself an artifice—of images and words.
Or we could say that words in their artifice are as natural as a vocabu-
lary of woods and mountains, cows and sheep articulating the horizon
with their inexplicable presence. It's not that silence/zero lies beyond
words, in things. It seems we must find it in words—in *medias res*—in
music—in and out of all the artifice that absorbs our attention.

Although Wittgenstein said, and some of us think we learned, what
cannot be said must be passed over in silence, Cage's desire to find the
silence of zero in what can be said may be even more useful. The silence
itself cannot be passed over. (When Wittgenstein read poetry to the pos-
itivists of the Vienna Circle, was he attempting to explore an articu-
lation of silence?) Both academic ambitions and daily habits of speech
conspire against the uncertainties that let languages breathe. Poets
launch their own conspiracies (literally "breathing together") of words
restored (and introduced) to strangeness—in Jackson Mac Low's and
Cage's work, as well as in Language and other experimental poetries—
to counteract syntactic word flows that operate autohydrodynamically
to fill every empty space, drown out what is structurally difficult to no-
tice. The silence in the poethical return to zero may do for language
what the silence in Cage's music has done for sound—expand the range
of what we can attend to, giving access to some of the Other Ness mon-
sters—playful and grim—we need to call into our ongoing conversa-
tions along with all our all-too-well-knowns. (G. Stein would say
"nouns.")

AND NOW A BRIEF EXCURSION INTO THE 19th
CONTEMPORARY
(WHAT'S THERE REALLY TO COMPLAIN ABOUT?)
((A question that only arises because the bulk of thought & lit still comes to us in 19th C forms.))

People say again and again that philosophy doesn't really progress, that we are still occupied with the same philosophical problems as were the Greeks. But the people who say this don't understand why it has to be so. It is because our language has remained the same and keeps seducing us into asking the same questions. As long as there continues to be a verb "to be" that looks as if it functions in the same way as "to eat" and "to drink," as long as we still have the adjectives "identical," "true," "false," "possible," as long as we continue to talk of a river of time, of an expanse of space, etc. etc., people will keep stumbling over the same puzzling difficulties and find themselves staring at something which no explanation seems capable of clearing up. (Wittgenstein, *Culture and Value*, 15e)

Sartre complained that wherever Flaubert's prose went, the grass stopped growing:

It was a question of denying the world or consuming it. Of denying it by consuming it. Flaubert wrote to disentangle himself from men [*sic*] and things. His sentence surrounds the object, seizes it, immobilizes it and breaks its back, changes into stone and petrifies the object as well. It is blind and deaf, without arteries; not a breath of life. A deep silence separates it from the sentence which follows; it falls into the void, eternally, and drags its prey along in this infinite fall. Once described, any reality is stricken from the inventory; one moves on to the next. Realism was nothing else but this great gloomy chase. It was a matter of setting one's mind at rest before anything else. (Sartre, *What Is Literature?* 124–25)

In the midst of this violent scene—prose transmogrified into serial killer, executing its self-dictated sentences on one victim after another—there is "a deep silence" that separates one syntactic snare from the next—a void, but one that's hardly empty. We can only imagine it via Sartre's gothic polemic chock-full (as romantic voids always are), brimming with victims of the novelist's need to impose will upon wor/l/d. Flaubert's bloated corpus has been finished off by Sartre.

That is, Sartre's prose delivers its own victim fully embalmed to the mid-20th C reader—a victim filled with his (Sartre's) fluid French sentences. Or perhaps that's the wrong metaphor. What about critic as vampire? Does Sartre draw his contentious energy from what blood can be found in the veins, if not arteries, of Flaubert's work? However we figure it, the predatory critical scene is littered with the dead.

(IS IT POSSIBLE TO AVOID OBLITERARY THEORY?)

We could go to the movie instead. In the midst of watching Isabel Huppert play Madame Bovary on the screen, notice that Charles Bovary—in the subtitles—has started to call his wife "Edna." A century of stored up wind breaks over the audience. The return to zero is accomplished with a pomo bang.

Does it serve him right? (What kind of question is that? Flaubert has served, continues to serve, us! ((Old art offers just as good a criticism of new art as new art offers of old.—Jasper Johns)))[7] We do know that Flaubert rather maliciously consigns Emma–C'est moi–Bovary to the fatal consequences of a life spent reading (in female addiction) the vacuous romance novels he himself was addicted to in his youth. (Doesn't Jane Austen enact a similar distancing from romance forms in *Northanger Abbey?*) The critic Andreas Huyssen describes the "master" peeking over the shoulder of Madame Bovary as she reads a literature awash with "romantic intrigue, vows, sobs, embraces and tears" as "detached" and "ironic." It is this irony that presumably saves the great author from "the delusions of the trivial romantic narrative" as well as the "banality of bourgeois everyday life" to become "one of the fathers of modernism, one of the paradigmatic master voices of an aesthetic based on the uncompromising repudiation of what Emma Bovary loved to read."[8]

But isn't it just that uncompromising master voice that fuels Sartre's vision of the intersyntactic void and its defiled flora and fauna—classified (or petty-bourgeois nickeled and dimed) to death? The picture that unfolds here is of the masterful 19th C novel as Foucauldian "panopticon"—a prison structure in which the author/ities can see/know/manufacture all "relevant" details of inmates' lives, thereby depriving them of that matrix of self-determined and chance detail that, when all is not said and done, constitutes a life. Omnipotent prison authorities, like omniscient authors, are invisible to the characters consigned to their prison wor/l/ds—both one-way systems of knowledge and control entirely dependent on apprehension by descriptive detail. It's interesting that this mastery of detail has become a hallmark of the craft of fiction in our time. It is what every workshop student is told to take on as an obsession.

> In the sight of God, no immensity is greater than a detail, nor is anything so small that it was not willed by one of his individual wishes. In this great tradition of the eminence of detail, all the minutiae of Christian education, of scholastic or military pedagogy, all forms of "training" found their place

easily enough. For the disciplined man, as for the true believer, no detail is unimportant, but not so much for the meaning that it conceals within it as for the hold it provides for the power that wishes to seize it. (Foucault, *Discipline and Punish*, 140)

ON THAT NOTE
TO THE NEXT

John Cage, in his "History of Experimental Music in the United States," after stating that the artist must do what's necessary in one's time, evaluates Varèse's contributions to music, first positively, then negatively. The negative assessment is reminiscent (minus the rhetorical drama) of Sartre's criticism of Flaubert:

> *Edgard Varèse...fathered forth noise into twentieth-century music. But it is clear that ways must be discovered that allow noises and tones to be just noises and tones, not exponents subservient to Varèse's imagination. What else did Varèse do that is relevant to present necessity? He was the first to write directly for instruments, giving up the practice of making a piano sketch and later orchestrating it. What is unnecessary in Varèse (from a present point of view of necessity) are all his mannerisms.... These mannerisms do not establish sounds in their own right. They make it quite difficult to hear the sounds just as they are, for they draw attention to Varèse and his imagination.*
> *What is the nature of an experimental action? It is simply an action the outcome of which is not foreseen. It is therefore very useful if one has decided that sounds are to come into their own, rather than being exploited to express sentiments or ideas of order. Among those actions the outcomes of which are not foreseen, actions resulting from chance operations are useful. (Cage, Silence, 69)*

These passages on Varèse follow a statement on the relation of history to what is "now" (i.e., anynow) to be done:

> *Why, if everything is possible, do we concern ourselves with history (in other words with a sense of what is necessary to be done at a particular time?... In order to thicken the plot. In this view...all those interpenetrations which seem at first glance to be hellish—history, for instance, if we are speaking of experimental music—are to be espoused. One does not then make just any experiment but does what must be done. (68)*

And this,

> *Nowadays in the field of music, we often hear that everything is possible... that there are no limits to possibility. This is technically, nowadays, theoretically possible and in practical terms is often felt to be impossible only because of the absence of mechanical aids which, nevertheless, could be provided if the society felt the urgency of musical advance. (67–68)*

"The urgency of musical advance"!—what an amazing notion. When and/or why would a society feel the "urgency of musical advance"? Or for that matter, the "advance" of literature? Why not stick with the tried-and-true? (Just as asking this question in its tired-and-true form—complete with vestigial question mark—can usually be relied on to protect us from the inconvenience of an answer.)

(CAN WE NOW AVOID OBLITERARY THEORY & SPITTING IMAGISTS?)

((And if we do will things get better?))

It's possible to open up a pass with language, to turn it into a red cape inviting the bull's charge. (Macho image. Why the macho image?) We could alternatively speak of "ice crystals formulating in the sky." Or exclaim, "The saint did it!" Something a little off—in a kind of delicious asymmetry with reasonable expectations. Little lamb who ate thee?, etc.

But suppose none of this, none of this language, literally takes a chance. That is, it doesn't involve the material and forms of language in chance. It is instead a game of images—*Imachismo* we could call it—mock chance for *bon chance* or *appetit*—Crown Roast and Mock turtle soup. (Are we ingesting the imagery with the food? If so, just what is it nourishing?) It doesn't require a transformation of one's sense of meaning (the relationships and connections between things) to intuit, no matter how quirky, what's going on. We've been trained in logics, even dislogics, of imagery for millennia. They are embedded in every manifestation of culture. Religions are founded on them, as are all other didactic institutions of family, fairy tale, and state. We learn the vocabulary of images that will attune our emotions to a particular social value structure even before we learn the words that will (at appropriate times and places) evoke them. We think, clearly this is the vaunted realm of the (etymologically cognate) imagination—the playing ground of great souls and sentimental common folk alike. And to a point we are right. Although the vestigial imagery that lost its vital, culturally formative functions decades, centuries, millennia ago must now be propped up by establishment guardians of greatness (museum culture). Is this more akin to a Dungeons and Dragons world of fantasy than to the active, play-full world of the imagination?

But, a voice protests, isn't *this* the really urgent question: Will the soul setting out from Olympus on iambics/dactylics/free verse...etc. at time *t* arrive in the local bookstore in time for a spring list epiphany?

You feel that you are doing a lot—something perhaps even grand—but all that you are doing is breathing. Nothing is happening in the world. (Winnicott, *Playing and Reality*, 26–27)

OF COURSE
YOU NEEDN'T BELIEVE A WORD OF THIS
NOR DOUBT EITHER
BETWEEN BELIEVING AND DOUBTING LIES PLAY

Playing is an experience, always a creative experience, and it is an experience in the space-time continuum, a basic form of living. The precariousness of play belongs to the fact that it is always on the theoretical line between the subjective and that which is objectively perceived....[T]he significant moment is that at which *the child surprises himself or herself*. It is not the moment of my clever interpretation that is significant. Interpretation outside the ripeness of the material is indoctrination and produces compliance....This area of playing is not inner psychic reality. It is outside the individual. (Winnicott, *Playing and Reality*, 50–51)

A REALISM NOT EXPANSIVE OR RISKY ENOUGH?

We could make a piece of music [or literature] *in which we would be willing to live, a piece of music* [or literature] *as a representation of a society in which you would be willing to live?* (Cage, I–VI, 178)

All this raises another permutation of the poethical question—what forms of life are replicated and induced by literary structures? (Specifically, which ones invite an active play of the reader's imagination engaged with the complex extrasubjective real?) The panopticon novel is a model of manipulative control of those elements—characters, scenes, information—the author chooses to present and assess, but it can also be a disciplining of language and reader away from playful and precarious valences. Neither is allowed to go *outside* and play. Flaubert's irony actually allows him to have things both ways—to eschew excesses of rhetorical moisture in his scorn for a structure that floods characters and readers with romantic fatalism, while employing basically that same impulsion of plot and character in a more elegant fashion. Irony is always a simultaneous use and disavowal. Dependent on its prey for its own logical substrate it can't move far beyond the disavowed structure. Kierkegaard, a great ironist himself, pointed out that once you have achieved a truly new stage, you have left irony behind. Irony is at best a useful transitional mode. And of course this is what those early modernists (and we) think we have valued in Madame Bovary as she turns her

wistful eyes (her prisoner's gaze) toward the 21st century. But her world—the claustrophobia inducing, underpopulated (with possibility, certainly not characters) world of the 19th C novel is still as much intact as was French imperialism at the time Flaubert was writing Emma into the vacuum left by his old addiction. Not an empty coincidence at all.

If irony carries on the established series with a twist, zero lies always outside the series. It is at the juncture where new series might or might not begin in any direction, alone or simultaneously: (HCE? Here Comes Everybody? Not quite yet.)

THE RETURN TO ZERO BEYOND IRONY

In order for a text to expect in any way to render an account of reality of the concrete world (or the spiritual one), it must first attain reality in its own world, the textual one. (Ponge, *Power of Language*, 48)

Bbbbbbbut! What can it mean to attain reality in the textual world?

As I look back, I realize that a concern with poetry was early with me. At Pomona College, in response to questions about the Lake poets, I wrote in the manner of Gertrude Stein...Since the Lecture on Nothing *there have been more than a dozen pieces that were unconventionally written including some that were done by means of chance operations and one that was largely a series of questions left unanswered. When M. C. Richards asked me why I didn't one day give a conventional informative lecture, adding that that would be the most shocking thing I could do, I said, "I don't give these Lectures to surprise people, but out of a need for poetry."*

As I see it, poetry is not prose simply because poetry is in one way or another formalized. It is not poetry by reason of its content or ambiguity but by reason of its allowing musical elements (time, sound) to be introduced into the world of words. (Cage, Silence, x)

TO THICKEN THE PLOT

Let's begin (again) as Cage did, with Gertrude Stein. For a radically different poethic. On the way to John Cage's avant-pragmatism we can look in on one of Gertrude Stein's novels, a mystery, called *Blood On The Dining Room Floor*.[9] It's an interesting case in/off point because the mystery has traditionally been a form in which the author "knows" (controls) everything from the first sentence on, including precisely what can and cannot be known by the reader at any given moment. But in *Blood* Stein repeatedly distances herself from claims of special access to knowledge about events and characters with constructions like "everybody knows," "anybody knows," "Everybody proposes that nobody knows even if everybody

knows." We can in fact say that the structure of this novel is a poethical questioning of the relation of knowledge to power over others (knowledge, in fact, as the construction of the other)—a question ranging in its implications from domains of science and technology, to epistemology, to gossip. Note how the permutations in the following sequence relinquish one kind of control (omniscience) while exercising another with the precarious, but artful, balance of play—analytical sleight of mind:

> In a hotel one cooks and the other looks at everything. That makes a man and wife. Everybody knows all that. As that can keep everybody busy....
> (Stein, *Blood*, 15)

And, as if in response to Sartre's critique of Flaubert,

> That is the way to see a thing, see it from the outside. That makes it clear that nobody is dead yet. (ibid., 19)

> And now to tell and to tell very well very very well how the horticulturist family lived to tell everything, and they live in spite of everything, they live to tell everything....

> It is of not the smallest importance what everybody knows about anybody's ways not of the smallest importance. In a way it does not make any difference even what is said. Not if it makes any difference anywhere. (ibid., 22)

Here is Stein's most explicit rejection of the role of omniscient author, followed by a movement of the language (for the next five lines) into poetry:

> This is not a description of what they did because nobody saw them do it....
> I feel I do not know anything if I cry.
> Slowly they could see their way.
> Everybody proposes that nobody knows even if everybody knows.
> There is no difference between knows and grows.
> Gradually they changed the garden. (ibid., 25)

This is an exploration of language *as* active exploration, where knowing is growing, unfolding, and perhaps most important, not knowing. The novel itself is a kind of garden that, as any gardener knows, is structure in dialogue with elements beyond one's control. It's quite clear to Gertrude Stein that the limits of her language are not the limits of her world nor of her reader's. As the American protopragmatist C. S. Peirce can still astonish us with, "There are real things, whose characters are entirely independent of our opinions about them."[10]

Stein's language is precise in its refusal to pin things down. It delights in motion. Her transition from prose to poetry as preferred genre was for the

sake of greater movement. Poetic language more than any other is language in motion with, at best, nothing settling in or down to the stasis of pseudocertainty. Movement, being composed of change over time, is the play of the medium in all the temporal arts—music, dance, and poetry.

THE RETURN TO ZERO OUT OF A NEED FOR POETRY

Perhaps the most sustained demand made on the writing that we identify with high culture is that it vitalize us; that it wake us up with its artifice to realities delicious to entertain and dangerous to ignore; that, in other words, it play high-risk language games with life/reality/pleasure principles and that those language games be worthwhile forms of life. (The pragmatist Cage would say "useful.") The question is not whether but which form of life a literature enacts. If not serial killing, or a sentencing of some terrifying kind, if not romantic escapism, if not ironic sprinting in place, then what? From Sartre's "the grass stops growing" to Stein's "to know is to grow" is an interesting transversal. Zeno would have been amazed.

Does "it" (anything) come down to where you would rather live—in Flaubert's panopticon; in, for example, Proust's expansive time machine; in Stein's garden ...? Of course the beauty of art is that none of these choices is terminal, or mutually exclusive. We can spend the summer in Stein, the fall in Flaubert, any season we choose in Cage. If the characters are more constrained, we might sympathize with them, learn from their bondage something about our own. But there is also Cage's haunting question: In this moment of our history where do we need to be, what do we need to do?—a poethical question that

RETURNS US YET AGAIN TO ZERO

<div style="white-space:pre">
 This second

 part is about structure: how simple it is
 , what it is and why we should be willing to
 accept its limitations.... Most speeches are full of
 ideas. This one doesn't have to have any
 . But at any moment an idea may come along
 . Then we may enjoy it .

 ...

 Structure without life is dead. But Life without
 structure is un-seen . Pure life
 expresses itself within and through structure
 . Each moment is absolute, alive and sig-
 nificant. Blackbirds rise from a field making a

 sound de-licious be-yond com-pare
</div>

Cage goes on, "I heard them/because/I ac-cepted/the limitations/of an arts/conference/ in a Virginia/girls'finishing school,/which limita-tions/allowed me/quite by accident/to hear the blackbirds/as they flew up and/overhead/./" ("Lecture on Nothing," *Silence,* 113).

This poetic statement (which could itself be read as a poem of ideas), written in 1949, sets out the moving principle of all of John Cage's sub-sequent art—sonic, visual, textual: to create structures with the inten-tion of making possible an active, unimpeded attention to the sounds, words, voices, bodies, lines, marks, colors, textures, and/or any other perceptible events/sensory delights...that by chance or intention pass through them. These blackbirds rise from a field in the midst of an ob-ligation to attend a conference at a Virginia girls' school, or—more im-mediately and concretely for the reader—out of an abstract discussion of structure, with startling words like *pure* and *absolute* behind them rather than, for instance, "twenty snowy mountains."

> I
> Among twenty snowy mountains,
> The only moving thing
> Was the eye of the blackbird.
>
> III
> The blackbird whirled in the autumn winds.
> It was a small part of the pantomime.
>
> VI
> Icicles filled the long window
> With barbaric glass.
> The shadow of the blackbird
> Crossed it, to and fro....
>
> VII
> O thin men of Haddam,
> Why do you imagine golden Birds?
> Do you not see how the blackbird Walks around the feet
> Of the women about you?[11]

Is there one among the blackbirds Cage sees whose eye was once "the only moving thing" in the wordscape of a Wallace Stevens poem? Or who "whirled in the autumn winds," or walked "around the feet/Of the women about" the thin men of Haddam, or whose shadow crossed the "barbaric glass" of icicles in the long window? I don't think a blackbird could have escaped Stevens's poetic aviary—trailing as it must "the bawds of euphony," "inflections" and "innuendoes," "glass coaches"

and "equipage" except possibly from stanza XIII, where it "sat/In the cedar-limbs." Yet that is questionable too, because it would be necessary for a mere bird to book a downgraded metaflight from a wor/l/d in which "it was evening all afternoon" into one where it was afternoon all afternoon.

The difference between the aesthetic framework that keeps these birds in their thirteen stanzaic aviaries, the better for us to contemplate, meditate on, and the (un)Cage(d) words of "Lecture on Nothing" does have something to do with owning and not owning language. Very little of the language in "Lecture on Nothing" retains a Cagean rhetorical coloring when it's lifted from the poem. In a sense the words in "Lecture" can rise out and return to ordinary life as easily as the blackbirds rise from a field, in the passing moment of savoring nothing more or less than the simple fact that they are there. There is nothing distinctive enough about this language to make us say it belongs to Cage. It's free to go. The structure, on the other hand, is pure and absolute Cagean artifice, although not a cage, anymore than an optical lens that helps us focus on a passing scene is a cage. I don't mean to suggest an invidious comparison to Stevens, whose language allows for something much more expansive and elegant than life in a cage. (Hence the architextural distinction, "aviary.") Yet his blackbirds will never fly out into everyday life. The fact that the major moving thing in the "Thirteen Ways" wordscape is Stevens's own mind is itself a source of pleasure in an attentive stillness. If it cannot be found in everyday life, it can enhance the experience of it. Cage, on the other hand, wants his work to enable attention to the world as it is.

THE BENDING LIGHT OF SPACE-TIME ZERO

It's often puzzled those familiar with John Cage's work—with its uncompromising dedication to the future—that his poetry was almost entirely taken from the previously used (although not owned) language of "source texts"—from the writings of Thoreau, Joyce, Wittgenstein, McLuhan, Fuller, Jasper Johns... and even the King James Bible. They have wondered, as skeptical critics of his chance-generated music have repeatedly assumed, whether Cage somehow suffered from a dearth of ideas of his own and so, unable to come up with anything new, recycled his favorite authors in a mechanically driven homage. If John Cage had nothing of his own to say, then why say anything at all? Yes. This question is very much to the point as Cage took it up in "Lecture on Nothing."

 I have nothing to say

 and I am saying it . . .
 for we pos-sess nothing . Our poetry now

 is the reali-zation that we possess nothing

 and

 .
 We need not destroy the past: it is gone;
 at any moment, it might reappear and seem to be and be the present
 . Would it be a repetition? Only if we thought we
 owned it, but since we don't, it is free and so are we
 Most anybody knows about the future
 and how un-certain it is.

 (*Silence*, 109–11)

What one might call the Buddhist letting go in this text has not lost
the echo of Gertrude Stein. Her syntax and vocabulary are unmistak-
ably present in its "everybody" or "most anybody knows" ethos. It lays
out a poetic program that Cage will follow over the next three decades.
The major departures from the Steinian poetics will be in the rejection
of devices of repetition (except occasionally as variation) and Cage's ex-
tensive and intricate use of chance operations.

> *A transition from language to music (a language already without sentences,
> and not confined to any subject....)...Languages becoming musics, musics
> becoming theatres; performances; metamorphoses (stills from what are ac-
> tually movies). At first face to face; finally sitting with one's back to the au-
> dience (sitting with the audience), everyone facing the same vision.
> Sideways, sideways. (Empty Words, 65)*

 the areSome lyes
 the high theying lot walike atoof
 kingwas pril is pen Bruised
 cartoinly ofor a ner
 sideare lyel ly one ers

 De mi likeis quite them (*Empty Words*, 57)

As music, as puzzle, rune, or koan this invites us by chance sideways
into word indeed, into and out of the familiar structures of language in
"*this season ewhich the murmer has agitated 1 to a strange, mad
priestessh in such rolling places i eh but bellowing from time to timet t
y than the vite and twittering a day or two by its course*" (*Empty Words*,
11). A season in language like fall for instance—tree structures bright

and bare as leafy alphabets twirl in the wind, as the Epicurean clinamen falls away from what seemed only a moment or two ago to be destiny.

We (scientific, experimental *we*) know now, or think we know, that we are all, always, in all ways in dialogue (*poly*logue!) with chance. This is the condition of our complex reality. To render by means of language any form of reality, we must first, as Ponge says, render it in the textual world. Cage's dialogue with chance is just such an attempt. It renders onto the page a complex realism as representation, cum enactment, of what may be the only viable form of life within the dynamic ambiguities of order/disorder that are the conditions of our global chaos. For Cage this vision is inseparable from the idea of Anarchy bringing the creativity of every individual into the social consensus where music moves back toward language:

<pre>
 Anarchy
 really does have The future
 people are talkIng
 abOut
 it is creative coNduct
 As opposed to
 subordiNate
 conDuct it is positive
 individuAlism to follow a way of thinking
 that pRoposes you can assume
 for your own acTs
 respOnsibility
 Visibly
 rEsponsible
 fiRst to yourself and then to society after the
 unworkability of caPitalism marxism
 authOritarian socialism anarchy seems for our liberation
 to be a Possibility once again as jorge oreiza said to me
 from failUre
 to faiLure
 right up to the finAl
 vicTory
</pre>

 (Cage, "Overpopulation and Art," 37)

> I think that one wants from a painting a sense of life. The final suggestion, the final statement, has to be not a deliberate statement but a helpless statement. It has to be what you can't avoid saying. (Jasper Johns)[12]

What Cage's poetry gives us through its use of defamiliarizing artifice and chance operations is a complex intersection of what poet and

wor/l/d can't avoid saying to/with/among three or more others. Here we are, in all this together, pulled in many directions of no *one*'s choosing, tracing complex trajectories we can neither predict nor control, although we can *attend* with great humor and great care. It is that part of reality that is the prime purview of this art—the complex anarchic harmonies, the infinite grace notes when wor/l/ds are left to talk among themselves. All this, not Q.E.D., but HCE—here comes everybody and everything we've shut out in search of a more generous and exploratory NOW.

Among Cage's working papers for his last poem, "Overpopulation and Art," was this sketch welcoming our twenty-first-century realities into his art:

my *h Ow does this*

V
E
R
P
O
P
U
L
A
T
I
O
N

Notes

INTRODUCTION

1. The word clinamen comes from Epicurus's disciple, Lucretius, whose *Rerum Natura* is homage and exposition of the Epicurean philosophy. The Greek word for swerve, *parenclisis,* doesn't appear in extant Epicurean fragments. I use swerve and clinamen somewhat interchangeably in the essays that follow.

2. Titus Lucretius Carus, *De Rerum Natura,* trans. W. H. D. Rouse (Cambridge, Mass.: Harvard University Press, 1992), 113.

3. *The Epicurus Reader,* trans. and ed. Brad Inwood and L. P. Gerson (Indianapolis, Ind.: Hackett, 1994), 54–55.

4. Ibid., 54.

5. Ibid., 32.

6. The questions and distinctions Huizinga discusses are invaluable, but his insistence that play is irrational and ruled by narrow game logics that cut it off from "external" realities and ordinary life would deprive it of its primary role in all aspects of the invention of culture.

7. Serge Schmemann, "U.S. Walkout: Was It Repudiated or Justified by the Conference's Accord?" *New York Times,* Sep. 9, 2001, 16.

8. Ibid. The last two quotes are from comments by President George W. Bush's national security adviser, Condoleezza Rice.

9. See Pierre Bourdieu, *The Logic of Practice,* trans. Richard Nice (Stanford, Calif.: Stanford University Press, 1995).

10. I'm indebted to Leslie Scalapino for the phrase "rim of occurring" in her *Objects in the Terrifying Tense Longing from Taking Place* (New York: Roof, 1994). I discuss this location of meaning in her own poetics in "Essay as Wager."

11. That work resulted in three of the essays in this book, as well as the volume *MUSICAGE* (Hanover, N.H.: Wesleyan University Press, 1996). I later learned of two other uses of "poethics": one that I was told had to do with literature but that I've not been able to trace; the other Richard Weisberg's *Poethics and Other Strategies of Law and Literature* (New York: Columbia University Press, 1992). Weisberg wants an Aristotelian "poetic ethics" in which truth is recognized as inextricable from beauty of rhetorical style. Although I don't agree with the conflation of beauty and truth or with Weisberg's frank neo-Aristotelianism, his starting point is the important insight that, since law is made out of language, the style (which Aristotle parsed into *ethos, logos, pathos*) of that language is always significant.

12. Nussbaum's sociopolitical ethic is posited on the idea of an essentially rational universal human nature with capabilities that should have the right to develop as fully as possible. The problem with this construction is that it fails to acknowledge the contextual contingency—and alterity—of the aspirations of those who are not part of Western rationalist value systems. For a full critique of Nussbaum's neo-Aristotelian universalism see two excellent essays by Jane Flax, "On Encountering Incommensurability: Martha Nussbaum's Aristotelian Practice" and "A Constructionist Despite Herself? On Capacities and Their Discontents." Both are in *Controversies in Feminism,* ed. James P. Sterba (Lanham, Md.: Rowman and Littlefield, 2001), 25–57.

13. Interestingly, multinational economics has reinvigorated the major cities of the world. In their heterogeneity and power they have much more in common with the historical city-state and with each other's cultures than they do with the small town and rural areas in their own countries.

14. "Form of life" is Wittgenstein's phrase for dense cultural practices that can be identified by their "language games"—rule- and use-governed linguistic habits. By foregrounding such practices, one might analyze just how parts of Bourdieu's *habitus* work. Foucault's analysis of "docile bodies" in *Discipline and Punish* is another productive model.

15. I discuss this question in the last essay in this volume, "UNCAGED WORDS."

16. *Humorous* here, as elsewhere in this book, connotes a connection with its ancient and medieval definition linked to fluids—in this case, fluid conceptual principles that in their propensity for shifts enable invention and change even in the midst of the most difficult and chronic struggles.

17. It's become fashionable in sci-math circles to refer to this as complexity theory, but I like the idea of chaos with its history of redefinitions from (in Western terms) at least the first millennium B.C.E. on.

18. Georg Wilhelm Friedrich Hegel, *The Philosophy of History* (New York: Dover, 1956), 457.

19. An observation I owe to Brian Rotman's extraordinary book, *Signifying Nothing: The Semiotics of Zero* (New York: St. Martin's, 1987). It is from the starting point of his discussion of the vanishing point that I constructed my idea of the grammatical punctum as vanishing point toward which the syntactical momentum of sentence and paragraph race. See, e.g., "UNCAGED WORDS" in this volume.

20. This idea is implicit in many of the essays in this volume; still on the level of an elaborated hunch, I attempt to give examples of how this works in the essay on Gertrude Stein.

21. I elaborate on this in the essay "The Poethical Wager."

22. "Composition As Explanation," in *A Stein Reader,* ed. Ulla Dydo (Evanston, Ill.: Northwestern University Press, 1993), 495.

23. Throughout this book I use D. W. Winnicott's notion of "in-between zones" as the location of cultural poesis.

24. Bourdieu, *Logic of Practice,* 53.

25. Ibid., 56.

26. For an illuminating discussion of some new forms of reading that recent poetries demand see Juliana Spahr's *Everybody's Autonomy: Connective Reading and Collective Identity* (Tuscaloosa: University of Alabama Press, 2001).

27. Nietzsche's aphorism #146 lurks here: "He who fights monsters should be careful lest he thereby become a monster. And if thou gaze long into the abyss, the abyss will also gaze into thee" ("Apothegms and Interludes," from *Beyond Good and Evil,* in *The Philosophy of Nietzsche,* trans. Helen Zimmern [New York: Modern Library, Random House, 1954], 466).

28. Theodore Roethke. "The Waking," in *The Collected Poems of Theodore Roethke* (New York: Doubleday, 1961), 108.

THE POETHICAL WAGER

1. A. I. Melden, *Free Action* (London: Routledge and Kegan Paul, 1961).

2. See D. W. Winnicott, *Playing and Reality* (New York: Tavistock-Methuen, 1984). Of course, it's all "object relations."

3. See the essay by that name in this volume for a discussion of these issues in relation to the work of John Cage.

4. See more about Gadda in ":RE:THINKING:LITERARY:FEMINISM:" in this volume.

5. John Cage, *Silence* (Middletown, Conn.: Wesleyan University Press, 1961), 68.

6. Italo Calvino, *Six Memos for the Next Millennium:The Charles Eliot Norton Lectures, 1985–86* (Cambridge, Mass.: Harvard University Press, 1988), 106.

7. Gertrude Stein, *Blood on the Dining Room Floor* (Berkeley: Creative Arts Books, 1982). See "The Difficulties of Gertrude Stein" in this volume.

8. Calvino, *Six Memos,* 107.

9. Ibid.

10. Ibid., 108.

11. Francis Ponge, *The Power of Language,* trans. Serge Gavronsky (Berkeley: University of California Press, 1979), 8.

12. See "Cybernetic Explanation," in Gregory Bateson, *Steps to an Ecology of Mind* (New York: Ballantine, 1990), 410.

WAGER AS ESSAY

1. In Piet Mondrian, *The New Art—The New Life: The Collected Writings of Piet Mondrian*, ed. and trans. Harry Holtzman and Martin S. James (New York: Da Capo Press, 1993).

2. Tina Darragh, *a(gain)²st the odds* (Elmwood, Conn.: Potes & Poets Press, 1989), unpaginated.

3. Michel de Montaigne, *The Complete Essays of Montaigne*, trans. Donald M. Frame (Stanford, Calif.: Stanford University Press, 1980), 72.

4. Samuel Johnson, *Samuel Johnson's Dictionary: A Modern Selection*, ed. E. L. McAdam Jr. and George Milne (New York: Pantheon, 1964), 167.

5. These two quotes are from Frame, *Complete Essays*, vi.

6. Ibid., v.

7. A very interesting picture of actively interpretive, intertextual renaissance reading practices is currently being reconstructed from evidence that includes visual representations of scholars at work, library reading tables and stands with multiple books open at once and/or sprouting book marks, and of course the presence of copious marginalia. See, particularly, William H. Sherman's *John Dee: The Politics of Reading and Writing in the English Renaissance* (Amherst: University of Massachusetts Press, 1995).

8. Barbara Maria Stafford, *Artful Science: Enlightenment Entertainment and the Eclipse of Visual Education* (Cambridge, Mass.: MIT Press, 1994), 310.

9. In the medieval Catholic Church *curiositas* was a sin.

10. Kierkegaard also saw a form of intellectual play, irony, as a transitional mode between stages of moral development. See particularly his *Stages on Life's Way*.

11. Winnicott, *Playing and Reality*, 100. Winnicott's sense that creativity (the play of the active imagination) is what brings us into meaningful contact with realities beyond subjective space is what John Dewey simply terms experience. For Dewey the function of art is to restore a vivid connectedness to the world that we too often lose in cultures that tend to produce distracted, alienated adults. Winnicott's *Playing and Reality* and Dewey's *Art as Experience* can be read as working on the same problem—the life worth living. Interestingly, Dewey was skeptical of the kinds of play theories of art that stressed "make believe" origins of art in dream or fantasy states. He writes, "In art, the playful attitude becomes interest in the transformation of material to serve the purpose of a developing experience. Desire and need can be fulfilled only through objective material. . . . Art is *production* and that production occurs only through an objective material that has to be managed and ordered in accord with its *own* possibilities" (John Dewey, *Art as Experience* [Carbondale: Southern Illinois University Press, 1989], 284–85).

12. In Theodor Adorno, *Notes to Literature*, vol. 1, ed. Rolf Tiedemann, trans. Shierry Weber Nicholsen (New York: Columbia University Press, 1991).

13. Theodor Adorno, *Aesthetic Theory*, trans. C. Lenhardt, ed. Gretel Adorno and Rolf Tiedemann (London: Routledge and Kegan Paul, 1984), 262.

14. My critique of Judith Butler's use of "intelligibility" as a final criterion has, in part, to do with this. See ":RE:THINKING:LITERARY:FEMINISM:" in this volume.

15. Theodor Adorno, *Aesthetic Theory* (London: Routledge and Kegan Paul, 1984), 262.

16. Ibid.

17. See Bourdieu, *Logic of Practice,* esp. chap. 3, "Structures, *Habitus,* Practice," for a useful tool in thinking about habitually reinscribed "climates of thought" whose omnipresence and enormous power anyone interested in innovation and change worries about.

18. In this Judith Butler is very close to Adorno.

19. Gertrude Stein, "Composition As Explanation," in *A Stein Reader,* ed. Ulla E. Dydo (Evanston: Northwestern University Press, 1993), 497. The Stein quotes extracted below are also from this essay.

20. Perhaps in contrast to Adorno's *de*classified zone.

21. John Cage, *Silence* (Middletown, Conn.: Wesleyan University Press, 1961), 122.

22. Much of Waldrop's poetry is essayistic in form, as are her novels, insofar as they manifest their own contingency.

23. Rosmarie Waldrop, "Alarms and Excursions," in *The Politics of Poetic Form: Poetry and Public Policy,* ed. Charles Bernstein (New York: Roof, 1990), 45. For many years first-year students at Bard College have been reading this essay with excitement in the Language and Thinking program, entering their own alarms and excursions into conversation with her text and each other.

24. Leslie Scalapino, *Objects in the Terrifying Tense Longing from Taking Place* (New York: Roof, 1993), 67.

25. Leslie Scalapino, *New Time* (Hanover, N.H.: Wesleyan University Press, 1999), 11–12.

26. Wallace Stevens to Hi Simons, Jan. 9, 1940, in *Letters of Wallace Stevens,* ed. Holly Stevens (Berkeley: University of California Press, 1996), 349.

27. Wallace Stevens, *The Collected Poems of Wallace Stevens* (New York: Alfred A. Knopf, 1967), 9–10.

BLUE NOTES ON THE KNOW LEDGE

1. G. E. Moore, "Proof of an External World," in *Proceedings of the British Academy, 1939,* 294–95.

2. Both statements from Moore, "Proof of an External World."

3. Virginia Woolf, *The Waves* (New York: Harcourt, Brace and World, 1959), 132.

POETHICS OF THE IMPROBABLE

1. Rosmarie Waldrop, *The Hanky of Pippin's Daughter* (Barrytown, N.Y.: Station Hill Press, 1986), jacket copy.

2. Theodor W. Adorno, *Minima Moralia: Reflections from Damaged Life,* trans. E. F. N. Jephcott (London: Verso, 1985), 25.

THE EXPERIMENTAL FEMININE

1. For discussion of the relation between invention and tradition in science see the work of Thomas Kuhn, esp. *The Structure of Scientific Revolutions* (Chicago: University of Chicago Press, 1973) and the title essay in *The Essential Tension* (Chicago: University of Chicago Press, 1981).

2. *Euripides*, vol. 3 of *The Complete Greek Tragedies*, ed. David Grene and Richmond Lattimore (Chicago: University of Chicago Press, 1959), 645.

3. To forget the agonistic, dynamic disequilibria of feminine/masculine that has from the start given the characteristic shape to Western culture can lead to untenable positions of, e.g., phallogocentrism. Freud, in his fascination with Greek mythology, did a very selective reading of it. See my discussion of recent phallogocentrisms among feminist theorists in ":RE:THINKING:LITERARY:FEMINISM:" in this volume.

4. Rosmarie Waldrop, *Reproduction of Profiles* (New York: New Directions, 1987), 7.

5. See, e.g., Rosmarie Waldrop's "The Ground Is the Only Figure, Notebook Spring 1996," in *Impercipient Lecture Series* 1, no. 3 (April 1997); and Ann Lauterbach's series *The Night Sky* (I–VII), which appeared in *American Poetry Review* from 1996 to 1999.

6. Ludwig Wittgenstein, *Tractatus-Logico-Philosophicus*, trans. D. F. Pears and B. F. McGuinness (London: Routledge and Kegan Paul, 1969), 89.

7. See Hans Blumenberg's *The Legitimacy of the Modern Age* (Cambridge, Mass.: MIT Press, 1983) for a fascinating discussion of the obsession of the Church fathers with the sin of *curiositas* (which I, not he, label feminine) and the necessity to justify a methodical curiosity as "preparation for the Enlightenment."

8. Ibid., 159.

9. Masculine-Feminine—fluid, dialogic, and migratory principles; Determinism-Freedom—most recently construed in terms of cultural construction rather than metaphysics; Order-Disorder—transvalued out of invidious comparison by John Cage's aesthetic (where they become intention and chance) and by Chaos theorists as the interdependent terms of all complex systems.

10. In her brilliantly instructive and insightful account of ancient representations of women, *Sowing the Body,* Page duBois quotes the last lines of the character Clytemnestra in *Iphigeneia in Tauris:* "How know/That this is not a story merely told/That I may have relief from bitter pain?" Speculating, duBois goes on, "This story may be a lie; the narrative of the tragedy may be a lie; all stories may be lies to stop pain. So Euripides puts his own text into question" (164).

11. Gertrude Stein, *A Stein Reader,* ed. Ulla E. Dydo (Evanston, Ill.: Northwestern University Press, 1993), 505–6.

12. Anna Kisselgoff, "Inspired by the Traditions of Africa but Ruled by a Contemporary Spirit," *New York Times,* Oct. 6, 1999, B-5.

13. Stein, *A Stein Reader,* 496.

THE SCARLET AITCH

1. This is the grand finale of Hegel's philosophy of history: "Philosophy concerns itself only with the glory of the Idea mirroring itself in the History of the World...the justification of God in History. Only *this* insight can reconcile Spirit with the History of the World [which is] essentially His Work" (Hegel, *Philosophy of History,* 457). For Lacan the symbolic, i.e., all of human culture, is in the name of the father, which is the source of all law.

2. Francis Ponge, *The Power of Language,* trans. Serge Gavronsky (Berkeley: University of California Press, 1979), 8.

3. The French poet Dominique Fourcade has claimed this. For a discussion see ":RE:THINKING:LITERARY:FEMINISM:" in this volume.

4. See Nathaniel Hawthorne, *The Scarlet Letter* (New York: Norton, 1988), 4–34.

5. Ibid., 23–24.

6. "She gained from many people the reverence due to an angel" (ibid., 25).

7. This was published on the internet on the Edge Foundation Web site http://www.edge.org/documents, accessed 1999. Rotman's *Signifying Nothing: The Semiotics of Zero* (New York: St. Martin's, 1987) is an extraordinary book on the history of ideas related to zero.

8. See James R. Newman, "The Infinite Abelian Group of Angel Flights," in *The World of Mathematics,* 4 vols. (New York: Simon and Schuster, 1956), 1543.

9. For an interestingly different way of looking at these matters see Julia Kristeva's *Revolution in Poetic Language* (New York: Columbia University Press, 1984). Although I use very different conceptual coordinates and don't agree with its conclusions, I have found part 1 of this book, "The Semiotic and the Symbolic," very useful for thinking about ways in which modernist poetries had "to disturb the logic that dominated the social order" (83).

:RE:THINKING:LITERARY:FEMINISM:

1. My use of the word *feminine* reflects the cluster of attributes that have constituted its current cultural construction in the literature. I have no intention of identifying essential characteristics of a feminine nature. If such characteristics exist, I could not distinguish them from what is culturally inscribed. None of this is to imply that there are not temperamental attributes influenced by so-called hard wiring. Whatever these may be, however, they must exist in a range of degrees across genders, reflecting, e.g., the range of hormonal distributions. For my agonistic definition of male/female see "The Scarlet Aitch" in this volume.

2. Judith Butler, *Gender Trouble* (New York: Routledge, 1990). Parts of this essay are in conversation with *Gender Trouble,* which Butler asserts has been significantly superseded by her subsequent work, e.g., *Bodies That Matter* (New York: Routledge, 1993), but I've seen no real revision of the particular arguments in *Gender Trouble* that I'm addressing here.

3. Dominique Fourcade has said this at many public occasions and in print. See, e.g., an interview in the literary journal *Java*, no. 17 (summer/fall 1998): 64–65.

4. In *Playing and Reality* D. W. Winnicott makes this important distinction between imagination as playful "work," i.e., negotiating a reality principle, and fantasy, i.e., daydreaming without consequences.

5. This movement from a picture theory of language to a use theory draws on and parallels Wittgenstein's move from the Positivist ambitions of the *Tractatus Logico-Philosophicus* to the *Philosophical Investigations'* use theory, where language is seen as an activity inextricably intertwined with forms of life.

6. See Toril Moi, *Sexual/Textual Politics* (London: Methuen, 1985), 42–49, for an interesting discussion of the "deep realist bias of Anglo-American feminist criticism. An insistence on authenticity and truthful reproduction of the 'real world' as the highest literary values."

7. See Richard Rorty, *Philosophy and the Mirror of Nature* (Princeton, N.J.: Princeton University Press, 1980), for a wide-ranging analysis and critique of philosophical consequences of "mirror" theories of knowledge.

8. For an important discussion of the way in which the feminist desire for epistemological grounding leads to the rejection of postmodern theory see Jane Flax, "The End of Innocence," in *Feminists Theorize the Political*, ed. Judith Butler and Joan W. Scott (New York: Routledge, 1992), 445–63.

9. See Foucault's discussion in *Discipline and Punish* (135–69) of the preoccupation with "details" and "little things" that is part of the discipline of "docile bodies."

10. I wholly agree with Judith Butler's emphasis on the performative as enactment rather than expression but not its slide into performance—which is, I think, a *back*slide into an old female trap.

11. I owe this idea to Jerome McGann, who, in correspondence, wrote of truth as "troth."

12. In fact I want to argue that the most original and vital writing being done by women in this country today has come from a very different sort of literary tradition, one that has to do not with mirroring but with inventive poethical enactments. By the term *poethics* I refer to a practice of theory and literature that, following Wittgenstein, takes the primary force of language to be the way in which its uses are enactments, rather than portrayals, of forms of life. For discussions of this kind of poetic tradition see, e.g., Marjorie Perloff's *Poetics of Indeterminacy, Poetic License,* and *Radical Artifice*; Linda Reinfeld's *Language Poetry*; Charles Bernstein's *Content's Dream* and *A Poetics*; and Peter Quartermain's *Disjunctive Poetics*.

13. All of the leading lights in the received feminist canon have received prizes, awards, tenured professorships, endowed chairs from the literary and academic establishments. They are clearly not seen as fundamentally threatening to business as usual in the masculinized academy.

14. I want to distinguish between "patriarchal"—which denotes masculinist authority in the hands of male persons, and which I take to be the closest male equivalent to "feminist"—and "masculine," which denotes traits found in women as well as men.

15. See Freud's 1909 paper "Family Romances," which, although one of his briefest essays, securely seals the fate of his progeny to reenact their thralldom to his authority. My reason for conflating Freud and Lacan in a per*plex*ity for women is that the authority of the "law of the father" is already fully established by Freud; Lacan has merely to append the phallic-symbolic with its linguistic permutations.

16. This has been noticed as the only space left, in Freudian-Lacanian psychoanalytic theory, for a feminine not yet under the law of the father to exist. Hence the *premie* nature of those modes generically identified with the feminine by the psychoanalytic French feminists—pre-Oedipal, precultural, prelinguistic, presymbolic, i.e., generally *pre*(mature?)—in the semiotic of *"jouissance,"* unable to intermingle with cultural logics or to articulate itself linguistically. It is at this point that one must question the whole psychoanalytic structure, i.e., look outside it, no? Perhaps we must move *forward* into the "unintelligible" that is pushing at the developmental edge of what can be articulated rather than moving regressively into the prelinguistic, which can—by definition—never be articulated.

17. See Peter Gay's revealing discussion of Freud's literary ambitions—with respect to Goethe and Schnitzler—in *Freud, Jews, and Other Germans: Masters and Victims in Modernist Culture* (New York: Oxford University Press, 1978), esp. 51–55.

18. That Freud was indeed both intellectually and morally courageous, as well as aesthetically and intellectually vital and brilliant, is reason for admiration but not necessarily persuasion.

19. The multiple field of psychoanalysis has yielded other models that are enormously useful. D. W. Winnicott's is only one example. But mainstream feminism depends heavily on generic versions of Freudian-Lacanian theory.

20. Kierkegaard, iconic ironist himself, (ironically?) makes the point that irony is necessary to productive critique but is not itself a move to a new form or stage of development.

21. For an analysis of ancient Greek constructions of the feminine, and their movement from metaphor to metonymy, see Page duBois, *Sowing the Body: Psychoanalysis and Ancient Representations of Women* (Chicago: University of Chicago Press, 1988). Janet Wolff writes interestingly of modernist and postmodernist constructions of the feminine in her *Feminine Sentences: Essays on Women and Culture* (Berkeley: University of California Press, 1990).

22. Italics here and in the two subsequent quotations are mine.

23. My guess is that there were many women who ventured to write in experimentally creative feminine forms but that they were quickly silenced by the authoritative voices (parents, teachers, husbands...) around them: "This is incoherent and confused!" It certainly still happens today.

24. This is a radical shift in the gendered demographics of experimental poetry that directly reflects societywide shifts in gendered demographics following WW II—medical and civil rights developments that made it possible for women to take control of their reproductive processes.

25. In a more recent anthology of experimental poetry, Dennis Barone and Peter Ganick's *The Art of Practice,* twenty-three of the forty-five poets included

are women. Maggie O'Sullivan's *Out of Everywhere* and Mary Margaret Sloan's *Moving Borders* are the first two anthologies to be entirely devoted to linguistically innovative poetry by women. The two volumes of *Poems for the Millennium,* edited by Jerome Rothenberg and Pierre Joris, contain a nearly equal ratio of men and women.

26. In post-Lacanian psychoanalytic theory *jouissance* is the literal *"je ne sais quois"* experience of pre-Oedipal sensual pleasures. It is thought to be lost to direct articulation since its source is presymbolic and prelinguistic. It is also widely identified with the feminine, although Kristeva stresses that it has been experienced by, and is therefore available to, both men and women.

27. This fact is lost to most linguistic scientists, which may be the reason why French psychoanalytic theories of language, with their reliance on Saussure, consign language to a rationalist symbolic realm.

28. Tardos's text engages with a representative four (English, French, German, Hungarian) of the multiplicity of languages that articulate our globe, creating a web structure of cross-linguistic, intercultural "unintelligibility" that acts as a field of generous and suggestive semantic play.

THE DIFFICULTIES OF GERTRUDE STEIN, I & II

1. Gertrude Stein, *Blood on the Dining Room Floor* (Berkeley, Calif.: Creative Arts Books, 1982), 42.

2. Gertrude Stein, *How Writing Is Written,* ed. Robert Bartlett Haas (Los Angeles: Black Sparrow Press, 1974), 24.

3. Woolf, *The Waves,* 132.

4. Ibid., 238–39. This is not the first time in *The Waves* that Bernard longs for a language that could be a description of Samuel Beckett's.

5. Quoted in Deirdre Bair, *Samuel Beckett: A Biography* (New York: Harcourt Brace Jovanovich, 1978), 523.

6. John Upham's quote ends an article in the *New York Times* on the murder of two Dartmouth professors by two teenage boys from this small Vermont town. See *New York Times,* Feb. 20, 2001, A12.

7. I owe an enormous debt to Ulla Dydo for this and other information surrounding the events of the summer of 1933 on which *Blood* is based, as well as for crucial help in constructing a sense of the literary context of the book. We had many conversations about this piece over a number of years. Dydo's skepticism about its value (based in part on Stein's own disavowal of it) led me to think through my strong attraction to it in much more detail than I might have otherwise.

8. Ulla Dydo, manuscript of *The Language That Rises: The Voice of Gertrude Stein 1923–34* (Evanston, Ill.: Northwestern University Press, forthcoming 2003).

9. They are "The Horticulturists," "A Water-fall And A Piano," and "Is Dead." The first is unpublished; the others appear in *How Writing Is Written.* I take, from Ulla Dydo, the correct dates of the actual writing of these pieces to be 1933. (Haas gives the original publication date as 1936.) For more on the context of all four pieces see Dydo's *The Language That Rises.*

10. This in instructive contrast to the sunny *Our Town* of Thornton Wilder, with whom she would become friends in the following year. Wilder acknowledged being influenced by Stein's *The Making of Americans,* to the point of saying his play was based on her work. Their interesting friendship is documented in Edward M. Burns and Ulla E. Dydo, eds., *The Letters of Gertrude Stein and Thornton Wilder* (New Haven, Conn.: Yale University Press, 1996).

11. Winnicott locates all creative cultural development in such "intermediate" zones, where precarious acts of play test definitions of reality. See esp. D. W. Winnicott, *Playing and Reality* (New York: Tavistock-Methuen, 1984).

12. In contrast to those novels that are called experimental because of their psychological or psychosocial content.

13. In this essay I am beginning to apply a conjecture about the fractal nature of Stein's compositions with words. This is a thought experiment that is a work in progress for me. I will be examining fractals and the self-similar patterns of Stein's writing in greater detail—in relation to information theory and ideas of autopoiesis—in a volume on Stein to be published by the University of California Press. That book will include selections of Stein's work that are particularly relevant to this kind of reading.

14. See, e.g., "Why I Like Detective Stories" (which I discuss below) in *How Writing Is Written.*

15. Ludwig Wittgenstein, *Philosophical Investigations,* trans. G. E. M. Anscombe, 2d ed. (New York: Macmillan, 1967), ix (italics mine).

16. Stein, *How Writing Is Written,* 28–29.

17. Ibid., 151. This is so close in spirit and language to John Cage's thought on the position of the contemporary artist (see esp. Cage's "Lecture on Nothing," in *Silence* [Middletown, Conn.: Wesleyan University Press, 1961]) that I think it beautifully demonstrates Stein's influence—acknowledged by Cage—on his poetics.

18. Tallique's debt to D. W. Winnicott and Michel Foucault is clear in this passage.

19. The New York City Opera's year 2000 production of *The Mother of Us All* was a great triumph, praised by critics, playing to full houses in Lincoln Center.

20. See Stanley Cavell, "The Fact of Television," in *Video Culture: A Critical Investigation,* ed. John Hanhardt- (Rochester, N.Y.: Visual Studies Workshop Press, 1990).

21. See the interesting essay "Gertrude Stein on the Beach," in Gerald Weissmann, *The Doctor with Two Heads and Other Essays* (New York: Vintage Books, 1990).

22. All of Wallace's books are currently out of print. *Terrible People* was available only in a large-print edition (Leicester: Ulverscroft Press, 1967) in the Washington, D.C., area public library system.

23. "Sentences," in *How To Write* (Los Angeles, Calif.: Sun and Moon, 1995).

24. "Finally George A Vocabulary Of Thinking," in *How To Write,* 293.

25. Edgar Wallace, *The Mouthpiece* (1935; reprint, Bath: Chivers Press, 1963).

26. Gertrude Stein, *Last Operas And Plays,* ed. Carl Van Vechten (Baltimore: Johns Hopkins University Press, 1995), 74–75.

27. Ibid., 55.

28. Gertrude Stein, *Gertrude Stein: Writings,* ed. Catharine R. Stimpson and Harriet Chessman, vol. 2, *1932–1946* (New York: Library of America, 1998), 127.

GEOMETRIES OF ATTENTION

1. This textual score is in *Silence* (Middletown, Conn.: Wesleyan University Press, 1961), 109–10. Cage first performed it at the Artist's Club, New York City (according to his head note), in 1949 or 1950.

2. Ibid., 109.

3. Ibid., 109–12 (excerpted selections).

4. Ibid., 113.

FIG. 1, GROUND ZERO, FIG. 2

1. This essay is a revised version of one I wrote for presentation at the 1989 CageFest at Strathmore Hall in Rockville, Maryland.

2. See, e.g., "The Difficulties of Gertrude Stein" in this volume.

3. Cage was delivering his Norton Lectures *(I-VI)* at Harvard during the 1988–89 academic year. Audiences had difficulty with the sustained meditative, contemplative attention these performances invite.

4. James Gleick discusses this in his book *Chaos: Making a New Science* (New York: Viking, 1987). Although the book was written for a lay audience, every scientist I know who's read it admires it greatly.

5. Quoted in Richard Kostelanetz, *Conversing with Cage* (New York: Limelight Editions, 1988), 115.

6. John Cage, *A Year from Monday: New Lectures and Writings* (Middletown, Conn.: Wesleyan University Press, 1969), 31.

7. See Cage's discussion of why he dropped "form" as one of his compositional elements in John Cage and Joan Retallack, *MUSICAGE: John Cage in Conversation with Joan Retallack,* ed. Joan Retallack (Hanover, N.H.: Wesleyan University Press, 1996).

8. See ibid. for a detailed discussion.

9. Huang Po, "The Zen Teaching of Huang Po on the Transmission of Mind," in *The World of Zen: An East-West Anthology,* ed. Nancy Wilson Ross (New York: Vintage Books, 1960), 72–73.

10. In instructive agon with the Hegelianism he wanted to leave behind. Dewey spent most of his life as a philosopher advocating an "experimental attitude" in aesthetics, moral thought, and educational ideas. John Dewey was never entirely able to replace his early Hegelian roots with the almost Buddhist spiritual pragmatism he preferred in his later life.

11. John Dewey, *Art as Experience* (Carbondale: Southern Illinois University Press, 1989), 25.

POETHICS OF A COMPLEX REALISM

1. John Cage, conversation with author, July 1992.

2. See Martin Duberman, *Black Mountain: An Exploration in Community* (New York: E. P. Dutton, 1972), 102.

3. Cage, conversation with author, July 1992.

4. Descriptions from the MOMA "Summergarden 1992" program. In conversation the day before this performance, John Cage remarked that he had thought of "ASLSP" because of the passage toward the end of *Finnegans Wake* that begins, "Soft morning, city! Lsp! I am leafy speafing" (619 ff.). A pianist preparing to play *ASLSP* might profit from this passage. One finds, "I'll wait. And I'll wait. And then if all goes. What will be is. Is is. But let them" (620); "Sft! It is the softest morning that ever I can ever remember me. But she won't rain showerly, our Ilma. Yet. Until it's the time" (621); "A gentle motion all around. As leisure paces" (622); "Softly so" (624); "So soft this morning, ours" (628).

5. Mineko Grimmer's sculpture, created for violin performance of *One⁶*, consists of an inverted pyramid of ice encrusted with pebbles hung over a single piano wire stretched across a tank of water. As the ice melts, the pebbles fall into the water and, now and then, by chance, hit the piano wire. This has the remarkable effect of making the chance operations that produce the sounds visible.

6. Michael Bach developed a new kind of curved bow for the playing of Cage's music, with a mechanism that allows the cellist to vary the tension on the hairs while playing. As has always been the case in the history of music, the dialogue between composer and performer, music and technology, continually opens up new possibilities. John Cage, shortly before his death, was composing a piece for Michael Bach, exploring new microtonal and other musical possibilities linked to bowing technique. He began composing while I was taping for *MUSICAGE*. His remarks on what he was doing are included in the conversations on music in that text. See John Cage and Joan Retallack, *MUSICAGE: John Cage in Conversation with Joan Retallack*, ed. Joan Retallack (Hanover, N.H.: Wesleyan University Press, 1996), 285–90.

7. From Adorno's "Lyric Poetry and Society," quoted in Martin Jay, *Adorno* (Cambridge, Mass.: Harvard University Press, 1984), 155.

8. Marjorie Perloff also points this out in a discussion of *Lecture on the Weather* in her book *Radical Artifice* (21–28).

9. This is, notably, the metaphysical "traffic" of Epicurus's vision of the interplay of chance and determinism in the makeup of the universe. See my "High Adventures of Indeterminacy," in *"Parnassus": Twenty Years of "Poetry in Review"* (Ann Arbor, Mich.: University of Michigan Press, 1994). In his later years John Cage spoke often of "traffic" as the characteristic sound structure of contemporary life and therefore of his desire to incorporate it into the forms of his music. This was another part of his poethical imperative: to "make a piece of music in which we would be willing to live…a representation of a society in which you would be willing to live" (Cage, *I–VI*, 178). This meant working

within the logics of a complex realist aesthetic—one that enacts the complexity and the actual conditions of the society in which we live.

10. In 1963 Lorenz published the groundbreaking paper "Deterministic Nonperiodic Flow," *Journal of the Atmospheric Sciences* 20, no. 2 (March): 130–41.

11. Gleick, *Chaos*, 198. See also David Ruelle, *Chance and Chaos* (Princeton, N.J.: Princeton University Press, 1991), esp. chaps. 10 and 11, "Turbulence: Strange Attractors" and "Chaos: A New Paradigm," 57–72.

12. Both programs are in the C language and were developed by Andrew Culver.

13. This difference will not be as great in a Cage performance, however, as in the mathematical model of a weather system, and it will not necessarily undergo a progressive magnification. See note 14.

14. After a December 1992 conversation with James A. Yorke, director of the Institute for Physical Science and Technology at the University of Maryland, College Park, and the mathematician who coined the phrase *chaos theory*, I thought it seemed more accurate (within the language game of the current complex sciences) to describe the scores Cage submitted to chance operations as characterized by "deterministic randomness" (where *randomness* is the scientific term for the more colloquial *chance*) than "deterministic chaos." The critical difference between the mathematical behavior of what are currently called chaotic systems and the notation sound elements in a Cage score has to do with the degree and nature of predictability. In models of deterministic chaos there is a high degree of short-run predictability that degenerates (very quickly) into randomness, or increasingly amplified unpredictability, over time. In Cage's scores the degree of unpredictability remains constant. There is a built-in (to the *ic* and *tic* computer programs) equal distribution of randomness. The indeterminacy included in the notation and the permeability of performances to ambient sound and individual interpretations mean, however, that butterflies are continually flying into and transforming the atmosphere of Cage's compositions when they are realized in concert. (And in some cases there may be amplification of unpredictability in performance. See part V of my text.) This in turn means that Cage's music, as an aesthetic of weather, is closer in its structure to our everyday experience of weather than to the computer models in the complex sciences, which start with fewer variables and yield more discernible patterns. As James Yorke has said, "Weather is wilder than 'chaos.' " Why connect Cage's aesthetic paradigm with chaos theory then? Because in all other respects, except that which makes the difference between a complex realist aesthetics and a mathematical model of complexity, it resembles this new scientific paradigm.

15. I first came across this Smithson idea of "ruins in reverse" in Marjorie Perloff's *The Futurist Moment: Avant-Garde, Avant Guerre, and the Language of Rupture* (Chicago: University of Chicago Press, 1986), 199. It is from Smithson's essay "A Tour of the Monuments of Passaic, New Jersey," in *The Writings of Robert Smithson*, ed. Nancy Holt New York: New York University Press, 1979).

16. Cage published "Macrobiotic Cooking"—remarks and recipes—in Rod Smith, ed., *Aerial 6/7* (Washington, D.C.: Edge Books, 1991).

17. From "Autobiographical Statement," read at CageFest, Strathmore Hall, 1989. Published in John Cage, *John Cage: Writer,* ed. Richard Kostelanetz (New York: Limelight Editions, 1993), 238.

18. Cage and Retallack, *MUSICAGE,* 61.

19. From remarks at CageFest, Strathmore Hall, Rockville, Maryland, 1989.

20. Ruelle, *Chance and Chaos,* 163.

21. David Ruelle and Floris Takens, "On the Nature of Turbulence," *Communications in Mathematical Physics* 20 (1971): 167–192; 23 (1971): 343–44.

22. N. Katherine Hayles, *Chaos Bound: Orderly Disorder in Contemporary Literature and Science* (Ithaca, N.Y.: Cornell University Press, 1990). See her "Introduction: The Evolution of Chaos," 1–28. What Hayles is discussing in this book are structural, working definitions of chaos (i.e., methodological programs and their paradigms) in the sciences and images of chaos in contemporary literature (i.e., literature envisioning and referring to elements of chaos rather than formally exhibiting principles of its dynamics). I've been most interested in discussing this latter—formal experiments embodying and enacting some of the interesting characteristics of chaos and other complex dynamics in the contemporary avant-garde, e.g., Language poetry and, of course, the compositions of John Cage.

23. It is interesting that Cage's nonperiodic music has also been seen as a failure of the experiment.

24. What is perhaps most interesting in this is that Ruelle tells the story of Professor Chance in passing, without any of the rhetorical machinations—of, e.g., irony or allegory—one has come to expect when a stock narrative form confronts something stranger than its fictions. Either of these literary modes—irony, allegory—would empty this encounter with Professor Chance of its peculiar and complex contingency, even as it filled it with overdetermined, portentously simplifying meaning. "Professor Chance" as character in any kind of narrative fiction—and all narratives are fictions on one level or another—would be rendered memento mori to his own lost vitality as an unremarkable oddment of ordinary life.

25. Ruelle, *Chance and Chaos,* 67.

26. For example, in "Comment on the Relations of Science and Art"—a paper that begins, "For reasons which will appear, the problem of the avant-garde...has caught my interest in unexpected and, I hope, fruitful ways"—Thomas Kuhn writes:

> People like [E.M.] Hafner and me, to whom the similarities of science and art came as a revelation, have been concerned to stress that the artist, too, like the scientist, faces persistent technical problems which must be resolved in the pursuit of his [sic] craft. Even more we emphasize that the scientist, like the artist, is guided by aesthetic considerations and governed by established modes of perception. Those parallels still need to be both underlined and developed. We have only begun to discover the benefits of seeing science and art as one. (*Essential Tension,* 343)

27. Douglas F. Hofstadter, *Metamagical Themas* (New York: Basic Books, 1985), 777.

28. See the discussion of this method of composing by means of the practical implications of the idea of time in Cage and Retallack, *MUSICAGE.*

29. "Autobiographical Statement," CageFest, Strathmore Hall, 1989.

30. Cage, conversation with the author, April 1992.

31. Ibid.

UNCAGED WORDS

1. *For the Birds.* These words may not be precisely John Cage's at all. They are taken from his conversations with Daniel Charles, which have, as text, an odd history. *For the Birds* is an English translation of a French transcription of interviews taped in English. The tapes were lost before they could be transcribed directly into English, and Cage himself said he didn't recognize much of the voice labeled "J. C." at the end of all that. So the puzzling over these words is not so much trying to get at what was originally said, which is clearly irrecoverable, as trying to make useful meaning of words that have the attraction of initiating a process of active "not-knowing," opening an edge in the mind, beyond which lie things not thought of before. This is an exhilarating notion, even if self-delusory. It has to do with the structure of the reading experience, the structure of language itself.

2. Tosu is quoted in Daisetz T. Suzuki, *Zen and Japanese Culture* (Princeton, N.J.: Princeton University Press, 1970), 37. John Cage, *Empty Words: Writings '73–'78* (Middletown, Conn.: Wesleyan University Press, 1979), 11.

3. From manuscripts for "Mushrooms *et Variationes,*" NYC–Tulsa, Okla.–Mountain Lake, Va., September–October 1983.

4. John Cage, *Art Is Either a Complaint or Do Something Else,* in *MUSICAGE: Cage Muses on Words, Art, and Music,* ed. Joan Retallack (Hanover, N.H.: Wesleyan University Press, 1996), from part 2.

5. Quoted in Deirdre Bair, *Samuel Beckett: A Biography* (New York: Harcourt Brace Jovanovich, 1978), 523.

6. CageFest, Strathmore, Rockville, Maryland, 1989.

7. Jasper Johns quoted in Cage and Retallack, *MUSICAGE,* 4.

8. Andreas Huyssen, *After the Great Divide: Modernism, Mass Culture, Postmodernism* (Bloomington: Indiana University Press, 1986), 44–45.

9. See " The Difficulties of Gertrude Stein, I & II" in this volume for a more detailed treatment of this work.

10. C. S. Peirce, *Values in a Universe of Chance* (New York: Doubleday, 1958), 107.

11. Wallace Stevens, *The Collected Poems of Wallace Stevens* (New York: Alfred A. Knopf, 1967), 92–93.

12. Quoted in Cage, *Art Is Either,* 4.

Bibliography

Adorno, Theodor W. *Aesthetic Theory.* Ed. Gretel Adorno and Rolf Tiedemann. Trans. C. Lenhardt. London: Routledge and Kegan Paul, 1986.
————. *Minima Moralia: Reflections from Damaged Life.* Trans. E. F. N. Jephcott. London: Verso, 1985.
————. *Notes to Literature.* 2 vols. Ed. Rolf Tiedemann. Trans. Shierry Weber Nicholsen. New York: Columbia University Press, 1991–92.
————. *Prisms.* Trans. Samuel and Shierry Weber. Cambridge, Mass.: MIT Press, 1984.
Albiach, Anne-Marie. *État.* Trans. Keith Waldrop. Windsor, Vt.: Awede, 1989.
Allen, Henry. "Deneuve's Masculine Mystique." *Washington Post,* Saturday, January 2, 1993.
Aristotle. *The Basic Works of Aristotle.* Ed. Richard McKeon. New York: Random House, 1941.
Austin, J. L. "A Plea for Excuses" [1956]. In *Philosophical Papers.* London: Oxford University Press, 1961.
Bair, Deirdre. *Samuel Beckett: A Biography.* New York: Harcourt Brace Jovanovich, 1978.
Baker, Peter. *Onward: Contemporary Poetry & Poetics.* New York: Peter Lang, 1996.
Baraka, Amiri. *Transbluesency: Selected Poems, 1961–1995.* New York: Marsilio, 1995.
Barone, Dennis, and Peter Ganick, eds. *The Art of Practice: Forty-Five Contemporary Poets.* Elmwood, Conn.: Potes and Poets Press, 1993.
Barrett, W. P. *The Trial of Jeanne d'Arc: A Complete Translation of the Text of the Original Documents.* London: George Routledge and Sons, 1931.
Barthes, Roland. *A Lover's Discourse: Fragments.* Trans. Richard Howard. New York: Hill and Wang, 1978.

259

Bateson, Gregory. *Steps to an Ecology of Mind*. New York: Ballantine, 1990.
Baudrillard, Jean. *The Ecstasy of Communication*. New York: Semiotext(e), 1988.
———. *Simulations*. New York: Semiotext(e), 1983.
Beckett, Samuel. *How It Is*. New York: Grove Press, 1964.
———. *Stories and Texts for Nothing*. New York: Grove Press, 1967.
Benjamin, Walter. *The Arcades Project*. Trans. Howard Eiland and Kevin McLaughlin. Cambridge, Mass.: Belknap Press of Harvard University Press, 1999.
———. *Illuminations*. Ed. Hannah Arendt. Trans. Harry Zohn. New York: Schocken Books, 1978.
Bernstein, Charles. *Content's Dream: Essays 1975–1984*. Los Angeles: Sun and Moon Press, 1986.
———. *A Poetics*. Cambridge, Mass.: Harvard University Press, 1992.
———, ed. *The Politics of Poetic Form: Poetry and Public Policy*. New York: Roof, 1990.
Bettelheim, Bruno. *The Uses of Enchantment: The Meaning and Importance of Fairy Tales*. New York: Vintage Books, 1977.
Bloom, Harold. *The Anxiety of Influence: A Theory of Poetry*. New York: Oxford University Press, 1973.
———. *A Map of Misreading*. New York: Oxford University Press, 1975.
Blumenberg, Hans. *The Legitimacy of the Modern Age*. Trans. Robert M. Wallace. Cambridge, Mass.: MIT Press, 1983.
Bourdieu, Pierre. *The Logic of Practice*. Trans. Richard Nice. Stanford, Calif.: Stanford University Press, 1995.
Bowden, Charles. *Blue Desert*. Tucson: University of Arizona Press, 1986.
Brossard, Nicole. *Picture Theory*. Trans. Barbara Godard. New York: Roof, 1990.
Browne, Sir Thomas. *The Prose of Sir Thomas Browne*. Ed. Norman J. Endicott. New York: Anchor Books, Doubleday, 1967.
Burns, Edward M., and Ulla E. Dydo. *The Letters of Gertrude Stein and Thornton Wilder*. New Haven, Conn.: Yale University Press, 1996.
Butler, Judith. *Bodies That Matter: On the Discursive Limits of "Sex."* New York: Routledge, 1993.
———. *Gender Trouble: Feminism and the Subversion of Identity*. New York: Routledge, 1990.
Cabanne, Pierre. *Dialogues with Marcel Duchamp*. Trans. Ron Padgett. New York: Da Capo, 1979.
Cage, John. *I–VI*. Charles Eliot Norton Lectures, 1988–89. Hanover, N.H.: Wesleyan University Press, 1990.
———. *Art Is Either a Complaint or Do Something Else*. In *MUSICAGE: Cage Muses on Words, Art, Music*. Ed. Joan Retallack. Hanover, N.H.: Wesleyan University Press, 1996. First printed in *Aerial* 6/7. Washington, D.C.: Edge Books, 1991.
———. *Empty Words: Writings '73–'78*. Middletown, Conn.: Wesleyan University Press, 1979.

———. *For the Birds: John Cage in Conversation with Daniel Charles.* Boston: Marion Boyars, 1981.

———. "History of Experimental Music in the United States" [1958]. In *Silence.* Middletown, Conn.: Wesleyan University Press, 1961.

———. *John Cage: Writer.* Ed. Richard Kostelanetz. New York: Limelight Editions, 1993.

———. "Lecture on Nothing" [c. 1950]. In *Silence.* Middletown, Conn.: Wesleyan University Press, 1961.

———. "Lecture on the Weather" [1975]. In *Empty Words: Writings '73–'78.* Middletown, Conn.: Wesleyan University Press, 1979.

———. "Overpopulation and Art." In *John Cage: Composed in America,* ed. Marjorie Perloff and Charles Junkerman. Chicago: University of Chicago Press, 1994.

———. *Silence.* Middletown, Conn.: Wesleyan University Press, 1961.

———. *X: Writings '79–'82.* Middletown, Conn.: Wesleyan University Press, 1986.

———. *A Year from Monday: New Lectures and Writings.* Middletown, Conn.: Wesleyan University Press, 1969.

Cage, John, and Joan Retallack. *MUSICAGE: John Cage in Conversation with Joan Retallack.* Ed. Joan Retallack. Hanover, N.H.: Wesleyan University Press, 1996.

Callater, K. *Reports from Teerts Egdir: The Other Book.* Washington, D.C., and Paris: Pre-Post-Eros Editions, forthcoming.

Calvino, Italo. *Six Memos for the Next Millennium.* Trans. Patrick Creagh. Charles Eliot Norton Lectures, 1985–86. Cambridge: Harvard University Press, 1988.

Carroll, Lewis. *The Annotated Alice.* Introduction and notes by Martin Gardner. Cleveland: Forum Books, 1965.

Cavell, Stanley. "The Fact of Television." In *Video Culture: A Critical Investigation,* ed. John Hanhardt. Rochester, N.Y.: Visual Studies Workshop Press, 1990.

Cha, Theresa Hak Kyung. *Dictee.* New York: Tanam Press, 1982.

Conley, Verena Andermatt. *Hélène Cixous: Writing the Feminine.* Lincoln: University of Nebraska Press, 1991.

Darragh, Tina. *a(gain)²st the odds.* Elmwood, Conn.: Potes and Poets Press, 1989.

———. "Don't Face off the Fractals (Revisited)." In *a(gain)²st the odds.* Elmwood, Conn.: Potes and Poets Press, 1989.

———. *on the corner to off the corner.* College Park, Md.: Sun and Moon Press, 1981.

Dewey, John. *Art as Experience.* In John Dewey, *The Later Works, 1925–1953.* Ed. Jo Ann Boydston and Harriet Furst Simon. Vol. 10. Carbondale: Southern Illinois University Press, 1989.

———. *The Quest for Certainty: A Study of the Relation of Knowledge and Action.* New York: G. P. Putnam's Sons, 1929.

Dodds, E. R. *The Greeks and the Irrational.* Berkeley: University of California Press, 1966.

Duberman, Martin. *Black Mountain: An Explorations in Community*. New York: E. P. Dutton, 1972.

duBois, Page. *Centaurs and Amazons: Women and the Pre-History of the Great Chain of Being*. Ann Arbor: University of Michigan Press, 1991.

———. *Sowing the Body: Psychoanalysis and Ancient Representations of Women*. Chicago: University of Chicago Press, 1988.

Dydo, Ulla E. *The Language That Rises: The Voice of Gertrude Stein, 1923–34*. Evanston, Ill.: Northwestern University Press, 2003.

Epicurus. *The Epicurus Reader*. Trans. and ed. Brad Inwood and L. P. Gerson. Indianapolis: Hackett Publishing Co., 1994.

Euripides. *Complete Greek Tragedies*. Vol. 3. Ed. David Grene and Richmond Lattimore. Chicago: University of Chicago Press, 1959.

Flax, Jane. "A Constructionist Despite Herself? On Capacities and Their Discontents." In *Controversies in Feminism*, ed. James P. Sterba. Lanham, Md.: Rowman and Littlefield, 2001.

———. "On Encountering Incommensurability: Martha Nussbaum's Aristotelian Practice." In *Controversies in Feminism*, ed. James P. Sterba. Lanham, Md.: Rowman and Littlefield, 2001.

———. "The End of Innocence." In *Feminists Theorize the Political*, ed. Judith Butler and Joan W. Scott. New York: Routledge, 1992.

Foucault, Michel. *Discipline and Punish: The Birth of the Prison*. Trans. Alan Sheridan. New York: Vintage, 1979.

———. *The Foucault Reader*. Ed. Paul Rabinow. New York: Pantheon, 1984.

———. *Power/Knowledge: Selected Interviews and Other Writings 1972–1977*. Ed. Colin Gordon. New York: Pantheon Books, 1980.

Freud, Sigmund. *The Standard Edition of the Complete Psychological Works of Sigmund Freud*. Ed. and trans. James Strachey. London: Hogarth, 1973.

Fröller, Dita. *New Old World Marvels*. Washington, D.C., and Paris: Pre-Post-Eros Editions, forthcoming.

Fuller, Buckminster. *Ideas and Integrities: A Spontaneous Autobiographical Disclosure*. Englewood Cliffs, N. J.: Prentice-Hall, 1963.

Gadda, Carlo Emilio. *That Awful Mess on Via Merulana*. Trans. William Weaver. New York: George Braziller, 1965.

Gay, Peter. *Freud, Jews, and Other Germans: Masters and Victims in Modernist Culture*. New York: Oxford University Press, 1978.

Geertz, Clifford. *Local Knowledge: Future Essays in Interpretive Anthropology*. New York: Basic Books, 1983.

Gilligan, Carol. *In a Different Voice: Psychological Theory and Women's Development*. Cambridge: Harvard University Press, 1982.

Gleick, James. *Chaos: Making a New Science*. New York: Viking, 1987.

Gregory, R. L. *Eye and Brain*. New York: McGraw-Hill, 1979.

Harryman, Carla. *In the Mode Of*. La Laguna: Zasterle Press, 1991.

Hawthorne, Nathaniel. *The Scarlet Letter*. 3d ed. New York: Norton, 1988.

Hayles, N. Katherine. *Chaos Bound: Orderly Disorder in Contemporary Literature and Science*. Ithaca, N.Y.: Cornell University Press, 1990.

Hegel, Georg Wilhelm Friedrich. *The Philosophy of History*. Trans. J. Silbree. New York: Dover, 1956.

Heidegger, Martin. *Being and Time.* Trans. John Macquarrie and Edward Robinson. New York: Harper and Row, 1962.

Hejinian, Lyn. *Happily.* Sausalito, Calif.: Post-Apollo Press, 2000.

———. *Writing Is an Aid to Memory.* Berkeley, Calif.: The Figures, 1978.

Hofstadter, Douglas F. *Metamagical Themas: Questing for the Essence of Mind and Pattern.* New York: Basic Books, 1985.

Howe, Susan. *The Nonconformist's Memorial.* New York: New Directions, 1993.

———. *Pythagorean Silence.* Montemora Supplement. New York: Montemora Foundation, 1982.

Huang Po. "The Zen Teaching of Huang Po on the Transmission of Mind." In *The World of Zen: An East-West Anthology,* ed. Nancy Wilson Ross. New York: Vintage Books, 1960.

Huizinga, Johan. *Homo Ludens: A Study of the Play Element in Culture.* Boston: Beacon, 1955.

Huyssen, Andreas. *After the Great Divide: Modernism, Mass Culture, Postmodernism.* Bloomington: Indiana University Press, 1986.

Irigaray, Luce. *Ce sexe qui n'en est pas un.* Paris: Minuit, 1977.

———. *This Sex Which Is Not One.* Trans. Catherine Porter with Carolyn Burke. Ithaca, N.Y.: Cornell University Press, 1985.

———. *Speculum of the Other Woman.* Trans. Gillian Gill. Ithaca, N.Y.: Cornell University Press, 1985.

James, William. *The Principles of Psychology.* Vols. 1 and 2. New York: Dover, 1950.

———. *The Will to Believe.* New York: Dover, 1956.

Janik, Allan, and Stephen Toulmin. *Wittgenstein's Vienna.* New York: Simon and Schuster, 1973.

Jay, Martin. *Adorno.* Cambridge, Mass.: Harvard University Press, 1984.

Johnson, Samuel. *Samuel Johnson's Dictionary: A Modern Selection.* Ed. E.L. McAdam Jr. and George Milne. New York: Pantheon, 1964.

Joyce, James. *Finnegans Wake.* New York: Viking, 1959.

Kandinsky, Wassily. *Sounds.* Trans. Elizabeth R. Napier. New Haven, Conn.: Yale University Press, 1981.

Kant, Immanuel. *Critique of Judgement.* Trans. J.H. Bernard. New York: Hafner, 1951.

———. *Critique of Pure Reason.* Trans. Norman Kemp Smith. New York: St. Martin's, 1965.

Keller, Lynn, and Cristanne Miller, eds. *Feminist Measures: Soundings in Poetry and Theory.* Ann Arbor: University of Michigan Press, 1994.

Kenner, Hugh. *The Pound Era.* Berkeley: University of California Press, 1971.

Kierkegaard, Søren. *Either/Or.* 2 vols. Trans. David F. Swenson and Lillian Marvin Swenson. New York: Doubleday, 1959.

———. *Stages on Life's Way.* Trans. Walter Lowrie. New York: Schocken Books, 1969.

Kostelanetz, Richard. *Conversing with Cage.* New York : Limelight Editions, 1988.

Kristeva, Julia. *Desire in Language: A Semiotic Approach to Literature and Art.* Trans. Thomas Gora, Alice Jardine, and Leon S. Roudiez. New York: Columbia University Press, 1980.

———. *Revolution in Poetic Language.* Trans. Margaret Waller. New York: Columbia University Press, 1984.

Kuhn, Thomas S. *The Copernican Revolution: Planetary Astronomy in the Development of Western Thought.* Cambridge: Harvard University Press, 1974.

———. *The Essential Tension: Selected Studies in Scientific Tradition and Change.* Chicago: University of Chicago Press, 1981.

———. *The Structure of Scientific Revolutions.* 2d ed. Chicago: University of Chicago Press, 1973.

Lacan, Jacques. *Écrits.* Trans. Alan Sheridan. New York: Norton, 1977.

Lauterbach, Ann. "The Night Sky, I–VII." *American Poetry Review,* 1996–1999.

Lorenz, Edward N. "Deterministic Nonperiodic Flow." *Journal of the Atmospheric Sciences* 20, no. 2 (March 1963): 130–41.

———. *The Essence of Chaos.* Seattle: University of Washington Press, 1997.

Lucretius. *On the Nature of Things.* Trans. W. H. D. Rouse. Cambridge, Mass.: Harvard University Press, 1992.

Mandelbrot, Benoit B. *The Fractal Geometry of Nature.* New York: W. H. Freeman, 1983.

McGann, Jerome J. *The Textual Condition.* Princeton, N.J.: Princeton University Press, 1991.

McGuinnes, Brian. *Wittgenstein: A Life.* Berkeley: University of California Press, 1988.

Melden, A. I. *Free Action.* London: Routledge and Kegan Paul, 1961.

Melese, Pierre. *Samuel Beckett.* Paris: Éditions Seghers, 1966.

Messerli, Douglas, ed. *"Language" Poetries: An Anthology.* New York: New Directions, 1987.

Meyer, Steven. *Irresistible Dictation: Gertrude Stein and the Correlations of Writing and Science.* Stanford, Calif.: Stanford University Press, 2001.

Moi, Toril. *Sexual/Textual Politics: Feminist Literary Theory.* London: Methuen, 1985.

Mondrian, Piet. *The New Art—The New Life: The Collected Writings of Piet Mondrian.* Ed. and trans. Harry Holtzman and Martin S. James. New York: Da Capo Press, 1993.

Monk, Ray. *Ludwig Wittgenstein: The Duty of Genius.* New York: Free Press, 1990.

Montaigne, Michel de. *The Complete Essays of Montaigne.* Trans. Donald M. Frame. Stanford, Calif.: Stanford University Press, 1980.

Moore, G. E. "Proof of an External World." *Proceedings of the British Academy, 1939.*

Newman, James R. "The Infinite Abelian Group of Angel Flights." In *The World of Mathematics.* 4 vols. Ed. James R. Newman. New York: Simon and Schuster, 1956.

Nietzsche, Friedrich. *The Philosophy of Nietzsche.* Trans. Helen Zimmern. New York: Modern Library, Random House, 1954.

Nussbaum, Martha C. *Love's Knowledge: Essays on Philosophy and Litera-*
ture. New York: Oxford University Press, 1990.

Ostriker, Alicia Suskin. *Stealing the Language: The Emergence of Women's Po-*
etry in America. Boston: Beacon, 1986.

O'Sullivan, Maggie. *Out of Everywhere: Linguistically Innovative Poetry by*
Women in North America and the UK. London: Reality Street Editions,
1996.

Owens, Craig. "The Discourse of Others: Feminists and Postmodernism." In
The Anti-Aesthetic: Essays on Postmodern Culture, ed. Hal Foster. Seattle:
Bay Press, 1983.

Paulson, William R. *The Noise of Culture: Literary Texts in a World of Infor-*
mation. Ithaca, N.Y.: Cornell University Press, 1988.

Peirce, C.S. *Values in a Universe of Chance.* New York: Doubleday, 1958.

Perloff, Marjorie. *The Futurist Moment: Avant-Garde, Avant Guerre, and the*
Language of Rupture. Chicago: University of Chicago Press, 1986.

———. *Poetic License: Essays on Modernist and Postmodernist Lyric.*
Evanston, Ill.: Northwestern University Press, 1990.

———. *The Poetics of Indeterminacy: Rimbaud to Cage.* Princeton, N.J.:
Princeton University Press, 1981.

———. *Radical Artifice: Writing Poetry in the Age of Media.* Chicago: Univer-
sity of Chicago Press, 1991.

———. *Wittgenstein's Ladder: Poetic Language and the Strangeness of the Or-*
dinary. Chicago: University of Chicago Press, 1996.

Perloff, Marjorie, and Charles Junkerman, eds. *John Cage: Composed in Amer-*
ica. Chicago: University of Chicago Press, 1994.

Ponge, Francis. *The Power of Language.* Trans. Serge Gavronsky. Berkeley: Uni-
versity of California Press, 1979.

Prigogine, Ilya, and Isabelle Stengers. *Order out of Chaos: Man's New Dialogue*
with Nature. New York: Bantam, 1984.

Quant, S.M. *Manual for Desperate Times.* Washington, D.C., and Paris: Pre-
Post-Eros Editions, frothcoming.

Quartermain, Peter. *Disjunctive Poetics: From Gertrude Stein and Louis Zukof-*
sky to Susan Howe. New York: Cambridge University Press, 1992.

Raworth, Tom. *Clean & Well Lit.* New York: Roof, 1996.

Reeder, Ellen D. *Pandora: Women in Classical Greece.* Baltimore, Md.; and
Princeton, N.J.: Walters Art Gallery and Princeton University Press, 1995.

Reinfeld, Linda. *Language Poetry: Writing as Rescue.* Baton Rouge: Louisiana
State University Press, 1992.

Retallack, Joan. "High Adventures of Indeterminacy." In *"Parnassus": Twenty*
Years of "Poetry in Review." Ann Arbor, Mich. University of Michigan Press,
1994.

Rich, Adrienne. "Phantasia for Elvira Shatayev." In *The Dream of a Common*
Language: Poems, 1974–1977. New York: Norton, 1978.

Roethke, Theodore. "The Waking." In *The Waking, Poems: 1933–1953.* Gar-
den City, N.Y.: Doubleday, 1953.

Rorty, Richard. *Contingency, Irony, and Solidarity.* Cambridge, U.K.: Cam-
bridge University Press, 1989.

————. *Philosophy and the Mirror of Nature*. Princeton, N.J.: Princeton University Press, 1980.

Rothenberg, Jerome, and Pierre Joris, eds. *Poems for the Millennium: The University of California Book of Modern and Postmodern Poetry.* 2 vols. Berkeley: University of California Press, 1995, 1998.

Rotman, Brian. *Signifying Nothing: The Semiotics of Zero.* New York: St. Martin's, 1987.

Ruelle, David. *Chance and Chaos.* Princeton, N.J.: Princeton University Press, 1991.

Ruelle, David, and Floris Takens. "On the Nature of Turbulence." *Communications in Mathematical Physics* 20 (1971): 167–192; 23 (1971): 343–44.

Said, Edward W. *Orientalism.* New York: Vintage, 1979.

Sartre, Jean-Paul .*What Is Literature?* Trans. Bernard Frechtman. New York: Harper and Row, 1965.

Scalapino, Leslie. *New Time.* Hanover, N.H.: Wesleyan University Press, 1999.

————. *Objects in the Terrifying Tense Longing from Taking Place.* New York: Roof, 1994.

Sherman, William H. *John Dee: The Politics of Reading and Writing in the English Renaissance.* Amherst: University of Massachusetts Press, 1995.

Silliman, Ron, ed. *In the American Tree.* Orono, Maine: National Poetry Foundation, 1986.

Sloan, Mary Margaret. *Moving Borders: Three Decades of Innovative Writing by Women.* Jersey City, N.J.: Talisman House, 1998.

Smith, Rod, ed. *Aerial 6/7.* Washington, D.C.: Edge Books, 1991.

Smithson, Robert. *The Writings of Robert Smithson.* Ed. Nancy Holt. New York: New York University Press, 1979.

Spahr, Juliana. *Everybody's Autonomy: Connective Reading and Collective Identity.* Tuscaloosa: University of Alabama Press, 2001.

Spiegelman, Art. *Maus: A Survivor's Tale I: My Father Bleeds History.* New York: Pantheon, 1986.

Spinoza, Benedict. *Ethics.* New York: Hafner, 1957.

Stafford, Barbara Maria. *Artful Science: Enlightenment Entertainment and the Eclipse of Visual Education.* Cambridge, Mass.: MIT Press, 1994.

Stein, Gertrude. *Blood On The Dining Room Floor.* Berkeley, Calif.: Creative Arts Books, 1982.

————. "Composition As Explanation." In *A Stein Reader,* ed. Ulla Dydo. Evanston, Ill.: Northwestern University Press, 1993.

————. "An Elucidation." In *A Stein Reader,* ed. Ulla Dydo. Evanston, Ill.: Northwestern University Press, 1993.

————. *Gertrude Stein: Writings.* Edited by Catharine R. Stimpson and Harriet Chessman. Vol. 2, *1932–1946.* New York: Library of America, 1998.

————. *How To Write.* Los Angeles, Calif.: Sun and Moon, 1995.

————. *How Writing Is Written.* Ed. Robert Bartlett Haas. Los Angeles: Black Sparrow Press, 1974.

————. "How Writing Is Written." In *How Writing Is Written,* ed. Robert Bartlett Haas. Los Angeles: Black Sparrow Press, 1974.

———. *Last Operas And Plays.* Ed. Carl Van Vechten. Baltimore, Md.: Johns Hopkins University Press, 1995.

———. *A Stein Reader.* Ed. Ulla Dydo. Evanston, Ill.: Northwestern University Press, 1993.

———. "A Water-fall And A Piano." In *How Writing Is Written,* ed. Robert Bartlett Haas. Los Angeles: Black Sparrow Press, 1974.

———. "Why I Like Detective Stories." In *How Writing Is Written,* ed. Robert Bartlett Haas. Los Angeles: Black Sparrow Press, 1974.

Stevens, Holly, ed. *Letters of Wallace Stevens.* Berkeley: University of California Press, 1996.

Stevens, Wallace. *The Collected Poems of Wallace Stevens.* New York: Alfred A. Knopf, 1967.

Suzuki, Daisetz T. *Zen and Japanese Culture.* Princeton, N.J.: Princeton University Press, 1970.

Tallique, Genre. *GLANCES: An Unwritten Book.* Washington, D.C., and Paris: Pre-Post-Eros Editions, forthcoming.

Tardos, Anne. *Cat Licked the Garlic.* Vancouver: Tsunami Editions, 1992.

Tompkins, Jane, ed. *Reader-Response Criticism: From Formalism to Post-Structuralism.* Baltimore, Md.: Johns Hopkins University Press, 1994.

Vickery, Ann. *Leaving Lines of Gender: A Feminist Genealogy of Language Writing.* Hanover, N.H.: Wesleyan University Press, 2000.

Waldrop, Keith. *Water Marks.* Toronto: Underwhich Editions, 1987.

Waldrop, Rosmarie. "Alarms and Excursions." In *The Politics of Poetic Form,* ed. Charles Bernstein. New York: Roof, 1990.

———. *A Form of Taking It All.* Barrytown, N.Y.: Station Hill Press, 1990.

———. "The Ground Is the Only Figure, Notebook Spring 1996." *Impercipient Lecture Series* 1, no. 3 (April 1997).

———. *The Hanky of Pippin's Daughter.* Barrytown, N.Y.: Station Hill Press, 1986.

———. *"The Hanky of Pippin's Daughter"* and *"A Form/of Taking/It All."* Evanston, Ill.: Northwestern University Press, 2001.

———. *The Reproduction of Profiles.* New York: New Directions, 1987.

Wallace, Edgar. *The Mouthpiece.* 1935. Reprint, Bath: Chivers Press, 1963.

———. *Terrible People.* 1926. Reprint, Leicester: Ulverscroft, 1967.

Weissmann, Gerald. "Gertrude Stein on the Beach." In *The Doctor with Two Heads and Other Essays.* New York: Vintage Books, 1990.

Wildman, Eugene, comp. *Experiments in Prose.* Chicago: Swallow, 1969.

Williams, Emmett, comp. *An Anthology of Concrete Poetry.* New York: Something Else Press, 1967.

Winnicott, D.W. *Playing and Reality.* New York: Tavistock-Methuen, 1984.

Wittgenstein, Ludwig. *The Blue and Brown Books.* New York: Harper and Row, 1965.

———. *On Certainty.* New York: J. and J. Harper Editions, 1969.

———. *Culture and Value.* Chicago: University of Chicago Press, 1984.

———. *Philosophical Investigations.* Trans. G.E.M. Anscombe. 2d ed. New York: Macmillan, 1967.

————. *Tractatus Logico-Philosophicus.* Trans. D. F. Pears and B. F. McGuinness. London: Routledge and Kegan Paul, 1969.

Wolff, Janet. *Feminine Sentences: Essays on Women and Culture.* Berkeley: University of California Press, 1990.

Woolf, Virginia. *The Waves.* New York: Harcourt, Brace and World, 1959.

Acknowledgments
of Permissions

Although the essays in this book represent an ongoing inquiry into a cluster of issues that have occupied my mind for several decades, many began as somewhat different pieces for specific occasions. I am grateful to editors and conference organizers without whose invitations some of these essays would surely not exist.

The second epigraph to the introduction, "Essay as Wager," first appeared in *The New York Times* and is reprinted here by permission.

"The Poethical Wager" first appeared, in a shorter version, in *Onward: Contemporary Poetry and Poetics*, edited by Peter Baker. It is printed here by kind permission of Peter Lang Publishing, Inc., New York. ©1996. All Rights Reserved.

"Wager as Essay" first appeared in *Chicago Review* 40, no. 1 (spring 2003). The first epigraph to this essay appeared in Theodor W. Adorno, "The Essay as Form," in *Notes to Literature*, vol. 1, translated by Shierry Weber Nicholsen. It is reprinted here by permission of Columbia University Press, New York. © 1991.

"Blue Notes on the Know Ledge" began as an essay invited by Lyn Hejinian and Barrett Watten, editors of *Poetics Journal*, for their issue on Knowledge (no. 10, published in 1998) and also exists in another form as a lecture-performance with syncopated slides, presented at Modern Language Association in 1996; MOCA, Washington, D.C., in 1997; and Bard College in 1997.

"Poethics of the Improbable: Rosmarie Waldrop and the Uses of Form" was first printed in *Contemporary Literature* 40, no. 3, © 1999, as the introduction to "A Conversation with Rosmarie Waldrop." It is reprinted by kind permission of the University of Wisconsin Press. The first epigraph to this essay first appeared in the Contemporary Authors Autobiographical Series, by Rosmarie Waldrop, Gale Group, © 1998, Gale Group. Reprinted by permission of The Gale Group. The second epigraph to this essay first appeared in *Two Novels by Rosmarie Waldrop:*

"The Hanky of Pippin's Daughter" and "A For/of Taking/It All." It is reprinted here by permission of Northwestern University Press. © 2001.

"The Experimental Feminine" began as a talk for a symposium, "Special Knowledges: Giving Voice to the Silenced," October 1999, conceived and coordinated by Tol Foster, sponsored by the English Department at the University of Wisconsin, Madison.

"The Scarlet Aitch" was, in different versions and parts, delivered as a lecture at "Poetry and Ethics: The Question of Language," a symposium cosponsored by the Lannan Foundation and Georgetown University, February 2000; and at "Poetry and Ethics," a symposium organized by Joanne Molina and sponsored by the Department of Philosophy and Religion at the American University, March 28, 1998. The first epigraph to this essay first appeared in D. W. Winnicott, *Playing and Reality* (New York: Tavistock-Methuen, 1984). It is reprinted here by permission of Thomson Publishing Services Company.

":RE:THINKING:LITERARY:FEMINISM: (three essays onto shaky grounds)" first appeared in *Feminist Measures: Soundings in Poetry and Poetics,* ed. Lynn Keller and Cristanne Miller. It is reprinted by kind permission of the University of Michigan Press, Ann Arbor, © 1994. All Rights Reserved. The epigraph to this essay first appeared in Theresa Hak Kyung Cha, *Dictee* (New York: Tanam Press, 1982). It is reprinted here by permission of the University of California Press.

"The Difficulties of Gertrude Stein, I & II" is an expanded version of a lecture written for "Gertrude Stein @ The Millennium," a conference organized by Stephen Meyer at Washington University, St. Louis, February 1999. Part 1 was first published in *American Letters and Commentary,* no. 13 (2001).

"Geometries of Attention" first appeared in a somewhat different version, accompanied by a visual text, in *On Silence,* a special issue of *Performance Research* (volume 4, no. 3 [winter 1999]), edited by Claire MacDonald and published by Routledge (London).

"Fig. 1, Ground Zero, Fig. 2: John Cage—May 18, 2005" was written at the invitation of Marilyn Boyd DeReggi for a John Cage symposium at the Strathmore Hall Arts Center in Rockville, Maryland, in 1989. It was first published by Rod Smith in *Aerial* 5, Washington, D.C., 1989.

"Poethics of a Complex Realism" first appeared in *John Cage: Composed in America,* ed. Marjorie Perloff and Charles Junkerman. It is reprinted by kind permission of the University of Chicago Press. © 1994 by the University of Chicago. All rights reserved.

"UNCAGED WORDS: John Cage in Dialogue with Chance" was commissioned by Julie Lazar, curator at the Museum of Contemporary Art, Los Angeles, for the catalog accompanying the exhibition, *Rolywholyover A Circus* (Rizzoli: New York, 1993).

A manuscript page from John Cage's "Overpopulation and Art"—"my now does this"—is reproduced in the essay "Uncaged Words" by kind permission of the John Cage Trust.

A page from John Cage's *Empty Words: Writings '73–'78* (Middletown, Conn.: Wesleyan University Press, 1979) (All Rights Reserved) is reproduced for the essay "Fig. 1, Ground Zero, Fig. 2" by kind permission of Wesleyan University Press.

Index

Compositor: Impressions Book and Journal Services, Inc.
Text: 10/13 Sabon
Display: Sabon

The Poethical Wager

The publisher gratefully acknowledges the
generous contribution to this book provided by the
General Endowment Fund of the University of
California Press Associates.